# THE
# JOYOUS
# VISION

# THE JOYOUS VISION

## A Source Book for Elementary Art Appreciation

**AL HURWITZ**

Coordinator of Visual and Related Arts
Public Schools, Newton, Massachusetts

**STANLEY S. MADEJA**

Vice President and Director of
Aesthetic Education
CEMREL, INC.

PRENTICE-HALL, INC., *Englewood Cliffs, New Jersey* 07632

*Library of Congress Cataloging in Publication Data*

Hurwitz, Al.
    The joyous vision.

    Bibliography:  p.
    1. Art appreciation—Study and teaching
(Elementary)
    2. Art appreciation—Study and teaching (Secondary)
I. Madeja, Stanley S., joint author.  II. Title.
N350.H87        701'.18        76-30339
ISBN 0-13-511600-7

Printed in the United States of America
10  9  8  7  6  5  4  3

Prentice-Hall International, Inc., *London*
Prentice-Hall of Australia Pty. Limited, *Sydney*
Prentice-Hall of Canada, Ltd., *Toronto*
Prentice-Hall of India Private Limited, *New Delhi*
Prentice-Hall of Japan, Inc., *Tokyo*
Prentice-Hall of Southeast Asia Pte. Ltd., *Singapore*
Whitehall Books Limited, *Wellington, New Zealand*

*The authors would like to jointly dedicate this book to their parents who knew little of art but a lot about growing boys.*

Benjamin and Ruth Hurwitz
Stanley and Catherine Madeja

# CONTENTS

## ACKNOWLEDGEMENTS:

Since a book of this sort is rooted in actual classroom practice, we feel we owe a special thanks to the following people who have tried so hard to develop the study of art appreciation in school systems:

Judy Morse, Newton Ma.
Pauline Joseph, Newton,Ma.
David Baker, Brookline, Ma.
Del Dace,Ladue, Mo.
Henry Ray, Warminster, Pa.
Larry Winegar, Jefferson County, Co.
Larry Schultz, Jefferson County, Co.
Molly Murphy, Brookline, Ma.
Phil Yenawine, Metropolitan Museum, New York, N.Y.
Nancy Keuffner, The Cloisters, Metropolitan Museum of Art, New York, N.Y.
Nadine Meyers, CEMREL, Inc., St. Louis, Mo.
Jeri Changar, CEMREL, Inc., St. Louis, Mo.
Bette Acuff, Teacher's College, Columbia University

Katherine Kissane of National Gallery of Art and Elaine Zetes of the Museum of Fine Arts in Boston were also of great help during a period of stress.

Since a portion of this book was based on a doctoral dissertation at Penn. State University, we would like to acknowledge the patience and guidance of Dr. Paul Edmonston, Chairman, Prof. Yar Chomicky, Prof. George Zoretich, Dr. Kenneth Beitel, and Dr. Harlan Hoffa, Head of the Department of Art Education, Pennsylvania State University.

Our appreciation also to CEMREL, Inc., and the Aesthetic Education Program staff for the use of material developed in that program, also special thanks to Shelia Onuska for her editorial assistance, and the JDR 3rd Fund for permission to publish teachers guide materials.

Harcourt Brace Jovanovich, Inc., should also be publicly thanked for their permission to use the materials quoted in their book, CHILDREN AND THEIR ART by Charles D. Gaitskell and Al Hurwitz.

# THE
# JOYOUS
# VISION

# BACKGROUND FOR APPRECIATION: DEFINITION AND HISTORY

<span style="float:right">1</span>

## INTRODUCTION

Art education in the public schools cannot at present be considered to have a prominent place in the mainstream of general education. For too long, art educators, particularly in the elementary schools, have treated the visual arts as a concern separate from general education. This text has been formulated and designed for the use of the elementary school classroom teacher to aid in the teaching of art. It is only recently that art educators have talked about programs that broaden the base for visual arts in the schools. There is a need to look at training in the visual arts in the context not only of using the artist as a model for behavior but also of developing the critic, appreciator, or member of the art audience as acceptable models for behavior. The ultimate outcome for a program in the visual arts should be based on the students' obtaining a general aesthetic education in the visual arts that will make them appreciators of and participants in the visual arts and engage them in the making of art for their own pleasure or for professional development. This should be true of art education in the elementary schools as well as at the higher levels.

The teaching of art in the public schools is going through a major transition as a result of which more emphasis is being put on the appreciation of art objects. This change has been an important factor in broadening the art experiences of children in the schools. It is evident that a total art education program should contain activities that not only

engage the student in producing art objects but also have as a general outcome the development of appreciation, valuing, and knowledge of art objects. Art education should give students the competence to make informed judgments about the aesthetic merit of works of art. Art appreciation should be increasingly worked into a broader concept of art education on all levels. This can be accomplished by designing programs that provide students with relevant information and, at the same time, will excite and motivate them to further study about the subject.

The connotation of art appreciation as a subject for the chosen or talented few is an unfortunate inheritance from the past. It is the art educator's responsibility to make the art program in the elementary schools appeal to the broadest range of students and contain the broadest range of content and teaching approaches applicable to the visual arts. The content for the elementary school should be the teaching of art history, art appreciation, and studio skills. The teaching approaches should range from discussion and visual presentations about art to direct experiences with art materials.

As an illustration of the seriousness of the problem, a supervisor in a suburban school system discussed with the authors the conditions that prompted him to initiate a program of art appreciation in his school system:

*Ten high school students identified as being committed to the visual arts by their teachers were offered the opportunity to spend three half-day sessions working on an environmental sculpture project at the Boston Museum of Fine Arts. These students were to work with a visiting sculptor from New York City who enjoyed critical acclaim for his work. The first session at the museum introduced the artist to the students. They viewed his work on exhibition and through slides, and listened to his own point of view as an artist and as an individual. The students had the aims of the project explained to them and were encouraged to enter into a dialogue with the artist about any aspect of himself, his work, or the proposed project. An embarrassing pause occurred at this point—there was total silence. After their return to the school, however, the students were most vocal, and negative, about the introductory session and asked to be excused from further participation in the project. Some of their comments were: "He's not an artist"; "What a bore"; "Does he really believe that's art?" "It doesn't make any sense"; "Is he paid to do that junk?" "I couldn't understand a thing he said"; "Who's he trying to impress?" These are but a few of the observations made by these students who were confronted with an artist, an art form, and a proposed activity which was outside their realm of experience. The nature of the artist, the art form, and the project is not the issue addressed here, but rather the*

*nature of art instruction which prepares students to deal with such a "confrontation."*

*The students discussed in this anecdote had an average of eight years of formal art instruction in the public schools. They were skilled in making art through a variety of media and techniques but, contrary to assumptions which are rampant in current art curricula, the making of art doesn't necessarily insure an understanding of art, an understanding demonstrated in heightened perception, reflective thinking, the employment of critical skills, openness to new and unusual experiences, a tolerance of the unique, and the use of an arts vocabulary. The absence of such understanding was obvious in the instance just described. Unfortunately, this very situation, and others similar to it, are all too common and they provide ample evidence of a need for direct, planned, instruction which will lead students to a full understanding of the nature, role, and product of an artist.*

<div align="right">

David Baker
Brookline Massachusetts Schools

</div>

The entire field of art education in the 1970s has attempted to redefine and expand its goals. The concern of art educators is that art be presented as having a generalizable content that broadens the goals of general education, and that art education move away from a limited project-and-process art curriculum to one that is more representative of the total discipline of art.

The National Art Assessment Project in 1971 published a major statement on goals that expanded the content of art education to include outcomes relevant to art appreciation. These objectives were the basis for the development of test items for evaluation of the effectiveness of art programs. The general goals are, "To Perceive and Respond to Aspects of Art," "To Value Art as an Important Realm of Human Experience," "To Produce Works of Art," and "To Know about Art."

In reviewing these general objectives for the National Art Assessment Program, one can see that at least half of the program goals are within the area of art appreciation, and here the relevance of this text becomes apparent. A resource for curriculum development in art appreciation is needed to help the teacher meet the broader goals now defined on a national level.

This text is not a curriculum, but rather is a tool from which activities, teaching strategies, subject matter, and curriculum designs can be drawn and an instructional program be formulated that meets the goals of art education. It should be noted that art teachers and classroom teachers in the elementary grades have the primary responsibility for implementing the art programs. They are the curriculum developers, and this text has been developed to assist them in that process.

# THE ELEMENTS OF ART APPRECIATION

One of the basic difficulties confronting those concerned with art appreciation has been to define this activity in a way that expresses its many possibilities. Let us make an attempt to pin down this rather elusive term and rid it of extraneous connotations. Webster's New World Dictionary defines appreciation as "to think well of; value, enjoy; . . . to estimate the quality or worth of . . . to estimate rightly . . . to be fully or sensitively aware of."[1] This definition goes beyond that of the Oxford English Dictionary, which refers one to the fifteenth-century French verb *apprécier*, which means "to appraise."[2] Since it is possible to "enjoy" and "to be fully or sensitively aware of" (Webster) without necessarily "appraising," we may conclude that one definition of appreciation can be expressed as extending from knowledge about art to dealing with feelings about art. It seems clear that any definition of art appreciation must acknowledge both its cognitive and affective aspects; and we must bear in mind that, to many educators, there is a necessary tension between the relative importance of knowing and feeling. There is also the conviction that knowing can extend and increase feeling, and that it takes both to create a truly meaningful response in the viewer. The dilemma of defining appreciation was expressed clearly by Osborne, when he wrote:

> *"Appreciation" is one of those utility locutions, so common in every language, which has made its way in response to a felt need until it now seems so essential that no synonym or substitute comes easily to mind. Indeed, when some years ago a paper of mine was to be translated into Polish, it came as a surprise to me to realize that language has no equivalent term, and the difficulties which we experienced in rendering it satisfactorily brought to light ambiguities inherent in the English word. In a practical way we all know what "appreciation" means—or everyone seems to know until the question is put. Yet the concept is difficult to pin down and there is no authoritative definition of it.*[3]

Osborne then compares the difficulty of formally defining "appreciation" with that of defining the term "aesthetics," reminding us that in both cases the very vagueness of the words has, in a sense, contributed to their usefulness. Dictionary definitions can provide the basis for only a part of the total experience. Critics, aestheticians, and art educators all can contribute to a more complete interpretation of the term. Othanel Smith, for one, does not fully accept Webster's definition and makes a distinction between appreciation and enjoyment, stating

that appreciation requires "logical operations," such as defining, valuing, and explaining, not normally found in enjoyment.[4] "Logical operations," however, are often a prelude to understanding, which in turn can heighten the pleasure of viewing art.

## Beauty

If our definition of art appreciation is to encompass the factor of pleasure as well as the problem of logical operations, we will have to deal with such issues as empathy, perception, knowledge, and the critical process. But first let us consider the crucial problem of beauty.

In 1933, a popular text contained the statement that art appreciation involves understanding and enjoying beautiful things. It was felt that the student's ability to appreciate came from a cultivation of his sense of beauty, also called the "aesthetic sense."[5] Indeed, this attitude was so prevalent that many people were unwilling to accept as works of art anything but the sensually pleasing. Works that depicted violent, ugly, or confusing subjects were often rejected and misunderstood. Several critics became so alarmed at the appearance of this kind of art that one stated, "Never in history has there been a similar collective effort to produce distortion, mutilation, dissonance, riddles and monsters."[6]

In order to understand the whole range of art, however, it becomes necessary to go beyond such conventionally cherished values as beauty and sentiment to other concepts. A Francis Bacon painting that is distorted and perhaps even frightening may be regarded as beautiful because of the way it was conceived and executed. The apprehension of beauty is no longer a major issue in contemporary aesthetics, and it is safe to say that even young children can be moved by art works that may have disturbing content.

## Empathy

Another aspect of appreciation is found in the concept of *empathy:* the need for the viewer to identify as closely as possible with the concerns of the artist. The viewer's empathy with the work becomes an important factor in a teaching situation or in regarding an object. Such empathy may be so intensely subjective as to cloud aesthetic considerations. For example, one may feel empathy with a portrait of a close friend or a relative. It may be a poor painting, but the viewer has close ties with the subject and "connects" with it in spite of its weak aesthetic qualities. Attitudes toward a work that are more aesthetic in nature are those that

heighten appreciation of the shapes or colors used. The feelings that move the viewer to empathize with the aesthetic qualities of the work or the subject become important in the act of appreciating the art object.

In the broadest definition of appreciation, then, the process becomes a matter of not only estimating or describing the quality of things but also, in some way, giving them value. The use of the term "art" means that appreciation of an art object consists in giving value to the art object after attending to the aesthetic qualities embedded in the object and that consideration be given to the act of perceiving or recognizing the aesthetic qualities of an art object. Appreciation is impossible without some dialogue between the viewer and the art object. Such interaction is the process by which works of art are analyzed and criticized and is the basis of the study of art criticism.

### Knowledge

General knowledge about the art work itself can be a contributing factor to the appreciation processes. This knowledge may be about such things as the historical context in which the art work was created, the style of the period in which the work was created and some of the characteristics of that style, and information about the artist: who he or she was, how he or she was trained, and by whom he or she was influenced. Knowledge of this type can contribute to general appreciation of the object.

Another knowledge base that can be useful for art appreciation is an understanding of art elements. The viewer who has working definitions of such terms as balance, coherency, texture, color, form, line, and composition will be better able to appreciate the art form and will be more receptive to the totality of the work than one who does not.

The viewer who knows more about the art object should be better able to appreciate the overall aesthetic qualities of that object. Knowledge and appreciation are, however, not synonymous. Knowing about the arts does not necessarily assure appreciation . Knowing about art forms is only one part of the total process of art appreciation and should be viewed as a means rather than an end. Instead, knowledge about the art object should be regarded as a reinforcing factor in the total process of appreciation, and information should be introduced into art activities only when it is useful and appropriate to the situation. We can say that knowledge helps set the stage for a higher level of feeling. Knowledge consists not only of facts that can be committed to memory but also of the ability to identify the formal components of an art object.

## Perception

A thorough analysis of perception as it relates to works of art appears in the writings of Rudolf Arnheim. In his *Visual Thinking,* Arnheim gives some useful information on the character of the perceptive process as it relates to the viewing of a painting:

> *It is in works of art, for example, in paintings, that one can observe how the sense of vision uses its power of organization to the utmost. When an artist chooses a given site for one of his landscapes he not only selects and rearranges what he finds in nature; he must reorganize the whole visible matter to fit any order discovered, invented, purified by him. And just as the invention and elaboration of such an image is a long and often toilsome process, so the perceiving of a work of art is not accomplished suddenly. More typically, the observer starts from somewhere, tries to orient himself as to the main skeleton of the work, looks for the accents, experiments with a tentative framework in order to see whether it fits the total content, and so on. When the exploration is successful, the work is seen to repose comfortably in a congenial structure, which illuminates the work's meaning to the observer.* [7]

Perceiving the object in this way goes beyond merely looking at an object, as perception implies some intellectual process. Arnheim makes it quite clear that the perceptual process is a cognitive function of human intellect.

Art appreciation is closely linked to the ability of the individual to perceive the object. Simply observing or looking at a work and recognizing it for what it is—a painting, a sculpture, a picture—is the lowest level of appreciation. Further analysis and description of the objects, whether by recognition of the parts or by recognition of relationships between the parts or through knowledge about the object, become higher levels of appreciation.

Madeja defines four levels of perceptual learning that are based on the work of Arnheim. [8] The levels are (1) observation, (2) description of visual relationships, (3) selectivity, (4) and generalization of form.

### Levels of Perceptual Learning

**Observation:** If acute visual sensitivity is to be an outcome of art education, then one of the major skills that must be developed by the child is observation. The term "observation" is difficult to define

since it alludes to many levels of understanding. Some people may observe phenomena but not be able to analyze their visual content; others may see parts of the whole but never the total object; while others may observe colors but not relate them to other visual elements, such as shape or texture.

Madeja speculates that children can be taught to observe, just as they are taught to read. Art exercises in observation can be designed so that the child becomes conscious of various types of visual stimuli. The student can be trained through art, as in the science lab, to develop a capacity for receiving and judging a variety of visual phenomena. The section on Visual Games, later in this book, will deal with this area.

***Description of Visual Relationships:*** How children begin to handle relationships in existing visual phenomena may well determine their ability to select and generalize visually in and out of the context of his environment. It would seem logical that if children were able to recognize and describe either visually or orally relationships between such art elements as line, shape, color, and texture, their chances of later being able to generalize and discuss formal relationships would be enhanced.

This hypothesis is supported by Arnheim, who states that visual perception constantly involves the apprehension of relationships between the whole of the visual field and some item within it. Piaget concurs and thinks that the establishment of relationships is one of the principal cognitive mechanisms. In perception, such mental operations function within "rules of grouping by similarity" such as shape, color, movements, as described by Gestalt psychologists. However, Arnheim makes a distinction between those groupings:

> *Perceptual grouping is not simply the connections of items that are identical or resemble each other by some mechanical criterion. Rather, resemblance is relative: whether two items resemble each other or differ from each other in size or color depends on the distribution of these perceptual dimensions in the total field.* [9]

Art does not exist in itself but because of the elements within it; art exists in concert with shape, texture, or color. Therefore, a synthesis must eventually occur in instruction that introduces these elements into the "field" in a Gestalt. In art appreciation, the field is the work of art.

The implication of Arnheim's theories for instruction in art appreciation is that art activities should be created that have different struc-

tural orientations. The first step might be the description and recognition of visual relationships without an overall context. Using the element of shape, for instance, children might be given a varied group of blocks with geometric and nongeometric designs on them to sort along these two parameters in a series of problems. A second set of activities might use other structural elements, such as line or color, in relation to geometric or nongeometric shapes in environmental settings, as in a room or in a given group of paintings. In this way, these elements are brought into a visual context; they are no longer abstract concepts for the student. In Piaget's terms, this is "concrete" experience applied to the early stages of art appreciation. However, it is imperative that the transfer be made from these simple classification and sorting tasks that use the elements out of context to activities that engage the student in perceiving these elements in works of art.

*Selectivity:* The process of selection is similar to the method by which a photographer chooses parts out of the whole by using a camera's viewfinder. The problem of selectivity involves the cognitive function of recognition and the ordering and simplification of visual phenomena. Selectivity, thus, is a part of direct perception. Arnheim indicates that all cognitive activity presupposes selection and that the mind must focus on the subject to be considered and thereby lift it out of the continuum of the total given world. To establish the proper range —how much to include, how much to exclude—is the crucial aspect of problem solving. Perception is selective by its very nature.

Selection of visual phenomena from any given natural or artificial environment becomes the source of information for making aesthetic judgments. Children, given a visual stimulus, must sort out the irrelevant visual components and extract content that has meaning for them. When drawing, children are continually selecting from visual stimuli and making judgments about what to include and what not to include in their pictures. Selecting during the early years may be only a matter of making choices about the visual components, but later it implies the organization of visual elements into compositions. This elementary exercise in developing and using criteria for selection is a necessary step toward conceptual thinking and is as relevant to the creation of art as it is to the appreciation of art.

*Generalization of Form:* "Generalization of form" implies the ability to synthesize visual principles. It implies that the student will have the ability to analyze visual phenomena and then be able to make a verbal statement. "Generalization of form" also concerns the ability to take apparently unrelated visual phenomena and bring them into a generalizable whole. The ability to talk about or explain the work of art

in its totality and generalize about its content distinguishes this kind of perception from the others.

The simple recognition of the parts or elements of the work does not involve the larger context of the work. In generalizing the form of the work, the student should be concerned, for instance, with the relationship between the colors in the painting and the linear design used to hold the painting together or with how an artist has divided the canvas and created a geometric pattern that gives the illusion of positive and negative space. These are generalizations about the form of the work of art that characterize the total composition and the relationships that exist between the elements.

The implication of this learning continuum for art appreciation is that activities emphasized in each category can be used for heightening critical and appreciative skills in all the categories and that the outcomes of these activities need not be mutually exclusive. For example, tasks that require the descriptions of visual relationships in painting do not exclude selection, although the ultimate instructional outcome may be the student's ability to describe the visual content.

The perceptual skill inevitably becomes involved with the problem of analysis. When one speaks of "understanding," it is assumed that one refers to the cognitive aspect of appreciation. In this respect, we are asking the child to forgo his or her feelings for the moment and to bring some objective power of analysis to bear on his or her confrontation with the object. Where authorities differ is in their apprehension of the degree and kinds of activities that such an analytic process entails. Insofar as one cannot analyze without first looking and then being able to give some evidence of the process, we may assume that appreciative cognition begins in perception. Aesthetic experience also cannot be separated from a pre-existing body of knowledge, judgment, and classification in the experience of the participant.

Barnes has made a particularly strong case for visual acuity, which provides the rationale for a number of the games and devices developed later in the text that involve comparing, selecting, and arranging.[10] According to Barnes, most people have never really learned to see except in the sense of recognizing an object for what it is. Because their vision extends only so far, they feel that beyond it there exists some magic key to art knowledge that, once possessed, will unlock all the secrets of art. The "magic" consists only of learning to see selectively in terms of past experiences, of fixing the multitude of sensations available to us into an intelligible pattern.

While Barnes's viewponts on the role of perception in art appreciation are shared by most critics, we must again be reminded for the purposes of this discussion that not only do these same writers differ as

to how heightened perception in art is to be achieved, but few, if any, of them have recommendations for achieving this below the secondary school level.

### The Critical Process

Integrally linked to the perception of the object is analysis of that object. Ralph Smith describes his method of critical activity as proceeding through four stages: description, analysis, interpretation, and evaluation.[11] Feldman's classification is similar.[12] He begins with description, proceeds to formal analysis, and, like Smith, follows this with an interpretive and judgmental stage. Each views description, interpretation, and judgment in basically the same light, yet interprets in his own way the analytic stage.

Broudy, in turn, describes four levels of critical activity, each dealing with different aspects of the work:

1. *The vividness and intensity of the sensuous elements in the works of art; the affective quality of the sounds, gestures, and so on.*

2. *The formal qualities of the object, its design and composition.*

3. *The technical merits of the object, the skill with which the work is carried out.*

4. *The expressive significance of the object, its import or message or meaning as aesthetically expressed.*[13]

While Broudy does not include judgment as a fifth level, his writing in general seems to place great value upon it.

Critical procedure is also suggested by Barkan and Chapman in *Guidelines for Art Instruction Through Television for Elementary Schools.*[14] In this publication, one of the few to deal with appreciation or aesthetic education for the elementary level, constant reference is made to description, interpretation, and explanation as levels of instruction, with judgment referred to as "tentative," that is, holding the percipient open to modification "in light of new experience and information."

One characteristic shared by all discussions of the critical process is the emphasis upon integrity of the art product and its effect upon the respondent. It is this belief in the value of the viewing experience as it relates to the contemplation of the art work that constitutes the most significant meeting ground of the viewer and the aesthetic properties of the art object.

In order to do justice to appreciative "knowing," one cannot scatter one's attentions. The object must be isolated as a focus of attention so that all of the perceptual, emotional, and intellectual resources of the respondent may be organized for greatest effect. This brings us back to the other shared view of appreciation and aesthetic education: the need for a critical process that can provide a bridge between a raw affective "psychological report" and a judgment whose defense relies on the logical processes. Another analysis of such a process is made by Ecker.[15] He divides the child's aesthetic judgment into two parts: a psychological report and value judgments. Ecker contends that when one looks at a work of art or an art event like a painting and responds to it by saying simply "I don't like it," or "I like it," this is only a psychological report, whereas value judgments are responses supported by arguments or evidence. On this basis Ecker develops a four-step strategy for teaching aesthetic judgment. Initially, the student learns to distinguish between psychological reports and value judgments. Finally, the student's contact with various art forms is broadened in order to enhance his ability to justify the merit of an object or event, whether he likes it or not. We would not in this text recommend classic criteria for what is beautiful and what is ugly and what is good art and what is bad art. What is implied here is that the nature of art appreciation lies in the *process* of perceiving rather than in learning various criteria on which to judge art. We think this is consistent with the changing nature of the art forms, as well as with what a school should be teaching relative to the visual arts. It is inconsistent to study art forms in any static format since the forms themselves are continually changing. Therefore, the implication for art appreciation in the school in the 1970s is that one *can* teach about the critical process but the student ultimately will have to formulate his or her own criteria based on knowledge of the elements that make up the work, the techniques used by the artist, and the context in which the work was created.

From this brief attempt at a theoretical basis for appreciation, it is possible to reach some consensus on terminology used to describe critical analysis; however, there is less agreement on the process itself. In general, we may say that the engagement of viewers in the critical process becomes an analytic method by which they (1) perceive the work of art; (2) describe the work of art; (3) become conscious of the qualities of the work and analyze its substance; and (4) make a qualitative aesthetic judgment about the merit of the work only after having experienced the previous three steps. These steps become important to the teaching of art appreciation as they are translated into activities for students. They form the process by which appreciation of art objects is heightened and taught and, we hope, enjoyed with greater intensity.

# DEFINING ART APPRECIATION
# FOR THE ELEMENTARY SCHOOL

## Emotional Appreciation/Intellectual Appreciation

When in 1942 Leon Winslow defined the term art appreciation for the elementary school, he described it as "the act of evaluating, understanding and experiencing art or any expression of art through sensitive awareness of design and perception of worth or value."[16] As he saw it, appreciation had two components: an emotional type of appreciation based upon the pleasure and insight derived from the experience, and an intellectual type of appreciation, based on an understanding of the principles and techniques involved as well as on the pride in being able to distinguish items of aesthetic value.

The shift in emphasis from such terms as "emotion," "pleasure," and "satisfaction" to such phrases as "skills of observation" and "critical judgment" is symptomatic of the changes that time has brought about. However, the relationship between analysis and emotional response has been posed with great frequency in the past three decades and remains yet to be clearly described.

As in all developing theories, care must be taken to avoid excesses on either side—and, in this case, particularly on the side of the current trend of analysis. One cannot take the theory and push it to its extreme. It seems clear that an art object cannot be understood solely by studying its individual components, although this process can have value. Irving Kaufman, while acknowledging that the structure of art objects deserves our attention, also notes that other factors must be considered: spiritual mystery, intensity, and integrity—values that may resist logical analysis.[17]

Of special interest to the teacher is philosopher Eugene Kaelin's acceptance of studio as well as discursive activity, for both are seen as acceptable to him as long as either process fulfills sound critical procedure—that is, using the art object as the major area of concentration. One tenet of phenomenological belief that could be questioned by the elementary art teacher is Kaelin's distrust of associative information. In his description of the "autonomy principle," Kaelin states, "No means are applicable which are imported into the process from another context."[18] Kaelin's distrust of "other contexts," however, may prove to be groundless in the classroom. Once aroused, the curiosity of children can often lead to behavior that might be considered critically invalid by professional critics, but highly relevant by a sixth grader. For example, how can "imported"—that is, associative—information be avoided

when a child wants to know why Vincent van Gogh, in a self-portrait, had a towel wrapped around his head?

There are times, obviously, when information that lies apart from the object cannot be avoided. The problem for the teacher is to use facts in such a manner as not to draw attention away from the main problem. Children, after all, love anecdotes and stories and are fascinated by personalities, and it is all too easy for teacher to capitalize on students' love of the sensational. Kaelin's insistence upon the total elimination of the extraneous is understandable for a teacher in the university. Children, on the other hand, are interested in many contexts of art, and to deny this interest may be to withhold information that may be crucial in building and maintaining interest. If we can accept the child's breadth of view, the door is open to quite a different means to developing response: the whole realm of multisensory reaction is now available to the teacher.

### Multisensory Response

Thus far, we have dealt with a critical foundation for art appreciation. A number of authorities have been cited to support the idea of intellectual, perceptual processes that engage the viewer in suggested sequences or orders of experiences—depending primarily on verbal evidence of perceptual acuity. The multisensory method, which in many ways runs counter to this, is currently in great favor in museum education. Museums deal with large numbers of children, and docents and teachers have, for the past few years, been developing new methods of involving children with art works. The multisensory method takes a broader view of empathy and invites the children to identify in many more ways with the art work. Reaction thus goes beyond language into gesture, and language itself becomes less descriptive and analytical, more poetic, metaphoric, and personally expressive. Children may be asked not only to describe the movement in a sculpture in terms of its design intent but also to assume physically the positions themselves. Parallel body movements, group body sculpture, or positions that are choreographed into simple dance patterns are often included.

The idea of sensory interaction also suggests fresh approaches to the use of visual resources. A 20-foot screen of an architectural study viewed in a small area invites greater participation than a small screen in a large room, and even the choice of the art works themselves must be reevaluated. Still lifes or intimate genre subjects are not as emotionally effective as full-scale Dutch interiors, a Bierstadt landscape, an historical scene by John Trumbull, a Piranesi dungeon, or Kurt Schwit-

ters' *Merzbau*. The child's total sensory apparatus can be brought to bear upon an art work, and we will see in later examples how the game "Receiving Pictures" asks children to respond in terms of smell, sound, movement, and touch.

We are now faced with two apparently opposing roads to appreciation, one based directly upon analysis of an art work and the other perceiving the work as a source of a variety of sensory reactions. It is the view of this book that both systems are valid and necessary components of a total process of appreciation. One approach may be more appropriate for one group as opposed to another; indeed, sensory approaches probably make more sense for primary-school children, whose vocabulary level may not allow for an effective descriptive/analytic method. Sensory approaches also are effective in setting the stage for other methods in that they involve children immediately and hold their attention for another level of engagement. Indeed, one may go so far as to say that any process that keeps children in the presence of an art work, that engages their curiosity and sense of pleasure, has merit.

The diagram below indicates three approaches to appreciation based upon proximity to the object under study.

*Phenomenological Approach:*
—Critical process based upon
—Description
—Analysis
—Interpretation

*Associative Approaches:* not directly related to the object. Uses biographical material, anecdotes, etc.

*Multisensory Approach:* utilizing full array of sensory other forms of empathic responses. The art work as stimuli for non-verbal reactions.

The teacher is the one who must decide upon the boundaries of the object. Must *all* of the issues be embedded in the image, or can the image, as a reflection of the artist's personality, culture, sex, or other factors, extend into other realms of meaning that invite exploration? The ultimate question may be: what kinds of knowledge *about* an event

enhance response? Such questions lie at the heart of the phenomeno-
logical debate, and, in seeking answers, teachers will have to keep their
eyes on the students as well as on the theory.

### Objects for Study: Natural Versus Artificial

No writer referred to has set any priority upon the kinds of art objects
to be appreciated. Indeed, the process of aesthetic and perceptual re-
sponse can be applied to both natural and artificial objects, although,
obviously, studio activity produces forms that only artists can create,
and, while attention can be focused upon natural objects, such as peb-
bles, microscopic forms, and erosion patterns, only the work of an artist
can lend itself to the examination of levels of meaning and content.
Consequently, the natural rather than the art object as a vehicle for
creating awareness has definite limitations. A pebble, while possessing
its own set of characteristics, has a relatively limited sphere of associa-
tion when compared to the mass of pebbles that make up a particular
tonal area in a painting.

Paintings, in and of themselves, are also believed to be more affec-
tive and value-laden in terms of student interest than natural objects.
Pepper is sensitive to such differences when he states:

> The main concern of aesthetic criticism is with works of art.
> Objects of nature—shells, ferns, mosses, trees, insects, animals,
> snowflakes, rock formatry, mountains, water, clouds, the sun
> and moon—come in for aesthetic approval and delight and the
> aesthetic perception of them is essentially the same as that for
> works of art, but not being objects of human construction they
> have not so urgently called for human criticism. Perhaps they
> should but in fact they rarely do. The great controversies of
> aesthetic judgment rotate about works of art. The practical field
> of aesthetic criticism is thus smaller than the total aesthetic
> field. It is the field of works of art. [19]

Once the distinction between study in the natural versus the artifi-
cial environment is drawn, the study of all patterns and shapes in nature
can be used as an adjunct of any sharpening of visual activity as long
as it is used in supporting the study of art objects. Study pebbles, by all
means, but only if the study has bearing upon some issue that resides
in the art object.

### Defining Art Appreciation for the Elementary Level

Now we are coming to a definition of art appreciation that has workable
implications for elementary school instruction. Art appreciation as it

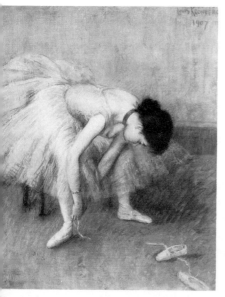

*reparing for the Dance* Louis Kronberg, Signed and dated 907. Bequest of Grace M. Edwards in memory of her mother, ᵤlia Cheney Edwards. Courtesy Museum of Fine Arts, Boston

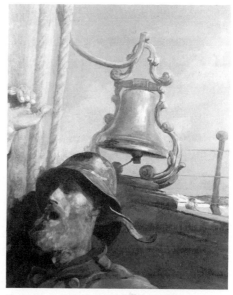

*The Lookout—"All's Well"* Winslow Homer Signed and dated 1896. Oil on canvas. 40 X 30¼ in. William Wilkins Warren Fund. Courtesy Museum of Fine Arts, Boston.

**When selecting objects for study, one should pay attention to the subject of the work. Prolonged associations with paintings will make children conscious of issues that exist apart from subject. These paintings were selected as "favorites" by a group of fourth graders.**

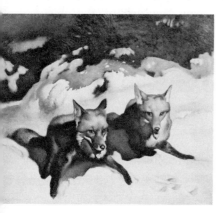

ᵥo *Foxes* George H. Hallowell American, 1871–1926 Gift of ᵉderick L. Jack. Courtesy Museum of Fine Arts, Boston.

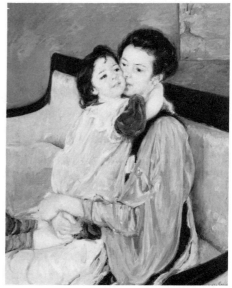

*Mother and Child* Mary Cassatt Signed. Painted about 1902. Oil on canvas. 36½ X 29 in. Gift of Aimee Lamb in memory of Mr. and Mrs. Horatio A. Lamb. Courtesy Museum of Fine Arts, Boston.

*background for appreciation: definition and history* **17**

involves children requires a confrontation between child and object and is composed of a series of interactions. This transaction is a complex of processes in part perceptual, in part emotional, in part intuitive; it is also associative in that the young respondent brings to bear on the experience those cultural and experiential endowments that are part of the total personality. Children respond to art in a holistic manner; their reactions are immediate, subjective, and rarely go beyond the "like/don't-like" stage. We may say that children are not really natural appreciators since appreciating requires some reflective process that goes beyond the stage of snap judgments. We may also assume that it takes a sensitive teacher to help educate the vision of the child so that appreciation may occur.

At one time or another the teacher may call upon a variety of resources in order to involve the child. As we will see, there is a time for emotions to take the center of the stage and a time for reason and reasoned language; there are situations where sound and movement may be called upon, and times when studio activity can provide the necessary link. This book will deal with a variety of approaches, yet all the views represented share a certain core of belief: that the art work is the major focus of attention and that dealing with art works is essentially a stimulating, worthwhile, and pleasurable enterprise.

## PROCESSES OF ART APPRECIATION

In this book we are attempting to put art appreciation into the context of art education and instruction in general. Art appreciation need not be a matter separate from the general concerns of art education or general education. The authors look upon appreciation as an interactive process that takes place between the viewer, the teacher, the object, and the setting. These four components make up the art appreciation process and contribute to the total art experience. How they are utilized and emphasized will vary with the teaching styles and nature of the content. Each plays a significant role in the teaching of art appreciation in the classroom.

### The Viewers

The viewers—in most cases, students—bring to the appreciation of the object their personal knowledge and cultural background, which affect their attitudes and perception of art forms. Their overall ability to perceive, both psychological and physiological; their level of development, that is, their age and maturity; their receptiveness and openness

toward the objects and events that they view—all will have an effect on their ability to appreciate art.

### The Teacher

All the factors that affect the students as viewers would also affect the teacher. The teacher, however, acts in an additional capacity as an intermediary between the students and the art object. The teacher's role is to develop insights for the students in terms of the five dimensions of the viewer. The teacher increases the students' perceptions of the work by designing instructional strategies and techniques that can expand the students' knowledge about the work itself. The teacher has many ways and methods for accomplishing outcomes outlined in this text. These become resources and strategies for the teacher to develop interaction between the student and the work. Teachers, too, should educate themselves. The greater the knowledge the teacher brings to the teaching of art appreciation, the more it will enhance his or her ability to teach the content and develop exciting and engaging activities for the students. This implies that the teacher must also have an ongoing program of art education for personal development that will broaden the experience of the student in the art appreciation process.

### The Object

In an art appreciation program, the most important part of the program is the art object to be studied. The art object can be a means for excitement, motivation, and enrichment of the program. It is the stimulus on which the program depends for developing and maintaining student interest and providing the content. A soundly conceived program is judged not on how well the student accumulates the facts and information about a work or art object, but on its contribution to the student's ability to perceive the aesthetic qualities of the work. This is the primary goal of the art appreciation program.

### The Setting

The location of the instructional program plays an important part in the effectiveness of the art apprecition process. Where is the instructional experience carried out? In the school, in the community, in the museum, or in a combination of settings? The classroom should not be the only setting for the art appreciation program. The museum, the community, the artist's studio are all places where appreciative activities can occur. The interaction between the student, the work, the artist,

and the setting is a positive element in the total teaching process. The setting can enhance and enrich the content and the concepts to be presented to the student and cannot be ignored.

In sum, the viewer, the teacher, the object, and the setting all relate to the art appreciation process, and the interaction between them constitutes the instructional program for art appreciation.

# A GLANCE BACKWARD:
# THE TEACHING OF ART APPRECIATION

In order to understand fully the changing character of art appreciation during this century, it would be necessary to make a close study of art curriculum guides, textbooks in art education, the professional literature, national and regional publications, dissertations, research material, and project reports of the U.S. Office of Education and the Department of Health, Education, and Welfare over the past seventy-six years. Although historical study is not our purpose, it may be advisable to cite a few significant perspectives that the past can offer in order to arrive at our view of art appreciation.

It is not easy to separate the history of appreciation from the development of general concerns in art education. In some instances the distinction is clear; in others the boundaries become blurred. There are also times when a change in the nature of instruction in appreciation is the result of a shift of emphasis elsewhere in the curriculum. Since this study is concerned primarily with appreciation, adjacent areas of art education will be discussed only as they relate to the subject under consideration.

For purposes of clarity, this section has been divided into chronological periods. Of course, these distinctions are not meant to be precise; trends come, go, and return, and writers may extend their influence over long periods of the time. Within the framework of these time sequences, we shall try to be as flexible as possible.

### Early Twentieth Century: The Picture Study Movement

Art appreciation in the first decade of the century is most closely identified with what was formerly called "Picture Study." Pre-World War I art supervisors—like the aesthetics educators of the 1960s—used a single art work (usually a sepia reproduction) as a focal point of instruction, but, whereas present-day emphasis is on the dynamics of the work, the Picture Study approach dwelt on such factors as the moral tone of a

work. A premium was placed on beauty, patriotism, religious values (both overt and covert), and other such sentiments, and critics and teachers placed a high priority on literary associations, story telling, and speculative discussions regarding the personal lives of the subjects of the paintings.

The Picture Study Movement was an accepted part of the arts curriculum, and the numerous course content descriptions of the period 1910–14 were specific in spelling out not only the particular art works to be used but also the framework for class discussion. In a random sampling of state course outlines of the period of World War I, the following artists appeared with greatest frequency:

Massachusetts—Younger Children
Millet, Boughton, Landseer, Bonheur, Corot

New York—Grades 5–6
Watts, Millet, Bonheur, Boughton, Inness, Alma-Tadema

Pennsylvania—Grades 5–6
Millet, Landseer, Boughton, Raphael, Lentz, Burne-Jones

The general tone of the works selected would indicate a reliance upon Barbizon, Pre-Raphaelite, and Victorian sources as well as artists with little or no lasting value in today's context (George Henry Boughton). Also included were painters who are still studied in contemporary programs (George Inness and Winslow Homer). Painters such as Edwin Henry Landseer (Queen Victoria's drawing teacher) and Raphael were apparently selected because of the story-telling possibilities of their works.

The following section from the St. Louis, Missouri, guide is quite specific in its recommendations for the teaching of art appreciation and represents a method typical of the guides of the period:

> *Picture study is to be pursued in all grades. The pupils in the fifth to eight grades, inclusive, are, in addition to the study of the picture, asked to write a brief composition about the picture and the artists for their grade. In studying the pictures the teacher should tell the pupils the most interesting points about the picture and the artist in a simple, direct way. The object of picture study is to bring the pupils in contact with some of the great works of art, and to arouse in them a love and appreciation of what is beautiful. With this thought in mind, the pictures chosen are such as time has tested. Another object in view has been to create a standard by which the pupils may judge the worth of new works of art as they meet them. When studying pictures the teacher should meet the pupil's love of the beautiful by giving him information and suggestions that will open before him the true meaning of the picture.* [20]

The concern for subject matter, the tendency toward poetic rhapsodizing, the interest in information that critics today would view as extraneous, all had as its model the writing of professional critics of the day. The ingredients in their writings often included description, speculation, and a heavy overlay of sentiment. This concern for lofty moral tone, narrative, and prettiness, however, can still be found in many contemporary classrooms because it reflects the tastes of many classroom teachers untrained in art and art appreciation.

### The 1920s

As the Picture Study Movement continued into the 1920s, Arthur Dow lent a different tone to the movement.[21] Dow gave teachers a set of

Drawing is often a preliminary stage of working for another material. Children should become acquainted with the processes which precede a final product. In this case preliminary sketches lead to a completed woodcut. Here, artist Sid Hurwitz tried out several versions in pen and ink before completing his idea in a woodcut.

© Sid Hurwitz

© Sid Hurwitz

principles of composition (developed from his study of Japanese art) that provided a readily grasped vocabulary of form that could be applied to any picture and that could thus serve as the criterion for the success or failure of a work. His basic principles of pictorial structure were line; notan, or value; and a regard for full spectrum color. In this

© Sid Hurwitz

© Sid Hurwitz

*background for appreciation: definition and history* **23**

book, *Composition,* published in 1899 and revised in 1913, Dow also provided a convenient set of teacher-directed exercises for the assimilation of his principles.

The compositional-analysis approach of Dow was similar to the earlier Picture Study approach. An example of this method was the "Living Picture," which was a staged theatrical enactment of a famous painting, lit and costumed as faithfully as possible for school assembly programs, and accompanied by descriptive, dramatic, and poetic readings with occasional musical accompaniment. This wedding of art and theater was to persist in some quarters until the 1940s and, in some cases, took the form of dioramas based upon paintings.

A significant change during the 1920s was the move away from sole emphasis on fine arts to a broader view of the subject matter of appreciation. Indeed, this view became so broad as to encompass such common items as household objects and the effects of mass production. Thus, writers became concerned with assisting in the art consumer's development of general taste in his daily life.

The concern for the environment of the child was also a part of the trend away from painting, and, in 1926, Helen Ericson, writing in *Progressive Education,* recommended closer attention to school surroundings and suggested color schemes, facilities arrangements, and display ideas for the "cultivation of art standards," a concern that is currently a part of Home Economics programs.[22] Art was moving away from "fine art" into the area of what would later be referred to as "applied art."

Margaret Mathias was one educator who expanded the subject content of art appreciation by going beyond painting into "all of the space arts—painting, sculpture, and architecture" and, in doing so, strengthened the bond of appreciation with the fine arts rather than with the arts of daily living.[23] Mathias also called for a duality of approach in maintaining a balance of *appreciation* and *personal expression,* and in this, she was in tune with the prevailing progressive attitude toward art education. This belief had strong support in *Progressive Education*'s special 1926 issue, "The Creative Experience." Through its statements and its illustrations of children's art, this publication took the most authoritative position of its time regarding the need for both the understanding and making of art. Frederick Gordon Bonser's "My Art Creed," published in that issue, found its way into numerous art guides of the period and reads as follows:

MY ART CREED
*I believe!*
*That the mission of art is to teach a love of*
*beautiful clothes, beautiful households, beautiful*

*utensils, beautiful surroundings, and all to the end that*
*life itself may be rich and full of beauty in its harmony,*
*its purposes, and its ideals.*

*That art appreciation and art values in human life*
*grow most consistently toward life control by the*
*exaltation of the element of beauty in all things.*

*That the appreciation of beauty in the thousand common*
*things of life will result in the final appreciation*
*of beauty as a dissociated ideal.*[24]

Bonser's creed in its idealism and its emphasis on the arts of living united the sentimental romanticism of the first decade of the century with the social awareness of the 1920s.

Reflecting the impetus toward scientific investigation in education, art education in the middle and late 1920s and early 1930s brought together a group of psychologists who attempted to apply Edward L. Thorndike's concepts of measurement to art and to the problem of appreciation. The effort to quantify various phenomena was characteristic of the testing movement that developed during and after World War I. We will cite a few representative examples. Christensen and Kaswaski asked children to discriminate between inferior and superior versions of the same art object, requiring that the students check their selections against a multiple choice listing.[25] McAdory prepared a preferential test on art appreciation that asked the child to rank four designs and objects for merit.[26] The items included common objects such as cars, homes, and dresses, and the subject was to choose the "best designed" or the one he or she liked best. The test was to measure the general art appreciation of the student, and the directions included a list of design elements to be used as a guide for selection.

The Meir-Seashore test also dealt with making a choice between pairs of pictures chosen for comparison except that, in this instance, each of the reproductions was taken from an original work by a professional artist, with one of the pair being altered.[27] The test was later revised in 1940, and a new edition was published in the 1960s. It is one of few art tests still being distributed. The testing movement of this period was short-lived, and research into the appreciative process was to be relatively dormant until after World War II.

### The 1930s

Art education during the 1920s and 1930s received significant support from the writings of John Dewey, Thomas Munro, and the work pub-

lished in the Albert Barnes Foundation publication, *Art and Education.* Philosophers and aestheticians were now joining the ranks of the psychologists in a mutual concern for art in the schools and helped formulate the interdisciplinary nature of art education that was to characterize the future course of the field. Although neither Dewey nor Munro were artists, both placed great value on the creative aspects of expression and response. Dewey rejected the popular view that creation was "active" and appreciation "passive," preferring to call the former "artistic" and the latter "aesthetic." He felt that both were a necessary part of education and rejected the distinction between fine and applied arts. Munro's case for the role of analysis in appreciation could fit easily into the current thinking of aesthetic education:

> *Artistic power is, on the whole, increased by intelligent analysis and reflection properly directed. Therefore, art and standards of taste should not be treated as matters of pure impulse and emotion, but discussed and analyzed to a considerable degree, that the problems may be intelligently dealt with and reasons for preference (for distaste and enjoyment) brought to conscious recognition. Pupils should be asked frequently to make their own choices and judgments of value clear, explicit, reasoned and supported by facts.* [28]

Munro, even more than Dewey, can be said to have been ahead of his time in his field. The failure of the schools to implement his ideas is due basically to the inability or unwillingness of educators to develop methods of applying his recommendations and theories directly in the classroom.

Dewey's conception of aesthetic experience was broad; it went beyond the museum object and encompassed, in theory, all aesthetic experiences that could be cherished for their own sake. Unfortunately, his ideas were more active on the level of the university than in the public school classroom, if curriculum guides of the 1930s are any indication. In addition, the proponents of today's contemporary aesthetic education movement rarely refer to him, possibly because his theories are too broad to be of service to those whose attentions are focused upon the examination of individual art objects.

In the senior high schools, some teachers in the 1930s were moving toward a relativist position, largely as a result of Munro's writings. His questionnaire for Picture Analysis, which is still felt by some writers to serve as a valuable instrument for teachers, provides useful examples for us. [29] Munro's first section is called "First Impressions of the Picture as a Whole" and is a clue to the goal of the questionnaire, which is to encourage respondents to make up their own minds, on the basis of

their own intense observation, experience, and likes or dislikes. Example: "What is most striking, interesting or unusual about the picture at first sight?" "What is most pleasing?" "Least pleasing?" "Why?" Munro then asks the reader to respond to sections dealing with elements such as line, light and dark, color, mass, space, and unity. Munro appeared to be asking students to make individual judgments based upon preference without asking for ultimate judgment. In that he accepted as valid all statements by children, he could be called a relativist.

While art appreciation programs of various kinds moved into secondary programs—notably in Clayton, Missouri, and New York City (1937)—little of comparable significance was being attempted in the elementary schools, where the emphasis still was on "expression." The New York City schools built their appreciation program upon a text book, *Exploring Art* by Luise Kainz and Olive Riley, and a glance at its contents reveals its emphasis on "everyday art"—that is, art in the community, in the house, in dress, in the useful arts.[30] The social role of the arts which had begun to be developed in the 1920s, reached a kind of climax in Melvin Haggerty's "Owatonna Project," which adopted the phrase "Art as a Way of Life" and demonstrated this stance by working with an entire community in an attempt to improve its standards of taste as well as its involvement with the arts.[31] It is, however, questionable whether the Owatonna Project in any practical way contributed to the art appreciation movement since it's orientation was social rather than appreciative in nature.

One researcher who was interested in the capabilities of elementary children was M. D. Voss, who in 1938 concluded that art appreciation—even on the primary level—could and should be taught in relation to the principles of art—that is, to the structure of art objects.[32] This method, she felt, could wean children away from their dependence on subject matter and turn their perceptions toward the organization of the work.

Betty Lark Horowitz, in assessing picture preferences of children from six to sixteen, provided information that was to influence greatly the selection of reproductions in elementary curriculum guides of the late 1930s and early 1940s.[33] She found that the tastes of the 461 children tested were derived from their regard for such elements as content (subject matter) and color. In another study, Lark Horowitz worked with two groups of children: "special" and "average" groups. In addition to differences in preference that related to sex, she noted the character of the gifted or "special" child:

> *The special (gifted) choice, though, differs inasmuch as the average child is guided mostly by subject interest, while the special child's choice is determined by qualities of an aesthetic*

*nature. His interest in facial expression is less personal, his interest in the technique is stronger. He alone is aware of design. These noticeable differences between the two groups of 12 and 15 year old children may be considered as an indicator of special artistic qualities in a child.* [34]

It was inevitable that a reaction set in that questioned the treatment of factors considered by some critics to be nonmeasurable. While Munro and others cautioned against the forced creation of categories for the convenience of statisticians, Ray Faulkner, to help clear the air, issued his own program for "A Research Program for Art Appreciation." He suggested the following as an agenda for investigation:

## WHAT IS ART APPRECIATION?

1. *What are the definitions and explanations in current use?*
   a. *In the dictionary.*
   b. *In the textbooks of appreciation.*
   c. *In the philosophical discussions.*
   d. *In the psychological experiments.*
   e. *In terms of everyday human behavior.*

2. *Which are the most useful to the teacher of appreciation?*
   a. *Is any definition sufficient?*

3. *What do we know about the psychological processes which are related to appreciation? Their nature? Their importance?*
   a. *Sensation.*
   b. *Perception.*
   c. *Intellection.*
   d. *Generalization.*
   e. *Verbalization.*
   f. *Affective states.*
   g. *Empathy.*

4. *How is appreciation expressed?*

5. *Is appreciation in different fields (art, music, science) similar?*

6. *How is appreciation related to creative activity?*

7. *How does training influence appreciation?*

8. *How does heredity influence appreciation?*

9. *How does knowledge affect appreciation?*

10. *How does critical analysis affect appreciation?*[35]

During the 1930s, various observers noted an increase in arts-related interests, not only in the schools but among the general public as well. There were reasons for this development, causes that were sociological as well as aesthetic. Some of these reasons were government support of arts projects under the Roosevelt administration, the acceptance of art into the complex of general education through the Progressive movement, the emergence of the museum as an educating force, and the previously mentioned interest of psychologists and philosophers.

The influence of the museum on art appreciation in the schools is a peculiarly American phenomenon. As early as the 1920s, battles were being waged regarding the role of the museum. Some saw it as a custodial institution and some as a community service agency. There were also various degrees of compromise between these two extremes. As Hausman states:

> *Whereas art museums in Europe have tended to serve custodial functions (storing the great collections of the church and state), museums in America (by circumstances and necessity) have conceived their roles more flexibly. There has been a much greater emphasis upon the museum in relation to its public. American art museums have assumed another role: that of becoming a communication center to meet the pressures for more information and knowledge about the works of art in their exhibitions.*[36]

The nature of the debate changed as educators and museum personnel gradually accepted the community-education role of the museum and turned their attentions toward the nature of the museum programs designed for both schools and the general public. Throughout the 1930s, new patterns for docentry as well as public education were developed. The Metropolitan Museum of Art, the Southwest Museum at Los Angeles, and the Cincinnatti Museum of Modern Art were but a few of the institutions that initiated new programs in art appreciation for children as well as adults, including Saturday morning programs, lecture classes, studio classes, and direct liaison with the schools.[37] Later in this book, we will take a closer look at contemporary programs in art appreciation developed by museums.

## The 1940s

The 1940s saw publication of a number of works that were to influence the thinking of art teachers in the area of appreciation as well as in the studio. The major art-appreciation issue of the 1940s and 1950s involved the relative importances of analysis and synthesis. This was not a new problem, but, phoenix-like, it was to rise periodically from its own ashes to be confronted by new coalitions of opinion. Dewey took issue with the popular tendency toward analysis wherein students in many secondary schools were required to do exercises involving the "elements" of design and composition. These elements were isolated, and no consideration was given to overall unification or to questions of content, meaning, or medium. Dewey felt it was impossible to separate such tasks without some ultimate synthesis of the parts into a meaningful whole. Dewey's theories were reinforced by the educator Belle Boas, who felt that analysis without synthesis was worthless, as did Kainz and Riley, whose text, *Exploring Art,* provided the basis for appreciation courses in New York City junior high schools.[38] Their suggested curriculum used in-depth studies of color and form as core elements and created the most ambitious program in art appreciation of any school system in the country. Their emphasis, though, was primarily on secondary schools; elementary programs in New York City and elsewhere continued to await the kinds of attention that the senior high art programs were receiving.

There was also concern for defining more carefully the distinctions between the study of art and the study of art history. Ralph Pearson questioned historical chronology as a basis for appreciation, stating that using such information as a frame of reference placed memory exercises of dates and places in the way of the student's direct response.[39] One result of this line of thinking was to encourage a study of past periods in terms of the important ideas in art that they exemplify rather than in terms of the "historical" facts associated with a particular object. Many senior high art courses even today use an "issues" or "problems" approach to art appreciation rather than the more conventional historical/chronological method.

In 1946 Edward W. Rannells issued a clear statement of a program for instruction in appreciation in the junior high schools.[40] Rannells and others felt that appreciation should be "taught," not "caught," that instruction should be a deliberate affair rather than being casually relegated to the studio or serving as an adjunct to interior design, industrial design, or commercial art classes. Rannells's nine objectives for art appreciation spell out the difference between the conventional studio program and what is now referred to as "aesthetic education." They are as follows:

1. To assist the learner, through directed visual and tactual experiences and the encouragement of intuitive means of understanding, to cultivate an aesthetic attitude, complementing the scientific attitude, in learning and in all varieties of experience.

2. To assist the learner, through experiences that involve the making of aesthetic choices, to develop emotional responsiveness to and intuitive knowledge of aesthetic qualities, or values in art, nature, things of use, everyday living, individual expression, human relationships, and social institutions and forms.

3. To assist the learner, through visual and tactile experiences and value commitments, to develop enjoyment of, liking for, and identification with, aesthetic quality or values of art, nature, things of use, everyday living, individual expression, human relationships, and social institutions and forms.

4. To assist the learner, through controlled kinesthetic experience, including experience of forms in motion, light and color in motion, gesture drawing, and accompaniment of music, to develop an awareness of bodily sensations, and an immediate kinesthetic responsiveness to all rhythmic forms of expression in the forms of art.

5. To assist the learner, through intimate visual and tactile experiences to materials in nature and in art, to develop a sensuous responsiveness to qualities such as plasticity, density, durability, texture, and color, and thus to develop an intuitive knowledge of aesthetic values and their expression in the forms of art.

6. To assist the learner, through visual and tactual experience of aesthetic materials and aesthetic processes, to develop an intuitive awareness of aesthetic requirements in art as a creative process and as an aesthetic form.

7. To assist the learner, through contact with contemporary and historical examples of art, largely by comparison and value judgments, to develop an awareness of the aesthetic values appropriate to each of the various forms of art according to medium and process, and according to purpose or function.

8. To assist the learner, through study of the lives and accomplishments of artists and through identification with them, to personalize and expand his experience with art.

9. To assist the learner, through group experience where the efforts are necessarily unified by the requirements of art rather than of individuals, to an appreciation of the purposiveness in a shared experience of art.

In 1940, the Progressive Education Association Committee on the Function of Art in General Education recommended the use of actual works of art rather than postcards, poor reproductions, sepia miniatures, or the other misleading versions of art works that were being used because of naïveté, limited budgets, or general nonavailability of better or original works.[41] Recognizing the limitations of many school systems, the committee used the phrase "whenever possible" in promoting the use of real art works. While this practice of obtaining actual works of art is accepted today—although it is not prevalent—it was a radical stance at the time.

Because of the improvement in photographic techniques and printing processes, the mid-1950s saw the introduction of more and better teaching materials for art appreciation, especially 35-millimeter slides and cheaper color reproductions. Television became a resource, and films and film strips continued to expand in number and improve in quality. The community became more of a resource for art, with field trips to local art museums becoming a standard part of art programs.

### The 1950s and 1960s

The 1950s and 1960s were a period of transition for art education, and a redefinition of art appreciation emerged during these decades. Since the 1930s, the teaching of art had been concentrated on the production of the art object and the art experience. Instructing the student in use of the various art media and techniques was the major outcome of art education programs. A conception of art education emerged in the 1960s that contained a significant shift in direction.

Art educators were beginning to consider the discipline of art as constituting a broader body of knowledge than just a body of art experience. The National Art Education Association, in a position paper published in 1968, noted that "art in the schools is both a body of knowledge and a series of activities."[42] This represented an "official" shift in emphasis from an earlier statement of beliefs that saw the art program as a body of "developmental activity" rather than as a body of "subject

matters."[43] Barkan anticipated the change in the National Art Education Association's tone when he urged that the focus of activity be shifted from the characteristics of the child to those of art. Barkan echoed the feelings of many educators of the post-Sputnik period by advocating a content emphasis, which art teachers had long neglected. A year later he stated that the content for the teaching of art included "the creative involvement of the learner in activities which interplay between the making of art, and the viewing, examination and analysis of qualities which appear in works by artists of today and from the historical traditions."[44] Eisner supported this when he wrote, "We believe that artistic learning is a very complex form of learning and is not an automatic consequence of maturation."[45]

The trend away from the child-centered approach, advanced by Lowenfeld and the developmental psychologists, was significant for the teaching of art appreciation because it legitimized the inclusion of art appreciation as part of the total art curriculum. It was now being advocated that the art program in the school have three major outcomes: (1) making the art object (the art "experience"); (2) knowing about art objects and events (art history); and (3) critical analysis of the art object (art appreciation).

### Summary of Historical Development

Art appreciation at the turn of the century was linked to the popular social mores of the time through its identification with beauty, quasireligious morality, and a desire for social graces. In light of today's thinking, such values are close to Kitsch, combining popularized versions of the theories of Leo Tolstoy and John Ruskin filtered through the middle-class vision of the Browning Societies and Chautauqua lecture circuit. In its zeal for recognition, art appreciation ventured into other corners of the curriculum—namely, oral and written English, drama, and, on occasion, music. To create its own identity it placed its faith in the compositional canons set down by various authority figures (such as Tolstoy and Ruskin), and, when it moved away from the fine arts, it turned its attention to objects of common use and to the influence of the environment itself. The Progressive era, in an effort to be consistent with its respect for the interests of the child, wedded creative expression with appreciation. Yet, as Logan reminds us, the Progressives came off somewhat better in studio activity than in appreciation.[46]

The movement toward testing for taste and discriminative skills was perhaps an attempt to establish some workable concepts of appreciation that could be defended on a scientific basis, and it led inevitably to misgivings on the part of many art educators, since the creation of

any empirical instrument necessitates making disputable assumptions about the nature of art.

From the field of philosophy and aesthetics came the prestigious support of John Dewey and Thomas Munro in developing the most solid theoretical groundwork for the study not only of art appreciation but also of the creative process.

The decade of the 1930s was a period of progress for art education not only in the schools but also in public awareness, as exemplified by the "Owatonna Project." Unfortunately, art appreciation as we have defined it did not play a major role, at least on the elementary level, at this time. The role of the museum was expanded as schools reached for more immediate contact with the arts and the Roosevelt administration brought support for the arts into numerous culturally deprived areas across the country.

The 1940s was the decade of influential publications by organizations, institutions, and individuals concerned about the arts in education. Viktor Lowenfeld and Herbert Read joined Dewey and Munro in extending the base of intellectual leadership of the profession, and all were concerned to some degree with the problems of appreciation. The 1940s and 1950s also saw the publication of public school texts that led to new curricula, particularly in several large urban systems. There were also signs that leadership at the state level was beginning to emerge. During the 1950s educators such as Rannells reiterated Munro's belief in "deliberate" education for appreciation and in so doing helped set the stage for the aesthetic education movement of the post-World War II period.

Industry's response to an expanding economy provided a seemingly endless flow of packaged audiovisual-resource materials, and the government's new role in support of education led to seminars, conferences, and sponsored research, which, in turn, permitted the proponents of art appreciation and aesthetic education to work in concert to train teachers and examine art education from broader interdisciplinary bases.

If the development of art appreciation could be summarized in terms of significant questions, the list might read, in part, as follows:

1.  How relevant are such values as moral tone, beauty, sentiment, and narrative to the study of exemplary works of art?

2.  How is the study of the elements of art related to the appreciation of art?

3.  What should the study of art appreciation include,

other than the fine arts? Should it go so far as the total environment to cover means of communication, dress, interior and industrial design?

4.  What values can be tested? *How* shall values be tested?

5.  What is the relation of analysis to appreciation? Is it a precondition for synthesis?

6.  Are perceptions cognitive, affective, or both?

7.  Are emotional responses ultimately of more value than logically developed conclusions?

8.  Is appreciation a relativist situation wherein an individual can make his own judgments, or are these values which are built into the art object and which can direct us toward criteria for analysis?

9.  Can appreciation be taught or is it "caught"?

10. How is art appreciation related to creative activity? Can the latter support the former?

11. How do we know when a child "appreciates"? Is it expressed in some observable way?

12. What can public agencies such as museums and galleries do to assist art teachers?

13. Whom shall art teachers heed in their search for assistance? Art Educators? Psychologists? Critics? Philosophers?

14. What shall be the role of art history in art appreciation?

15. What instructional materials are appropriate?

16. How does one separate the elementary from the secondary art program in answering the above questions?

If one could chart a comparison between past and present methods used in the teaching of art appreciation, it might look like the following:

| *Past* | *Present* |
|---|---|
| 1. Emphasized immediate reactions to a work of art. | 1. Defers judgment until the art object has been examined. |
| 2. Instruction was primarily verbal and teacher-centered. | 2. Instruction may be based on verbalization, perceptual investigation, studio activity, or combinations of these. |

| | |
|---|---|
| 3. Relied primarily on reproductions. | 3. Utilizes a wide range of instructional media—slides, books, reproductions, films, and, most important, original works of art, visits to museums and galleries, and visits from local artists. |
| 4. Based primarily on painting, because of its "story-telling" qualities. | 4. May encompass the complete range of visual forms from "fine arts" (painting, sculpture) to applied arts (industrial design, architecture, and crafts). May also include mass media, television commercials, films, and magazine layouts. |
| 5. Used literary and sentimental associations as a basis for discussion. Concentrated on such qualities as beauty and morality to the exclusion of formal questions. | 5. Bases discussion on the formal qualities of the art work. Recognizes beauty and other sensuously gratifying qualities as one part of the aesthetic experience, but takes into consideration such characteristics as social criticism, anger, and compassion, which may make a visually abrasive and shocking art form. Does not seek to make moral judgments, but leaves these to the student as part of the interpretive level. |
| 6. Concentrated on the "great monuments" of art. | 6. Avoids reverence for the past; shows respect for artistic efforts of all epochs and all cultures. |
| 7. Drew instructional material from the culture of Western civilization. | 7. Allows examples of art works to encompass whatever cultures are most appropriate to represent a particular artistic point. |
| | 8. Uses multisensory responses as a means of developing empathy. |

## NOTES

1. *Webster's New World Dictionary of the American Language* (Cleveland: World Publishing Co., 1957), p. 71.

2. *Oxford English Dictionary* (Oxford: Clarendon Press, 1933), p. 411.

3. Harold Osborne, *The Art of Appreciation* (London, Ontario: Oxford University Press, 1970), p. 16.

4. Othanel Smith, "The Logic of Teaching the Arts," *Aesthetics and Criticism in Art Education,* Ralph Smith, ed. (Chicago: Rand McNally & Co., 1966), pp. 50–51.

5. Rose M. Collins and Olive L. Riley, *Art Appreciation for Junior and Senior High Schools* (New York: Harcourt Brace and Co., 1933), p. 3.

6. *Ibid.*

7. Rudolf Arnheim, *Visual Thinking* (Berkeley, California: University of California Press, 1969), p. 13.

8. Stanley S. Madeja, "Early Education in the Visual Arts," *Art for the Preprimary Child* (N.A.E.A., Spring, 1972), pp. 110–27.

9. Arnheim, *Visual Thinking*, p. 6.

10. Albert Barnes, *The Art in Painting* (New York: Harcourt Brace and Co., 1937), p. 5.

11. Ralph Smith, "An Exemplar Approach to Aesthetic Education," Bureau of Educational Research, College of Education, University of Illinois, Project No. 6-3-6-06127-1609 (Washington, D.C.: U. S. Office of Education and Department of HEW, 1967).

12. Edmund B. Feldman, *Art as Image and Idea* (Englewood Cliffs, N.J.: Prentice-Hall, 1967), p. 295.

13. Harry Broudy, B. Othanel Smith, and Joe Burnett, "The Exemplar Approach," *The Journal of Aesthetic Education* (Spring, 1966), pp. 13–23.

14. Manuel Barkan and Laura Chapman, *Guidelines of Art Instruction through Television for the Elementary Schools* (Bloomington, Indiana: National Center for School and College TV, 1967), p. 12.

15. David Ecker, "Justifying Aesthetic Judgments," *Art Education* (May 1967), pp. 5–8.

16. Leon L. Winslow, *Art in Elementary Education* (New York: McGraw Hill Book Co., 1942), p. 272.

17. Irving Kaufman, *Art and Education in Contemporary Culture* (New York: The Macmillan Co., 1966), p. 453.

18. Eugene Kaelin, "An Existential-Phenomenological Account of Aesthetic Education," *Pennsylvania State Papers in Art Education,* Paul Edmonston, ed. (1968), p. 19.

19. Stephen Pepper, *The Basis of Criticism in the Arts* (Cambridge, Mass.: Harvard University Press, 1965), p. 142.

20. Royal Bailey Franum, "Present Status of Drawing and Art in the Elementary Schools of U.S.," *Bulletin, U.S. Bureau of Education* (1914), p. 153.

21. Arthur Dow, *Composition* (Garden City, New York: Doubleday, 1913). See p. 39 for example of his exercises.

22. Helen Ericson, "Influences in the Cultivation of Art Appreciation," *Progressive Education*, 3, no. 2 (1926), 182.

23. Margaret Mathias, *Art in the Elementary School* (New York: Charles Scribner's Sons, 1929), p. 154.

24. Frederick Gordon Bonser, "My Art Creed," from "The Creative Experience," *Progressive Education* (June 1926), p. 104.

25. E. O. Christensen and T. F. Kaswaski, "Test in Art Appreciation," *Art Psychology, University of North Dakota* (January 1925), Bulletin, no.3 p.3.

26. Margaret McAdory, "McAdory Art Test" (New York: Columbia University, Teachers College Bureau of Publications, 1929).

27. Carl E. Seashore, "Meir-Seashore Art Judgment Test," *Science* (April 15, 1929), p. 69.

28. Thomas Munro, *Art and Education* (Philadelphia: Barnes Foundation Press, 1929), p. 222.

29. Thomas Munro, "Methods of Teaching Art Appreciation," *Bulletin Western Arts Assoc.,* 18 (1932), 4.

30. Luise Kaniz and Olive Riley, *Exploring Art* (New York: Harcourt Brace and Co., 1948).

31. Melvin Haggerty, *Art as a Way of Life: The Story of the Owatonna Project* (University of Minnesota Press, 1935).

32. M. D. Voss, "Art Appreciation Process at the Child Level," *Phychological Monographs* 48 (1936), 2–3.

33. Betty Lark Horowitz, "An Appreciation of Children I—Preferences of Picture Subjects in General," *Journal of Education Research* (1937), p. 31.

34. Betty Lark Horowitz, in *Journal of Education Research,* 2 (1938), 598.

35. Ray Faulkner, "Educational Research and Effective Art Teaching," *Journal of Experimental Education* (September 1940; June, 1941).

36. *The Museum and the Art Teacher: Final Report,* Jerome J. Hausman, ed., George Washington University and the National Gallery of Art (Washington, D.C.: U.S. Office of Education and Department of H.E.W., December 1966).

37. *Ibid.*

38. Kainz and Riley, *Exploring Art.*

39. Ralph M. Pearson, *The New Art Education* (New York: Harper and Bros., 1941).

40. Edward Warder Rannells, "Art Education in the Junior High Schools," *Bulletin of the Bureau of School Service* (College of Education, University of Kentucky) 18, no. 4 (June 1946), 106–8.

41. Progressive Education Association, *The Visual Arts in General Education* (New York: Appleton-Century Crofts, Inc., 1940), p. 40.

42. *The Essentials of a Quality Art Program* (Washington, D.C.: N.A.E.A., 1968).

43. *Art Education,* 2 (March-April 1949), 1.

44. Manuel Barkan, "Means and Meaning," *Art Education,* 18, no. 3 (March 1965), 4–6.

45. Elliot Eisner, "Teaching Art to the Young, a Curriculum Development Project in Art Education," Final Report, Elliot Eisner, Project Director, Sponsored by the Charles F. Kettering Foundation (Stanford, California: Stanford University Press), p. 12.

46. Frederick Logan, "Progressive Education: Creative Expression and Art Appreciation," *College Art Journal,* 2 (1952), 145.

# TEACHING FOR APPRECIATION:

2

The word "program" is used advisedly. The purpose of this book is to provide some theoretical background as well as a variety of suggestions for activities. Programmatic approaches that suggest specific sequences of activities have been avoided. Exemplary courses, however, will be described later in the text.

The present section deals with the most important sources for experiences within the sphere of appreciation. The word "program" implies a curricular entity: a body of instruction planned for an extended period of time. The classroom teacher and the art teacher will, in many cases, not have the time for such a formalized approach and will have to opt for more dispersed instruction. This may mean a kind of informal ongoing series of activities offered from time to time, as well as some form of integration of art appreciation into other subject areas. The following activities and strategies for developing art appreciation can be of use whether the teacher chooses a formal approach based upon scheduled classes or an informal method based more upon the exigencies of the situation.

## DISCUSSION TECHNIQUES: LANGUAGE AND ART

Feldman poses the question, "Why do all of us, experienced critics or not, enjoy talking about art?" He then replies by stating, "Talk about art, or art criticism, is probably one of the ways we share the contents of our inner lives without embarrassment. Art criticism is very much like teaching: it is the sharing of discoveries about art, or in some cases about life, where art has its ultimate source."[1]

It is precisely because of the broad context of art that children of all ages are so quick to respond to discussion. Until the child has had some experience with the channeling of his perceptions with particular ends in mind, however, his talk about art may be a rambling, highly subjective affair that uses the art work somewhat like a Rorschach test. Whatever the state of preparation, children for the most part enjoy discussing works of art—*if ways can be devised to accommodate the comments within the limitations of the average class size.* Most teachers use the traditional Socratic method, putting questions to the class and utilizing answers either to pursue an issue or allow it to lead naturally to another problem. This is only partially successful since it can rarely involve more than a minority of students.

Viktor Lowenfeld extended his well-known use of dialogue from picture making to the area of appreciation.[2] With his customary regard for the child's level of expression and response, he probed for reactions to art works, urging the child to clarify the memory and sense impressions for picture appreciation as well as for picture making. Basing his discussions on three components—(1) the percipients, or viewers, (2) the subject of the work, and (3) the means of expression—he asked such simple questions as "Do you like it?" "Why?" or "Why don't you like it?" Aiming always at a close identification with the artist as well as the art work, Lowenfeld saw little value in formal pictorial analysis or "understanding" and emphasized the untrained capacities and interests of the child. The art work, to Lowenfeld's way of thinking, was of less importance than the development of the child as a thinking, feeling, sensing, responding personality. While such approaches are certainly valid, we now know that children can be taken considerably beyond this level of response.

By contrast, Ralph Smith's discussion techniques attempt to move the attention of the child toward a more objective regard for the art work.[3] Like Lowenfeld, Smith concentrates upon the single "exemplar," but, unlike Lowenfeld, he requires a depth of attention not customarily thought of as being appropriate to the elementary level. Smith's study, while providing a valuable model for discussion techniques, was derived from one teacher (Smith) dealing with five selected sixth graders for a series of Saturday morning sessions—a rather limited situation when compared to the normal public school classroom.

### Large Group Discussions

Discussion in terms of large group involvement has definite limitations. Too often, the highly verbal minority dominates the process, while the

Some of the vocabulary of art is best understood through demonstration by the teacher or visiting artist. One example is a technical term such as "glazing," as used here by Isabel Bishop. Of course, the same picture could be used to prompt questions such as, "How does the painting show the relationship between drawing and painting?" or "Is it possible to relate the mood or feeling of the painting to the title?"

*Ice Cream Cones* Isabel Bishop Painted in 1942. Tempera and oil on masonite. 34 X 20 in. Charles Henry Hayden Fund. Courtesy Museum of Fine Arts, Boston.

nonverbal class members, either because of shyness or inability to match the leaders in articulateness, are content to sit and listen. Discussion, however, should not be avoided if other modes of involvement are present. Gaitskell and Hurwitz, in *Children and Their Art*, have described how a professional art historian, Professor James Ackerman, chairman of the Department of Art History at Harvard University, conducted a class discussion with a group of sixth graders.[4] This lesson represents one model for class discussion that is worth studying. The following segment of an actual teaching session demonstrates what Ackerman considers important when discussing painting with sixth graders. Because of limitations of space, excerpts of the tape have been interspersed with descriptions of what transpired.

Dr. Ackerman began by making the point that the basic task of the session was not only to look at but also to talk about what was seen and that looking would come naturally to the children since they lived in a visually oriented society with constant exposure to television, films, and mass printed media. He then listed on the blackboard four terms he felt were needed to discuss the paintings to be shown:

1.  Technique—the ways in which artists use materials.

2.  Form—the structure and interaction of components of an art work. The class seemed to understand the word "shape" as a component of "form" and the teacher accepted this.

3.  Meaning—the intention; the ultimate significance of an art work. Because the children had some difficulty absorbing this concept, Dr. Ackerman accepted the term "subject" in its place.

4.  Feeling—the emotive power that is elicited from a work.

Ackerman used the comparative method to develop the class discussion. On one screen he showed a slide of an Impressionist oil painting of poplars, and on an adjacent screen he projected an Egyptian wall fresco showing trees framing a pool containing fish and ducks.

Dr. A: *Who would like to try to describe the painting techniques of these two paintings?*

Student: *The trees are watercolor . . .*

Student: *I think they're oil.*

Dr. A.: *You're right; that is an oil painting. How about the other . . . ? [A lot of whispering but no volunteers.] Take a guess.*

Student: *Watercolor—maybe tempera?*

Dr. A: *Why do you say that?*

Student: *It's flat and bright, not shaded like oils.*

Dr. A: *Very good—flat is a good word, except that in this case the effect is due to a fresco technique. Anyone know what fresco is? [Silence.] Well, it was used by the Egyptians as a way of making painting part of a wall. They did this by using tempera paint on fresh plaster mixed with water and lime. Now back to your "flatness." If you've ever painted on plaster you know it gets soaked up and dries quickly. That doesn't allow for much shading or roundness of forms and instead gets the painter to work in clear, flat areas of color. How did this artist make his shapes seem clearer?*

Student: *He put lines around them.*

Dr. A: *Very good. Would you care to point to one part of the painting to show what you mean? [Student points to outline of pool.] Now, let's look at the subject. Can we say that one of these paintings is more true to life than the other? Let's take a vote. How many say the poplar trees are more "true to life"? [The class votes as a group in favor of this one.] Why is that?*

Student: *Well, it doesn't look exactly like a photograph but it almost could be one.*

Dr. A: *Which do you like better? [The class votes for the Impressionist.] Let's see how the painter looks at his subject . . . Anyone care to comment?*

Student: *Well, it's more like real life in the poplars.*

Student: *The ducks are real life.*

Student: *But it's mixed up in the fresco.*

Dr. A: *I think you are trying to say that there are two points of view in the Egyptian's. Who can go to the screen and point to one point of view? [One student volunteers and points to the aerial perspective of the pool.] Where are we standing when we look at the pool?*

Student: *Above—we're above it.*

Dr. A: *How about the ducks?*

Student: *You're in front of them.*

Dr. A: *Good. Then we might say that in one way the Egyptian artist used his space and subjects with a lot more freedom than the other artists. But what does the Impressionist painting offer us instead of different points of view in the same picture?*

Students: *You can see more . . . more details . . . more real . . . [etc.]*

Dr. A: *Would you agree with me that there are many ways of being "true"; that the Egyptian painting shows us the way we know things to be and the Impressionist more the way we are likely to react? . . .*

Ackerman's approach was based on the assumption that children should have specific things to look for and that, furthermore, things will move more quickly if children are presented with a vocabulary of significant terms to guide their perceptions. Of course, Ackerman had the advantage of being a guest. He also brought with him a calm sense of authority that the class recognized and responded to. His use of two slide projectors for a comparative method was also effective, as this approach had not been used previously with this group.

Working in a clear, open space the leader discusses with the group the directional forces within the painting.

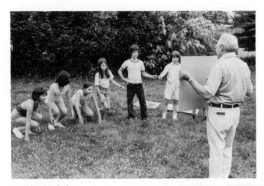

© Richard Sobol

The group creates the diagonal thrust of a painting by Vasili Kandinski.

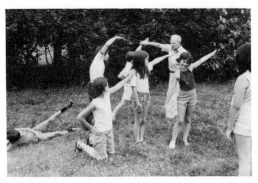

© Richard Sobol

Under the direction of a group member, the perpendicular structure of a Mondrian is created.

© Richard Sobol

## Discovery Process

In a follow-up session with Ackerman's class held by one of the authors, an attempt was made to shift Ackerman's method to a discovery process

—that is, to restructure the situation so that the class could deduce, with the teacher's guidance, what the issues were.

Now the children were shown four reproductions and were asked simply to name all the differences they could detect among the works. The four paintings used were Raphael's *Madonna and Child,* Kathe Kollwitz's *Killed in Action,* Willem De Kooning's *Woman,* and Vasili Kandinski's *Improvisation.* (They thus began with a unanimous opinion —that the four pictures shown were obviously different in many respects.) As various differences were noted, the teacher wrote them on the blackboard, setting them down in columns according to whether they related to materials, subject, meaning, form, or style. When the children's powers of feeling and observation were apparently exhausted, the teacher wrote categorical headings above the columns, pointing out that what the class had really done was create its own critical system. Such an ordering of concepts demonstrated to them that there were many ways to discuss a work of art. Instead of providing the pupils with answers prior to the discussion, the teacher sought to elicit responses by posing questions that centered about a single conceptual problem—the ways in which artists differ in their work. In order to deal with such a problem, the children had to become engaged in such processes as visual discrimination, ordering, comparison, classification, and generalization.

During the "discovery" discussion, the teacher translated the rough vocabulary of the class reactions into a vocabulary for criticism, adding some important characteristics that had been missed. When the task was completed, the comments listed on the board were those shown in the accompanying chart.

The discovery discussion laid the groundwork for subsequent lessons. The "media" column provided the background for a visiting artist to demonstrate the difference between oil and watercolors; the "meaning" classification prepared the class for a lesson in comparison of styles, in which it was shown a variety of paintings, each of which took a different stylistic approach to the same theme.

---

**Results of a "Discovery" Discussion**

| | |
|---|---|
| Materials—<br>What We Work With | "Kollwitz uses crayons: it's more a drawing." (Teacher explains difference between drawing and lithography.) |
| | "The Raphael must be oil." |
| | "The De Kooning could be tempera or house paint." |

"The Kandinski painting is thin, it could be water color."
(Teacher explains that if oil paint is thinned with enough turpentine it can have the transparency of water color.)

Subject—
What We Paint

"Kollwitz has a sad mother and hungry children."

"Raphael has a happy mother and child."

"The De Kooning is called *Woman* but it takes you a long time to see her."

Meaning—
Why We Paint

"Kollwitz's mother is worried about how she will feed her children."

"Kandinski's has no meaning; it's just shapes, lines, and colors that go all over the place."

"I can't tell what the Kandinski and De Kooning are all about."

"The Raphael is a religious picture."

Form—
How a Painting Is
Designed

"I see a triangle in the Raphael and up-and-down forms painted really sloppy in the De Kooning." (Teacher: "We call this painterly, not sloppy.")

"The Raphael is quiet. The Kandinski is loud." (Teacher: "What makes one picture 'loud' and another 'quiet'?")

"Kandinski makes you look in different 'directions'—up, over, and around."

Style—
What Makes Paintings
Look Different from
One Another

"The Raphael looks so real you could walk into it."

"The Kollwitz is real too but in a different way." (Teacher defines "selective realism.")

"I can't recognize anything in the Kandinski like I can in the others." (Teacher defines "nonobjective" and "abstract.")

Raphael
  "smooth"
  "like a photograph"
  "done carefully"
De Kooning
  "sloppy"
  "done really fast"
  "more wild"
  "messy"
Kandinski
  "wild"
  "like a third grader's picture of space"

*Note:* Object: To create categories that may serve as a basis for building subsequent sessions in art appreciation.

*Source:* Charles Gaitskell and Al Hurwitz, *Children and Their Art: Methods for the Elementary School* (New York: Harcourt Brace Jovanovich, 1970), p. 435.

Children, like all of us, enjoy studying art by comparing varying treatments of similar subjects. In these two nineteenth-century family studies, a number of factors can be noted, such as the nature of perspective, the degrees of modeling in face, clothing, and fabrics, and the use of "props" to support characters. The teacher might also note the resemblance of one of the fathers to the actor Henry Fonda.

*The Rev. John Atwood and His Family* Henry F. Darby Signed and dated 1845. Oil on canvas. 72 X 96¼ in. M. and M. Karolik Collection. Courtesy Museum of Fine Arts, Boston.

*Joseph Moore and His Family* Erastus Salisbury Field Painted in 1839. Oil on canvas. 82 3/4 X 93¼ in. M. and M. Karolik Collection. Courtesy Museum of Fine Arts, Boston.

Ecker in commenting on the "discovery" lesson stated:

> *This approach has at least two virtues. First, it encourages children to look at paintings on their own without being told beforehand what to look for, except in a general way. Thus the teacher avoids placing restrictions on what the children are likely to perceive in the works. Second, the approach no doubt encourages children to talk about many more aspects of an art work than they would ordinarily tend to talk about. Yet, strictly speaking, the students could only be said to discover a system*

> *of criticism if they can actually guess, on the inductive evidence of the teacher's performance in sorting their comments, what the items in each of his columns have in common, e.g., materials.*[5]

Ecker then suggests a variation that would carry the discovery process one step further by asking the students to "write down all their remarks on separate slips of paper and pool them. The teacher then asks the students to group the slips according to significant similarities and differences in their statements, generating as many groups as seem required." Ecker's suggestion has the advantage not only of a more profound involvement of the class but offers the possibility of total participation—always a problem with large groups.

### Talking About Art

Talking about art is a vital component of any program of art appreciation. Making art takes a child to a world apart from words, yet language about art has its own distinctive character. Because children spend so much time with language, discussion can provide its own distinctive insights into the critical experience. Words can tell us what we see, and special words guide our vision to new paths of discovery whether in the realm of seeing, feeling, or fantasizing, depending always upon the nature of the work and the goal of the lesson. After his own investigations of what he terms "creative talk," Ecker has concluded,

> *Children can think creatively in the kinds of language that might collectively be called aesthetic inquiry. Children not only talk about art but also talk about their talk; they not only criticize art objects and events but also reflect upon the nature of the critical act itself. In fact, when their powers of imagination and curiosity are unrestrained, five levels of inquiry can be identified. If we count art production and appreciation as the first level of inquiry, we find children (1) creating and appreciating art, (2) criticising it, and (3) challenging or supporting the judgments of others, whether adults or children. Moreover, we find them (4) theorizing about the nature of art and criticism, and (5) analyzing theories and arguments.*[6]

There are a number of theories that attempt to account for the nature of children's verbal response. Brent Wilson's "aspective instrument," described elsewhere in this book, is one of the most detailed analyses of linguistic behavior. C. W. Valentine[7] reduces Wilson's categories to four basic sorts of reaction, and these provide sound and practical guidelines for the teacher who is beginning to study children's reactions to art. Valentine feels that his categories of reactions override

*Movement within Orange* William Barnet American, 20th century Anonymous Gift through the Federation of Modern Painters and Sculptors, Prov. Courtesy Museum of Fine Arts, Boston.

**A wealth of art terms can lie in one painting. The meaning of such terms as shape, size, balance, movement, and contrast can be better understood by a class study of William Barnet's *Movement Within Orange*.**

age factors and should apply to most children from elementary to secondary levels. The terms he uses are as follows:

ASSOCIATIVE—having to do with some personal reference from the experience of the child. Ex.: "This one reminds me of the first day of spring."

SUBJECTIVE—having to do with affect or feeling. Ex.: "This painting makes me feel happy just to look at it."

CHARACTER—having to do with characterizing the work adjectively. Ex.: "It's very quiet; you could hear a mouse in that room."

OBJECTIVE—having to do with the child's descriptive powers which center around such formal elements as quality or presence of line, structure, or some visual force. Ex.: "Too many lines; it's confusing."

Valentine's responses are sound guidelines for discussion, and a teacher can guide the class toward one domain or another, but critics

since Valentine—notably, Feldman—feel it is important to take the process further into speculation regarding meaning and the sensing of the connection between the intention or meaning of the work and objective, character, or other responses. These are all stages of thinking that must precede validity of judgment on the success or failure of the work.

One of the authors decided to use Valentine's categories as a basis for a discussion of an etching by Harold Altman. This artist was chosen because there was a distinct mood character in his work, and because it was felt the technique and the subject matter would be of interest. With Valentine's reactions in mind, the discussion of the etching produced a number of comments that clearly supported Valentine's theory. The questions posed by a fourth grade were framed from the four reactions listed by Valentine. The comments of both teacher and pupils are analyzed in parenthetical phrases.

Question: *What is happening here—what's going on?*

Answer: *I think it's a park. A mother is playing with her child, etc.*

Q: *Is it a nice park? Would you like to be there?*

A: *Yes, yes. It looks quiet. I don't think there's a playground there. It looks dreamy. I was once in a park like that. (character—associative)*

Q: *You say you would like to be there, why?*

A: *Well, I said it looks dreamy . . .*

Q: *What do you mean "dreamy"? There are bad dreams and good dreams.*

A: *No, I mean nice dreamy—quiet and soft. It's peaceful. Yes, no fighting— no loud noises. (subjective)*

Q: *Suppose this picture were a person. What kind of person would it be? This is harder to answer, but you know what I mean.*

A: *Nice. It would be a nice person. (Associative)*

Q: *Wouldn't he be mean to you?*

A: *No, oh no. I would talk to him.*

Q: *Him? Why not a "her"?*

A: *It could be a her. It could be an older person—not young.*

Q: *You have told me Mr. Altman has given us a pleasant place. It's soft and quiet, nice things happen there. What do you think he did to make us feel this way? It just wasn't an accident, was it? (linking forms and meaning)*

A: *Well—everything is quiet. I mean there are no strong colors. (objective)*

*All his lines are fuzzy. He has hundreds of lines—little ones. (objective)*

Q: *Very good, I agree with you. You seem to be telling me that Mr. Altman's etching, which is a kind of drawing, makes you feel a certain way, and the way you feel comes out of the way he draws and the kinds of shapes he uses . . . (relative objective comment to intent of artist)*

A: *Yes, he's a good artist. (judgment)*

---

### Sample Questions Utilizing the Terminology of Art

| *Art Terminology* | *Painting* | *Question* |
|---|---|---|
| Social Criticism | *The Senate* (William Gropper) | After a visit to the United States Senate, the artist painted his idea of what he saw. In your opinion, this artist seemed to feel that: The only things senators did were read papers, sit around, or make speeches that no one cared about. All senators are not the dedicated public servants we think they are. Most senators read papers in order to know what was happening in different parts of the country. |
| Depth | *The Last Supper* (Leonardo da Vinci) | In this wall painting, what gives you the feeling of depth? The direction of the lines in the construction of the room. The strong and bright colors. Both. |
| Paint Quality (Technique) | *Lady with a Parasol* (Auguste Renoir) | The edges of the objects in this painting are mostly: Unclear and fuzzy. Sharp and exact. Both |
| Line Quality | *Killed in Action* (Kathe Kollwitz) | We can describe the line in this print as: Delicate and soft. Strong and bold. Both |

| Meaning | *Killed in Action* (Kathe Kollwitz) | Which statement best describes what is going on in this print? A mother is resting with her children. A mother is expressing misery in front of her children. A mother is playing with her children. |
|---|---|---|
| Style | *The Last Supper* (Leonardo da Vinci) | The style (the artist's own way of painting) of this picture is called: Realism (looks lifelike). Selective realism (partly real). Abstract (simple, unrecognizable objects). |
| Composition | *Starry Night* (Vincent van Gogh) | The stars dominate this painting. Van Gogh makes them stand out by: Using bright colors and swirling patterns. Making the stars large and placing them over a major portion of the canvas. Both |

---

Levels of inquiry can develop best through the use of language, and, in order to develop facility with words, the teacher must use art works to direct attention to specific meanings. The following table demonstrates how elements of an art work can be used in a selective fashion to develop an art vocabulary. Slides or reproductions may be used to have students consider the relative accuracy of a series of statements made about an art work.

In general, the following suggestions should be borne in mind in class discussion of art works:

In selecting works for study, respect the natural preferences of children. Research can provide cues for selection. Williams and others have noted brightness, realism, familiarity with subject matter as bases for preference.[8]

Select the work with care: the point of the discussion should be embedded in the specific character of the painting, the scultpure or the building.

Two or three examples are more effective than one as all of us learn more quickly through contrasting images. Three Rouaults will tell us one thing; a Rouault next to a Wesselman next to a Wyeth has something else to tell us.

These two paintings invite the eye to travel back and forth. Recognizable objects or personal associations do not stand in the way of this kind of direct visual experience. Veils of color and adjustments of tone support the action of the forms. These pictorial forces can be sensed even without color.

*Selene II* Claudia Carrel Acrylic on canvas. Gift of Dr. and Mrs. William H. Chasen. Courtesy Museum of Fine Arts, Boston.

*Variant: Three Reds Around Blue* Josef Albers Signed and dated 'JA 48' Oil on masonite. 22½ X 29 3/4 in. Gift of Mr. and Mrs. Herbert M. Agoos. Courtesy Museum of Fine Arts, Boston.

Reorganize the class for viewing: remember that each child is entitled to a "front row" seat. Children should learn early that seeing is a positive act involving intense visual concentration. Therefore the relation of viewer to object is an important consideration.

When in a museum encourage each child to discover his own "viewing space," a distance that is determined in part by the object, in part by his own feeling of comfort.

Always honor the child's vocabulary, and when appropriate write the correct art terminology down so the entire group can study it.

Periodically have a student come to the picture to point to the passage or object under discussion.

Avoid reproductions that are too small (usually under 12" by 18") or that are of poor quality. You may even want to show more than one reproduction of the same painting in order to stress the unreliability of the reproduction process.

When possible, use an art object you, the teacher, feel positively about. If you feel warmly about it yourself, it will show and that is all to the good.

The larger the projected image, the better. Large-scale images make stronger responses.

One way to involve a noncommunicator is never to ask a question with a right or wrong answer. Once embarrassed by an incorrect response, a student may never volunteer again. It's usually acceptable to ask a question if one is reasonably certain that a correct answer is forthcoming. Questions on the descriptive level are recommended, such as those dealing with the obvious predominance of a subject, color, or other design element.

### Setting the Stage for Viewing

One method of opening the door to discussion is to precede the contact with the art work by having the class engage in some activity that bears some relationship to the work to be discussed. For example, if the teacher wants to talk about Breughel's *Games,* she or he might first ask the class members to pretend they were sitting on the roof of their own school and to record the action on the playground below. Their concentration upon Breughel's painting following this exercise might be con-

siderably more intense. Another example would be to discuss what goes on in our minds when we study ourselves in a mirror. Do we like what we see? Do we ever speculate what we will see in the future? What do we *want* to see? After painting or drawing their own response to such questions, they could then study Pablo Picasso's *Girl in the Mirror* and attempt to get at Picasso's intent and explore his use of shapes and colors as evidence of his point of view.

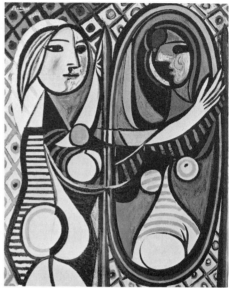

PICASSO, Pablo. *Girl Before a Mirror.* 1932, March 14. Oil on canvas, 64 X 51 1/4". Collection, The Museum of Modern Art, New York. Gift of Mrs. Simon Guggenheim.

West Newton Public Schools

**Art works make for a rich source of related ideas. Studio projects that are based upon such sources can provide evidence of the student's understanding of the work. Picasso's *Girl in the Mirror* serves as motivation for a drawing. This fifth-grade artist dealt with the meaning of mirror images rather than copying the painting itself.**

Another way to prepare for viewing is through a more generalized method of heightening observation. This exercise comes from the many theater games that actors use as warm-up exercises.[9] Here is one example. Divide the class so everyone has a partner. Partners face each other and study each other's appearance, fixing in their memory every detail. After two or three minutes of intense observation, the partners turn their backs to each other, and each makes some changes in his or her appearance—such as changing the position of jewelry, unbuttoning

shirts, or untying shoe laces. The players are then asked to face each other and see if they can observe the changes their partner has made. After two or three rounds, they are geared for a more active approach to looking, seeing, and identifying the elements of art work.

Another variation is to have the whole class study the room as carefully as possible. They then close their eyes in order to allow the teacher, or student player, to make some changes within the room. The problem is to see who can spot the changes. Over a period of three rounds, this can get progressively more difficult—from changing the position of the teacher's desk to changing the position of some object on the desk.

Following is a transcript of a dialogue taken from a videotape of a fifth-grade discussion of a Vasarely painting after the class had been asked to make a crayon drawing that would "fool the eye." The commentary on the lefthand side of the page reminds us of the varieties of sources for discussion that can be tapped in a relatively short time. It is an excellent example of a guided discussion—that is, of a questioning process specifically planned to get at issues the teacher feels are important. A complete account of the project may be studied in the exemplary programs section in Chapter 3.[10]

---

**Teacher/Class Dialogue**

*Commentary*

| | |
|---|---|
| The teacher begins on a descriptive level ("What do you *see*?"). | Ms. Murphy holds up the Vasarely nonobjective painting. "Michael, what do you see?" Michael: "A square in the middle." David: "It looks like lots of squares put together—blue and yellow and black." "You are describing it well. Jill?" "It looks like a deep hole that goes deeper and deeper . . . . ." |
| The students move to an associational level ("What does it *remind* you of; what is it *like*?"). | Other children volunteer the following: A cellar, a well that has windows in it, a pyramid, a camouflaged box, and "there are some pictures like that, that when you look at them for a long time, it's like moving." |
| The teacher adds information about the painter's style. | Ms. Murphy, "Yes, the artist makes the point of trying to fool your eyes. His name is Vasarely, by the way. And he does a whole lot of pictures like this. They're called optical illusions." |
| The students are asked to *account* for the artist's effects. | The children continue to describe their experiences with the picture. She asks, |

| | "How do you think that he makes your eye think there's a hole in the paper?" They answer: "He makes it smaller and smaller and smaller. He makes it—like darker and darker." |
|---|---|
| Students now respond on a *sensory* level (aural-rhythmic). | With the teacher's encouragement, the children begin to describe what the picture sounds like. "It sounds like a quiet sound getting louder and louder. It was sort of like a slow beat. And then it started getting faster and louder . . . " Ms. Murphy: "Could someone *sing* the picture, do you think?" Jill: "Do you want it in English or in noise?" |
| Teacher introduces specially designed support materials. | Ms. Murphy then introduces a booklet she had made consisting of puzzles and tasks for the children involving optical illusions. "With your crayon, see if you can make the middle square jump out of the paper." Child: "How come it can't jump in?" Second child: "Make a little square, maybe dark on the outside . . . " |
| The class concludes the Vasarely experience with another studio assignment. | The final experiment, of course, was for the children to make their own nonobjective pictures. |

Direct approaches are those that have as their primary focus the object rather than the viewer, and indirect approaches attend to issues that occupy a position somewhat apart from the object but that are recommended as a preliminary stage for appreciation. The following columns may help to point out the distinctions.

| *Direct* | *Indirect* |
|---|---|
| Any critical process that is centered upon a particular work. | Regarding Paul Cézanne's *Card Players*, improvise a dialogue in which the subject of the painting might be involved. |
| Speculative questions: for example, in observing a work by Degas, "What is there about the ballet and the theater that appealed to Degas?" "How can you tell?" "Are there any clues in his handling of media?" | Regarding a group study by Fernand Léger, "Suppose these figures began to move about—what would it look like?" |
| Studio exercise: placing tracing paper over a painting and recording the structural directions which operate beneath realistic forms. | Regarding Théodore Géricault's *The Raft of the Medusa*, a Manet seascape and a Léger study of urban and mechanical forms: "Suppose you had to find a musical equivalent to these paintings, which of the following records would you choose? I'll |

play you a brief selection from each and you choose the appropriate pieces."

Regarding the viewing of a Piet Mondrian, a Kandinski, and a Franz Marc: "As I show each slide, let me see what it does to your bodies; try to feel the movement of the paintings and let's see what happens to you as a result of your looking."

---

To be more explicit, the class discussion led by Professor Ackerman is an example of direct activity. The Arts Awareness program described in the Museum section is indirect, since the art works are used as motivation for sensory activities rather than as centers of attention to which all activity is directed.

*Spring on Brimmer Street* by R. Bliss Bequest of Maxim Karolik. Courtesy Museum of Fine Arts, Boston.

**What Is "Real"?**

*Spring on Brimmer Street* by Bliss can be discussed in relation to the nature of perspective and the use of space to engender mood. Children on first viewing will categorize this as being "realistic." The more the picture is studied, the greater becomes the discrepancy between the "realism" of the painter and that of the camera. Children were asked to rate these three paintings from "most real" to "least real."

*Gaspay Peninsula* Milton Avery Oil on board. 13½ X 16¼ in. Gift of the Stone Foundation, 1971. Courtesy Museum of Fine Arts, Boston.

*Easter. 1948* William A. Cheever American. Abraham Shuman Fund. Courtesy Museum of Fine Arts, Boston.

## A Depth Approach to a Single Work: *Guernica*

One of the most thorough analyses of children's language of visual response was attempted by Brent Wilson in the development of his "aspective instrument."[11] After working with 483 subjects from the fifth through the ninth grades, Wilson concluded that there were twenty-four categories of verbal response covering the kinds of comments that children could make about an art object. These categories, in turn, were divided into subcategories of judgmental responses, descriptive responses, and aspects of painting categories.

By categorizing and scoring an individual's language, it was possible to determine the methods children used to evaluate paintings, the manner in which they responded (for example, whether they analyzed or synthesized the aspects of paintings; whether they told anecdotes about the paintings), and what aspects they viewed in the paintings (for example, whether they looked for literal, sensory, formal, symbolic, emotional, contextual, or pervasive aspects of paintings).

Working from thirty-four carefully selected twentieth-century paintings, Wilson discovered that there was very little difference in perceptual modes among his population and that perceptions among all grade levels tested were directed toward the more literal aspects of the works. In order to move children to a more critical frame of mind, Wilson created an entire program for fifth and sixth graders designed to alter their perceptions by providing instruction in language and critical behaviors that involved skills of analysis and description, interpretation, and so on. Wilson assumed that as the children learned to use language as a means of pointing to alternative ways of studying a painting, they would eventually change their perceptions of art from narrow, customary ways to broader or more aspective ways. Wilson administered his Aspective Perception Test to the group both before and after his experiment so that changes in linguistic behavior could be studied. Wilson describes the instructional program as follows:

> *After the pretest the control groups received art instruction (primarily involved with the production of paintings and drawings) as usual for a period of twelve weeks, with approximately ninety minutes per week spent in art activities. The time was used flexibly at the discretion of the teacher.*
>
> *The experimental groups received an entirely different type of art instruction. In preparation for the experimental treatment a series of lessons were written. The lessons centered, in part, around some of the ideas contained in Rudolf Arnheim's book,* Picasso's Guernica: The Genesis of a Painting. *Arnheim's book included forty-five preliminary and working sketches made by Picasso for* Guernica. *Arnheim presented Picasso's sketches chronologically and showed through the changing*

sketches what he considered to be Picasso's process of visual thinking. The material prepared for the students' use contained thirty-five of Picasso's sketches and was organized to use language to point to the various qualities and aspects of the sketches and the completed Guernica.

The instructional procedure was to furnish each student with one or a number of Picasso's sketches for Guernica. After viewing the sketches the students read about particular aspects of the sketches. The reading material was carefully structured to introduce different aspects of the paintings. In other words language was used to point to aspects of art works. Once a term was introduced it was reinforced numerous times in succeeding lessons. Each viewing and reading session was immediately followed by another carefully structured session where the teacher reinforced concepts from the reading by asking the students to make verbal comparisons between two or more sketches and to detect various relations of aspects between the sketches and the final mural. Thus, the students used their newly acquired language to describe their perceptual experiences. Near the end of the project the students were given sketches with no accompanying written material and were asked to write about specific aspects of the sketches. At no time was there any attempt to indicate relations between Picasso's work and any other works of art. In other words, teaching for transfer was specifically avoided.

During the experimental treatment the students continued to paint and draw occasionally, but the major art instruction was of the nature described above. The project lasted twelve weeks, utilizing two or three half-hour sessions.

At the conclusion of the experiment Wilson discovered that there were indeed significant differences between the language used by the control and the experimental groups. He concluded as follows:

The findings of the inquiry were that by carefully programming language and structuring experiences related to perceiving paintings it is possible to significantly alter the perceptual mode fifth and sixth grade students use in perceiving paintings. Students in the experimental groups did significantly alter their perceptual mode of perceiving from a customary toward a more aspective mode as indicated by an analysis of the language they used to describe their perception. [Wilson's emphasis.]

Of particular note were the significant differences in the way the control and experimental groups analyzed and noted relationships in paintings and made judgments about the paintings based on analysis. The experimental groups also directed their attention toward the sensory qualities, Shape and Color, and the formal aspects, Movement-Direction and Value Contrast, more than did the control groups. It was most interesting to note that the number of references to literal aspects of

*paintings was reduced significantly as the experimental groups gained skills in perceiving aspects other than literal.*

### Another Depth Approach to a Single Work: *Hide and Seek*

Henry Ray, director of Teaching Learning Resources in Warminster, Pennsylvania, has developed a depth approach to art appreciation that involves dozens of slides taken from one complex work.[12] As Wilson designed an entire unit of study around Picasso's *Guernica,* Ray has used Pavel Tchelitchew's *Hide and Seek* as the basis for a series of sessions wherein fifth and sixth grade children sought out and discussed the artist's use of embedded figures and figure/ground ideas. So rich is the painting in its use of shifting visual ambiguities that Ray had no difficulty in maintaining the interest of his students over an extended period of time. He has written of the experience:

> *Approximately forty slides, most of them selected details or portions of the paintings, are the means for this remarkable journey into the world of art. Some details are quickly seen and identified—other details more subtle and sometimes a part of two images, demand very thoughtful "reading" of the picture. Most of us viewing the picture will quickly find the hand and the foot of the central multiple image of the painting. Many of us will have difficulty seeing the trunk of the tree as the head of an aged Viking with its left eye formed by the butterfly on the tree trunk, its right eye by the arm of the girl spread eagled against the trunk, its nose formed by the girl's torso.*

Part of Ray's approach was to combine the perceptual experience with a studio activity. In this instance he gave each student a print of a tree. The students were then encouraged in improvising their own images, working from the complex of bare branches, limbs, and other sections of the reproduction. This activity provided the class with a direct link to the kind of visual improvisation which distinguishes Tchelitchew's painting. Ray comments:

> *Perhaps the most important personal development that can occur through art experiences of this type is the development and growth of that inner vision which increases one's power of communication and nourishes the roots of expression. The natural world has a different look than it has ever had before. A special new world is created—and it's a better world.*

While such an approach can be used in any classroom that can accommodate slides, Ray had the unique advantage of a building especially designed for media presentations on an ambitious scale. Ray and

architect John S. Carver designed a domed cyclorama known as the Special Experience Room that could provide sensory learning experiences that are difficult, if not impossible, to achieve in a conventional classroom. Through the use of his audiovisual equipment (projectors, overhead projectors, super 8 and 16mm films, and so on), Ray is able to study not only paintings on an unusual roomsized scale, but also cloud formations, aerial views, and a great variety of patterns, and textures from the natural world. Because of the size of the projections he is able to more intimately involve children with them. Through a careful selection of images he is able to relate perception of nature to perception of art works.

## A Depth Approach to a Single Artist: The Renoir Room

While Wilson and Ray have provided models for using a single art work as a basis for extended study, Albert Cullum used many works of a single artist to create an environment for study.[13] In order to create his "Renoir Room," Cullum first stripped his sixth-grade classroom of all extraneous material and then displayed over fifty reproductions of paintings. Moving his desk into the hall and arranging his chairs into small viewing groups, Cullum set up the kind of gallery atmosphere he would need for the activities that followed.

The students then entered a research phase, gleaning all the information they could regarding their subject from both school and public libraries. Their purpose was to prepare presentations for the rest of the school, and in the two weeks that followed, Cullum's class conducted tours, gave gallery talks, and led discussions for the second, third, fourth, and fifth grades. Like every art teacher, these students were faced with the problem of selecting content and activities that were appropriate for the age levels and activities to be dealt with. Cullum was particularly pleased with the growth in art vocabulary. He noted:

> *A whole new world of words opened up to them—impression, spontaneity, inspiration, technique, contemporary, classical, realism, modern, creative freedom, palette, influence, neoimpressionist, opaque, original, vigor, sensibility, dynamic master, exquisite, salon, composition, texture, bourgeois, progressive, austerity, chromatic, post-impressionism, and many, many more. What a wonderful new wealth of words the students learned, used, and understood.*

Cullum followed his "Renoir Room" project with a similar treatment of five periods of Picasso's work (fifty examples) and began a program of lending reproductions through the library of another school.

Another depth approach was used in the Newton schools, where a parent who majored in art history volunteered to create an exhibition around the life and works of Henri de Toulouse-Lautrec. The show was mounted in the library and labeled with explanatory materials, and a taped commentary was created by the exhibit director to guide the children through the show. Portable cassette tape recorders were borrowed so that small groups of children could absorb the paintings in a more leisurely, informal manner.

Depth approaches for a painting or an artist offer definite advantages. The children enjoy a rare opportunity to live with a visual experience over an extended period of time. For the majority, it is probably the first time they have experienced more than the most superficial encounter with art. The depth approach can offer the possibility of revealing layers of meanings and experience, taking the child well beyond the limitations of the first impression.

## VISUAL GAMES

The visual experience demands that the viewer be able to perceive the properties, organizing factors—design elements, if you will—that are inherent in any work of art. Visual games, therefore, are prepared materials designed specifically to focus the students' perceptions on a given task. The theory of games requires that the process of playing be both rule-governed and entertaining. Since in most instances the student deals with art works, it is assumed that the pleasurable aspects of game playing will provide some positive attitudinal changes toward art in general.

All of these games are rule-governed in the sense that all tasks require specific kinds of conduct and rule out others, but only in limited situations does one "win" or "lose." There is some justification for this concept in the dictionary definition of the word "game." Webster's defines "game," at least in part, as follows: "An amusement, diversion, scheme or strategy employed in the pursuit of an object or purpose; a physical or mental competition conducted according to rules, each side striving to win and to keep the other side from doing so." In this context, one can also note with satisfaction that one of the oldest formulas for effective instruction, "to teach and to delight," makes precisely the same connection between learning and enjoyment. The games used in an art appreciation program have certainly been designed for both "amusement" and "delight" and for "pursuit of a purpose" or "to teach"; they become competitive only if the teacher elects to score them for correct answers. Since "strategies for visual discovery" is a

somewhat cumbersome phrase, the word "games" has been adopted because it holds positive connotations for children. In any case, the games concentrate on the study of visual objects in which the participant is required to seek out similarities and differences of form and content.

The process of organizing information relies, in part, on ideas from Gestalt psychology. Visual games also draw upon Piaget's theory of mental operations—particularly in the area of classifications. Dealing with visual categories is a means of organizing perceptions that comes naturally to children as one step in cognitive development. Related to this are the exercises devised by Johannes Itten for his students in the Bauhaus basic design course.[14] Itten worked with contrasts as one way of attaining clarification skills; he used paired concepts such as the following:

| | |
|---|---|
| smooth—rough | diagonal—circular |
| black—white | still—moving |
| long—short | strong—weak |
| thick—thin | quiet—loud |
| pointed—blunt | high—low |

One can deal with such discriminations with one's body and sense of hearing as well as with one's vision. Visual games use carefully selected examples and groups of art works in which particular visual tasks are embedded.

Feldman notes that certain principles that have broad universal application are particularly appropriate for the study of art works.[15] The following specific principles are taken from Feldman and may apply even more directly to the sorting, matching, and categorizing demands of the games:

1.  *Perception is of whole* gestalten, *or configurations, which comprise the fundamental units of experience.*

2.  *The organism imposes wholeness upon the objects of its perception because of the way it organizes psychological energies during the perceptual process.*

3.  *If visual forms are unstable or incomplete (and they always are, in some sense), the human organism completes them according to psycho-physical laws governing its perceptual behavior. Such completion is called closure.*

4.  *Closure is needed to form a* gestalt, *because the organism will not tolerate instability in its search for perceptual clarity. "Closure" can also be interpreted as*

*that final stage of recognition or discovery which reveals to the child the wholeness, the completeness, of a work.*

5.  *Regularity, symmetry, simplicity, and closure are characteristics of energy distributions during perception. These psycho-physical terms correspond to these aesthetic terms: rhythm, balance, unity, and coherence.*

The games described below are built upon simple Gestalt principle. The reader may not be able to locate all of the works listed, but the principles of the games structure can be applied to any number of reproductions, available through museums or other sources.

### Match the Boxes

This game is designed for use in the primary grades and makes use of a series of square plastic boxes each side of which contains a partial segment of a reproduction. (Containers designed to display photographs can be purchased at stationery stores.) The child is asked to match the sides and thus to complete the images. The student is dealing with six paintings that the teacher can select for whatever stylistic content or art form he or she deems appropriate. The teacher may choose the paintings according to the style or degree of complexity of the composition: the first group providing the simplest task, artists with the most different styles, and the last group dealing with artists of a more limited stylistic vocabulary.

Of course the game could be prepared for architecture or sculpture, but, as usual, painting is stressed because of the interest in color.

© Richard Sobol

© Richard Sobol

© Richard Sobol

© Richard Sobol

**"Match the Boxes" works equally well with teams or individually.**

Lower-grade children and beginners can do well with Group A, but Group B calls for more practice and greater perceptual acuity.

| Group A | Group B |
|---|---|
| Differences | Similarities |
| Rouault | Sisley |
| Mondrian | Pissarro |
| van Gogh | Monet |
| Dufy | Derain |
| Manet | Bonnard |
| Byzantine mosaic | Vuillard |

### Style Matching Game–A

This is a variation of the previous game and is easier to prepare. Each student is given a packet of twelve reproductions. He or she is then asked to arrange these into six pairs of matching artists (for example,

pairs Paul Klee, Marc Chagall, Claude Monet, John Marin, Henri Matisse, and Paul Gaugin). Clues for matching are derived from style, that is, from similarities of color, subject matter, degree of realism, brush work, and handling of form. These characterize the work of an artist and are selected because they remain discernible regardless of subject matter. Style Matching Game–A was designed to be played by individuals working alone. The following transcript is taken from an introductory session and is an initial exercise for the entire class. Nine large reproductions were used—four pairs (Marin, Georges Rouault, van Gogh, Thomas Hart Benton), and a "joker" (George Inness) without a matching partner. In order to provide the following material, six sixth-grade students volunteered to match the artists in front of their classmates to demonstrate for the entire group the kinds of decisions that had to be made and the kind of language used.

These comments were recorded as the individual artists were discussed:

van Gogh, Vincent

> I like how he uses color—it's bright and light.
> He makes the lines in different ways. They go in different directions.
> He showed the movement of the water.
> You see lines—the outlines of things.
> Shows texture—look how thick it is.

Rousseau, Henri

> The dark colors stand out.
> Both have dark big trees.
> This is realistic; it looks like oil paint.
> You can see how the tree lines are shaped at the ends.
> This comes on bold.
> The way people really look.
> It's realistic.
> People look like dolls.
> Look how fine the sky is compared to this sky. [van Gogh]

Benton, Thomas Hart

> The sky looks like cotton.
> The clouds are fluffy, like fur. [body gesture, feeling cloud]
> He shaded everything. [had to use body gestures to indicate the animated quality of Benton's composition]
> There are dark colors and light colors.

ROUAULT, GEORGES

> The lines are messy.
> Rough—the paint is rough.
> They're not solid lines.
> The lines are like lead—they're the same in both paintings.
> He used religious figures.
> The lines start and stop again.

MARIN, JOHN

> The subject matter is the same; both of them are cities.
> Busy and crowded.
> It looks like a skyline.
> Not much detail.
> Everything is every which way.
> He leaves spaces.
> They're both done by watercolors.

This transcription may provide some idea of the kind of verbalization that occurs when small teams of students play Style Matching Game–A. In attempting to ascertain how far the players worked from art terminology rather than associative or subjective responses, a tally was kept of word usages on the righthand side of the paper. The letters FE stood for a category that dealt with the formal elements of the work (color, shape, line texture), S for style, Sub for subject, M for mood. The tally shows that out of thirty-five references made by students in discussing the pairs, twenty-one remarks dealt with the formal elements, six with style (which could be interpreted as the end result of formal elements), four with subject, and three with mood. It would thus appear that one can make a case for the games as an effective strategy for weaning the child away from mere *psychological reacting* to a more *objective description* of the object utilizing art vocabulary.

### Style Matching Game–B

This style matching exercise is another variant of the two previous games, and, while it requires similar behaviors, it is structured on a simple to complex format. The student is confronted with a series of two-by-three-foot cardboard mats, each containing six postcards. A pair of matching works by one artist (for example, van Gogh) is paired in isolation on the bottom right-hand corner. Next to this pair is a grouping of four other reproductions by four different artists, only one of which is a van Gogh. The exercise is to identify the mate to van Gogh in the

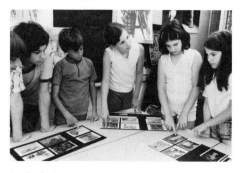

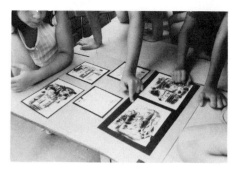

**The first Style Matching Game begins on a simple level of matching cartoons. Succeeding groups become increasingly subtle in their differentiations. Note variety of backgrounds, which are changed on a weekly basis.**

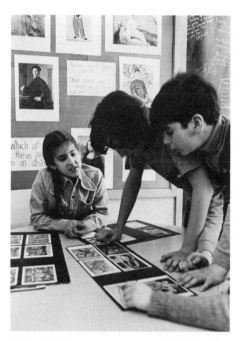

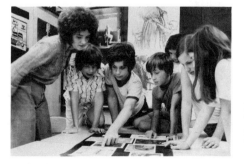

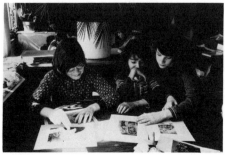

*teaching for appreciation: programs in action* **69**

group of four. The collections are numbered so that they may be dealt with in a prescribed order ranging from simple (dissimilar) to complex discriminations. A highly dissimilar group would be to match a Mondrian in a group that has Mondrian, Rouault, De Kooning, and Andy Warhol. A similar, but more difficult, problem would be to match a Monet in a group of Impressionists. Collections could also be devised for matching cartoons (simple), and furniture and architecture, which would be quite complex.

### Match by Touch

Another variation of style recognition is through touch. In a game developed in the Newton public schools program, a group of museum replicas was assembled and placed in cloth sacks. Photos of matching sculptural styles were set up, and the players were then asked to match photos to replicas by touch. The examples selected were of contrasting styles in the treatment of surfaces as well as form. Five heads were selected (an African mask, a classical Greek, an Egyptian, an Auguste Rodin, a Jacob Epstein) and also an abstract piece of acrylic sculpture and Henry Moore's *Reclining Figure*. The photos, it should be noted, were not duplicates of the models, but were other works of the same school or artist.

### Reduction-Sorting Game

The players are given a group of 16 postcard reproductions and are asked to subdivide them in accordance with a stated perceptual task.

EXAMPLE: FIRST PHASE

> First, divide the sixteen reproductions into two piles of eight. One pile should contain abstract and nonobjective examples; the other would contain examples of selective realism and realism. (Children should be prepared for the terminology of the games through previous examples, class activities, and discussions.)

> ABSTRACT TO NONOBJECTIVE
> Hartung—*The Whirlwind*
> Kandinski—*Composition 8-260*
> Boccioni—*The City Rises*
> Dubuffet—*The Walk*
> Pereira—*Melting Horizon*

How does the artist achieve realistic effects? The handling of space, size, perspective, and use of light and dark are recognizable factors. The second stage of discussion can go beyond realism toward structure and design. Such discussion can precede the visual games described in this chapter.

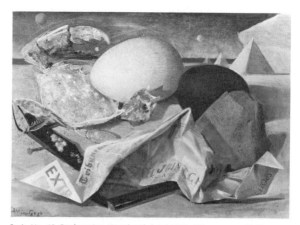

*Basic No. 12* Gardner Cox Signed and dated 1950. Oil on canvas. 22 X 31 in. Abraham Shuman Fund. Courtesy Museum of Fine Arts, Boston.

Mondrian—*Composition Red, Yellow, and Blue*
De Kooning—*Door to the River*
Pollack—*No. 7*

REALISM TO SELECTIVE REALISM
Jawlensky—*Egyptian Girl*
Delacroix—*Lion Hunt*
Monet—*Boulevard des Capuchines*
Renoir—*Lady Sewing*
Hopper—*Early Sunday Morning*
Vermeer—*Officer and Laughing Girl*
Matisse—*Lady in Blue*
Balla—*Winding Staircase*

SECOND PHASE

Now divide the pile of eight abstract to nonobjective reproductions into two piles of four—one group that emphasizes the use of line and one that relies on the use of texture as a major characteristic.

LINE
Pereira—*Melting Horizon*
Mondrian—*Composition Red, Yellow, and Blue*
De Kooning—*Door to the River*
Pollack—*No. 7*

TEXTURE
Hartung—*The Whirlwind*
Kandinski—*Composition 8-260*
Boccioni—*The City Rises*
Dubuffet—*The Walk*

THIRD PHASE

Now divide the eight examples of realism to selective realism into two piles of four—one pile that relies on use of texture and one pile that relies on arrangement of geometric shapes.

TEXTURE
Jawlensky—*Egyptian Girl*
Delacroix—*Lion Hunt*
Monet—*Boulevard des Capuchines*
Renoir—*Lady Sewing*

GEOMETRIC SHAPES
Hopper—*Early Sunday Morning*
Vermeer—*Officer and Laughing Girl*
Matisse—*Lady in Blue*
Balla—*Winding Staircase*

FOURTH PHASE

One could further divide examples of nonobjective/line into other groups: one pile that looks active and one pile that looks more passive. For example:

PASSIVE
Pereira—*Melting Horizon*
Mondrian—*Composition Red, Yellow, and Blue*

ACTIVE
De Kooning—*Door to the River*
Pollack—*No. 7*

FIFTH PHASE

One could divide the examples of the abstract/nonobjective/texture group further: nonobjective examples and abstract examples. For example:

NONOBJECTIVE
Hartung—*The Whirlwind*
Kandinski—*Composition 8-260*

ABSTRACT
Boccioni—*The City Rises*
Dubuffet—*The Walk*

SIXTH PHASE

Other possible divisions. Divide the four examples of realism/selective realism/texture into two piles of two: one pile that looks active and one pile that looks passive.

ACTIVE
Jawlensky—*Egyptian Girl*
Delacroix—*Lion Hunt*

PASSIVE
Monet—*Boulevard des Capuchines*
Renoir—*Lady Sewing*

SEVENTH PHASE

Divide the four examples of realism/selective realism/geometric shapes into two piles of two: one pile of two examples of selective realism and one pile of two examples of realism.

REALISM
Hopper—*Early Sunday Morning*
Vermeer—*Officer and Laughing Girl*

SELECTIVE REALISM
Matisse—*Lady in Blue*
Balla—*Winding Staircase*

The reduction sorting game can, of course, be reversed. The player or players can be given a collection of reproductions and asked to create their own sequences. Teams of players are suggested as well as individuals because the task of creating categories leads to heated discussions, and if you can get youngsters arguing about art, you are well on your way to creating the sort of climate that can facilitate learning in appreciation.

## Tic-Tac-Toe

This game is popular because it divides the entire class into competitive teams. In this situation, there are two groups, each side with its appointed leader. The teacher shows slides and asks each leader to confer with his or her teammates before coming up with the correct answer to the questions that are posed by the teacher regarding the slides. If the answer is right, the leader gets to place an X (or an O) on the grid drawn on the blackboard. If it is wrong, the leader is not allowed to add to the grid, and it then becomes the other team's turn. The teacher poses the question and may choose to place any frame of reference upon the slide. If the painting were *Guernica,* the teacher might ask the following:

The artist who painted this is _____ _____.

This painting is:

1. a celebration
2. a protest

The style of this painting is:

1. realistic
2. selective or stylized realism
3. nonobjective

Black and white is used because:

1. Picasso doesn't like color.
2. He didn't have any colors at the time.
3. He feels color wouldn't be as effective as black and white for what he has in mind.
4. He didn't know how to use color.

An influence from the past on this painting comes from:

1. Cubism
2. Impressionism
3. The Fauves, or Wild Beasts

Obviously, no question can be asked unless the vocabulary has, at some time or other, been previously discussed. The teacher may limit team discussion to a certain length of time if desired, and this only intensifies the heat of the argument between the two teams. It is a rare and salutary pleasure to observe children in violent discussion over a

painting, dealing with questions like those just cited. Tic-Tac-Toe is the only game that capitalizes on competitiveness in building class interest. It may appear "gimmicky" at first glance but is recommended because of the serious discussion it engenders within a context of play.

### Receiving Pictures

Harris has stated, "As we grow up in a highly visually oriented world and in a verbally oriented culture, [the child] leans more and more on what he sees and on the use of language to substitute for feeling, doing, handling, reaching, touching."[16] The Receiving Pictures game is an attempt to deal with such responses through language. (In the description of the Metropolitan Museum's Arts Awareness project in a later chapter, we will see how movement and other sensory responses are used in reacting to art.)

In Receiving Pictures, words are used to reflect a full range of sensory responses. Recognizing the child's familiarity with language, we ask the student to verbalize around sensations such as sound, touch, smell, and spatial awareness.

This game also fulfills the first two stages of Ecker's recommendations for the discussion of art:

> First, get the students to report freely their feelings, attitudes, and immediate responses to a given artwork (their own or a masterpiece). Second, point out to students that there are differences in how people (including their teacher) respond to what is apparently the same stimulus, and that this is a consequence of different experiences and learning.[17]

The method used in the following lesson uses small-group (five students) involvement to get at broad sensory responses to an art work. In assigning tasks to the groups, the teacher asks the students to "open" themselves, that is, to "receive" the painting within multiple sensory frames of reference. Some of the questions they must ask themselves are, If this painting were music, what would it sound like? If you were to walk into the painting, what would the space be like? If you could smell the painting, what would it smell like? If you could move like the painting, what would you do with your body? Such questions deal with:

1. The vividness and intensity of the sensuous elements in the works of art: the affective quality of the sounds, colors, gestures, and so on.

2. The formal qualities of the object: its design and composition.

3. The expressive significance of the object: its import or message or meaning, as aesthetically expressed.

The lesson also represents an attempt to work with subjective and intuitive responses. In earlier grades, children are encouraged to use their natural repertoire of modalities of investigation, such as kinesthetic-motor, tactile, sensory, olfactory. As children grow older, teachers have a tendency to minimize such experiences, requiring greater emphasis upon linguistic activities.

Lowry Burgess from the Massachusetts College of Art conducted a session of Receiving Pictures as follows. Fifteen large reproductions representing a wide range of periods, styles, and subject matter were brought into the classroom. The entire class was shown all of the reproductions and then asked to break up into groups of four or five. Each group selected a painting that particularly appealed to it.

The materials distributed included writing paper, pencils, and assorted reproductions. From the reproductions presented to this class of five groups, the following were chosen by students: Joan Miró's *Personages*, Maurice Utrillo's *Montmarte*, Rembrandt's *Man in a Gold Helmet*, Francisco Goya's *View of Toledo*, and Vasili Kandinski's *Composition 8, #269*.

The class was then given a series of questions that it first answered privately and then shared with other members of the group and, finally, with the whole class. Paper and pencils are provided for a recorder to write individual answers. Questions are asked one at a time by the teacher and are followed with a discussion of students' responses. Each question applies to all pictures. The following includes a record of an entire session. The teacher began by stating: "You are often asked questions, and there are many ways of answering any one question. For instance, let me ask you, 'Where do you find an apple?' "

Answers included "a tree," "a bowl," "the refrigerator," "your mouth."

"So you see, there are many ways to answer one question. In this case you answered from memory or past experiences. But now let me ask you if it is a sunny day today. [Answers: "yes"] Well, how did you decide that? [Answers: "From looking," "By seeing"] So some questions can be answered by looking or experiencing or observing. Today I am going to ask you some questions about the reproduction your group chose, and after each question, please jot down notes so they can be shared with the rest of the class. By individually experiencing or looking at the reproduction we should be able to share a wide variety of answers." Burgess then introduced the second question.

*"Look carefully at your reproduction and write down on your paper what*

*you see. In other words, take an inventory of your reproduction and list everything you see in it. Just tell me everything you see."*

Answers:

| | |
|---|---|
| reddish red | a head |
| a squiggle | rectangular shapes |
| feet | a lot of overlapping |
| a star | a tail |
| a body | dog's teeth |
| solid shapes | a texture |

After listening to the students' replies, the teacher commented:

*"So people see different things. Some of us first see details such as a squiggle or a tail, and others of us see big things such as a lot of overlapping. Now look again and see what your reproduction sounds like, moves like, feels like, tastes like, and smells like."*

Answers:

| | |
|---|---|
| noisy | freedom |
| a circus | paint |
| a Mexican band | sawdust |
| fast | fireballs |
| gaily | licorice |
| jumpy | fresh air |
| sky writing | penny candy store |
| an LSD trip | summer |
| confused | |

Burgess now asked:

*"Now memorize the reproduction. Pretend you are never going to see it again and you want to remember everything about it. Just look really hard at it for the next few minutes. Now close your eyes and try to recreate it. Now open your eyes. What did you forget?"*

Answers: [Reaction of astonishment]

*"That red shape," "those lines," "the background texture."*
The final two questions were:

*"How many of you first thought of big things? Did any of you start by remembering little things first?"*

*"Now try to imagine what it would feel like if you went into, that is, inside, the picture. Then, what would it feel like if the picture came out and around and surrounded you?"*

Answers:

*"I'd be running," "scary," "I wouldn't know where to go first; it would be like a dream, like I was sitting on a mobile."*

He concluded:

*"So you see, there are many ways of looking at pictures and, by trying them, we feel like we are really getting to know the picture well, as if it is becoming a long time friend."*

### The Color Adjustment Game

This game was conceived as one means of getting at the unity of a work of art.[18] It asks the player to respond to the totality, the coherence of a painting and to discriminate between a work in its original form and an altered version. The children become aware of the importance of color nuance and, after a period, are able to detect those changes in tone and intensity that set up an imbalance in a painting.

The Color Adjustment Game is based on a series of 8" X 10" prints selected especially for this situation. It includes twenty-four reproductions representing three copies each of eight different paintings. In

© Richard Sobol

© Richard Sobol

**These jigsaw paintings are not random segments of a work but are designed to reflect parts of a work that relate to the total structure.**

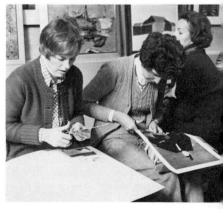

© Richard Sobol

each set of three reproductions, one copy is left intact, while the other two have one section that has been tampered with, for example, painted over lightly with watercolors in such a way that the artist's use of color is altered. The game is presented so that each student examines each set of three reproductions, seeking the color distinction. He picks out the unchanged reproduction and then passes the set on to his neighbor. The students then discuss the reasons for making their particular choices as the teacher places the sets before the class. Watercolors are used because their transparency and delicacy make the task of selection more difficult. The teacher discusses with the class the concept of an artist's particular color palette and how artists' personal color language varies, and asks each student to look closely at his reproductions until he can "see" the total effect of the artist's color feeling. The student is asked to visualize how the overall effect of the picture was changed by painting over one particular area with a tone that is consciously planned to upset the unity of the whole. Care is taken in doing this since the objective is to make the painting look as if the new color was not obviously or crudely added. When the class is finished, they pass their sets around and discuss the differences.

The following reproductions are used in sets of three: Willem De Kooning—*Door to the River,* John Marin—*Lower Manhattan,* Claude Monet—*Haystacks at Giverny,* Paul Cézanne—*Rocks and Pines,* Max Beckmann—*Rugby Players,* Arshille Gorky—*Artist and His Mother.*

### Memory Game

Here the group is asked to study a painting closely, memorizing as much of the painting as they can. They are then asked to turn their backs to the painting. The teacher goes around the class asking each student to name any object or relationship among objects in the painting. The one who is asked to name what he remembers may not repeat what someone else has said. This process gets more difficult as the characteristics are ticked off. When no one has anything to add, the group turns around to see what it has left out. Slides as well as reproductions can be used.

### Creating Emotions Game

Classification games can be designed around emotional as well as perceptual discrimination. Not only can students discover that art can evoke different emotions, they can also study the ways in which artists achieve the emotional qualities in a painting. This game deals with the question, "How does the painting make you feel?" and stresses the

factor of empathy or identification with a painting on a more subjective level. It also gives the students a good vocabulary exercise.

Stage One: Sorting of twenty reproductions according to four given categories of emotions.

Stage Two: The creation of a descriptive word list dealing with the emotions. One group of students is asked to create its own "emotion" categories after careful study of twenty reproductions. A group of six sixth-graders and one of the authors decided upon the following sub-categories, based upon two major categories of reproductions:

| Active | | Passive | |
|--------|--------|---------|--------|
| Students' Words | | Students' Words | |
| (1) | (2) | (3) | (4) |
| funny | exciting | peaceful | sad |
| humorous | electrifying | restful | lonely |
| playful | sizzling | calm | depressing |
| joyful | sharp | cold | pessimistic |

Students are asked to divide twenty reproductions into two piles of ten each. One pile has paintings that have the emotions in categories 1 and 2 (active); the other pile, emotions in categories 3 and 4 (passive). They then divide each pile of ten into two subpiles of five each following all of the listed categories of 1, 2, 3, and 4. The players' emotional responses will rest largely upon subject matter, style, color, and other characteristics of the paintings. The children are told to feel as well as look more intensely at each painting as they try to place a painting into a category. Teachers should stress the fact that emotions are both personal and universal, that emotional identifications are also derived from our own experience, and that "correctness" or consensus is not an issue.

## Matching Statements and Images

One purpose of art games—indeed, of any aspect of an appreciation program—is to keep the child in the presence of art works for an extended length of time. An observation of the general viewing public at an exhibition will soon reveal how little time people spend before art objects; indeed, were one to time the first dozen or so viewers, the average attention span would be tallied in terms of seconds rather than minutes. People have a tendency to linger if there is some overwhelming evidence of technical facility, overtones of pornography or eroticism, or some vivid anecdote or scandal that surrounds the work. The

newer or more foreign the visual experience, the less time is spent looking; and the closer the work touches the personal experience of the naïve viewer, the longer he or she will remain to observe it.

Matching Statements and Images is another game that cannot be played unless the player spends time in close study. The format is quite simple and may employ reproductions ranging from postcards to small museum reproductions. Sets or groups of pictures are pasted on large pieces of cardboard or in a scrapbook. Each group contains one statement about the pictures. Such statements can come from critics, historians, or the teacher. After reading the text, the player is asked to make a judgment or select an answer and then to turn to the back of the book to check the validity of his answer.

STATEMENT #1

Certain changes of painting style preceded the Impressionist movement. One change can be seen in the way paint was applied. The four paintings shown above go from examples where the style is so realistic that one can barely see the brush strokes to an Impressionist painting where the brush texture is thicker and more freely applied. Going from A to D, indicate the order which leads from classicism (most realistic) to Impressionism (most painterly).

Select correct answer:
A—Ingres; B—Courbet; C—Boudin; D—Monet

STATEMENT #2

A Primitive artist is someone who has never had professional training, that is, has never gone to an art school. Primitive paintings, therefore, often have a stiff, childlike look about them. One of the above is the work of a real primitive painter and the other is a trained artist working in a primitive manner or style. The third is by a nonprimitive painter.

Select correct answer:
Grandma Moses—primitive artist    Doris Lee—trained artist
Norman Rockwell—a nonprimitive painter

STATEMENT #3

The Renaissance period in art had many styles of painting— usually associated with particular schools or cities. As an example, in Florence, the work was more "linear" with clear edges,

while in Venice the style was looser, more painterly, with softer edges. Which of the above paintings was done by a Florentine artist and which by a Venetian?

Select correct answer:
Botticelli—Florence   Titian—Venice

## The Visual Treasure Hunt

The development of the Visual Treasure Hunt was a joint effort of one of the authors and a teacher working with a staff member from the Fogg Museum at Harvard University. A student can begin anywhere at his own level and proceed at his own speed. (Indeed, the group must do so or an entire class may congregate before a single painting.) As is indicated in the instruction sheet, everyone gets a prize—a museum reproduction postcard of a work of his or her choice. The important thing about the hunt is that while it involves the full class simultaneously, it encourages individuals to work at their own rate of speed.

The Visual Treasure Hunt works in this manner. Before the teacher is ready to present the "Hunt," he or she must visit the museum and place numbers on those paintings that are to be used. Since exhibits come and go, each worksheet must be created anew. This is not as difficult as it appears, since the pattern of questioning lends itself to similar kinds of exhibits. Upon arriving at the museum, each student receives two sets of directions. The instruction sheet (white) is distributed and discussed in the reception area of the museum and the "Hunt" sheet (pink) is passed out in the gallery of the "Treasures."

### THE INSTRUCTION SHEET

*A visual treasure hunt in the Fogg Art Museum: A statement for the Student: This Visual Treasure Hunt is a game designed to help you enjoy looking at paintings. It is not a test and it will not be graded. Each person will search by himself. When we are all finished, we will compare our answers.*

*You have up to one hour to go on the Treasure Hunt. The "treasures" you are looking for are waiting to be discovered in the paintings displayed in this room. You will find small circular white labels next to each painting which will show you what number to use when telling us which paintings you select. Please DO NOT TOUCH any of the paintings, because your fingerprints could never be removed, and we would be asked to leave the museum.*

*There are thirteen (13) questions on your correction sheet. Answer as many as you can, but don't worry about it if you don't finish. Some of the questions may not be easy! Fill in your answers by using the numbers next to the paintings. In some*

cases, more than one answer could be right. You will be given clues to help you find the answers.

You will notice right away that these paintings are alike in many ways. You have probably noticed that they are much different from the other paintings in the Fogg Museum which you passed on your way into this room. These pictures are what we call non-objective; that is, they have no recognizable subject matter such as people, flowers, or houses. They were all painted within the last twenty years, and many of the artists are still living, so this is contemporary art (although many other styles are now in existence). Yet no two of them look exactly alike. But then, none of you look the same either!

After the Visual Treasure Hunt, we hope that the next time you visit an art museum you will find lots of things to look for in a painting, even if it doesn't have a subject (that is, if it is not a picture of something). You will probably be able to point out things to your parents or friends that they have missed! (There will also be a small surprise waiting for you when you complete the Treasure Hunt.)

THE HUNT SHEET

### Visual Treasure Hunt—Part II

1.  A painter can apply his pigment (paint) in different ways. Paint which is very thin creates a *wash* (it looks watery). A thick, textured surface is called *impasto*. It makes you want to feel the surface, but remember to touch it with your eyes only.

    In which painting is the pigment applied as a *wash?*
    _____

    In which two paintings has the artist used an *impasto* technique?_____

2.  Nonobjective paintings are composed of lines, colors, and shapes and do not have recognizable objects in them.

    Do you see any paintings created with the following geometric shapes?

    Circles_____

    Squares_____

    Triangles_____

3.  Some of the paintings are *calligraphic*, that is, they are made up mostly of different kinds of lines.

    Which paintings are composed of:

thick, straight lines?_____

thin, straight lines?_____

thick, curved lines?_____

thin, curved lines?_____

4. Sometimes you can tell from the way a painting looks how
the paint was put onto the canvas.

Which painting looks as if it *might have been* created

with a small brush?_____

with a large house paint brush?_____

by rubbing?_____

by pouring?_____

by dribbling or dripping?_____

In which paintings can you see layers of pigment?_____

5. A composition which is symmetrical has sections which
are similar or equal in shape, color, etc.

Can you find any paintings in this room which look sym-
metrical?_____

Are they *exactly* the same on both sides?
Yes_____No_____

6. Locate painting number 7.

Which side of this painting seems to come out *towards*
you?     Left_____Right_____

Which side seems to recede (move away from you)?
Left_____Right_____

7. Every part of a painting is important, including the *nega-
tive spaces* (the spaces between lines and shapes).

In which paintings have the artists *made the negative*

*spaces play* an important part of the composition?

_____

_____

_____

8. Planned Paintings: Some artists plan their work very carefully.

   In which painting in the room can you see the lines drawn by the artist before he started to paint?_____

   Paintings with Accidents: Other artists paint loosely and freely and even use accidents in their work._____

   Which paintings look the least planned?_____

9. The *style* of a work of art shows the artist's particular way of feeling, working, and depicting forms. (Even your handwriting has a unique style which allows you to tell your writing from anyone else's.)

   Which painting seems almost similar in style to No. 3?

   _____

   Which one looks most like No. 1 in style?_____

10. You will notice that the colors in some of the paintings are so bright that they almost hurt your eyes. We call these *intense* colors. The colors in other paintings are less intense, that is, more quiet or *dull.*

    Which painting has the *most intense* colors?_____

    Which painting has the *dullest* colors?_____

    In which paintings do you find the sharpest *contrast* (difference) of colors?_____

11. The lines, colors, and shapes used to make a painting can create a quiet, calm feeling. They might also seem very excited, active or *dynamic.*

    Which painting looks most calm to you?_____

    Which painting seems most dynamic?_____

12. Different paintings can convey different moods or feelings.

    Which painting makes you feel happiest?_____

Which one seems sad or scary?_____

Which one seems most exciting to you?_____

13. You have been given a small reproduction of painting Number 2.

Is there any difference between the reproduction and the original painting?_____

After the Visual Treasure Hunt is completed, the class is taken to the main gallery so that some idea of the children's response to the works may be gained. Disagreements are discussed, and students defend their positions by pointing to the original works. This need not be played in a museum if good, large reproductions are available in an improvised gallery space located in a school.

Remember while playing any of these games that talking about art involves a much greater range of conceptualization about art than is usually realized. It is only when a teacher begins to probe deeply into reactions that the possible range of intellectual "muscle flexing" becomes apparent. The skills listed below will give some idea of the kinds of analytical and perceptual processes that can be brought into play during the course of the games activities.

| Conceptual Abilities | Children's Statements |
|---|---|
| Recognizing | "That's the Degas; the other one's a Rembrandt." |
| Comparing | "The one by Redon is more quiet—more soft than the Kandinski." |
| Generalizing (Ex: In Discussing Impressionism) | "This group is done in small dabs and spots of color; nothing is just plain flat." |
| Conjecturing (Ex: After Studying Caravaggio) | "Well if it was daylight it wouldn't be as interesting; lights and shadows couldn't be as strong." |
| Deducing and Reconstructing Putting Evidence Together | "Yes, he (Monet) added lots of white—if he wanted more sunlight, he would use lighter colors. It makes the church look more cheerful, too." |
| Synthesizing (Ex: Orozco's *Zapatistas*) | "If they are soldiers, they are going to fight and the sharp lines in the soldiers and the sky make it look like something exciting is going to happen." |

| | |
|---|---|
| Questioning (Ex: Picasso) | "Can he draw better if he really wants to? Why doesn't he use shading like the others?" (Ingres used for comparison.) |
| Describing (Ex: Marquet) | "It's a city scene, just after a rain—the colors are greyish and there is a reflection on the street, but no rain." |
| Allegorizing (Ex: *Guernica*) Through Recognizing Relationships | "Well, he didn't use color because the scene looks sadder in greys. Also his lines are sharp because terrible things are going on. Of course it's a war." |
| Thematic Awareness (Ex: Cassatt) | "Not much is going on—but the mother is bathing her child. It would be a good picture for Mother's Day." |
| Informed Judgment Defending One's Position | "I like it—(I don't like it) because—"I think the picture by Renoir is better than the other because . . ." |
| Searching | Teacher: "Look again—you're so busy looking at the subject you haven't studied the color. What does the color tell you?" |

The twelve categories of commentary listed above, and there are obviously others depending on one's system of linguistic organization, offer some indication of the kinds of thinking that can go on when children become involved in a close study of art works. The quotations listed above came from a mixed fifth- and sixth-grade class conducted by one of the authors.

### Compositional Exercise or Decomposing the Picture

This is a studio exercise that also can be done from reproductions but is more effective in a museum. The class is divided into teams of four, each team being assigned to one painting (or sculpture). The teams are instructed (somewhat) as follows:

> *Every picture you see is composed of recognizable, that is, "real" objects which can be reduced to simpler shapes, directions and lines. At times a group or cluster of these may make up a larger pattern. The way they all fit together gives us the composition or structure of an art work. Now you couldn't copy the painting if you wanted, and besides we don't have time for that, so see if you can just put down all of the most important lines, directions, and large shapes that are made up of smaller things. You will end up with an abstraction of the picture rather than a picture of the picture, if you know what I mean.*

*teaching for appreciation: programs in action*  **87**

### Searching for Formal Structure

The student selects a painting by Diego Rivera as a subject for her exercise. (The teacher made the initial choice of reproductions and selected the works for their clarity of structure and subject matter appeal.)

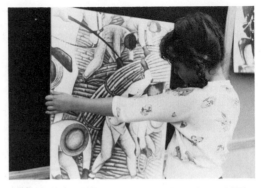

© Richard Sobol

The student places a sheet of tracing paper over the subject and, instead of tracing it, seeks out the major directional forces.

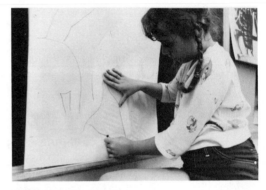

© Richard Sobol

The student then seeks the secondary lines of structure.

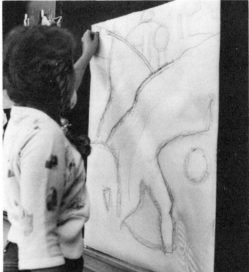

© Richard Sobol

The teacher may give a demonstration—perfectly acceptable since any copy of her work would be irrelevant to the problem. She answers any questions the class may have, and they go to work, usually on the floor. Ten minutes is about enough time before calling "time."

When finished, the class sits before one of the assigned paintings, and the renderings are placed against the wall. The class then discusses differences, similarities, and outstanding compositional characteristics. A variation of this experience is to do it in the classroom, allowing a member of the class to draw on acetate that has been trimmed to the proportions of the painting being studied. When all acetate sheets are placed together, it becomes readily apparent where divergencies of shapes and lines exist. In any case, the activity requires close scrutiny, perceptual judgment, and dramatizes the artist's concern for unity and structure. The selection of art works is of utmost importance. The Renaissance is recommended as a particularly appropriate period from which to select works with a balanced relationship of parts to wholes. Avoid abstractions, as the process of selection has already been taken care of. The most difficult problem for the players is to make a distinction between realistic forms and the historical movements and directions upon which recognizable forms are based.

A variation on this exercise can be done with the student placing tracing paper over a reproduction to draw the directional forces within the painting.

## The Description Game

This can work with a full class, although participation becomes increasingly difficult beyond fifteen participants. The only special equipment needed is blindfolds. After these have been applied, the teacher selects a "critic" from the group whose blindfold is removed. The group is then informed that the critic will describe to the best of his ability a particular painting. The critic is asked to be as comprehensive as possible in his description listing only those elements that he feels would be commonly recognized and accepted as true to the painting. In one case, the class was prepared by a previous classroom discussion of Feldman's definition:

> *Description is a process of taking inventory, of noting what is immediately presented to the viewer. We are interested at this stage in avoiding as far as possible the drawing of inferences. We wish to arrive at a simple account of "what is there," the kind of account about which any reasonably observant person would agree.* [19]

As the critic proceeds, the participants stand silently, reconstructing in their minds' eyes their own version of the critic's vision. When

the critic has exhausted his descriptive vocabulary, everyone removes his blindfold. There is usually a wave of exclamation of dismay and surprise as the class is confronted by the discrepancy between critical description and the actual painting. This is then followed by spontaneous criticism of the critic, who is faulted for mistaking blue for turquoise, orange for red, a rectangular vertical shape for one that veers toward the triangular vertical, and so on. At this stage, the teacher acts as arbiter, clarifying some observations and correcting others. A new critic is chosen, usually the most critical of the respondents, blindfolds are applied, and the group moves (slowly) to the adjoining gallery, where the process is repeated. The new critic treads a bit more slowly than the previous one, knowing she will be held accountable for what she says. When she is through, the blindfolds are removed and the process of description is once again questioned, dissected, and analyzed with a degree of intensity rarely reached in a professional art magazine. The teacher may want to play critic himself (if he has the courage). Only he can decide when the class has had enough and the time has come to switch the attention of the class. A class can usually go for three or four "rounds" before attention begins to wane. It is possible to conduct this activity with reproductions or slides, but it is more effectively held in the presence of the genuine object. While this is a good exercise for both speech and observation, it also dramatizes the fact that language, while it does not provide a true equivalent for art, can provide a basis for future appreciative experiences.

## EXTENDED GAMES

Extended games involving one or more players differ from the previously described games in that they are sequential with a continuum of activities wherein each stage of involvement is linked to what has gone before. When played by a group, extended games also provide richer inter-player experiences. One sound model for study is the "Gallery Game" designed by Mary Erickson and Eldon Katter of the Kutztown State College Department of Art in Pennsylvania. The fact that this and many other strategies for involving children with art works are now part of a teacher training program is yet another encouraging sign of the profession's growing interest in the development of appreciation as a basic area of education for the contemporary art teacher.

The Gallery Game is an easily constructed game that familiarizes players with art concepts, encourages verbal responses to art works, and provides for group interaction.

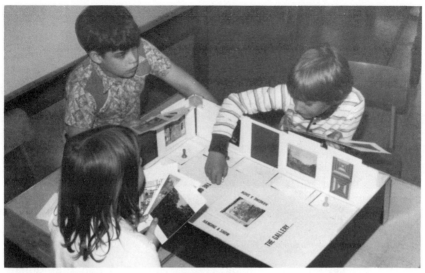

© Mary Erickson

**Students Playing the Gallery Game**

**Each picture postcard reproduction becomes a painting in the gallery when the sides of the game board are raised up.**

EQUIPMENT FOR THE GALLERY GAME:

"The Gallery" game board:

"The Gallery" game board consists of a 22" X 28" center section called the "gallery floor" and four attached side panels called the "gallery walls." The center section has fourteen 3" X 5" spaces marked off around the perimeter for positioning the requirement cards. For each requirement card space on the floor, there is an adjacent 5" X 7" space on the gallery wall for the art cards.

Deck of fourteen or more requirement cards:

Requirement cards, typed on 3" X 5" index cards, are made up of descriptive statements, all centering on one major art concept. The following are examples from a deck of cards on the concept of space: "the artist uses converging lines to show receding space"; "the artist uses a succession of planes to create the illusion of depth"; "the artist uses a framing device to separate the picture space from the viewer's space." Similar sets of cards are developed around other art concepts such as style, line quality, subject matter, or some cultural context.

*teaching for appreciation: programs in action* 91

Deck of at least forty art cards (reproductions):

Small art reproductions, such as museum postcards, standardized in size and appearance by mounting them on 5" X 7" index cards.

Tokens for each player.

Rules for Playing "The Gallery Game":

1. The requirement cards are shuffled and then distributed to the fourteen positions around the gallery floor.

2. Art cards are shuffled and four are dealt to each player.

3. The first player rolls a die and moves the appropriate number of spaces around the gallery floor. If the player has an art work which satisfies the requirement stated on the card on which he has landed, the player may then donate his art card to the exhibition by placing it on the position adjacent to the requirement card. If the player cannot fulfill the requirement with any of the art works in his hand, he may discard an art card and draw one new one from the reserve cards.

4. Succeeding players follow in turn, each player trying to add works to the exhibition by satisfying the requirements as stated on the cards on which he lands. If a player thinks he has an art work which fills the requirement better than the art work already hanging where he has landed, he attempts to convince the group that his art work is more appropriate. The group decides by voting which painting will be used.

5. The game is over when all the wall spaces are filled and the group decides by consensus that they have mounted a good exhibition, that is, an exhibition where each conceptual statement is clearly exemplified in an art work. The player who has made the most donations is declared "Patron of the Arts" and is the winner of the game.

Variations of the Gallery Game:

A more realistic model of a gallery can be constructed if slots are used to secure art cards and the side panels are erected to create a three-dimensional game board. For an even more realistic format, use full-size art reproductions and the walls and

floor of the classroom instead of the game board. Students move themselves, instead of tokens, around the gallery. By varying the requirement cards, content and vocabulary can be adapted to a wide range of experience and age levels.

ANALYSIS OF GALLERY-GAME STRUCTURE:

The extended-time structure of the gallery game affords its players an opportunity to move from a simple activity to more complex intragroup activities. Learning activities range from a beginning matching task which familiarizes players with game content to later debate tasks which require players to present and weigh competing evidence and arguments.

Socially, the activities range from individually-oriented to group-oriented activities. At the outset of the game, individual players make independent decisions. As the game progresses, players begin to compete. It becomes necessary for a player to support his independent decisions with evidence acceptable to the other members of the group. To conclude the game, all players must reach a consensus, that is, they must together form a collective opinion. The discussion which this engenders is the most valuable part of the process.

Through this extended-time, sequential-activity game, students learn that they can make group decisions on complex issues without appealing to the authority of the teacher. As the strategies and structures of games change, so does the range of learning experiences.

# ROLE PLAYING THROUGH IMPROVISATION

Getting the student to analyze works of art critically and to pick out their aesthetic qualities need not be a difficult problem if it is approached with some imaginative teaching techniques. Role playing is one such technique: Various problem situations are set up, and the student acts out the role of a consumer of art, an art critic, an art dealer attempting to sell a work. Improvisations can also develop out of the paintings themselves. As an example: What are Cézanne's *Card Players* discussing? What might be the exchange of conversation between father and son in Rembrandt's *Return of the Prodigal*? There are many possible variations, one of which is to role play characters within a painting or piece of sculpture. Other subjects for improvisations may be

developed from Rodin's *Burghers of Calais,* Rembrandt's *Night Watch,* and Breughel's *Games.* Students will have to study the works carefully in order to create a character, dialogue, and possibly a dramatic situation from the evidence in the art work. Costuming and settings can be designed by the students for the role playing situations. A primary reference work for these techniques is Viola Spolin's *Theatre Game File,* which has already been cited.

### A New Community Art Museum

Your city has just been given a grant of $5 million by a wealthy benefactor to build an art collection. The city has matched that amount and has decided to construct a new museum to house the collection. A curator has been assigned the task of assembling the collection.

The students will play the role of trustees and curator. The problem posed to the student-curator is this: The $5 million can be used for the purchase of works of art, paintings, sculptures, prints, artifacts, or other significant art objects that have historical and aesthetic value. However, a stipulation to the grant was that the works must have relevance for the people of the community.

After the teacher has presented the problem to the class, questions are posed to each student as a starting point:

1.  What should be the purpose of an art museum in our community? Should it be historically representative of the community and its values, or should it lead and mold aesthetic values? Does it play the role of a repository of culture or does it provide a wide range of cultural experiences which have relevance to the community?

2.  What is the makeup of the community? Who lives here and what type of art collection would have meaning to the people?

3.  Who should make the decision as to what kind of art collection will be housed in the museum? How should this decision relate to or involve community values?

4.  What art works are available for new museums and what do they cost?

After these initial questions have been researched and discussed, the next step is to define the limits of the problem. The *number* of works the students may select for the collection should be specified.

One strategy is to use large existing collections such as those at the National Gallery of Art, the Metropolitan Museum, or the Museum of Modern Art as sources for the new collection. In each of these collections the major works are well-documented and information is relatively accessible to the student. Another strategy would be for the teacher to define a *wide range of works,* not only paintings, which could be used as the starting point for the collection, and for the teacher to indicate where source information is available. Some preliminary preparation on the part of the teacher to gather and identify sources is needed.

The *costs of the works* would be arbitrarily set by the teacher based on the current market. The important point is not the price *per se,* but the value of each work relative to other works in the collection. For example, prints, because they are multiples, are cheaper than drawings, and drawings are less expensive than paintings. Old Masters, Rembrandt or Franz Hals, are relatively more expensive than work by artists of a later period, such as Renoir. Contemporary works of James Rosenquist or Roy Lichtenstein are still less expensive, and works by less famous artists are even more affordable. The general concept here is that age and reputation have some effect on the dollar value of an art object. Age, of course, may or may not be related to the aesthetic value of the work.

The students would have to do research on their own to determine the relative aesthetic worth of the art object to the collection they are assembling. Such information as who the artist is and his stature in the field, the period and country, the medium used, significant historical data, how the work was constructed, or other related information about the art object would also affect its aesthetic worth.

After the basic research is completed on a number of works of art, the students should have a general idea as to the range of objects available to them. The next step is for them to determine what type of collection they think would be appropriate for the community museum. It is necessary for the teacher and the class to refer back to the initial questions about community needs, interests, and values and how the collection should relate to these. This, of course, is a hypothetical situation, and therefore the teacher has the option of directing the student to certain conditions within the community that the students should consider. For example, the community could have a large American Indian population. This may greatly affect the choices that the students make relative to various works of art that represent this group and reflect its cultural values.

After determining the relationship between the community and the museum and its collection, the students then develop a rationale for

their collection based on (1) a general plan for the collection so it works as a single entity, (2) what works are available for them to select from, (3) the budget that has been given to them to purchase the works, and (4) the type of collection that would be applicable for the people of the community.

The outcome of this project for the students is that they simulate behaviorally the curator's role, making decisions about assembling a collection for a particular audience. Student discussion about the positioning or fitting of work into the total concept of a museum and a collection is important. The students thus gain some understanding of how and why a museum's collection is developed. More important, this project helps explain the historical and cultural significance of an art museum to its community and how it may relate to the people within that community. Much of the success of this exercise depends on the resources available to the students: the more information they have, the more interesting and exciting the project will be.

### An Art Auction

A similar problem-solving situation can be built around an art auction. Groups of art objects, again varied in quality and media, can be offered, and the students' task is to analyze the works for their aesthetic value and for the approximate dollar amount that can be safely invested in the work. The students represent themselves as art collectors building a personal art collection. They would be encouraged to do research about the works of art. The kinds of information they would have to find out would relate to historical background, the media used, the approximate value, and the works' economic and aesthetic growth potential. (Some groundwork for this research should be laid by the teacher.) The outcome of this problem would be similar to that of the art museum problem: determining the aesthetic criteria for acquiring the work of art and assessing the economic basis for its purchase relative to its present and future value.

The students would play two roles, collectors and auctioneers. The auctioneers would have to know the relative dollar values and aesthetic qualities of the works so as not to let the works go for less than they are worth. Collectors would have to know the works' worth in relation to the design and scope of their own collections. The content for a collector could be defined by the students, or a particular content area could be assigned—French Impressionist works, or twentieth-century prints, or American drawings, and so on. A range of types of collectors should be considered so that the auction has good balance, with many students researching and bidding on many different objects.

The actual art auction would take place after the students have researched the objects available. The objects could be presented to the students in a number of ways:

1. Slides of the works available for auction would be presented to the bidders.

2. Reproductions of the art objects could be used.

3. Actual works in museums in the local community could be used, with the students visiting the museums to view the works, then using postcards or slides of the objects for representation in the auction.

The collectors would have a set amount of money they could spend on their collections. A simple system can be worked out so that the bid can be recorded against the amount of money available to each of the collectors. A dialogue as to the relative aesthetic and economic worth of the objects available should be encouraged among the bidders. And some justification for the amounts that are spent on various works should be a part of the total experience.

A culminating activity would be a justification for the purchase of works for each collection. This justification would include the rationale for a student's purchase of the particular works, how the works fit into the overall concept of the collection that he is developing, and the implication of the acquisition of these works for further development of the collection.

The variations on the museum and the auctioning experiences are many, and the teacher can build upon each of these activities from year to year. The key to the success of either activity is the amount and quality of materials made available to the students. An art resource center should be developed with prints, slides, book catalogues, periodicals, and art history texts made available to the students. A suggested list for starting this type of center is included in the Appendix.

### Designing a Structure

One basic objective of the teaching of art appreciation in an elementary or secondary school is to develop an awareness of the role of art in each student's life. Any art appreciation program should educate the student as a consumer of art in the broadest sense; he should be able to make basic aesthetic judgments about things that affect his life style—his home, his clothing, his furniture, and other objects. A strategy to achieve this end is to have the student assume the role of a designer who must solve all the problems inherent in creating an object or structure.

Such a problem-solving situation was created for the design of a playground structure in the Arts and General Education Project in the

University City Schools, University City, Missouri.[20] Students at Daniel Boone Elementary School worked with a class of architecture students from a local university to design a playground structure. The elementary students representing each grade played the roles of clients and were responsible for the preliminary design ideas to be communicated to the architects, such as the purpose and function of the structure, the site where it was to be located, and the financial limitations under which they were to operate.

Small student groups were set up to make preliminary designs by drawing them and discussing them with one another. These groups discussed a number of alternatives for the design of a playground structure for their school. Generally the discussion centered around such questions as:

> What should you be able to do on a playground structure— climb on it, slide down it, have spaces to crawl through?

> Should it have movable components, such as swings or a hanging rope?

**Elementary students meeting with architecture students to select model for construction.**

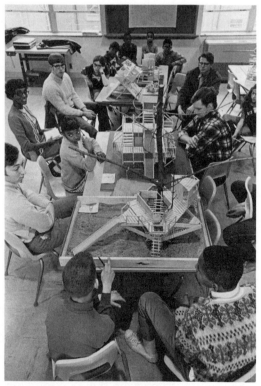

© Richard Sobol

How would the structure relate to the existing environment or setting?

What materials would be used—wood, concrete, metal, or other materials?

Should it be painted with bright colors or should the materials be used in their natural state?

What feeling should be conveyed by the structure?

Should the design be related to the purpose of the structure?

In these early meetings, there was much excitement and enthusiasm shown by both groups. It was rather difficult to channel the younger group of elementary students into a specific problem-solving situation. However, through a number of meetings and the use of an arts consultant, the students did address themselves to the specific problem, and final criteria for the structure were developed and presented to architects:

1. Provide a unique and aesthetic design with a given budget of $800.

2. Design a structure of durability that preschoolers as well as sixth graders would find entertaining.

3. Include within the structure a place of amenity.

4. Design a structure that would enhance aesthetically the total environment.

5. Design a structure that would require minimum maintenance.

6. Design a structure that could be easily constructed using simple tools and unskilled labor.

Along with the criteria, a number of drawings by the students were used to illustrate their ideas. From the criteria and the drawings the student architects developed forty-five designs. The elementary student group, the clients, then spent an afternoon listening to the architecture students present their designs.

Cheryl, a client whose uncle was among the architecture students, did not permit his relationship to interfere with her criticism. Speaking of his model, she told him, "I guess it's good, but the design doesn't add to our visual environment." Generally the clients were firm in their opinions: "Not for $800!" "No imagination!" "Seems dangerous!" "You

© Richard Sobol

**A fourth grader enjoying the structure he helped design and construct.**

forgot about the little kids." After three hours, fifteen projects had been selected, some of which presented engineering problems. The architecture staff at the university studied the selected projects for any other problems unforeseen by the elementary students and reduced the number to ten.

The ten projects went on display in the auditorium at Daniel Boone, and all the students were permitted to discuss and examine them for five days before confidential closed voting. The finalists were invited to explain their projects, giving the estimated costs and discussing the length and complexity of the actual construction. One model of multiple portable components of varying sizes had received a considerable number of votes prior to the formal presentation but was ultimately rejected. The student criterion was simple: They reasoned that if youngsters could move the forms of this structure with so much ease to create other designs, so could vandals.

The entire student body continued to discuss and evaluate the ten models for a week. The design finally selected is probably best described by a Daniel Boone student:

*In all, the structure has three stories, and near the slide there's a little lookout tower, one story higher. You can either just stick your head up or there's enough room for one person to go up in it and sit down.*

**The playground structure after completion.**

*The thing I think everyone likes the best is the slide. Even all the older kids enjoy it. Aside from that there is a tunnel on the second floor to climb through. Above on the third floor you can walk on a bridge (leading to the slide), and there's a pole to slide down on. You can reach the pole from either the third or second story.*

*If you feel tired of climbing to the slide the same way every time, you can climb up going over the slide because of planks put there. While climbing all around, you can look at brightly colored posters all over that have geometric designs.*

*"The structure" is the greatest thing, I think, because you can do so many things on it. Also, it's so big that a room of twenty-five children could easily play on it and have the same, if not more, amount of fun as if only a few were on it (unlike most other playthings).*

## MUSEUM APPROACHES

Museums are often more adventurous in their approaches to art appreciation than the public schools. This may be because docents and volunteers have greater flexibility of time, unique resources, lack of pressure from other instructional responsibilities, and a need to demonstrate

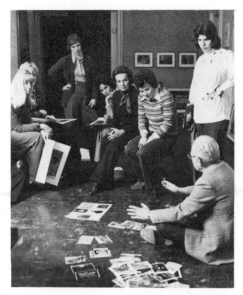

**Working with Docents: The Museum of Grand Rapids, Michigan.**

**Explaining the Reduction Sorting Game.**

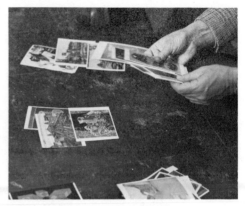

**A single group of pictures can provide multiple combinations of visual tasks.**

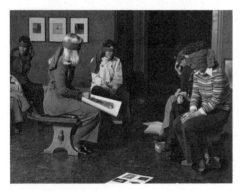

**Blindfold description. Building an image of a painting through hearing it described.**

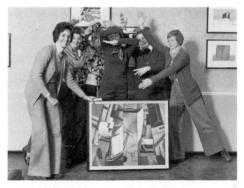

**Reflecting visual forces of a painting with one's body.**

greater community participation. Whatever the reasons, the museum educators not only seem to have outdistanced the schools in innovative ideas in the critical domain of learning, but have, as a group, moved away from the historical/lecture method to more dramatic, experiential approaches.

## Experiential Involvement

Bonnie Baskin, educational director of the University Art Museum of the University of California, at Berkeley, is one of the leaders in experiential involvement for children.[21] She cites, as her source of methods, ideas derived from open education and alternative and affective philosophies of education like those publicized by such nonart educators as Herndon, Holt, Silberman, and Leanard. Her own description of how her staff (mostly art majors from the University) operate gives some indication of how they go about involving children with the museum collection:

> On the whole, groups are frequently guided into placing themselves inside landscapes—exploring the terrain through each of their five senses and perhaps finding and meditating in resting-spots they may choose within it. They intuit the thoughts, lifestyles, and personalities of portrait subjects and, with abstract paintings, often sense the sounds, smells, tastes, textures, relationships, and energies of colors and shapes. With sculptures they find favorite sections and vantage-points and imagine how pieces might, for instance, move and sound if they were to become kinetic. Art works are frequently recreated through sounds, poems, impromptu drama, human sculptures, short stories, and free movement. . . .
> A guide might ask each child to name his favorite color, find it in an abstract painting, and describe its taste, smell, movement, energy, effect on adjacent colors, texture, weight, sound, or other sensory attributes.
> Children and adults often diagram simple abstract paintings, especially the Hofmanns, with pencil and paper and then number color-areas by their order of projection from the picture plane; always, each person sees a different order, and comparing diagrams reveals both the artistic principle and the relativity of perception. Almost all groups seem excited by giving sounds to colors and thereby orchestrating paintings with a single dense sound or a melody-line of tones.

The following tour activities and questions give some idea of how the program works in specific terms:

> Take the exact pose and facial expression of a person in an art work. "Become" that person by sensing that person's character and relationship to his/her surroundings. How does it feel to be that person? What are you doing and thinking as that person? Trace the path of air through a painting or through and around a sculpture. Where do the spaces change? Where, how, and why do the flow and the feel of the air vary?

*For a realistic-seeming painting:* how *is it* not *like a photo-graph?* *(Also, compare landscapes as to use of color, quality of line, stroke, quantity of paint on the brush, composition, sense of weight, pervasive underpainted color, the expressed concepts of nature, and the human relationship to nature, etc. What do these different elements contribute to each painting?)*

*How does your eye travel over the art work? What attracts it and how does the artist emphasize those elements? What paths of light, line, forms, color, subjects' glances does your eye follow?*

*Wordless looking.*

## A Multisensory Experience Center for a Museum

The design of Art Works, an experience center in the Brooks Memorial Art Gallery in Memphis, Tennessee, grew out of a desire by John Whitlock, the director, to provide a place where children could have a wide range of sensory experiences relating to the overall goals of the Gallery. When it came time to design the experience center, the Education Committee of Brooks Memorial did not want to duplicate any existing gallery or provide a traditional children's gallery, but rather to provide a space filled with a repertory of experiences engaging children and exciting them about the art gallery and its contents, a space where experiences and information could be presented through a variety of techniques and media.

The Art Works is a living space, not a static exhibit, where children are confronted with real experiences related to the creation, appreciation, and preservation of works of art in and out of the museum. It also brings related art forms in theater, dance, music, and literature into the museum. The Art Works functions as a way of transmitting information about the nature of the arts experience to an audience. It is not a room with a single function, but rather a multipurpose, ever changing space. The primary audience for Art Works is children from ages five to fifteen. However, adults are not excluded. The overall purpose of Art Works is to educate, and activities emphasizing experiences rather than simply the processing of information are designed to implement this goal. In other words, its purpose is to encourage student involvement and interaction with people—artists in various media—and things—works of art. Art Works educates its special audience about the Brooks Memorial Art Gallery and the collection it houses, providing not only information about art objects but also a way of perceiving and appreciating their content.

The outcomes for the children relate to the total educational program now being conducted through the Education Department of the Gallery. They are:

1. To develop experiences for children five to fifteen which convey ideas and information about the museum.

2. To provide the children with experiences which impart information and ideas which enhance their ability to understand and appreciate the arts in general and this museum collection in particular.

3. To enhance children's appreciation and perception of works of art and the role they play in everyday life.

4. To give the children opportunities for receiving information and ideas through various media about the arts.

5. To provide an opportunity within the context of a museum for children to enjoy "studio" experiences relating to the overall goals of an art museum, activities and experiences contributing to a feeling of joy, excitement, and appreciation of the arts and the museum.

The design task was to create an environment that would express the nature of the Center and help accomplish these goals. The space had to be designed to fulfill three primary functions: a producing space, a media space, and a performance space. These functions were not regarded as mutually exclusive, but as interchangeable, and the structural components were designed to be compatible. When the space is set up as a media space, it must facilitate activities that use the media and technology for transmission of information or ideas about the collection. As a performing center, the space is arranged to accommodate activities in drama or dance or other "happenings" that need open spaces. The Art Works as a producing space allows for activities that are more manipulative, as in the visual arts or sounds, where work surfaces are needed. Possible activities for each function and their special requirements for space and equipment are listed below.

| *Activity* | *Requirements* |
|---|---|
| Producing Space | |
| 1. Visual art activities | 1. Space division |
| 2. Space and form manipulation | 2. Lighting and sound manipulation |
| 3. Editing and recording of sounds | 3. Work surfaces for art activities |
| 4. Visual artists at work | 4. Video and audio recording and editing |
| 5. Composers at work | capability |

**Media Space**

| | |
|---|---|
| 1. Media manipulation | 1. Projection surfaces of all types |
| 2. Media presentations | 2. Tapes, records, films, slides |
| 3. Art appreciation games in sound, vision, and movement | 3. Video and audio transmission and recording capability |
| | 4. Lighting controls |
| | 5. Space division |

**Performance Space**

| | |
|---|---|
| 1. Dance or dance involvement | 1. A performance platform |
| 2. Drama activities | 2. Modular elements for manipulation and arrangement of space |
| 3. Performing artist or groups at work | 3. Lighting and sound manipulation |
| | 4. Projection surfaces |

---

Each of the three functions of Art Works is served by some common elements: a central sound system; a projection system capable of supporting a variety of media such as slide projectors, film projectors, and video; a transmitting and recording capacity to be used for sound, radio, video, film, and photographs; a theatrical lighting system; and self-standing space dividers that can allow a variety of ways of arranging the space. These common elements are contained in a grid system providing connecting points every two feet in the walls, ceiling, and floor, and free-standing pie-shaped modules.

The activities are designed around aspects of the possible relationships of art to movement. An understanding of these relationships will enhance the student's appreciation and understanding of art objects in the Brooks collection. The first concept is that, just as we move and things around us move, artists create movement as an element of the work of art or as part of the subject matter. A multiscreein, slide-and-sound presentation is the initial activity to illustrate the concept. The first part of the show concentrates on movement within our environment, with special emphasis on the body in motion and things in the environment that move—animals, trains, planes, automobiles. The second part uses art works within the collection that emphasize movement: the Thomas Hart Benton painting *Engineer's Dream,* Leonard Baskin's print *Porcupine,* Paul Jenkins's painting *Phenomena Leaning Echo,* Sebastiano Ricci's painting *Infant Moses Saved by Pharoah's Daughter,* Arthur Davies's painting *Forest Bathers,* Reginald Marsh's painting *Dead Man's Curve,* and the George Rickey sculpture *Two Lines Oblique.*

After viewing the presentation, students engage in activities designed to introduce movement with the body as an instrument. Elastic

bands, stretch-fabric bags, reflective surfaces, and projection equipment are used in the movement exercises. These techniques are similar to those of Alwin Nikolais in his dance theater, which introduces props, lighting, and other theater elements as part of the dance. Drawing with your body is a game in which students are asked to observe a work of art in the Brooks collection and then close their eyes and "draw" the art object with their finger, hand, head, foot, or complete body. In order to do this with some sensitivity, they may have to take a second look at the art object and then return to Art Works to continue with their "drawing." This is a movement and visual perception activity that links the child with the art in the collection and stimulates and heightens his visual awareness of what the work of art looks like, how much space it occupies, and what its dominant elements are.

Similar to drawing with the body is the sculpture game, derived from the "Statues" game many children play in their backyards. It takes physical movement as an element in art works and relates it to visual movement. The object is to freeze in a "sculptural" position—to become a copy of a sculpture in the Brooks collection. Students can play this game individually or one child can be designated as the sculptor to "sculpt" the rest of the students into a group work. Each of these activities is recorded on videotape for playback before the participants leave Art Works so they can see the art they created with their bodies.

After the body movement activities, the student then begins to represent movement in visual art activities. One very successful studio activity is the creation of "body murals." One child stretches out on a large piece of paper, and another traces his body shape on the paper. The "body design" is completed by drawing the shape, texture, and color of clothing, hair, face, hands, and feet. To finish this project, the children cut the individual bodies out and arrange them on one of the walls, creating a complete mural or frieze. The students may take their individual cut-outs with them when they leave.

A second concept dealing with the relationship between art and movement is that space affects movement: We move in different ways because of the size and shape of different spaces. The activities used to define this concept are centered around the various ways of dividing space: symmetrical and asymmetrical, open and closed, light and heavy, hard and soft, and personal and group space.

The activities in this series make use of the grid system in the walls, floor, and ceiling of Art Works. A variety of sizes of rectangular plastic fabric panels with grommetted holes are used with elastic connectors to create a "tensile" sculpture. The sculpture is really a new environment within the given space and creates a new dimension in the area. The fabric and walls are projection surfaces as well, and images are

Students working on a motion mural using their own body forms as a starting point.

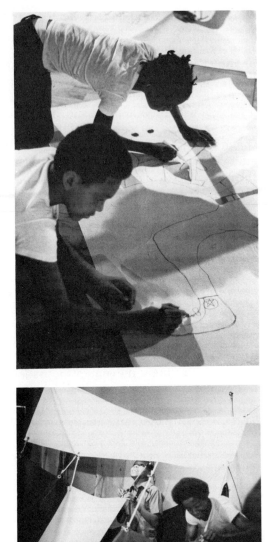

Visitors to the Art Works constructing a tensile sculpture.

projected with slide projectors to create spatial illusions. After completing the sculpture, the students are asked to move within the spaces they have created. Their movements through the space are recorded on videotape and then played back. The color videotape provides immediate feedback for the children and functions as a stimulus for future groups. A discussion on how the space they created affects their movements is then carried out as a culminating activity. The third concept

relating movement and art is that we can create works of art that move or have movement as an element. The students create a group mural using movement as the primary element or subject matter on topics such as "Things Which Move in Our Environment" or "Animals on the Move" or "People on the Move." The mural is created in a variety of art media using crayons, water-soluble markers, construction paper, and wrapping paper. The whole activity is again recorded on videotape for playback.

Another series of activities is designed around drawing the body in motion. A short film on gesture drawing is viewed to acquaint the students with the basic technique. Traditional drawing exercises are introduced as warm-ups. Line is the principal element used to create the feeling of motion in the drawings. Drawings from the Brooks collection that show bodies in motion are used with this activity.

Art Works extends the reach of the Brooks collection beyond the walls of the museum building and beyond the usual audience of museum-goers. It enhances the children's appreciation of art through a special multisensory, multiarts environment within the museum proper, and, through the materials that it develops and the programs that it sponsors, Art Works also provides the museum with a place in local schools that is vital to a museum's educational function.

## STUDIO APPROACHES

In relating studio activities to the study of art, the task is not to copy a work so much as to build upon some formal or theoretical concern of an artist, a particular work, or a movement. Art history can be used as motivation for the kind of original problem solving that is valuable in any art activity and can be effectively used as a source of motivation. Such approaches can be handled in two ways. A teacher can discuss slides and reproductions relating to the problem in advance in order to focus the attention of the class on a particular problem, or the task can be assigned first and the class can then be shown how a particular artist dealt with the problem. Examples: "You all have an object you have selected from the still life table. Look at it from all directions and see if you can combine two or three points of view into one design." When the students have completed the task, the teacher then shows examples of Cubist art where multiplicity of view is particularly obvious. Students may then be asked to point to the parts of the paintings which correspond to the assignment. Or, the teacher may begin the activity by showing reproductions of Cubist art and then ask the students to proceed with their assignment.

It is entirely conceivable that a complete art program based on the study of professional art works could be designed. The relationship between many art historical activities and the social studies program should also be apparent. A sampling of activities that have been attempted in the classes of the authors follows:

| Art Works | Studio Activity |
|---|---|
| Jan van Eyck's *Giovanni Arnolfino and His Bride*<br><br>Pablo Picasso's *Girl Before a Mirror* | Paintings or drawings that utilize a mirrored reflection as part of the composition. Since many artists have utilized convex and concave mirrors in their works, three kinds of reflectors may be used: conventional mirrors, mylar mirrors, which distort in one way, and hub caps, which change reality in still another way.<br><br>Questions for discussion: Compare the use of mirrors in Picasso and van Eyck. |
| Egyptian wall sculpture | Depict human figures, animals, and plants in shallow bas-relief using linear rather than raised masses. In order to create a frieze, line a shoe box with a slab of clay, cast in plaster, and line up figures in a continuous row. |
| Henri Matisse's *Still Life: Goldfish and Sculpture*<br><br>Picasso's *Three Dancers* | After setting up a still life of large, simple forms (pitchers, plates, flowers arranged on several levels), the teacher asks the students to do a tempera painting in flat tones, not concerning themselves with texture or shading. This may be preceded by a lesson in contour line drawing. |
| Fresco: any work executed in this style (for example, Sistine Chapel ceiling) | Pour a thin (1.5 in.) slab of plaster of paris in a shoe box or box lid and execute painting in water color or thinned tempera paint. When work is complete, rub surface lightly with fine sandpaper to simulate age, flaking, etc. |
| Architectural structure (for example, St. Basil's Cathedral, Moscow, or Notre Dame Cathedral, Paris) | Cut up segments of building structure into structural component parts such as entrances, domes, buttresses, etc. Have students enlarge their assigned segments six to twelve times. When complete, "rebuild" the structure, keeping fitting components together. Plan this "Blowup" project to fill |

| (Cont.)    Art Works | Studio Activity |
|---|---|

<table>
<tr><td></td><td>an entire wall. Tempera or colored chalk will give you the most accuracy, but a collage treatment will create the most exciting design.</td></tr>
<tr><td>Sumerian seals</td><td>Each child receives a stick of chalk and a cutting device such as a nail file or a Sloyd knife. Designs of the students' choice, based upon pictographic forms, are carved into the chalk, which is then rolled across slabs of clay and fired, but left unglazed.</td></tr>
<tr><td>Byzantine mosaic, <em>Empress Theodora and Her Attendants</em></td><td>Children treat the human figure through the mosaic technique of fitting together small bits of colored tesserae. Ideally, they should be using hard substances such as clay, glass, or glazed tile. They can, however, get a firsthand acquaintance with the process using colored paper.</td></tr>
<tr><td>François Rude, <em>La Marseillaise</em><br>Nicholas Poussin's <em>The Rape of the Sabine Women</em><br>Theodore Gericault's <em>The Raft of the Medusa</em><br>or any other work with a dynamic interplay of visual forces, thrusts, directions</td><td>If possible, procure a slide of the work and, in presenting it to the class, bring it into clear focus through graduated stages. Ask the students to view the work as a pattern of motions and directions as well as recognizable objects. The activity consists of setting down in crayon any large or small directional forces—be they curved or straight—which the students can discern in the work. The result should be an abstract of the original rather than a laborious copy.</td></tr>
<tr><td>Vincent van Gogh, <em>Self Portrait</em><br>or<br>Rembrandt, <em>Self Portrait</em><br>Use three or more of these portraits</td><td>Using at least three or preferably more self-portraits of Vincent van Gogh or Rembrandt, who were prolific in producing images of themselves, try to convey the idea that the artist has a different conception of self at different periods in his life. The emphasis is on how the portraits change due to the artist's conception of the subject, the psychological content, the varied styles of the artist over a period of time, and the medium itself. These all have an effect on the subject matter, on how the artist portrayed himself. The studio activity involves students doing self-portraits over a period of time. Different mediums would be used—painting a self-</td></tr>
</table>

portrait, drawing a self-portrait, or a collage of yourself. The culminating activity is a look over time at how a student interprets his own image, noting the differences and similarities among their own interpretations of themselves. Background materials such as van Gogh's letters to his brother, Theo, and reference material on Rembrandt's life in his own writings and the writings of others, can be used to enhance the historical content of the unit.

Vincent van Gogh, *The Bridge at L'Anglois,* china ink drawing in the Los Angeles County Museum of Art

Hsu Wei, *Bamboo Section of Hand Scroll,* ink on paper, Freer Gallery of Art, Washington, D.C.

Two ink paintings, one a drawing by van Gogh, the other a traditional Chinese ink painting on rice paper, are used as examples to illustrate the technique of drawing with a brush. Exercises in traditional calligraphy using Chinese or Japanese characters can be used as a starting point for the studio activity. A very traditional approach can be used, based on the hand positions and strokes as defined in any book on Oriental calligraphy. Calligraphy becomes an individualistic and expressive art form after the basic techniques are mastered. The bamboo hand scroll with calligraphic figures illustrates the expressive character of calligraphy and how it is integrated into the subject matter of the scroll. The van Gogh drawing uses very short strokes of the brush and is pointillistic in character. The studio activity is an extension from calligraphy into brush painting, using subjects of the students' choice. This tradition emphasizes the idea that one stroke of the brush is all that can be made. It is a very direct approach to painting in which the subject is reduced to its simplest linear components. A related activity would be based on van Gogh's technique of using either a brush or a pen to create an ink drawing. Here again there is a change of medium in that the pen can be controlled more than the brush and gives a much more precise definition of the forms. The subject matter can be landscape or other forms in nature such as animals or birds.

Theo Van Doesburg, *The Cow,* Museum of Modern Art, series of eight pencil drawings

These three works illustrate an artist's concept of abstraction. Doesburg and Matisse have taken familiar objects, a cow and the

Henri Matisse, *Jeannette I, II, III, IV, V,*
Bronze, Hirschhorn Museum, Washington, D.C.

human figure, and abstracted them. The
studio activity would be for the students
to take one object from nature or an artificial object and do analytic drawings as realistically as possible, and then selecting
out parts that they can emphasize, to distort or rearrange so as to abstract the
form. The studio project would be a series
of five or six drawings that would represent an abstraction of a single object, using
an approach similar to Doesburg or
Matisse. A variation could be a change of
medium going from a pencil drawing to
cut paper collages, then to water color,
changing the character of the subject by
changing the medium. A final activity is to
display the drawings in a series from the
realistic interpretation of the subject to
the abstract.

Théodore Géricault, *Studies of a Cat,*
pencil, Fogg Art Museum, Harvard
University

Paul Klee, *Fritzi, 1919,* pencil, drawing of
a cat, Museum of Modern Art

This is a study for young children of an
animal of their liking. The animal can be
from the zoo or a favorite pet or a live animal or bird brought into the classroom and
used as the model. The problem is to view
and study the animal from all different
perspectives: from behind, above,in back,
in front, and to draw as many interpretations of the animal as possible. Géricault
and Klee give two impressions of cats.
Gericault's very realistic and graphically
representational, and in Klee's work a
very abstract, childlike, and expressive
impression. Various mediums can be used
for drawing: pencil, crayons, or felt-tip
markers.

Georges Seurat, *A Sunday Afternoon on
the Island of LaGrande Jatte,* Art
Institute of Chicago.

Georges Seurat, *A Study for Le Chahut,*
Albright-Knox Art Gallery

Pablo Picasso, *Card Player,* Museum of
Modern Art

Pablo Picasso, *Musicians,* Museum of
Modern Art

Four paintings are used to represent two
styles of modern artists: Pointillism, a
style used in the Impressionist movement
of the late nineteenth century, characterized by Georges Seurat, and Cubism,
which Pablo Picasso and Georges Braque
popularized in the early 1900s. The characteristics of each style should be explained. The studio problem is for the
student to pick a subject and work in a
pointillistic style. A good beginning activity is to use a wooden pencil with a round
rubber eraser with a stamp pad to create
circles of solid color. This emphasizes the
idea that small dots or points of color can

*teaching for appreciation: programs in action*   113

be used to build up larger forms. To rein-
force the concept of the dot patterns
creating colors, a magnifying glass can be
used to investigate four-color printing in
the newspaper for the dot patterns, which
cannot be seen without magnification.
This is an excellent example of what the
pointillists were trying to create in their
paintings. Tempera painting on the sub-
ject chosen by the student is the culmi-
nating activity. The task is not to repli-
cate pointillist painting, but to use the
technique and style to develop new forms
of visual expression.

The same task can be related to Cubism,
which is the reduction of forms to geo-
metric patterns. Picasso and Braque can be
used to show the various approaches to
cubistic representation of objects. The
problem would be to take existing subject
matter, analyze it, and reduce it to the
basic geometric forms, as the cubists did.
This could be a developmental process
with the students working on a variety of
subjects over a period of time and contin-
uing to reduce them to their simplest geo-
metric forms. Drawing with various media
could be one approach; collages of cut
paper or newspaper can be combined.
Forms can overlap, interpenetrate and
deal with multiple views.

In this chapter we have attempted to direct attention to the role
and nature of language and have suggested means of dealing with the
perceptual level of appreciation. We have also discussed the broader,
multisensory methods now being developed by museums, and shown
how activities with art media can involve children with specific prob-
lems in art. Obviously, there are more suggestions than could be accom-
modated in any one program. Teachers who desire to initiate their own
program will have to devise a sequence of experiences ideally drawn,
to one degree or another, from all of the approaches discussed in this
chapter.

Balance between the approaches described in this chapter can also
be maintained within a single lesson or unit. Let us take as an example

of a sequence two class sessions dealing with the vocabulary of style recognition. The right-hand column deals with curriculum, and the left-hand relates the learning to the methods described in this chapter.

---

Title:  Studying Nonobjective Art          Level:  Grade VI

### Session I

| | |
|---|---|
| Perceptual/visual games | Teacher presents examples of realistic, abstract, and nonobjective painting. After a discussion of terminology as evidenced in the paintings, she distributes a set of style-matching games and asks the students to separate one style from another. |
| Perceptual identification | The teacher initiates a discussion by showing an example of an intermediary category of stylized or simplified realism (for example, José Orozco's *Zapatistas*) and asks the group to classify it as real or abstract. Since the work has elements of both, students will disagree and will have to defend their point of view by direct referral to the work. |

### Session II

| | |
|---|---|
| Language as a means of clarifying visual qualities and relationships | The teacher shows the class two examples of nonobjective painting, one by Vasili Kandinski and the other by Piet Mondrian. The class is asked to set down a list of adjectives that describe the painting, and, as they are read, the teacher records them on the blackboard. She then suggests words they have missed that refer to vital aspects of the painting such as directionality, passivity, complexity, and so on. |
| Multisensory response | The teacher asks the class to stand and divides them into a Kandinski and a Mondrian "team." Each team is asked to assume body positions that reflect the structure within the paintings. |
| Studio activity | The class is asked to create a nonobjective painting and to work from the point of view of either Kandinski (tempera painting) or Mondrian (cut paper). The critical and descriptive vocabulary that the children and teacher have jointly created provide the frame of reference for their work. |

---

Every teacher works within a body of constraints. The resources at that teacher's disposal, the readiness of the students, and the willingness of the teacher to train himself or herself in what may be a totally new area will surely determine the "program in action." What we have tried to provide here is some new directions for teachers to consider when developing their programs.

## NOTES

1. Edmund Burke Feldman, *Art as Image and Idea* (Englewood Cliffs, N.J.: Prentice-Hall, 1967).

2. Viktor Lowenfeld and Lambert Brittain, *Creative and Mental Growth*, 4th ed. (New York: Macmillan, 1964).

3. Ralph Smith, *An Exemplary Approach to Aesthetic Education: Final Report*, Cooperative Research Project 6-3-6-06127-1609 (Washington: U.S. Office of Education, 1967).

4. This dialogue is taken from Charles Gaitskell and Al Hurwitz, *Children and Their Art: Methods for the Elementary School* (New York: Harcourt Brace Jovanovich, 1970), pp. 430–33.

5. David W. Ecker, "Analyzing Children's Talk about Art," *Journal of Aesthetic Education*, 7, no. 1 (January, 1973), 70.

6. *Ibid.*

7. C. W. Valentine, *The Experimental Psychology of Beauty* (London: Methuen, 1962), p. 419.

8. F. Williams, "Investigations of Children's Preferences for Pictures," *Elementary School Journal*, vol. 25, pp. 119–26.

9. Two major sources of ideas for other activities related to observation are Viola Spolin's *Improvisation for the Theatre* (Evanston, Ill.: Northwestern University, 1963) and her *Theatre Game File* (St. Louis: CEMREL, Inc., 1975).

10. The teacher is Molly Murphy and her curriculum "game" is described by David Ecker in "Evaluating the Arts Curriculum: The Brookline Experience," *Art Education: Journal of the N.A.E.A.* (February, 1974).

11. Brent G. Wilson, "An Experimental Study Designed to Alter Fifth and Sixth Grade Students' Perception of Painting" (University of Iowa, unpublished manuscript).

12. Henry Ray, *Art Education: Journal of the N.A.E.A.*

13. Albert Cullum, *Push Back the Desks* (New York: Citation Press, 1967), p. 53.

14. Johannes Itten, *Design and Form: The Basic Course at the Bauhaus* (New York: Reinhold, 1964).

15. Feldman, *Art as Image and Idea.*

16. Dale Harris, "Learning Theory, Cognitive Processes, and the Teaching Learning Component," *A Seminar in Art Education for Research and Curriculum Development,* Edward Mattil, ed., Cooperative Research Project V-002, U.S.O.E. (University Park: Pennsylvania State University, 1966), pp. 141–65.

17. David Ecker, "Justifying Aesthetic Judgments," *Art Education* (May 1967), p. 6.

18. This idea was developed by Elliott Eisner and his staff for the Kettering Foundation Project of Stanford University.

19. Feldman, *Art as Image and Idea.*

20. Stanley S. Madeja, "All the Arts for Every Child," Report of the Arts in General Education Project, University City, Mo. (The JDR 3rd Fund, 1973), pp. 56–60.

21. Bonnie Baskin, *Art Education: Journal of the N.A.E.A.*

# 3

# EXEMPLARY UNITS AND PROGRAMS

If this book is to have any relevance to the teaching of art appreciation in the school, inclusion of a number of examples of how to organize an instructional program for the classroom seems appropriate. This chapter includes examples of both instructional units and complete art appreciation programs. Each unit or program has been used effectively in the teaching of art appreciation at the elementary level. The examples should be considered as suggested approaches to organizing art appreciation content for instruction rather than intact instructional programs to be implemented as described.

When one is designing a unit of instruction for art appreciation, the content may be organized in a number of different ways. For example, the starting point may be the art object: a painting or a piece of sculpture. Or the unit may be organized around the artist: who he or she is, how he or she works, what he or she produces. A movement, period, or style, such as Impressionism or Cubism, may be the focus of the unit. Or technique—sculpture, painting, drawing—may be the central issue. A teacher can begin with the formal properties of the work—color, texture, and shape—or with stages of the critical process. Any of the above can be combined with studio activities. Different starting points and methods of organizing the content are illustrated by the units of instruction contained in this chapter. In the Newton program, a number of the lessons start with art objects as the central focus. Other units such as the Circus and the Arts have a theme that is the organizer. The theme puts the work itself into a context, which is better understood by the student. The theme of a unit can vary from topical ones based

on concepts like the circus, the family, or portraits, to ones that deal with periods or style, such as Cubism, Pop Art, or Expressionism.

A distinction should be made here between total *programs* for art appreciation and *units* of instruction, which should be viewed as subsets of more extensive programs in art education.

# EXEMPLARY UNITS IN ART APPRECIATION

This section contains units developed primarily by teachers and art supervisors in public school settings. The Circus and the Arts and the Machine in Art units were products of the Arts in General Education Project in the University City, Missouri, public schools. These units are examples of how a theme can be used to organize the subject matter. The Brookline, Massachusetts, schools' unit called Painting Watching utilizes techniques of formal criticism to engage the students in a dialogue about the artist and his work, as does the Art Criticism unit developed by the Florida Art Curriculum Development Project.

### The Circus and the Arts

This unit was developed by classroom teachers at the elementary level with the help of arts specialists as part of the Arts in General Education Project in University City, Missouri.[1] The unit dealt with the visual arts but also used other art forms and objects in the environment as organizing concepts. It was designed for use with primary students.

The circus is an event familiar to most children, and in this unit it is used as the core idea for a number of activities in the visual arts. Students are acquainted with works of art that have been created by different artists, the main concept being that the circus has evolved its own art forms, such as wagons, graphics, and costumes, based on a design or style that is characteristic of circus art and that has also provided the subject content for many artists. Alexander Calder, Fernand Léger, Henri de Toulouse-Lautrec, Georges Seurat, Georges Rouault, Walt Kuhn, and others have used the circus as subject matter for their paintings, prints, and drawings.

Within this unit the students are engaged in various activities all relating to the circus. And they are constantly referred to works of art that have been produced by artists about the circus, such as the set of drawings by Toulouse-Lautrec. It is important in art appreciation that the students reflect on the concept that the subject matter has influenced the character and nature of the work itself. Toulouse-Lautrec, for instance, was very much attracted to the line qualities of the subject

matter and reflected this in his drawings and paintings. He was concerned that the drawings capture the personality of circus people, the movement of animals, the excitement of the occasion.

From these activities the students move into more participatory experiences about the circus. They create their own art forms from the circus, such as wagons and drawings, paintings and graphics, and finally their own circus. They design the setting and the costumes, and even create the acts.

Another segment of this unit is Circus Graphics. This portrays the signs and symbolism used to publicize the circus. Along with the sculpture and decorative elements of the wagons and other circus paraphernalia, the circus graphics become art forms from the circus itself. This fact illustrates how a circus creates its own style for visual expression and how these objects become works of art in their own right which should be appreciated. Circus art forms, such as wagons, the horses of the carousel, the costumes, the posters, all have design elements that stylistically distinguish them from works about the circus.

### The Machine and the Arts

This unit was based on a show that the Museum of Modern Art mounted in New York in 1968. Titled "The Machine," the show was an exhibition of works that used the machine in our technology as subject matter.[2] The works in the exhibition were selected because they demonstrated a particular interest by the artist in the world of machines and technology. In designing the unit for art appreciation, the theme acts as a unifying element for activities and provides a wealth of art objects from which to draw. The works that were selected are both two- and three-dimensional and show the machine used as subject matter as far back as the fifteenth century. The following works were used as the basis of this unit:

*Drawing for Flying Apparatus,* Leonardo da Vinci. Drawing, Italian, 1485–90. Biblioteca Ambriosiana, Milan.

*Triumphal Procession of Maximilian I,* The School of Albrecht Durer. Woodcut, German, 1526. Metropolitan Museum of Art, New York.

*American Rocketship,* Winslow Homer. Drawing, American, 1849. Museum of Fine Arts, Boston.

*The Old Locomotive,* Lyonel Feininger. Lithograph, American, 1906. Museum of Modern Art, New York.

*Speed of an Automobile,* Giacomo Balla. Tempera, ink, and watercolor on canvas, Italian, 1913. Stedelisk Museum, Amsterdam.

*Twittering Machine,* Paul Klee. Watercolor, pen, and ink, Swiss, 1922. Museum of Modern Art, New York.

*Homage to New York,* Jean Tinguely. Drawing, American, 1960. Museum of Modern Art, New York.

*The Motorist,* Henri de Toulouse-Lautrec. Lithograph, French, 1869. Art Institute of Chicago.

The unit utilizes the machine as an example of the common objects that the artist often portrays because they have an effect on his environment. For example, Feininger was very impressed with the locomotive. He did a whole series of sculptures and paintings of locomotives. Utilizing more than one artist and looking at the works not only as representative of different periods, but also in terms of how the artist interprets the machine, become the basis of the activities that are developed in the unit.

The first set of activities is based on comparisons, using the works listed here. For example, the lithograph by Toulouse-Lautrec of *The Motorist* is quite a literal interpretation of speed, motion, and a motorist of that period driving an automobile. It is Impressionistic in its style; however, the motorist himself is quite distinguishable. It presents the satirical implication of the blackened face and belching smoke that the subject in the background will have to deal with in a very short time. This differs from Giacomo Balla's *Speed of an Automobile* series, in which he uses a primarily Futuristic style to interpret the ideas of speed and the automobile in motion. Nowhere in the painting does one discern the form that the automobile takes, but the repetition of lines and forms within the painting works visually to describe the speed and motion of the machine. By contrasting the artists' interpretations of a machine in the two paintings, the student begins to understand better the purpose of painting and its critical properties.

The second part of the unit is devoted to students involving themselves in interpreting machines through different media and materials in the visual arts. Three sets of activities are based on both contemporary and traditional approaches to the subject. The first set of activities is basically composed of drawing activities in which the students are asked to find things which are mechanical or machinelike to draw. Pieces from the junk yard are brought in for the students to draw, and they put these kinds of forms together, organizing them into a composition. A second set of activities is designed around a tour of an industrial

complex that provides source material for painting or drawing. As many works of art as possible beyond the ones suggested should be introduced. The Museum of Modern Art catalogue for their show is an excellent source.

The last set of activities is built around the concept of moving sculpture. Utilizing whatever machine technology is available, students are asked to make a moving machine that is also aesthetically pleasing. There is a wide range of solutions to the problem, and, depending on the age level of the children, this can be an exciting activity. A simple machine might be based on the principle of the mobile. This can be a cliche if it is not approached properly, but the idea of balancing various elements by strings or wires becomes one way of developing a kinetic sculpture. Another approach is to utilize various gears that are available. Gears that come from small machines, old clocks, or watches are excellent sources for movement. This activity depends upon the availability of this kind of material to the students, but, again, the junk yard or junk shop is a good source. A teacher with some experience in science can also suggest ways in which simple motors can activate materials.

### Painting Watching

The intent of this Brookline, Massachusetts Schools' unit on art appreciation is to introduce students to formal art appreciation exercises and to introduce the unit as a vital element of the system-wide curriculum.[3] Through participation in in-service curriculum workshops, the art staff determined the structure, goals, and materials to be used in the unit, which was planned around a unit of five sessions.

| To the following questions | The staff decided |
|---|---|
| What would be taught? | An Art Appreciation unit titled "Painting Watching." |
| To whom? | Third-grade students. |
| By whom? | Elementary art specialists. |
| Using what concepts? | Four elements helpful in "making an appreciation" of a work of art are (1) the historical and social context of the work, (2) simple description, (3) formal analysis, and (4) interpretation. |
| Toward what ends? | (A) To cause students to consider the nature of an artist, what he does, the manner in which he works, and his reasons for working. The unit would deal with responses to art as well as the varied expressions of art available in society. |

(B) To introduce new information to students through observation, discussion, directed-work assignments; to use this as a basis for developing an art "vocabulary." The justification of aesthetic judgments is properly carried out in descriptive language, which must be referentially adequate.

(C) To prompt the development of critical skills in students by comparing works.

**By what means?**

Three examples of work were selected to link the concepts to the goals:

(A) A third-grader's painting, an original painting by the teacher, and a large reproduction of a well-known professional artist.

(B) For a directed task, through the use of a "work book" designed by the art specialist who piloted the program.

(C) For an activity, independent painting through the use of tempera paint, brushes, paper, and so on.

**In what order would the tasks be performed?**

The unit would be designed to span two formal class sessions and three periods devoted to independent painting activity. The first formal session would be spent viewing and discussing the paintings and would last approximately thirty-five minutes. The second formal session would review, examine, and compare the results of the work book task and introduce and demonstrate the media and tools that students would use for independent painting. After these sessions students would be encouraged to paint in the "open studio" areas whenever they were so moved. (It should be understood that the organization of the elementary self-contained classroom provides for "open" time periods each day for all students.)

Thus:

(A) Children would look at and compare a painting of the student, teacher, and professional artist.

(B) Children would then be *led* into a discussion about the nature/role/purpose of the person who painted the picture.

(C) Children would be encouraged to discuss the "pictorial" qualities of the three paintings.

(D) At the end of the discussion, the children would be assigned a task which would reinforce and assess their understanding.

(E) The children would be encouraged to paint independently in an "open studio" setting.

**Under what conditions?**

(A) For discussion purposes, students would gather in an informal manner around the teacher in an area

of the school which is conducive to discussion activities.

(B) For the direct task, students would be given a "work book" to complete on their own time. Students would compare responses to the work book during a second class session.

(C) Students would be given the time to paint independently in an "open studio" setting, supervised by both the classroom teacher and the art specialist. This area would be established in the students' classroom as well as the art room.

What are the criteria for judging the success of the unit? (Evaluation)

(A) Concepts/activities should demonstrate that problems in philosophy of art and art criticism are basically linguistic and may be resolved by close attention to the ways we use ordinary and critical language.

(B) Concepts/activities should emphasize the nuances and diversity of talk about art: defining, explaining, describing, hypothesizing, interpreting, etc.

(C) Concepts/activities should be organized so that the student learns to appreciate works of art, *as the art historian would,* by attending to such operations as: simple description, formal analysis, and contextual relations.

---

The teacher, being sensitive to the age level of her intended audience, kept content simple without sacrificing the substance of the program. Excerpts from a videotape made of Ms. Murphy's presentation of the Painting Watching Unit illustrate this best. Parts of this presentation figure in the section on discussion techniques in the previous chapter. She began as follows:

> *I brought something for you to do, I brought something for you to see, and I brought something for us to talk about. A lot of you will have ideas, and it will be fun to hear everybody's ideas.*

She then asked, while showing separately a third-grader's painting, her own watercolor, and an illustration of a Vasarely painting (she began the discussion with the child's work):

> *Would you say that the person who painted* this *picture is an artist?*

After allowing for responses from the class, she introduced her leading idea:

> *You can be as old or as young as you want to be and still be an artist—if you do the best job you can and it's something that's important to you.*

Ms. Murphy went on to explain that a boy in the room next door was excited by something he saw on the way to school:

> *A truck "was making all kinds of noise and it was going so fast" he couldn't "figure out what it was and where it was going." When he got to school and came down to the studio that was what he was thinking about. And it was important to him to put it down on paper, so he did. He did the best job he could, and it was an important thing for him to paint—so he was an artist on that day.*

She next displayed her own watercolor, and explained her motive for painting it:

> *It was a dream that I had three nights in a row . . . and the fourth morning I woke up and I thought—Oh, I've got to do something about that dream. So I painted a picture of it.*

After considerable discussion along this line, the Vasarely painting was introduced. The teacher stated:

> *I brought this one because it's a different kind of art than the other two I just showed you. It's called a nonobjective painting.*

On a television playback, the teacher discusses a Vasarely with her third-grade students. From the videotape of Brookline School's unit on art appreciation.

© Ken Bernstein

She then, through questions, led the class to a definition of the term. From this point on, discussion centered on Vasarely and his painting. Also, one more piece of information was pushed:

> He [referring to Vasarely] does a lot of pictures like this. They're called optical illusions because he's trying to fool your eye. What do you see?

The responses from the children were like a ping-pong game with rapid serves and returns:

> It's stairs going deeper and deeper.
> He makes it smaller and smaller and smaller.
> I think it's like light on the outside and darker—down and down.

A little later, Ms. Murphy asked:

> Think, in your heads, what would this picture sound like if you could hear it?

Some of the replies were:

> Like when you look into a deep hole, you can echo through it.
> It sounds like a trap door.
> Well, ah. Do you want it in English, or in noise?

To conclude the discussion, Ms. Murphy assigned a class task:

> Look, I've made a book. I called the book "Surprise the Eyes" because that's what Vasarely was trying to do.

The booklet contained puzzles whose solutions called for a close study of Vasarely's painting, as well as the art terms that were emphasized in the discussion. One of the puzzles was a diagram of the painting, and, while showing it, Ms. Murphy made an important qualification:

> I copied part of this puzzle. Now earlier I told you that sometimes I'm not an artist. This is one of those times because I wanted you to have a good puzzle. But I wouldn't hang this on my wall. It's not that important to me. So I was a good copier, but I wasn't an artist when I did this because it wasn't really my work.

The students were most eager to deal with the assignment, and, as Ms. Murphy later reported, several asked for extra booklets to try other solutions. After completing the prepared exercises, the students were encouraged to paint their own nonobjective pictures.

The school media specialist produced a videotape of Ms. Murphy's introductory class session. This was done with two aims in mind: (1) to evaluate the unit as an instructional strategy and (2) to use it as a means for introducing and disseminating the unit to arts specialists throughout the school system.

As an instrument for evaluation, the videotape is unique. It documents not only the sequence and nature of all dialogue, but also those vital visual cues that inform the degree of success of any instruction. It allows for extensive examination, through replays, of any aspect of a given lesson, whether it's the substance of the lesson or the dynamics of student and teacher. The videotape of the Painting Watching unit provided ample evidence that met the criteria for judging the success of the unit and demonstrated that the instructional strategy and content were appropriate for third-grade students. Further, it reassured Ms. Murphy of the competency of her presentation and at the same time suggested ways of improving her performance.

### A Lesson on Art Criticism

A lesson on art criticism that uses a hierarchy of objectives as an organizing device was developed by the Art Curriculum Development Project in the state of Florida, which was directed by Jo D. Kowalchuck of Palm Beach County Public Schools. This is one of many lessons designed for use in the state art guide.

The content of this lesson is designed to enable the student to make and justify statements about the aesthetic merit of art work.

> Goal: To make and justify statements about the aesthetic quality and merit of works of art.
>
> Subgoal 1: Know and understand criteria for making aesthetic judgments.
>
> Subgoal 2: Know the range of criteria that is used in making value judgments of art.
>
> Pre Objective: After many experiences in perceiving and responding to works of art and encouragement in supporting personal statements by pointing out visual clues, the student will begin to understand that there are different criteria in judging works of art (some more valid than others).
>
> Performance Objective: After many experiences in perceiving and responding to works of art and encouragement in supporting personal statements by pointing out visual clues (use of

sensory qualities, relationships, expressive qualities) in works of art (e.g., Hicks's *The Peaceable Kingdom*), the student will begin to understand that there are different criteria in judging works of art.

Teaching Strategy: The Teacher might begin by asking two children (possibly known antagonists) to come to the front of the room.

*"Jimmy, if Ron went by your chair and kicked you, what would you do?"*

*"Kick him back!"*

*"What happens in school when you fight?"*

*"The teacher makes us stop, or we might have to go to the office and see the principal."*

*"Why?"*

*"Because we're not supposed to fight."*

*"That's right! We're trying to learn that there are better ways of taking care of things than by fighting. People who fight can also get into trouble with the police. Countries which fight have wars. Who can think of a word that means the opposite of war? . . . Peace? . . . Which is better, war or peace? Practically everyone has feelings like Jimmy and Ron here—that they get angry and want to fight. Maybe we know we shouldn't fight, but we do. Some animals do this, too. Can you think of some animals who always fight? Does this picture give you some ideas?"*

Show Hicks's *The Peaceable Kingdom*

Continue the discussion, asking the students to identify the animals and other objects in the painting, encouraging them to look closely for details which give clues for interpretation. Bring out the idea that these animals usually fight, and that by putting them together in a peaceful situation, the artist indicates his wish that we all may live in peace. Other questions might lead the students to reason that this picture was done "a long time ago" because of the style of clothing, the sailing ship, the words "fatling, lambkin," etc. Read Isaiah 11:6–9, describing the peaceable kingdom, and show by questions and answers that the desire for peace has been with us since biblical times a very long time ago.

To summarize, the students will:

1. Describe objects (the child, animals, grapes, trees, ship, clothing, etc.)

2. Analyze formal elements (shapes, colors, repetition, etc.)

3. Interpret what they see ("Why is the child wearing red, white, and blue?" "Could this possibly happen in real life?")

Assessment:

Any response is acceptable *if* the student supports his comment by referring specifically to the clues in the reproduction.

Content:

Generally, children in K–2 should be encouraged to describe objects, analyze formal elements, and interpret (not judge) what they see. Students may be guided into using criteria which are based on experiences in perceiving and responding with increased reason and sensitivity rather than more personal preference or other superficial criteria. Everything said about the picture should be supported by visual evidence.

A possible range of criteria follows:

1. Unity-well-organized composition ("formalist"):
   *"All the parts fit together, look good together"*

2. Intensity of feeling or experience ("expressive"):
   *"It makes me feel scary ... or sleepy, sad, excited, etc."*

3. Subject or theme has several meanings:
   *"Everyone thinks it means something different"*

4. Importance of message or meaning ("instrumentalist"):
   *"This chair would be good to curl up in" (function)*

5. Technical achievement:
   *"The artist draws well"*

6. Emphasis:
   *"Feels like ..." "... reminds me of ..." "It looks real"*

7. Originality:
   *"It is different"*

8. Status:

   *"It is important because it is a picture of a king"*

After the discussion, the students might be asked to choose an animal or person and produce a picture which deals with some aspect of friendship.

# EXEMPLARY PROGRAMS IN ART APPRECIATION

The Arts Awareness Project of the Metropolitan Museum of Art, the Aesthetic Education Program of CEMREL, Inc., the Newton Art Appreciation Program, and the Corpus Christi Program in Aesthetic Inquiry are four programs described in this section that have as their major outcome appreciation of the art forms. An aesthetic education program engages the student not only with *visual* art forms but those from other arts areas. It is exemplary of the broader context in which visual art appreciation can take place. The program's overall goal is a general aesthetic education for every student.

The Newton program is an example of a grade-level concentration in art appreciation that is a supplement to, rather than a replacement for, a regular art program. It concentrates on the art object itself and broadens the student's perception of the art object by engaging him in art appreciation activities. The Art Awareness Project is an example of an art appreciation program in a major museum. The Corpus Christi model concentrates largely upon the critical domain, relying heavily upon linguistic and perceptual activities.

## An Aesthetic Education Program

The goal of the elementary component of the Aesthetic Education Program, directed by Stanley S. Madeja, is to develop a curriculum in aesthetic education using all the arts for grades K–6, which will be an integral part of every student's general education.[4] The aim of the Program is to create an aesthetic sensitivity within each student, not necessarily to train him as an architect, painter, writer, or filmmaker. The Program is developing a K–6 series of instructional materials that teach a specific concept and provide maximum individualized learning with a broad range of multimedia materials.[5] The students work with the materials to perceive, analyze, talk about, produce/perform, judge, value, and react aesthetically to the works of art and the environment. These activities will lead them to experiences and insights fundamental to a lifetime of decision-making based on increased aesthetic awareness.

The basic components of the program are instructional units that are adaptable to regular classroom use under the direction of a nonarts teacher and can be used separately or in conjunction with other materials. The materials are structured to teach a specific concept and each set contains all the materials and instructions necessary for teaching. The instructional materials may consist of games, masks, puzzles, cameras, records, films—whatever format best demonstrates and teaches the concept.

The Aesthetic Education Program is rigorously conceptualized and, like the Newton effort, represents an attempt to wed the capabilities of ten- to twelve-year-olds to the nature of the critical processes. The ideas of important figures from the fields of aesthetics, criticism, and art education have, in both cases, provided the theoretical basis for the assumptions, concepts, and activities upon which curricula are designed.

---

**Aesthetic Education Program Kindergarten Through Grade Three by Series and Title**

| *Aesthetics in the Physical World* | *Aesthetics and Arts Elements* | | *Aesthetics and the Creative Process* | |
|---|---|---|---|---|
| Introduction to Light K and 1* | Texture | K and 1 | Making Patterns into Sounds | 1 |
| Introduction to Motion K and 1 | Part and Whole | K and 1 | Examining Point of View | 2 |
| Introduction to Sound K and 1 | Tone Color | 1 | Perceiving Sound Word Patterns | 2 |
| Introduction to Space K and 1 | Dramatic Conflict | 1 | Relating Sound and Movement | 2 |
| | Rhythm/Meter | 2 | Creating with Sounds and Images | 2 |
| | Setting and Environment | 2 | Analyzing Characterization | 2 |
| | Nonverbal Communication | 1 | Creating Word Pictures | 3 |
| | Shape | 2 | Constructing Dramatic Plot | 3 |
| | Shape Relationships | 2 | Creating Characterization | 3 |
| | Shapes and Patterns | 2 | Arranging Sounds with Magnetic Tapes | 3 |
| | Movement | 3 | Forming with Movement | 3 |

| *OUTCOMES* | *OUTCOMES* | *OUTCOMES* |
|---|---|---|
| The student is familiar with the physical properties of light, motion, sound, and space. | The student is able to describe the part/whole relationship of elements in the physical world by identifying the elements of each art | The student organizes his own method, or structure, for completing a whole design. The student can describe |

*The number or "K" following the titles indicates the grade level.

The student is aware of the aesthetic qualities of light, motion, sound, and space.

The student engages in aesthetic encounters with light, motion, sound, and space.

form and their relationship to the whole work.

The student, given a work of art, is able to identify and describe the elements which are dominant within the work.

The student begins to develop a critical language for describing works of art and the environment.

and analyze the aesthetic decisions he used in completing the whole work.

The student transforms the elements into whole works in a number of arts disciplines and, therefore, can contrast the methods, or structures, of the individual disciplines.

The student is able to criticize, using his own aesthetic criteria, his own work and that of his peers.

## Aesthetic Education Program Grades Four Through Seven by Series and Title

| *Aesthetics and the Artist* | *Aesthetics and the Culture* | *Aesthetics and the Environment* |
|---|---|---|
| Actor 4 and 5* | Cultural Aesthetics: Where? 5 and 6 | An Aesthetic Field Trip 6 and 7 |
| Visual Artist 4 and 5 | Cultural Aesthetics: Why? 5 and 6 | Imaginary Environments 6 and 7 |
| Choreographer 4 and 5 | The Individual: Aesthetics and the Culture 5 and 6 | Aesthetics of Personal and Public Spaces 6 and 7 |
| Writer: Poets, Storytellers, and Playwrights 4 and 5 | Values: Aesthetics and the Culture 5 and 6 | Around and Through the Environment 6 and 7 |
| Composer 4 and 5 | Aesthetics and the Culture: How? 5 and 6 | Environments of the Future 6 and 7 |
| Architect 4 and 5 | Aesthetics and Our Culture 5 and 6 | Aesthetics of Technology 6 and 7 |
| Filmmaker 4 and 5 | | Aesthetics of the Arts in the Environment 6 and 7 |
| Critical Audience 4 and 5 | | |

| *OUTCOMES* | *OUTCOMES* | *OUTCOMES* |
|---|---|---|
| The student understands that artists are individuals involved with everyday human concerns as well as with artistic concerns. | The student is aware that the need to be expressive is identifiable in cultures. | The student analyzes, judges, and values his environment for its aesthetic properties. He makes informed aesthetic judgments about problems which affect the general human condition. |
| The student perceives, analyzes, and describes the process that artists use in creating a work of art. | The student learns that the aesthetics of his culture influences his individual expression and is a resource for it. | |

*The numbers following the titles indicate the grade levels.

The student engages in activities similar to those artists use in creating works of art.

The student can describe and analyze the similarities and differences of artistic modes and forms across cultures.

The student understands that cultures have aesthetic values and that what is valued as aesthetic in one culture may or may not be considered aesthetic in another.

The student makes decisions relating functional and aesthetic considerations in the environment.

The student is aware that aesthetic considerations play a major role in the affective quality of his environment.

The student critically analyzes the condition of the environment.

The student demonstrates his interpretation of a quality environment by organizing art elements and environmental components.

---

The materials are not organized in a rigid sequence but are planned to fit into content groups called centers of attention. The centers of attention are focal points for student activities in aesthetic education and are representative of aesthetic phenomena and the relationships among them. The three centers of attention for the primary grades are Aesthetics in the Physical World, Aesthetics and Arts Elements, and Aesthetics and the Creative Process. There are forty sets of materials projected for the primary program, each representing about ten hours of instruction. As students progress through the grades, they will explore additional aspects of aesthetic education: Aesthetics and the Artist, Aesthetics and the Culture, and Aesthetics and the Environment. These materials may be used at varying grade levels depending on student readiness and in various combinations and sequences. The decision is left in the hands of the individual school. Tables 3.1 and 3.2 show the outcomes by series and the materials which can be used to reach them. A brief description of the centers of attention follows.

The Aesthetics in the Physical World group uses light, sound, motion, time, and space as fundamental elements of aesthetic phenomena to show that all phenomena, natural and artificial, can have aesthetic qualities. Activities in the units are aimed at familiarizing the student with the physical properties of these elements and opening them to their possibilities.

The Aesthetics and Arts Elements materials help students learn to identify elements such as texture in music, shape in the visual arts, and movement in the environment and to relate them to the structure of

a work of art. The emphasis is on beginning development of a critical language, necessary to making aesthetic judgments about art.

In the Aesthetics and the Creative Processes group, students take elements of the arts and transform them into a work of art. Creating Characterization, Constructing Dramatic Plot, Relating Sound and Movement—participation in all these activities is aimed at demonstrating to the student the basic similarity across disciplines of the creative process in originating an idea and then organizing elements into an end product to communicate it.

Aesthetics and the Artist materials emphasize how professionals in the arts organize art elements into a whole work. Through the artist's role, students see how the aesthetic aspects of physical phenomena, the elements of an arts discipline, and the creative process come together in what the artist does and how he does it. The students also critically explore the works of various artists.

The Aesthetics and the Culture series lets the student investigate the indicators by which we recognize the aesthetics of a given culture, providing him with a basis for comparing cultures on aesthetic as well as social, political, and economic grounds. The units emphasize the art forms of a variety of cultures as well as the value systems that determine their creation.

The materials in the Aesthetics and the Environment grouping examine the aesthetic characteristics of the natural and artificial environment and assess the effect of both on human beings. They emphasize the need to consider aesthetic as well as social and political factors when making decisions about all aspects of our environment.

Some of the materials in the Aesthetic Education Program are more directly related to the teaching of art appreciation than others. The three sets of materials described in more detail belong to the Aesthetics and Arts Elements group and the Aesthetics and the Artist group. The units are divided into lessons that have a separate concept and objective, and each lesson has one or more activities for the student in the classroom that are designed to meet the objective of the lesson.

The following sequence is composed of three units that are directly applicable to art appreciation at the elementary level. The first unit, *Part and Whole,* describes the elements that exist in each art form and relates to general characteristics of the whole work. The second unit is an in-depth investigation of one element in the visual arts, *Texture.* The sequence moves from the very broad base of investigating all the elements in various art forms to one element in one art form. The third unit described is the *Visual Artist,* which concentrates on how the artist organizes the elements into whole works of art, thus explaining and exemplifying the creative process.

***Part and Whole:*** This set of materials represents the abstract organizing principle upon which the other units in the Aesthetics and Arts Elements series are based. In terms of art, texture and shape are parts of whole visual art works. The text "Part and Whole" shows how a whole work of art is made up of parts, that some wholes are also parts, and that some parts are also wholes. Through activities that emphasize these relationships, the students perceive how parts (shapes, lines, colors, and so on) function together in determining the whole art work. Then they explore the concept that introducing different parts into a whole can create a new whole. The unit was developed by Jeri Changar and the Aesthetic Education Program staff.

The outcome for the student is to develop his ability to respond to an art work's parts and their organization, to develop this perception of how parts function together in determining the whole art work.

Materials for the student:

Face puzzles
Mime puzzles
Art parts
Photographs and story cards

Materials for the teacher:

"Part and Whole" study cards
Slide presentation (12 slides)

Part and Whole consists of three lessons. Lesson One deals with the concept that a whole is made of parts, and the student is given illustrations from his environment and from works of art to illustrate this concept. Lesson Two gives more examples of this concept but also introduces the idea that some wholes are parts and some parts are wholes.

Lesson Three illustrates through the use of art forms outside the visual arts that the student can change the parts and make new wholes as the artist does to create new works of art.

Following is an abridged version of Lesson One, "A Whole Is Made of Parts," and descriptions of two of its four activities.

A WHOLE IS MADE OF PARTS

Concept
Being able to discern the parts of a thing—be it a toy, a family, or an art work—can contribute to a broader understanding of the whole.

## GENERAL OBJECTIVE OF THE LESSON

After completing Lesson One, which has four activities, the students will know that things people perceive as wholes can be broken down into meaningful parts. They will be able to identify parts within wholes of many kinds.

There are two activities which deal with parts and wholes in the environment. In Activities Three and Four the students relate this directly to art objects. For example:

### ACTIVITY THREE: PARTS AND WHOLES IN PICTURES

The students each draw a picture of something their family does together. They examine their own drawings and learn that they use some of the same parts (elements) when they draw a picture that artists use when they create an art work. Through arranging shapes, lines, etc., from a painting included in their "Part and Whole" books, the students see that people use certain elements to create a whole idea in an art work whether the idea expressed is realistic or abstract.

#### MATERIALS:

Construction or manila paper, 18" X 24" or 12" X 18"

Bags of painting elements (for optional activity; not included with the package: Make up bags enough for students to work in pairs with one bag. Put only about a half dozen shapes in a bag.)

#### CLASSROOM MANAGEMENT

Estimated time required: 30 minutes

#### PROCEDURE

Ask the students to draw a picture about something their family does together. Discuss with them what kinds of things these might be (sharing meals, taking a trip, watching TV, etc.).

After they have completed their pictures, ask the students specific questions:

*"What parts did you use to draw the people and things in your picture?"*
*[Shapes, lines, colors, etc.]*

This is the most important part of the activity.

Compare the students' pictures to similar subjects painted by artists.

*"Did you use the same parts in your picture that the artist used in his?" [Yes. They used shapes for the people and things and color and lines for the grass, etc.]*

You may want to do this in small groups by having the students put up their pictures and talk about all of them.

Based on the same concept, here is an optional, additional activity which you may want to try. In addition to having the students draw objects, give them a bag of the same shapes, lines, etc., that they see in the artist's painting. Have the students rearrange these elements into their own pictures given a specific logic, that is, "Make a picture of a busy place," or "Make a funny picture." Point out to them that to create their own pictures, they are using the same parts they saw in the artist's picture. After they have used the parts provided they may want to add some of their own.

The lessons are not limited to the content of one art form, but explore the concept of part-whole in dance, music, theater, and literature. A series of puzzles and word cards are used to engage students in activities that heighten these concepts. A slide presentation is used to show the visual elements as parts of the whole in natural objects and works of art.

ACTIVITY FOUR: A SLIDE PRESENTATION

The objective here is simply to have the students become more aware of the parts of an art work. During your discussion of the slides, give many students an opportunity to respond. Let the students talk as much as they like about the last two slides (painting and sculpture). Listen to what they say, but don't be concerned about their using correct terms. You may want to tape their discussion and listen to it yourself later. This will give you an idea of how much the students understand and whether and what you may want to reinforce. A suggested dialogue and questions for the slide presentation are included for the teacher.

(SLIDE 1: FRUIT SHAPES)

ASK:

*"Which shape is different? Why?" [The pear shape, second from the left, differs from the others, which are lemon shapes.]*

*"How could you tell it was different?"*

*"What other parts do you see in the picture? What colors? What lines? Anything else?"*

(SLIDE 2: FISH)

ASK:

*"What part is different here? Why?" [The fish in the upper-left corner differs in color from the others.]*

*"What other parts do you see? If there was a texture to the fish, where would you think the most textured part would be? Why?"*

*"How would the fish feel if you touched it with your finger?"*

(SLIDE 3: LINES)

ASK:

*"What part is different? Why?" [The third to last line in the row is thicker than the others.] "Do you think the lines have texture. If so, what kind? Do you think that everything has texture?"*

(SLIDE 11: PAINTING)

ASK:

*"What parts are the same?" [answer]*

*"Why?"*

*"What parts are different?" [answer]*

*"How?"*

*"Do you see any parts you have seen before? What are they?"*

Help.the children expand on their answers. Compare the two paintings.

(SLIDE 12: SCULPTURE)

Compare the two sculptures. Introduce the word sculpture.

ASK:

*"What parts are the same?" [answer]*

*"Why?"*

*"What parts are different?" [answer]*

*"How?"*

*"Do you see any parts you have seen before? What are they?"*

Talk about texture in relationship to the sculpture.
[End of slide presentation.]

As a culminating activity for the unit, the students look at photographs of paintings and sculpture and talk about the parts in relationship to the wholes. They should also discuss how the whole work makes them feel or what it makes them think about.

FINAL ACTIVITY:

MATERIALS:

15 SETS OF VISUAL ART CARDS

CLASSROOM MANAGEMENT

Estimated time required: 30 to 40 minutes

PROCEDURE

Give one set of visual art cards to each pair of students. Keep the group together.

Have the students spread the cards out in front of them so that they can view them all at the same time.

Select one reproduction at a time and ask the students to tell you what parts they see.

Ask the students how each whole picture makes them feel and what they think each is about.

Ask individual students to select two pictures that have some parts that are the same. Ask,

*"What parts are the same? Why?" [Review texture, shapes, lines, etc.]*

At the conclusion of this activity have the students work with the "Part and Whole" book. Have the students look at the pictures which are of various art forms and activities and try to answer the questions on the pages:

*"Artists use parts when making art forms like sculpture, plays, stories, music, or dance. Can you name the art forms?"*

*"They are all made up of parts. How many parts can you find?"*

The pages are designed to help the students review what they have already experienced with the materials. Exercise: Give a child or team a postcard reproduction of a painting that demon-

strates a close relationship of parts to the whole. (A "flat" work by Matisse works well.) Ask them to cut up the card into the parts of the composition and reassemble it to discover how sections of an object all work together to create a coherent "whole." Ask them which picture or pictures have to do with music, which with a television play, which with a story, which with art, and which with dance. (Are TV plays written with commercial breaks in mind? Should they be?) For each picture, ask the students to pick out the parts. Pointing is still an acceptable response.

Briefly go back through the study cards and encourage the students to talk about what they learned throughout the unit.

*Texture:* The unit on Texture is an example of an Aesthetic Education Program unit for grades K–1.

Texture is one of the elements manipulated by artists to represent the meaning or feeling they want to convey. The materials illustrate the use of texture in the visual arts by establishing a link between student activities and works of art. The unit was developed by Nadine Meyers and the Aesthetic Education Program staff.

There are four lessons, each with a separate objective. In the first lesson students use texture bags to experience materials tactually; they describe what they are touching; and they relate their perceptions to similar texture surfaces in their own environment.

In Lesson Two, the texture bags serve as stimuli for examining how body movement is influenced by the textures. Using photographs, Lesson Three adds a visual dimension to the students' experience of texture. The students correlate the visual images of textures shown in photographs with their tactual counterparts, the materials in the bags. In Lesson Four, the students investigate reproductions of paintings, relating the artist's use of texture to the materials found in the bags.

Suggested art activities are introduced throughout the teaching of the materials. The students are encouraged to make texture collages and murals and their own texture bags from available materials, to take texture rubbings from surfaces in the environment, and to create textured surfaces in clay. Through the art activities, the students are engaged in recording three-dimensional textures in two-dimensional mediums and in creating two- and three-dimensional works of art.

The tactual, verbal, kinesthetic, and visual modes of approaching texture used in these activities provide a variety of encounters that will heighten the students' awareness of texture in their environment and in works of art.

3 sets of 8 texture bags, each set divided into 2 groups of 4 bags each

Group A: Red texture bag containing synthetic fur
Pink texture bag containing ridged material
Yellow texture bag containing coarse matted fiber
Orange texture bag containing foam rubber

Group B: Light blue texture bag containing shag carpet
Dark blue texture bag containing wire screen
Green texture bag containing acetate
Purple texture bag containing rubber stipple mat

3 sets of 12 photographs correlating to the textures in Group A

3 sets of 12 photographs correlating to textures in Group B

12 art reproductions, correlated with texture bags in Groups A and B

Materials for the Teacher:

1 set of 40 word cards

1 mystery bag

1 Teacher's Guide

These materials are the basis for the teaching activities outlined in each of the lessons. Sample lessons are outlined that engage the students in dialogue about the textures in the bags. This encourages the student to expand his general vocabulary and, in later lessons, his critical language.

LESSON ONE:
Touching and Talking about Texture

Concept:
Different textures have individual qualities that make them feel different from one another and, in some cases, determine their function.

General Objective of the Lesson:

The students will tactually perceive and verbally describe qualities of texture. A sample activity in Lesson One concentrates on feeling and talking about texture.

ACTIVITY 1: FEELING TEXTURE

GENERAL DESCRIPTION

The students will discuss the different qualities of various textures presented to them in the package. They will relate those textures to other textures they are familiar with. In addition, they will see that texture may be related to function.

MATERIALS:

Texture bags, Set A

Texture bags, Set B

CLASSROOM MANAGEMENT

The texture bags in Set A may be introduced one bag at a time, or all four bags may be dealt with simultaneously for two or more class sessions. When Activity 1 is repeated, the bags in Set B are used.

Allow two sessions of thirty minutes each for this activity— one for the bags in Set A and another for those in Set B. Alternative time periods may be used depending on the students' attention span, such as four sessions of fifteen minutes each, etc.

PROCEDURE

Demonstrate that different surfaces feel different by leading the students on a texture walk. Say to them,

*"Have you ever felt anything like the texture in the red bag?"*

*"Yes."*

*"Where?"*

*"The inside of my slippers. It keeps my feet warm, and it's nice to walk on."*

*"How does it keep your feet warm?"*

*"Well, it covers my feet."*

*"Does it bend and move with you?"*

*"Yes, it's soft and it bounces when I walk."*

Ask the students to invent uses for the material. They should try to pair function with textural qualities.

*"Let's make up as many uses as we can for the material in the red bag."*

*"I think it would make a good pillow."*

*"Why?"*

*"Because it's not hard. Because it's soft and thick and furry. It holds up my head and moves with me."*

Reverse this process by suggesting functions for the material. Once again the students are encouraged to examine the textural qualities. Say to them,

*"Would the material in the red bag make a good car (pillow, rug, scrub brush, wallpaper, coat or dress, table)? Why or why not?"*

The following example shows how one teacher used the categories taken from design elements as a guide when working through several of these discussions. The questions are posed according to the nature of the object. The bag being discussed, the pink bag, contains the ridged material.

*"Let's walk around the room and feel the surfaces of different objects."*

*"Do all these things feel the same? How do they feel different?"*

*"How do they feel the same?"*

*"How many different surfaces can you find in the room?" (Or out of doors, if weather permits.)*

Distribute texture bags to the students. Stress that there is nothing inside the bags that can hurt them. However, because they do not know what is inside, they should put their hands in the bags slowly and gently. The activities with the bags are designed to help the students find out about surfaces by touching them only. Therefore, they are not to look inside the bags. No peeking!

Do not be surprised if your students immediately try to guess what the textures are rather than describing how they feel. The students like to label the materials as grass, fur, etc. To redirect their focus to the textural quality, simply ask,

*"How did you know it was [grass], [fur]? How does it feel? Was it that feeling that made you think it was [grass], [fur], etc.?"*

Ask the students to relate the textures they touch in the bags to textures they are familiar with in their own environment. Have them identify where they have come into contact with materials like these before. When they are feeling the texture in the pink bag (the ridged material), for example, ask,

*"Have you ever seen a material which is hard, bumpy, and slippery like this one?"*

*"Now each of you name something you have seen and felt which is similar to the material in the pink bag. Tell us why it is like this material."*

Reinforce accurate associations and try to direct the students to several kinds of things, as, for example, construction materials, furniture, food, animals, or nature textures.

Now help the students find their own words to describe the textures in the bags. Give them specific textural qualities to attend to. Knowing that the material—for instance, the red bag's synthetic fur—is soft, fuzzy, and smooth, ask if they are feeling the opposite. Have them exercise and explore their own vocabularies.

*"Is it rough?"*

*"Is it hard?"*

*"Can you bend it?"*

*"Is it solid?"*

*"Can you feel separate pieces?"*

Words are only one of several cues to what the students are experiencing. If students are shy about expressing themselves, this does not mean they are not experiencing sensuous textural qualities. Watch for nonverbal cues also: hand reactions, body movements, facial expressions, and sounds.

Start the students thinking about how texture may be related to function. Thinking about the use or function of a specific material can make them aware of sensual, tactual attributes such as:

*"When you rub your hand over the surface, what do you feel?" [ridges, grooves, bumps, ripples, waves]*

*"How do you know they are bumps?"*

*"How does a bump feel?" [You know it is a bump because it goes up and down, high and low.]*

*"Can you show me with the hand not in the bag how your fingers inside the bag move over the material?" Have the students illustrate what they are feeling. [height, shape]*

*"Now let's close our eyes. Keep your hand in the bag. Follow the directions and see if you can answer these questions."*

*"Can you place your fingers across the bumps?"*

*"Can your fingers jump from one ripple to the other?" [yes]*

*"What are your fingers jumping over?" [gully, depression, groove, hole]*

*"Can you place your fingers inside the groove? Does it have a bottom? Does it have sides?"*

*"How far apart are the bumps?" [height, density]*

*"In our class we have some children who are taller and some children who are shorter. Some of our friends are skinny and some are heavy. Are the bumps inside the bag like the children in the room? Are they all different sizes?"*

*"Place your fingers across the bumps again. Are all the bumps the same height?"*

*"Do some bumps stick up higher than others?"*

*"Are some bumps fatter than others?" [uniformity, height]*

*"Can you press the high spots down?"*

*"Do they move?"*

*"Why can you or why can't you move them?" [flexibility, pressure]*

*"Can some of the bumps move while others cannot?" [uniformity in flexibility]*

*"So far we have been rubbing our fingers across the ridges. Now try rubbing your fingers in the other direction."*

*"Does it feel the same?"*

*"What is the difference?" [shape]*

Make sure you know what qualities the students are attending to when they make comparisons between the textures. When one student placed a hand in the bag containing the corrugated vinyl, he said, "It is like a brick wall." Although the student was ignoring the long, tubular shape of the corrugated vinyl and the rectangular shape of the brick, he was still making definite distinctions. After further questioning it became obvious that the student was comparing the regular occurrence of the bumps in the bag to the uniformity of the brick pattern, depressions in the corrugation to the groove of the mortar, and the solid quality of both materials.

In the later lessons, the student engages in games and activities that encourage him to describe texture in various ways. Terms are introduced through use of word cards that add to his understanding of the element of texture in the visual arts. The student looks at art reproductions and attempts to describe the feeling or idea the artist is trying to express through the use of texture. Reproductions such as van Gogh's *The Starry Night,* Matisse's *The Purple Robe,* Vasarely's *Copella,* and Tanguy's *Rapidity of Sleep* are used. The texture bags are used with each art reproduction and are the stimulus for dialogue and discussion. The student examines art reproductions and describes the textural qualities that are present. The last activity suggested for the unit is as follows:

Instruct the student to put all eight bags in front of him.

Distribute the photographs.

THEN SAY TO THE STUDENTS:

*"Find the bag(s) that have textures that are the same or nearly the same as the textures you see in the paintings."*

In most cases several bags will be needed to describe fully the textural qualities in a painting. The students can further explore

the different textures they see by sharing their responses and discussing their different choices.

In relating texture and subject matter, ask general questions:

*"What do you think the artist was trying to tell us?"*

*"What if he used a different kind of texture? would he be saying the same thing? Would you feel the same about the works?"*

*"What kind of texture would you use?"*

*"What kind of mood has the artist created? Happy, sad, spooky?"*

*"How did the textures he used help create the mood?"*

One point you might want to note for your students, if they mention it: Some of the art works shown in the photographs are sculptures, and some are paintings which use impasto, so that the texture on the actual work of art could be felt in the same

*Stormy Sky, Venice* Walter Barker Signed and dated 1958. Oil on canvas. 64 X 84 in. Anonymous Gift. Courtesy Museum of Fine Arts, Boston.

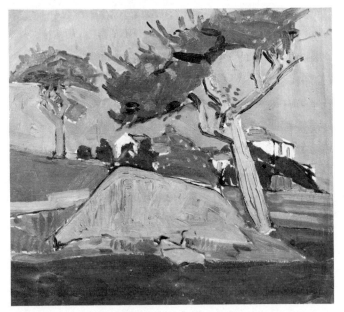

*Hillside Near Gloucester* Stuart Davis Painted in 1915–1916. Oil on canvas. 22½ X 18 3/4 in. Abraham Shuman Fund. Courtesy Museum of Fine Arts, Boston.

Studying terminology of paintings requires examples that are particularly strong in specific visual characteristics. A question for students could be as follows: "Of these four paintings, one achieves its power through the use of line; another through texture; another could be called "painterly," while another uses contrast to reinforce its flow of rhythm. Match the descriptions with the paintings."

*Flowers with Picture of the Resurrection* Alexis Paul Arapoff Gift of the Division of Education. Courtesy Museum of Fine Arts, Boston.

*New England Editor* Thomas Hart Benton Signed and dated 1946. Oil and tempera on gesso panel. 30 X 37: Charles Henry Hayden Fund. Courtesy Museum of Fine Arts, Boston.

way as the materials in the bags. Other paintings, however, are flat and only make us think we can feel the textures in them. Some painters give us the feeling of a third dimension through the use of color or lights and darks on a totally flat surface; others give us this feeling by actually building up the paint or by adding other materials to the canvas.

*The Visual Artist:*   This unit, the Visual Artist, is designed for the middle grades to answer the question "What is an artist?" The emphasis of the unit is on the artist's perception and interpretation of his environment through visual images. In this unit the student hears interviews with artists about how they live and work, and sees works that show the relationship of the artist's work to his environment. The activities for the classroom allow the student to put himself in the place of the artist and explore what motivates his critical choices. The materials are designed to engage the student in the activities and processes that the artist uses in making aesthetic judgments about his work. They also use the artist as subject matter and answer such questions as "Who is he?" "Why does he work the way he does?" "Where does he get his ideas?" and "How does he identify his own work and that of other artists?" The unit was also developed by Jeri Changar and the Aesthetic Education Program staff.

MATERIALS:

*A Special Place,* a book on the Visual Artist
Taped interviews with artists

*Student Activity Book*
Teacher's Guide
Filmstrip (slides); of artist work
Artist's Idea Pack; includes three idea card decks:
    "Things I See," "Things I Know," "Things I Imagine"
Artist's Planning Puzzles, one black and white, one colored
Shape bag
Student response sheets for final activity

The set of materials is divided into five lessons. They are as follows:

*Lesson One:*   How Artists Look at Their World in Many Ways: We Can Look in Those Ways, Too!

*Lesson Two:*   How the Artists Get Ideas and We Do, Too!

A puzzle using geometric shapes is used to promote student understanding of how an artist makes his decisions. Working with the puzzle resulted in such statements as: "I started over three times. I wonder how many times an artist starts over."

Black-and-white illustrations make up a puzzle in the Visual Artist unit.

*Lesson Three:*   How the Artists Make Decisions and We Can, Too!

*Lesson Four:*   Artists Have Their Own Ways of Working and We Can Often Identify These.

*Lesson Five:*   People Have Different Feelings about the Same Art Works, and So Do You. Let's Examine Your Feelings.

Two lessons (Lesson One: Activities 1–4, and Lesson Four: Activities 1–2) from The Visual Artist materials are excerpted. You will note that the students are engaged in ways of perceiving and observing the world as an artist does and then encouraged to engage in art activities that heighten this perception.

LESSON ONE:   Artists Look at the World in Many Ways. We Can Look in Those Ways, Too!

CONCEPT

The perceptual awareness of artists affects the objects they create. The perceptual awareness of those who view the work affects how they see it.

GENERAL OBJECTIVE OF THE LESSON

Through *A Special Place* and the tapes, the students will see how visual artists perceive their environment and interpret

their experiences. Involvement in these activities will help the students to become aware of their own perceptual skills.

After participating in the six activities involving perceptual awareness, the students should be more observant and aware of things they see around them.

SOME NOTES ON VISUAL PERCEPTION FOR THE TEACHER

There are several types of visual perception, among them the practical, the curious, the imaginative, and the aesthetic. In the process of creating visual images, artists may perceive their environments through all of these types of vision.

Throughout the unit, the students will continue to explore how they see, and to compare their visual awareness to that of artists. The activities within each of the lessons are designed to give the students an opportunity to increase their perceptual skills. They will be involved in experiences that relate to the kinds of perceptual experiences artists might have and to how artists interpret these experiences through their work.

Lesson One is a group of activities which help the students to see how observant they are. You may also think of other ways to expand their visual perception. For each activity, read the students' instructions and the materials addressed to you very carefully.

LESSON ONE FOR THE STUDENTS:

*Artists Look at the World in Many Ways.*
*We Can Look in Those Ways, Too!*

How aware are you of the things around you? Remember how the artists talked about where they got their ideas and how they found the things to use in their art. They were always looking and seeing things in many ways. How many times have you looked at designs on sewers, beams of wood, and the way a person sits, the colors around you, the skyline, how plants grow, and so forth? The next few activities will help you see how observant you are.

How much are you aware of all the things around you? How many ways do you look at one particular object? Try the activities in this section and see what happens.

LESSON ONE: ACTIVITY 1 FOR THE TEACHER

The purpose of this activity is to help the students become aware of how observant they are and to increase their powers of observation.

You can vary the number of changes to be made. Watch for the students who begin to make subtle changes rather than the initial obvious ones. Point these out to the other students.

LESSON ONE: ACTIVITY 1 FOR THE STUDENTS

### How Much Do You See?

| | |
|---|---|
| Exploring and Imagining | You will do this activity with the whole group. |
| Planning and Doing | Divide the group into two rows facing each other. Each of you should closely observe the partner's opposite—the partner's dress, hair, accessories, etc. Then turn your backs to your partners, and each of you make three changes in your appearance. When you face each other again, each of you must identify what changes your partners have made. You can change partners and repeat this two or three times. |
| Showing and Sharing | After you have tried the activity once, consider the following questions: |
| | How good a detective were you in recognizing your partner's changes? |
| | Were you able to make the changes on yourself easily? |
| | Can you think of more changes you could have made? |

LESSON ONE: ACTIVITY 2 FOR THE TEACHER

The purpose of this activity is to help the students realize how much there is to see beyond the first glance or observation.

Ask the students to "stretch their eyes." Project slide. Be sure that everyone has a turn to point out something in the picture.

LESSON ONE: ACTIVITY 2 FOR THE STUDENTS

### More How Much Do You See?

| | |
|---|---|
| Exploring and Imagining | "Stretch your eyes!" With the whole group, you are going to look at a slide of a painting. Each of you will take a turn describing in one or two words one thing you see in the art work. Each of you will have a turn, and no one is to repeat anything that another person said. [The slide can be of any sub- |

ject but use an established artist. Try a variety of works from nonobjective to representational.]

| | |
|---|---|
| Planning and Doing | Here are some things to think about and discuss as a group: |
| | Do you think the artist actually saw all the things that you saw in the picture, or do you think he or she also used imagination and added some things for interest? Give reasons for your opinion. |
| | What do you think the artist might have left out? |
| | Were you surprised by how many things the group could find in the picture after you looked at it carefully for a while? |
| Showing and Sharing | You might want to try working with the painting slide on your own with a small group of friends. |

---

## LESSON ONE: ACTIVITY 3 FOR THE TEACHER

The purpose of this activity is to have the students examine how aware they are of the things around them. Pretend that they are having a treasure hunt.

Drawing materials are needed for this activity.

Make sure the students bring back their drawings. Ask them if they added things. Ask if they thought they would even find more things to add if they took their picture home a second time.

Display as many drawings as possible. Try to display all of them.

## LESSON ONE: ACTIVITY 3 FOR THE STUDENTS

---

**How Aware Are You?**

| | |
|---|---|
| Exploring and Imagining | You have just had a chance to see and hear what artists do, where they get their ideas, and what kinds of decisions they have to make. All the artists talk about things they see around them. Have you ever taken a close look at the objects in your environment? How aware are you of the things around you? |
| Planning and Doing | Try this: |
| | Draw a picture of your trip from school to home. Put in everything you can remember seeing. When you go home to-night, take your picture with you and check to see what you left out. How many things did you forget? Write what you left out on the back of your picture. |

Share your experience with your teacher and friends. Tell them everything you left out. See how your friends did. Look at their pictures. Ask how much they remembered. Suppose your picture was mailed to an overseas sutdent. How much could they tell about your way of life and your environment?

## LESSON ONE: ACTIVITY 4 FOR THE TEACHER

This is essentially a drawing activity. Its purpose is to help the students notice more things and more details of what they notice. It is to force them to look closely at any object from more than one view. As the students are working, encourage them to move around and look at the objects from many points of view. Help them understand "point of view."

Make sure that all students have opportunities to display their work.

## LESSON ONE: ACTIVITY 4 FOR THE STUDENTS

**Can You Stretch Your Eyes?**

Exploring and Imagining

"Stretch Your Eyes." Look all around your classroom and find something you have never noticed before. It could be an object or something about your teacher or another student. It should be something that interests you that you have never been concerned with before.

Planning and Doing

Try this:

Get a piece of construction paper (12" × 18"). Fold it in fours. Draw your new discovery in as much detail as possible in the first box. Draw it again in each of the remaining boxes, but in a different way each time. For example, you might use color on some, black and white on others. You might show it up close or far away. You might draw its back or side or top or bottom. Take special care with each drawing. Remember, this should be something you never paid much attention to before.

Showing and Sharing

When you're finished, share your drawings with your teacher and ask her or him to display them.

---

LESSON FOUR:   Artists Have Their Own Ways of Working.
We Can Often Identify These.

### CONCEPT

As experience with art work increases, students grow in their ability to identify and analyze works by a particular artist.

When the students have completed the two activities of this lesson, they should have learned to start looking at art works in terms of the creative process the artist engages in and the outcomes of that process. They will know that they can become familiar with the characteristic ways a particular artist works and in this way often identify the work of a particular artist.

## LESSON FOUR FOR THE STUDENTS:

*Artists Have Their Own Ways of Working.*
*We Can Often Identify These.*

### GETTING ACQUAINTED

In the next two activities, you are to look at the work of several artists. As you look, you will begin to see that certain artists use color, line, shape, and textures in ways that are similar to certain other artists and in very different ways from some other artists. You will begin to see also that artists may express their ideas in several works of art in ways looking very much alike from work to work. Remember that we have heard that an artist should be unlike every other artist in some way. In other words, each artist has his or her own way of expression which becomes his or her own style. [Refer to the perceptual games described in Chapter 2, particularly Style Matching and Reduction Sorting.]

### LESSON FOUR: ACTIVITY 1 FOR THE TEACHER

The purpose of this activity is to have the students look at art works in terms of the kinds of decisions that the artists made.

Use the questions suggested in the students' directions. Remember, there are no right answers. Allow the students to express their ideas. Encourage them to keep searching.

### LESSON FOUR: ACTIVITY 1 FOR THE STUDENTS

#### EAMINING ARTISTS' WORK

[Get a partner and the filmstrip.] Look through all the pictures first. Then look at one at a time and ask yourselves these questions:

*"What do you think was most important in the artist's work? Color, shape, line, texture, or form? Why?"*

*"What was each artist's work about?"*

Things to think about or discuss with the whole group:

FRANZ HALS
1. What do you think is most important in this painting? Do you think it is the person or the shape and colors the artist used to paint this person? Why?

JEAN INGRES
2. What about this person? How is she painted differently from the first one? What do you think is most important in this painting?

ALBERT RYDER
3. Which do you see first, the colors and shapes or the subject? Which do you think was most important to the artist?

SALVADOR DALI
4. What do you think the artist was trying to say? Why do you think he painted the clocks the way he did?

VASILI KANDINSKI
5. What is most important—color, line, texture, shape? Why? What do you see first when you look at it?

LOUISE NEVELSON
6. What is most important here? Is it how the shapes fit together? What do you think she was trying to say?

ROBERT RAUSCHENBERG
7. What do you think about how the artist put this painting together? What do you think he was trying to say?

CLAES OLDENBURG
8. Why do you think the artist made this kind of sculpture? Is he the same one who did the hamburgers in slide 3, Lesson Two?

HELEN FRANKENTHALER
9. What is most important in this painting—color, shape, or subject? Why?

Artists make many decisions when they put together a work of art. Each decision is very important in terms of how the final work will look. Think about what you do when you put together a work of art.

This activity is not a test. Reassure the students on this point. Its purpose is for the students to see how perceptive they are. They will share ideas with other students to reinforce the concept of this lesson, that as experience with art work increases, they will grow in their ability to identify and analyze works by a particular artist. The students will also see again that each person brings a different point of view to a work of art.

---

**Recognizing an Artist's Work**

Exploring and Imagining

Wait for your teacher to direct this activity so that the whole group can do it together. You are going to look at several works of art to see if you can pick out the paintings and sculpture done by the same artist.

This is another chance for you to do your own thinking and then share your ideas with others. This is not a test.

Planning and Doing

On the next five pages, you are going to make some decisions. You are to number your paper like the following sample.

On the first page you are to look at the five works of art and decide how many of them were done by the same artist.

Circle the numbers of those paintings on your answer sheet. In the section labeled "Things that are the same," write all the things that are the same in the works of art that you think were done by the same artist. You can just make a list; you don't have to write sentences. Don't write anything about the pictures that you think were not done by the artist. On the part of your paper labeled "Where the artist gets his ideas," write whatever you want. Do the same for each of the five pages of pictures.

Showing and Sharing

When you are finished you will share your ideas with your teacher and the rest of the class.

---

| | page 1 | page 2 | page 3 | page 4 | page 5 |
|---|---|---|---|---|---|
| | 1 2 3 4 5 | 1 2 3 4 5 | 1 2 3 4 5 | 1 2 3 4 5 | 1 2 3 4 5 |
| Things that are the same | | | | | |
| Where the artist go his idea | | | | | |

## The Newton Program in Art Appreciation

The Newton school system provides a program entitled Art Appreciation for Fifth or Sixth Grades. Since the course is taught by one part-time art teacher, not more than four schools can be serviced in any one year. A principal must request the program, which is designed on either a one- or two-semester arrangement. The art appreciation program cannot, however, be offered to any school without certain commitments on the part of the school. Nor is the program a substitute for the regular art program; it is always in addition to it. The conditions the schools must meet are as follows:

1. The principal must commit the school to at least three field trips. Two of these must cover major art galleries and the Massachusetts College of Art. The third site is chosen by the art teacher and usually covers a local exhibition of special interest to the students. Examples: Joseph Cornell's "boxes," Marisol's sculpture, Louise Nevelson's sculpture, Indian art and artifacts, etc.

2. The art teacher must be assured of a minimum of one hour a week for the time stipulated, and should a lesson run over an hour, the classroom teacher must be

willing enough to go beyond the period. Occasionally, he or she will take care of a follow-up or related activity in the absence of the appreciation teacher.

3. The classroom teacher is to be considered an active partner on the assumption that the experience is in-service training which will enable him or her to use some or all of the techniques in classes the following year, when the appreciation teacher has moved to another school. This means the host teachers help prepare for the class, work out details for field trips, attend to the cleanup, and do not use the period for coffee breaks, grading papers, or other needs. They must also participate in in-service sessions with the art appreciation teacher and the classroom teachers of the other schools that are involved.

The office of the art supervisor, which sponsors the course, offers in return the following:

1. The services of a special teacher to conduct the course.

2. All support materials, including games, slides, films, reproductions, original paintings, etc.

3. At least one "guest," usually an artist who conducts a demonstration.

4. Some form of presentation to the Parent Teachers Association. This is not required, but recommended, and may take the form of a short talk with slides, or an exhibit prepared by the teacher as a presentation by students.

The goals of the program are to (1) open the student to a variety of modes of expression and create attitudes of acceptance towards the new, (2) provide the student with a critical vocabulary that will facilitate his or her ability to talk about art, (3) take the student beyond immediate snap judgments, or what Ecker terms "psychological reports," to a process that relates description to analysis to interpretation, (4) enable the student to make discriminations among the formal qualities of art works, (5) make art viewing a more pleasurable experience for the child, and (6) dispel incorrect ideas and illusions regarding the nature of art and artists.

The schedule follows a relatively fixed, sequential format, and although portions of it change from year to year, such adjustments are mainly additions that the teacher feels can enrich and improve learning. For this reason, the two-semester plan is recommended over the single-semester plan.

The program is designed from a series of appreciation concepts. The lesson descriptions, concepts, and other information follow. (Note the use of some of the games described in Chapter 2.)

INTRODUCTORY LESSON—I

Title and Concept:

CREATING CRITICAL CATEGORIES

"Art works can be discussed in terms of media, subject matter, style, content (meaning)."

LESSON DESCRIPTION

Original art works are brought to class. Since they represent a range of at least four media, subjects, style, etc., the class is asked to list the differences. From this discussion, a series of "critical categories" are listed that in turn provide the basis for future lessons: media, subject matter, style, content (meaning).

MATERIALS

Original artworks:
Oil paintings
Watercolors
Collages
Prints

**Arthur G. Dove's *Long Island* can provide effective motivation for the understanding of collage.**

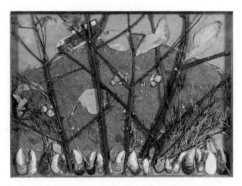

*Long Island* Arthur G. Dove Signed and dated 1925. Collage on painted panel. 15 X 20 3/4 in. Abraham Shuman Fund. Courtesy Museum of Fine Arts, Boston.

Title and Concept:

ORIGINALS/REPRODUCTIONS/PRINTS

"There are significant differences between original paintings, reproductions, and original prints."

Lesson Description

Discuss the terms *original, reproduction, print.* Show examples of each. Establish a working definition of a print as an image that an artist creates on one surface and transfers to another surface.
Present a printmaking activity involving a choice of at least three media so that the students can become familiar with and understand the nature of at least one medium [monoprint, collograph, linoleum].

Materials

Original blocks and prints (relief)
Original painting
Reproduction of a painting
Studio materials for monoprinting

Introductory Lesson—III

Title and Concept:

FUNCTIONS OF ART

"Visual works of art are created for a variety of reasons, all of which fulfill specific needs."

Lesson Description

Discuss and list on board reasons why artists create—for example, decoration, social commentary, expression of religious beliefs, recording history, story telling, expression of inner feelings. Slides are shown, and the class is asked to apply information just discussed. Introduce filmstrip on Marisol. Discuss the many reasons that Marisol gives for being an artist. Ask class to watch for these. After filmstrip, discuss class's reactions and pass around *Time* magazine cover.

Materials

Slides:  *Egyptian throne chair*
 *Persian drinking vessel*

> Lascaux cave painting
> Mathieu: calligraphic design
> Kollwitz: mother-child drawing
> Steinberg: cartoon
> Goya: Shooting on May 3, 1808

Filmstrip:
Famous artists at work—Marisol

*Time* magazine
cover by Marisol, *The American Family*

## SPECIAL PROBLEMS

Be careful not to overdo the time spent discussing the concept through slides.

## PERCEPTUAL LESSON—I

Title and Concept:

STYLE

"Paintings can be divided into three broad areas of style—realistic, abstract, and nonobjective."

## LESSON DESCRIPTION

Show slides illustrating each of the three style distinctions. Set up and play the style categories game using slides. This game is based on a variation of tic/tac/toe. Class is divided into two teams. Slides are flashed on screen—if team identifies correct style area for slide, then they get to fill in a box of the tic/tac/toe grid. First team to get three in a row wins. Set it up so each team has a leader to whom all team members must report reaction —thereby setting up discussions each time a team has a turn. These discussions are most important to the value of game. Game to be used—Style Matching.

## MATERIALS

Slides (about 30) cover a wide range. Some of the artists represented include: realistic—Wyeth; abstract—Cubists; nonobjective—Kandinski.

## SPECIAL PROBLEMS

Organization of game must be clear with game rules spelled out so there is no confusion.

Title and Concept:
IDENTIFICATION, SELECTION, CATEGORIZATION, RECOGNITION

"Paintings can be discussed according not only to style, but also to special concerns within a particular style."

Lesson Description

The class is divided into groups, each with its own collection of 24 postcard reproductions. They must (1) divide the pile into two categories—realistic and abstract—then (2) divide each of these two piles into two sets each with its own particular formal concern. For example, the realistic set may be divided into a major concern for "line" and one for "color." Use the Reduction Sorting Game as described in Chapter 2.

Materials

The collection of reproductions. Reduction Sorting Game.

Special Problems

Creating the game: Many examples are needed in order to create the needed number of categories.

Perceptual Lesson—III

Title and Concept:
ART GAMES

"Artists tend to work in a style, or formal language, that is unique to them, both as individuals and as followers of a particular school or movement. The style of an artist can be recognized by studying a small section of work and recognizing it as a part of the whole work."

Lesson Description

The class is divided into groups that move from one game center to another. Since some of the games may already have been demonstrated, new versions will have to be used. A suggested studio exercise is to have a group do six three-second scribbles and then have another group see if they can match the scribbles. This is one way of dramatizing the basis of an individual style. See if the class can describe differences between scribbles.

Materials

12" X 18" newsprint and black crayons. Puzzles, cubes, and Style Matching Game.

MEDIA LESSON

Title and Concept:

MEDIA

"Artists use different materials to achieve their ends."

LESSON DESCRIPTION

Set up a large vertical still life, for example, a barrel, a rack, streamers, balloons, rope, feathers, a skull, a flag, an umbrella. Have students fold a long vertical piece of drawing paper into four horizontal sections. Provide four different kinds of materials to draw with—for example, crayon, marker, pastel, bamboo pen, or brush. Instruct the class in use of materials and ask them to do a vertical contour drawing of still life, but change drawing tool at each horizontal fold. When finished, discuss the differing visual qualities that the media choice brought to each horizontal drawing section. Show examples listed below and list adjectives that describe characteristics of media used by artists.

MATERIALS

Slides of variety of linear treatment: Ben Shahn, Pablo Picasso, Kathe Kollwitz, Raoul Dufy, etc.

SPECIAL PROBLEMS

The student should be made familiar with contour drawing since a linear approach takes less time to complete.

CRITICISM AND ANALYSIS—I: INFERENCES, INTERPRETATIONS

Title and Concept:

IDEAS AND THEMES

"Artists get ideas and work with themes from a wide variety of sources."

LESSON DESCRIPTION

The teacher discusses the concept, then flashes examples of art works on the screen. The class, using a check sheet, indicates the category of the slide or reproduction. Theme sources and examples are as follows:

Social protest—Goya, Harlem wall murals, Daumier
Worship—Cathedrals, Raphael, Dürer's *Hands Praying*
The Good Life—Renoir, Vermeer
Mythology—Ingres, Greek vase
Social Status and Class—Van Eyck, Daumier, Millet

Love—Rodin, Cassatt
Decoration—Tattoos, interiors, textiles
Communication—Posters

MATERIALS

Reproductions
Slides
Preparation of check sheets

CRITICISM AND ANALYSIS—II

Title and Concept:
THE ELEMENTS

"Art works, whatever their style, are made up of what we call formal elements. These are used in different ways. The elements of art include: line, shape, color, texture, space, composition."

LESSON DESCRIPTION
(See *Media* lesson for *Line*)

TEXTURE

A studio activity that asks the student to study the qualities of texture through mixed media (rubbings, tempera paint, and collage). The student is asked to create as many textures as possible either by manipulating materials to change the surface in collage or through surface using a pencil rubbing to simulate different textures. He is also asked to keep some unifying structure in mind.

CRITICISM AND ANALYSIS—III

Title and Concept:
FORM AND CONTENT

"The form, or structure, of an art work is related to what the picture means, or what the artist is trying to say."

LESSON DESCRIPTION
Students pull slips of paper out of a hat, upon which are written words, phrases, or quotations: "riot," "summertime," "one picture is worh 10,000 words," "smile and the world smiles with you," etc. They are asked to convey the meaning of language through visual symbols using cut paper. They must avoid any realistic images and carry the meaning only through color, shape, and relationships between the elements. Words are

listed on the blackboard and the class matches images and word meanings.

MATERIALS

Cut paper, paste, scissors.

Follow-up slides of pictures that clearly link form or style to content. Examples: Kollwitz; Orozco's *Zapatistas;* Dali's *Remembrance of Things Past;* portions of Picasso's *Guernica,*etc.

CRITICISM AND ANALYSIS—IV
Title and Concept:

**Pictures That Invite Speculation**

Children enjoy speculating about the meaning of art works. These four examples suggest a wide range of meaning. The clues are anecdotal while D meaning is embedded in Biblical narrative. The degree of consensus of interpretation will obviously be less in A and B than C and D.

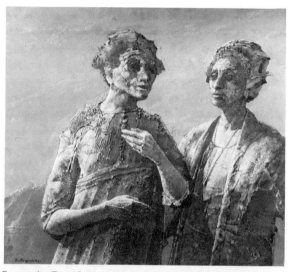

*Conversation (Taxco)* Ray Acampora (American, b. 1926) Gift of National Academy of Design. Courtesy Museum of Fine Arts, Boston.

*Marriage Party* Howard Gibbs Charles Henry Hayden Fund. Courtesy Museum of Fine Arts, Boston.

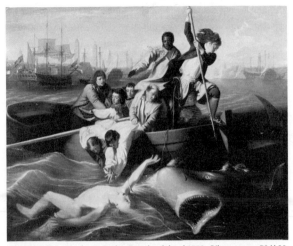

*Watson and the Shark* J. S. Copley Signed and dated 1778. Oil on canvas. 72 X 90 ¼ in. Gift of Mrs. George von Lengerke Meyer. Courtesy Museum of Fine Arts, Boston.

*Joseph and His Brothers* D. Aronson Encaustic. 46¼ X 40 in. Gift of the Stone Foundation, 1971. Courtesy Museum of Fine Arts, Boston.

## FORMAL ANALYSIS

"The structure or composition of a painting is made up of shapes, colors, directions, lines which may or may not be seen

as recognizable objects. The structure may be easy to see. It may also be 'hidden' and require close looking."

LESSON DESCRIPTION

Each student is given a reproduction of a painting or a piece of sculpture, a sheet of acetate, and a black grease crayon. Every student has the same art work. They are asked to place the acetate over the reproduction and indicate with the crayon the direction, the geometric substructure, the major rhythmic movements of the composition of the work. The difference between this and merely tracing the work should be made very clear, and if anyone is in doubt, the teacher should give a demonstration of the process. When the class is finished, all the acetates should be piled together, and placed on an overhead projector. The class can then discuss the degrees of agreement or difference that exist in the massed pattern of lines. Art works should be selected carefully for their relative ease of discernment. (A complex religious painting of the Renaissance has more to offer than an Impressionist seascape.) Option: Since the crayon is easily erased, the teacher may want to give the class a preliminary try by having each student choose his own reproduction.

MATERIALS

One reproduction for each student.
One sheet of acetate for each student.
One soft grease crayon for each student.

HISTORICAL LESSON

Title and Concept:
ISMS: WHAT ARE THEY AND WHY?

"Since art changes with the times, the work of artists can often be identified with groups who bring about change."

LESSON DESCRIPTION

Teacher discusses the idea, then introduces reproductions of selected schools of painting (Surrealism, Impressionism, Pop Art, and Cubism). Slides are avoided at first, as all styles must be visible at the same time for comparison. The teacher mentions a particular characteristic, then asks the class to select the painting that exemplifies it. The teacher then shows slides of other examples and asks class to identify movements on a check sheet.

MATERIALS

Slides or reproductions
Preparation of check sheets

THE "REAL" WORLD OF ART—I

Title and Concept:
VISITING A MUSEUM

"The public views major works of art in museums. Museums are one reliable source of quality art of all periods of art. We assume that the art of museums has stood the test of time."

LESSON DESCRIPTION

Choose from the list of museum games described earlier. Plan a field trip to a local museum—if possible with the museum's permission. The "Visual Treasure Hunt" [described in Chapter 2] can easily take different forms. If the museum is large and sells small reproductions of its important works, buy each student a small reproduction and set the students out in groups to find the originals. Another form is to prepare a written sheet with questions whose answers must be hunted down—for example, of the ten works in this room, which one has the most vibrant palette, which one is the most active, which one is quietest, calmest, which one relies most heavily on use of line, and so on?
Other possibilities include the following:

PICTORIAL ANALYSIS

Take acetates and markers and ask students to look at a particular painting and find in it its major elements of movement and design. Record these on acetate. When back in class, overlay acetates on overhead projectors to see similarities and differences in interpretations.

THE DESCRIPTION GAME

Blindfold all students but one. Ask the one to describe the elements and mood or feeling of a painting in the room. Others remove blindfolds and determine which painting was described. Play as long as interest is high. In large museums, the game site can be varied by changing room location.

MATERIALS

This will vary with the game: originals at the museum, mimeographed answer sheets, art materials (crayon and paper), blindfolds.

Secure enough parent helpers or guides so that the students can move freely in small groups. Confer with museum docents in advance. You may need their assistance.

Place numbers near paintings in advance (this requires permission).

## THE "REAL" WORLD OF ART—II

Title and Concept:

### VISITING AN ART SCHOOL

"Artists go through a period of training in a specific place, as do doctors, engineers, policemen, and others. The equipment and space they need and the way they spend their time is different from what regular schools provide."

LESSON DESCRIPTION

Arrange a visit to a local art school or art department in a college or university. Discuss with the class the nature of an artist's training and education. Try to visit at a time when many studio classes are in session so the students can observe as wide a variety of activities as possible. Sometimes the art school will be able to arrange helpful activities—for example, allowing children to try potters' wheels, viewing student movies, providing guides for shows, simply answering questions.

MATERIALS

An obliging art school!

SPECIAL PROBLEMS

As in the case of all field trips, adequate preplanning is a must. Count on a half-day.

## THE "REAL" WORLD OF ART—III

Title and Concept:

### THE ARTIST AT HOME AND AT WORK

"Artists work in a variety of ways and in a variety of environments."

LESSON DESCRIPTION

Arrange with local artist or artists to visit their studios. (In many cases, studios are combined with homes.) It is helpful if more than one location can be visited (three is a good day's program).

In the Boston area, the Boston Visual Artists Union cooperates in making artists and their studios available. These studios are clustered geographically and the field trip is capped off with a visit to the B.V.A.U. gallery in downtown Boston. If no such organization of artists exists in your area, then contacting artists on an individual basis often proves fruitful.

MATERIALS

Obliging artists who are willing to show their professional selves and who like children.

SPECIAL PROBLEMS

Adequate preplanning.
Maintaining balance of sexes among artists.
Locating helpful artists.
Pre-field-trip discussion relating to the kinds of work the students will be seeing. Showing examples of work in advance builds suspense and a sense of anticipation.

THE "REAL" WORLD OF ART—IV

Title and Concept:

VISITING AN ART MARKET PLACE

"Artists must have a place to show and sell their work. Galleries are different in this respect from museums."

LESSON DESCRIPTION

The class visits the gallery center of a city. As each gallery is visited, the information of previous classes is called upon as the class is asked to comment on the art works. Exhibit announcements are collected and displayed in the art room after the trip. Children can be asked to rate in order their favorite shows and to discuss their reasons for acceptance or rejection. The gallery that receives the most votes should receive a letter of appreciation from the class. The artist may be interested in the appeal of her/his work to young people.

THE "REAL" WORLD OF ART—V

Title and Concept:

THE VISITING ARTIST

"One good way to learn about the process of picture making is observing an artist at work, listening to his comments, and asking him questions."

LESSON DESCRIPTION

[This lesson is described fully in Chapter 5, section entitled
"Case Study: The Art Supervisor as Visiting Artist."]

The key to the success of the Newton program is the time that was taken to prepare and assemble the needed resource material. All materials (slides, games, reproductions, and films) were prepared by teams of curriculum workers during the summer prior to the initiation of the program. Funds, therefore, are crucial, and to secure funds a proper rationale must be prepared by the teacher or the supervisor and presented to the superintendent, the director of curriculum, or whoever is in a position to allocate monies.

## The Corpus Christi Program in Aesthetic Inquiry

The Corpus Christi Program in Aesthetic Inquiry is a model program for the upper elementary grades based on applying research techniques. Corpus Christi Elementary School is a Roman Catholic parochial school in New York City. What follows is an abridged version of a report written by Bette Acuff, who developed the curriculum, and evaluation procedures; and trained elementary teachers to use the program.

Students of two fifth grades in an urban school participated for a period of four months in a variety of activities (primarily in the critical domain) that were intended to increase the range of perceptual and discursive skills utilized to encounter art forms—specifically paintings. The program's effectiveness was evaluated by teacher and student questionnaires, by content analyses of children's comments about each of three paintings, and by a paired comparison measure of aesthetic preference.

The major assumptions upon which this program is based are as follows:

1. It is both advisable and possible to enable children to see a wider range of qualities and to understand the significance of a greater variety of paintings than they would without instruction. As they gain new information, the quality and character of their perceptions will be altered: Their expectations about what is important to look for will be changed, as will their disposition to respond. One may predict, then, that children can be sensitized to expressive visual form and can become more receptive to a diversity of forms that present different aspects of reality.

2. A powerful means of promoting sensitive awareness in children is to afford them many opportunities to encounter and attend to a variety of paintings and analyze the forms presented; to generate a number of ideas about the quality and meaning of these forms; and to evaluate their ideas in light of several sources of information. This series of related processes is called "Aesthetic Inquiry."

Several factors affect the quality of children's encounters with art. There are specific skills to be learned: skills of attending, describing, interpreting, and evaluating used by the art critic to explain the work to himself, as well as to others. There is also the character of the situations in which those skills are learned and exercised—situations in which divergent responses are encouraged by the teacher. The students are thus rewarded for taking the risks involved in developing a number of ideas, some of which may prove—in light of further evidence and information—to be unacceptable. The support of various tentatively held thoughts leads the students to realize that the processes of mental reflection can be richly rewarding because they open new pathways to experience. This experience is characterized by intensified responses to artificial images as well as to visual forms in the natural world. Susanne Langer refers to such responses when she says, "art is the objectification of feelings and the subjectification of nature."[6] These two outcomes are important for the growth of the children's humaneness, but they do not come about naturally as the result of maturation. Rather, they emerge as the children are helped to acquire certain perceptual abilities and modes of discourse that enable them to see and imagine relationships they have not seen or imagined before.

3. While critical skills (attending, describing, and interpreting) can provide new avenues of approach to the visual arts, there is another essential aspect of the aesthetic response that occurs at a deeper level of consciousness. Without this component in our response to a work, attending to and describing its visual qualities becomes an exercise of intellect that is devoid of the full energy and richness of life. Unless we open the self to the full measure of our response to the work—unless we are able to give ourselves to evoked feelings, images, and sensations potentially within the encounter—we miss the essence of the aesthetic experience. It is only when we are able to *receive* the experience so that deeper levels of the self resonate within that we may say our encounter with a work has "stirred" us in a significant way.

How does one develop the propensity for openness to feelings and sensations on a deep level? One does not see conditions that foster openness to inner dimensions in the bustle of the ordinary classroom or in the major institutions of our society. How can conditions for fostering inner openness be achieved?

The technique of "twilight imaging" may be used to facilitate connection with the deep levels of being.[7] By becoming still, relaxed, and letting the breathing become slow and rhythmical, children are lulled into a receptive state that permits them to attend to and receive the images that arise from within them. Images may be auditory, visual, visceral, or kinesthetic, or any combination of these. At the beginning,

the "twilight" state may be induced by a group leader or teacher. Later, the children may induce the relaxation themselves by focusing on personal images recalled from previous imaging experiences or on images presented by visual forms. When imaging is evoked by the latter, the viewers experience an integral component of the creative stream from which artistic expression is born. They function at a level of being that enables them to participate in the creative process of the artist. Thus, their evoked images may enrich their perceptual experience with visual forms.

4. One means of assessing changes in children's sensitivity and ability to respond to paintings is to listen to their own comments about their reactions and thoughts to a number of paintings and to analyze these remarks for their content. One can thus infer, from the nature of the interpretations, the kinds of metaphors construed and the kinds of meanings they extracted from the encounter. We infer from the evaluations students make, and the reasons they give for their judgments, the criteria they are using for making evaluations. (The analysis of children's remarks about three paintings was the major basis for evaluating the effectiveness of the program. The category system used in the analysis will be discussed later.)

5. Another way to assess changes in perception is to ask the students to *choose* among alternative descriptions or evaluations of particular paintings. They indicate their choice by marking on a sheet the alternatives they consider to be the most telling analysis of particular works. Activities requiring children to make such choices are used in the Program in Aesthetic Inquiry.

6. Still another way of assessing these changes is to ask the child to choose on the basis of personal preference between exemplars—pairs of paintings or other art objects—and to compare the choices of instructed and uninstructed children to an external standard of aesthetic quality.

These assumptions and the practices related to them have been used in the program whose description follows.

In the planning of the Program in Aesthetic Inquiry, the process of inquiry was analyzed, and opportunities were provided for students to practice each of the component phases in the critical process: Skills of defining, explaining, describing, hypothesizing, interpreting, and elucidating and justifying aesthetic judgments were to be elicited by the activities presented.

Whether in the self-directed, small-group activities or in the large-group lessons conducted by the teacher, student behaviors were clearly specified in advance. This served two purposes. (1) It facilitated the development of a sequence of lessons that would move students from

simple to more complex learnings, so that learnings would be cumulative and appropriately paced. (2) Statements of student objectives in behavioral terms at the beginning of each large group lesson were intended to clarify the thinking of the teachers about the conduct of the various activities that made up the lesson and helped alert the teachers to desired student behaviors so that they could act to promote and reinforce such behaviors within the context of the lesson and evaluate whether or not desired learnings had taken place.

Although some student outcomes were specified in advance, other activities included in each lesson were open-ended and presented sufficient novelty and ambiguity to arouse curiosity and debate and to promote inquiry.

Model critical performances were provided in some episodes for students to consider or emulate. Information from historical and cultural sources was included in certain lessons to broaden the cognitive field students could bring to bear on evaluating such critical performances. Not only was the use of expressive language encouraged, but also children were requested to identify or to generate alternative expressive descriptions and metaphors for qualities noted in paintings. Thus, the importance of language in structuring and facilitating thought and communication was recognized in all lessons.

Determining the scope and structure of content within a particular learning process was accomplished by referring to the kinds of students who were to participate in the program and by considering the social climate of the school. Among social considerations were time-space constraints built into the existing school setting and adult attitudes toward the relative value of art experiences for children within the framework of their total school experience. Keeping in mind the limitations just mentioned, five interrelated dimensions of curriculum organization were considered: content, learning activities, teaching strategies, instructional materials, and evaluation.

*Content:* The selection of content for the program was made from the viewpoint that organizing ideas should satisfy the following criteria:

1. They should reflect the qualities and attributes of the objects of study—paintings.

2. They should have sufficient scope to be presented in a variety of activities and to employ various teaching strategies to convey them—that is, they would permit flexibility in teaching and a variety of student responses.

3. They should be of sufficient interest and of an appropriate level of difficulty for the students to be taught.

4. They should be understandable to teachers having little art training.

An example of the way organizing ideas were used is the activity in which a Boccioni painting was explored and discussed by students. The concepts were "Artists use a variety of visual devices which violate viewer expectations of pictorial representation. Such devices may puzzle, startle and surprise the viewer, causing him to notice for the first time new aspects of reality and experience."

In this activity, the fifth-grade child is confronted with a painting that represents an ambiguous visual configuration, such as *Dynamism of a Cyclist* by Umberto Boccioni. The painting offers a richly textured surface composed of subtly modulated areas of color: tints and tones of blue, yellow, orange, rose, and green. Although the title suggests the depiction of a man and a motorcycle, there is no distinct image of either. Instead, there are whirling masses of color and slashing curved and straight diagonally oriented linear elements. The pervasive quality of the configuration is one of sweeping motion, speed, and action. Forms are suggested, but the viewer must work to construct the Gestalt of man and machine. Light-hued circular areas in the lower corners could be rotating wheels of the cycle; the curve of a blue area in the upper center could be the sweep of the jacketed arm of the cyclist; other circular forms could be headlights; blue, yellow, and green areas could be tree forms, building facades, or patches of sky.

The child may be asked if he has ever seen a cyclist. What has he noticed as the cyclist rode by? Has he ever ridden on a motorcycle? How did it feel? What did he see as he sped by the passing landscape? The child's attention may be called to the texture and the circular and triangular forms of the painting. What do they make him think of? Can he find curved lines, straight lines? In what directions do they go? What do they do to the appearance of the painting? Its feeling? Does he think the painting shows movement or not? Why? Does it show some other things? What are they? What kinds of shapes can he find? What does he think the artist could be trying to show by using such shapes, lines? How does the painting make him feel?

Comparisons are made between the child's life experience with motion and speed, his expectations of representations of those sensations, and distorted, novel representations employed by Boccioni. Remarks may be recorded under headings and compared:

*What we expect to see in real life as we watch a motorcy-
clist*
*What the artist shows us in his painting that is unusual
or unexpected*
*What new things he makes us become aware of*

Ideas listed under the first heading give the child the opportunity to describe sensations and personal experiences. Ideas listed under the second heading require him to note characteristics of the painting and to grope for adequate descriptions of visual qualities. Ideas listed under the third heading require him to formulate metaphorical language, to interpret, and to voice evoked feelings and ideas.

Activities using the body as a sensing instrument—feeling body movements and interpreting them through the use of color and line— were used in conjunction with this discussion.

*Learning Activities:* Learning activities were selected and organized in terms of probability of their promoting the acquisition of new insights and ideas and the mastery of new skills—in short, those that would encourage students to perform at a higher level of proficiency.

Activities were sequenced so that students could first think in simple terms about concrete and specific facts and later engage in more complex thinking and reasoning processes. Activities were also selected on the basis of function: Some provided for the *intake* of information (observation, reading, listening); some facilitated the *organization of information* (such as drawing, diagramming, comparing, contrasting, categorizing); some provided the opportunity for the students to *demonstrate* what they had learned by stating perceptions, supporting opinions or judgments, evaluating several paintings or modeled performances according to certain criteria. Some activities provided the opportunity for the students to *express themselves* by creating a new interpretation of a painting or an original art product. Several activities were designed to promote *openness to and awareness of* physical sensations and inner imagery.

*Teaching Strategies:* The combination of procedures to be employed by the teachers in order to engage the students in learning were modeled, explained, and discussed with the participating teachers. Briefly, teachers were trained in techniques for establishing a nonthreatening instructional situation—one in which students would be encouraged to advance a great number of tentative ideas, so that a wide variety of perceptions could be evoked.

The use of questions was especially important, since it was the teacher's task to initiate and sustain discussion and promote observation, description or comparison, explanation or interpretation, and evaluation or judgment. Questions were used to develop the following critical skills:

1. *Focusing and scanning.* Questions to call attention to visual qualities; to *focus* on one aspect or to *scan* for a variety of them.

2. *Comparing and judging.* Questions to promote comparison and differentiation between qualities as presented in one or more paintings.

3. *Categorizing.* Questions to call attention to the need for organizing related concepts and classifying them together under a new heading; this promoted the relation of ideas and the development of new vocabulary.

4. *Explaining conceptual connections.* Questions requiring the student to explain the connection between observations of qualities and interpretation, thus helping to organize separate observations into a meaningful whole—to observe further in order to fill in informational gaps not noted before.

5. *Generating alternatives.* Questions requiring students to generate alternative descriptions, interpretations, or evaluations to promote inductive reasoning, openness to a number of ideas, and flexibility and fluency in thinking.

6. *Searching for new information.* Questions to motivate students to search for additional information by perusing the painting again in the encounter or by searching in written materials. Students were encouraged to initiate their own questions about the painting or artist, which they researched further.

**Materials:** The materials for instruction and evaluation include the following:

1. *Teacher's manual.* The manual includes a rationale for the program, suggested teaching strategies, brief description of the phases of art criticism, description of

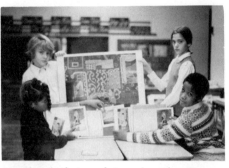

The Critic's Cards Game.

Learning Packets and Accompanying Reproductions

The object of the game is to develop color discrimination skills: to promote visual scanning of paintings for particular hues and values.

Playing the Find-a-Line Game.

By matching cards showing linear patterns of paintings with cards reproducing those paintings, the child focuses on the element of line as it functions as a compositional device. In a gamelike context, the child is exposed to a number of paintings of various styles, thus increasing the visual information store. Discrimination in color may also be attended to in the following types of matches: pairing different values of the same hue; pairing the same value of different hues; matching a value card with a painting card in which that particular value appears.

the category system used for describing and interpreting art forms, and detailed activity plans to be used with large groups.

2. *Learning packets.* The packets contain tape-recorded descriptions of paintings that point out various visual qualities, supply new art vocabulary, and furnish several models of the stages of art criticism. Most packets contain small reproductions of paintings; some contain worksheets. Children worked with the packets in groups of five or six. They could stop and start the tape whenever they wished to engage in discussion, writing, or drawing, as the occasion demanded.

3. *Art games.* These games are intended to provide practice for children in applying concepts of color, line, shape, texture, composition, and expressive qualities in a gamelike context. The games were introduced following small or large group lessons that dealt with the concepts to be practiced. Several children were introduced to the game by the teacher; these children then taught the others to play each game. Games could be played during free time and were a favorite pastime during lunch hour for some children.

4. *Art critic's dictionary.* The dictionary consists of four sections: one dealing with color, one with line, one with perspective, and one with biographical information about artists. In each of the first three sections, there are descriptions and explanations of various aspects of each of the concepts. The text is illustrated by color swatches, small colored reproductions, or line drawings.

5. *Visual materials.* These consist of original paintings and large and small reproductions of paintings. Large reproductions are mounted on cardboard so they can be displayed. Sufficient small reproductions printed on heavy paper are provided so that each child has his own to use as reference in discussions. Paintings used vary with respect to visual complexity and style of representation. Five types of paintings were used:

*Naturalistic.* Paintings that tend to be photographic or naturalistic, that emphasize literal reference to natural forms and human events.

*Seminaturalistic.* Paintings whose subject matter can be associated with natural forms, but whose style of representation is such that conventions of linear perspective or naturalistic size or color relationships have been somewhat distorted by the artist for expressive effect.

*Impressionistic.* Paintings whose forms are less sharply contoured than the first two categories and that emphasize different values of hues applied in small adjacent areas to delineate forms and create the illusion of light effects on forms.

*Surrealistic.* Paintings whose forms are either highly distorted or that make use of strange juxtapositions of shapes and colors; whose symbols are related to dreams or the unconscious, are highly metaphysical, and not easily decoded.

*Nonobjective.* Paintings whose forms and color configurations are not easily related to or inferred from literal reality; whose symbols are opaque, nonreferential.

**Evaluation:** Evaluation strategies were planned in a variety of ways and drew upon research practice in order to establish validity. Evaluation components were incorporated in each lesson—sometimes in the form of worksheets that students completed during discussions or during "treasure hunts" that involved touring the art gallery of a nearby university or an exhibit of paintings or reproductions set up in classrooms or a corridor in the school. The quality of remarks contributed by children in group discussions and in the small group activities was noted by the curriculum planner and the teachers. These notes guided the revision of future presentations so as to clarify certain concepts deemed important to the development of skills of art criticism.

Sometimes children were asked to draw certain attributes of paintings as a means of evaluating their perceptual discrimination. In one activity, children made use of "clues" printed on slips of paper to guide them to find objects in an exhibition. Their facility in finding the object sought and their questions as they continued their search gave us an indication of their ability to handle such concepts as texture, material, and facture. One of the art games included in the program served both as a teaching and an evaluative device, as it indicated the ability to discriminate differences in hue, value, and intensity. Another game provided feedback to both student and teacher about ability to discrimi-

nate line movement and pattern, and the interrelationships of shape in composition. Paintings, drawings, and collages produced in conjunction with some lessons also gave evidence of a child's ability to apply art concepts in his own work. (See the Visual Treasure Hunt described in Chapter 2 under the Museum Games Section.)

Children and teachers were interviewed during the course of the program about their reactions to the activities, and revisions were made on the basis of these interviews. At the end of the program, children and teachers were surveyed to evaluate their reactions to various activities and to the materials included.

Teachers' evaluations revealed frustration about the fact that they did not have enough time to conduct properly some of the activities included in the lessons; they felt the program would have been more effective if the children had had sufficient time to become more deeply engrossed in the discussions and related productive activities. Teachers also expressed concern that the spatial limitations of the school did not allow for sufficient privacy for children engaged in the small group activities to work undisturbed or without disturbing others. Apparently, the distractions of traffic moving through the room designated for small group activities interfered with students' concentration. With two exceptions, the teachers judged the lessons to be appropriate in form and content for the students involved.

Student evaluations revealed that more than half the students enjoyed most of the activities. The preferences tended toward short discussions and more active engagement in art activities related to the critical art concepts presented in the context of discussions. Not all the children had an opportunity to play all the art games; those who did play were in favor of the games about two to one. Less than a third of the children reported using the Art Critic's Dictionary. Those who used, but did not like it found that it "had too many hard words." (Apparently, the visual exemplars included in the book were not sufficiently powerful illustrations to convey the concepts to children of this age.) Children were evenly divided in their opinions about the small learning packets; those who disliked them found them confusing, difficult, and too long. The majority of students were enthusiastic about gallery and museum visits and judged the activities they engaged in while there to be exciting. A small number of children suggested that more such visits should have been included in the program.

The effectiveness of the program in promoting broader scanning of greater variety of visual qualities of paintings and the ability to describe the range of perceptions and feelings evoked in the experience was evaluated by performing a content analysis of the remarks of the children about paintings. All children were privately interviewed.

They were shown three paintings differing in visual complexity and style of representation. The first painting shown was naturalistic, the second surrealistic, and the third nonobjective in style. (Interviews were tape-recorded and later transcribed.)

Some interview questions elicited statements about perceived aspects of the painting and about feelings or associations evoked by what was seen. Interpretations of the meanings conveyed, as well as evaluations of the artistic merit of the work, were elicited by other questions. Children were asked to tell whether or not they liked each painting and to give reasons for their preferences. They were questioned further about the painting they selected as the one they preferred most.

Children's responses were coded from interview transcripts by trained judges. (The category system used in classifying responses proposes to code aesthetic discourse so as to take into account the major components of the painting and the phases of aesthetic inquiry through which the viewer proceeds as he comes to understand the painting and make judgments about its aesthetic value. The phases conceptualized following Feldman's discussion are description and analysis, interpretation, and evaluation.[8] Remarks are classified as predominantly descriptive, interpretive, and evaluative, according to the categories shown on the list that follows this discussion.)

As a group, children were also shown sixty paired slides of paintings, architecture, and a variety of other art forms. The test was adapted from the test instruments used by Irving Child, who has been investigating aesthetic sensitivity for over a decade.[9] Children selected the picture they "liked best" and marked their choices on an answer sheet.

A comparable group of fifth graders, who had not received instruction in Aesthetic Inquiry, were also interviewed and given the slide test. Their responses to both the testing situations were compared with those of the children who participated in the program of aesthetic inquiry.

*Summation of Data:*   Analysis of the interview data indicates the program was successful in modifying the patterns of attending to qualities of paintings and in increasing the ability to discuss them by referring to formal and expressive qualities. Children evidenced considerable changes in modes of perceiving and describing with respect to naturalistic and surrealistic paintings and slightly less striking changes with respect to the nonobjective painting. Trained children paid considerably more attention to textural and surface qualities; formal elements, such as line and shape; relations between complexes within the painting and organizing principles of the total visual configuration; expressive qualities of the parts of the painting and the pervasive quality of the whole. Trained children also paid more attention to the

subtleties of style and the materials used in the painting's construction than untrained children.

Trained children were *similar* to untrained children with respect to perception and description of color, space, and depicted objects or events. Training was not effective in increasing knowledge of type of art form or historical or cultural information relevant to particular paintings. (Since training did not emphasize these aspects as much as the skills of attending, describing, and interpreting, this finding is not surprising.)

Data related to interpretation suggest that trained children are more able to give diverse interpretations of paintings but are not necessarily more skilled at interpreting paintings through the use of metaphor or at supporting their interpretations by referring to expressive or formal qualities than are untrained children.

Data related to evaluation and judgment suggest that the trained children do not differ from untrained children in their ability to generate diverse judgments and evaluations. Trained children do, however, support preferences and evaluations by referring to technical aspects and expressive attributes of paintings more frequently than do untrained children.

Several explanations could be advanced for the fact that there was less difference in interpretive and judgmental performances between groups than in descriptive performance. These explanations relate to (1) the development of cognition as a function of maturation, (2) the influence of language on perception and inference, (3) the optimum length of time necessary for the acquisition and integration of the complex of abilities involved in interpretation and judgment, and (4) the effect of general life experience on providing a reservoir of associations that an individual may use in interpreting or construing meaning in an encounter with paintings.

With regard to the first aspect—the development of cognition—it should be noted that the children participating are just entering the stage of formal operations described by Piaget. The ability to think hypothetically and deductively develops over a period of several years, becoming fully functional in most individuals during the thirteenth year. Thus, the cognitive operations necessary to engage in sophisticated interpretations and the making of judgments are just beginning to be integrated in children of this age. Perhaps these children are not able to profit from the instruction offered, since they are not cognitively equipped to deal with information in a manner conducive to sophisticated inference and judgment.

The influence of language on perception, the ability to formulate and express ideas, and the length of the instructional program are

interrelated. It is possible that a year-long program—with additional opportunities for the acquisition of concepts and vocabulary, and the opportunity to observe and practice relating descriptions to interpretations and evaluations—would improve interpretive-judgmental performance.

The role of life experience outside the formal educational setting as a contributing factor to the ability to make rich interpretations is not within the control of the educator. Nevertheless, it needs to be considered as a dimension that contributes to interpretive performance by the children who engaged in the program described here.

The program was not significantly effective in altering children's preferences for particular painting styles. Trained children continued to prefer naturalistic paintings most, surrealistic paintings next, and nonobjective paintings least.

Training did not increase the preference for works of high aesthetic quality, *as measured by the testing instrument used* (the Child Aesthetic Preference slide test). However, it must be noted that, due to color distortions, size reduction, loss of detail, and other transformations in the visual character of art works through the use of slide reproductions of them, the results of this test cannot be taken too seriously. Again, the program did not emphasize a great amount of historical information, although some was provided for certain lessons. Thus, these children did not bring to the slide test sufficient familiarity with the historical associations that would have enabled them to agree with the expert opinion used to validate the test items.

---

**Review of Teacher and Student Behavior Promoted in the Activities in the Program of Aesthetic Inquiry**

*Teacher Behavior (or behavior modeled in the individualized taped lessons)*

1. Provides visual exemplars as basis for discussion.
2. Paces the presentation of information to ensure increments the student is capable of mastering during each episode.
3. Establishes a non-threatening climate that encourages the student to generate and verbalize ideas freely:
   * acknowledges uncertainty by stating, "I don't know but perhaps we can find out if . . ."
   * accepts all ideas offered in a nonjudgmental way.

*Student Behavior*

1. Attends:
   * focuses on relevant attributes of the painting.
   * scans one or more paintings in terms of particular attributes.
   * attends to evoked feelings and images.
   * scans memory for relevant information
   * attends to teacher statements and questions.
2. Makes statements:
   * analyzes qualities and relationships which contribute to the total quality of the work.

- depersonalizes ideas by listing, or by other means that ensure anonymity to their authors.
4. Models:
   - the expression of warranted uncertainty.
   - the skills of art criticism.
   - the alternative interpretations of paintings that illustrate different styles and levels of criticism.
   - information search strategies.
5. Makes statements:
   - supplies information and vocabulary.
   - makes explicit statements encouraging cooperative efforts in searching for relevant information.
   - suggests strategies of search.
   - elaborates student comments.
   - encourages students to attend to and express evoked personal feelings and images.
   - encourages students to initiate questions about things they don't understand.
6. Gives feedback and reinforces desired behaviors:
   - praises careful scanning of visual qualities; astute comparisons; apt descriptions; thoughtful evaluations.
   - praises the generation of alternative descriptions, interpretations, and evaluations.
   - praises search for more information from a variety of sources.
   - praises the expression of personal feelings evoked by the painting.
   - praises the use of metaphorical language to relate what is observed to what is interpreted.
7. Questions:
   - to focus attention on specific attributes of paintings.
   - to promote scanning for visual, formal qualities.
   - to promote comparing and judging.
   - to promote scanning of memory for relevant information.
   - to promote categorizing of attributes noted into relevant aesthetic categories.

- compares exemplars: i.e., compares different aesthetic qualities or compares alternative descriptions, interpretations, or evaluations.
- generates alternative descriptions, interpretations, or evaluations.
- evaluates the merit of the work, stating criteria.
- evaluates the merit of proposed alternative descriptions, interpretations, and evaluations in light of pictorial evidence, accumulated knowledge.
- explains conceptual connections between what is observed and what is inferred.
- categorizes related attributes or qualities.
- states preferences and gives supporting evidence for them.
- expresses evoked feelings.
- describes evoked images.
3. Initiates questions about qualities of the painting or about the validity of opinions expressed.
4. Searches for information about artists' paintings in books and other written materials.
5. Responds to environment created to induce imagery:
   - relaxes muscles, breathes deeply, slowly, rhythmically.
   - follows suggestions for guided imagery.
   - guides train of own imagery (responds to motivating imagery suggested by leader).
   - relates stream of imagery to group, or paints, draws evoked imagery if desires to do so.

- to promote the explanation of conceptual connections between what is observed and what is inferred.
- to promote the generation of alternative descriptions, interpretations,and evaluations.
- to promote information search.
- to challenge, probe, or prompt the student to express his ideas more clearly and fully.

8. Leads group in relaxation and imaging exercises:
- arranges physical environment so students may stretch out on floor without touching each other.
- induces relaxation by verbally directing tensing and relaxing of muscles; suggesting slow, rhythmic breathing.
- induces guided imaging by reading or describing (in relaxed tone of voice) a series of changing images.
- induces unguided imagery by describing train of images from which individual students may depart in alternative directions.
- sits quietly relaxed while students follow own imagery.
- suggests students who desire to may share their imagery with others by descriving, painting, drawing, etc.

---

In summary, the program appeared to be effective in increasing the range and scope of the visual qualities attended to and described. Thus, what one may call the first level of critical skills was developed in these children. The more complex skills of connoisseurship—such as interpretation, evaluation, and justifying aesthetic judgments by reference to visual qualities—apparently need more time than was provided for their development and integration into the preadolescent's repertoire of behaviors. Nonetheless, the results of this program suggest that children are capable of benefiting from a series of experiences in the critical domain. If critical experiences were integrated into art programs over an extended period of time, the promise of developing the capacity for aesthetic response is great.

## Museum Projects in Art Appreciation

For the past decade, museums have been attempting to eradicate their elitist image by developing closer liaisons with their communities. This has meant—among other things—devising programs that would invite, rather than merely permit, large groups of schoolchildren to their premises. The Metropolitan Museum of Art in New York City is currently offering a number of programs that use its impressive resources in a variety of ways. The programs we describe were selected because of the differing philosophies they represent. While both offerings are directed at secondary schools, the techniques they employ are appropriate for the elementary level of instruction.

   *Arts Awareness Project:*   This program was financed primarily by the National Endowment for the Arts and is designed around multi-

**Students in New York's Metropolitan Museum of Art participate in movement exercises related to a sculpture exhibit.**

© Karen Gilborn

© Karen Gilborn

sensory nonverbal responses to art objects.[10] The instructional staff consisted of specialists not only in studio art and art history but also in music, movement, photography, and video. Each teacher devised some means of relating to the art works through his or her own discipline. Bernard Friedberg described the process as follows:

> *The central theme of Arts Awareness, around which the teaching method was developed, is that certain aesthetic qualities are common to all the arts—such things as texture, line, space, structure, color and mood—and that these qualities are translatable from one art form to another.*
>
> *As a simplified example, a curved line drawn on a sheet of paper can be observed in a similar curve in a piece of sculpture, or heard in a melodic line of music, or felt in a body movement in the dance. Through this consideration of line from many vantage points and from attempting to express the characteristics of a line in many different forms, the student actively confronts the abstract concept of line. In this interrelation of artistic forms the student begins to see and relate in a new way to the shapes, movements and structures in his daily life. Activities were devised to lead the student toward a perception of increasingly complex combinations of artistic elements and to encourage a response, an understanding through action (often non-verbal), to visual and other sensory stimuli through taking pictures, playing various simple musical instruments, painting and dancing.*
>
> *As an exercise in line and motion, students were asked to observe a statue in the Greek sculpture gallery, walk around it, and stopping at three different angles, to draw with one sweep the line of motion perceived at each angle. They then took one of their sketched lines, visualized its shape and walked it on the floor, slowly at first, then more rapidly, then at varying speeds. Students were then asked to create the same line with hand motions as they moved about the floor. Two or more students then moved about using their lines as guides and a series of dance movements emerged.*
>
> *In a second dance exercise, using the already sketched motion lines, students were asked to visualize the line in the air. Then, starting with the hand, to trace the line in the air using broad, sweeping motions. The leg and the torso were then used to trace the same line and extend it in the air until it was past the normal reach, causing a body movement to continue the line. Jennifer Muller described what she was attempting: "By body movement, with each student responsible for his own perception and creation of a visualized line, I hoped to show non-verbally that sculpture comes from real life and that each movement made by an individual is, in a sense, a piece of sculpture."*

Every arts team made its own plan, which was consistent with the central philosophy of the program—that is, that certain properties are

shared by *all* of the arts and enjoy transferable relationships. An example of how the Visual Arts team prepared its sequence of activities follows:

VISUAL ACTIVITIES

> *Goal: To create an awareness in students of the expressive qualities, as well as limitations, of form and line.*
> *Materials: Strong light source, large sketch pad or blackboard, drawing materials.*
> *Location: Classroom and galleries containing line drawings of figures, ideally Greek vases, Egyptian painting, or porcelain.*
> *Directions: After a warm-up that has students use nonverbal gestures to communicate feelings to one another, have them stand in such a way that they cast shadows (forms). First suggest specific ideas—such as friendship, mother-child love, anger—for them to convey by moving their shadow silhouettes. Then have them think of their own feelings to express, and have others in the group—looking only at the shadows—guess what is being portrayed.*
> *Using either a blackboard or sketch pad, the teacher should draw a line of any sort and ask what the students think it "means."* Get someone to alter the line to change its "meaning." *Next, students should draw a line that indicates direction, agitation, or suspension, then things like sadness or fun.*
> *Proceed to a gallery and look at art for what form and line communicate together.* Have students imitate figures in works of art, both pose and expression, then alter their tableaus by changing the energy level or emotional qualities.

The approach used by the Arts Awareness project bears a close relationship to that used by Lowry Burgess in his lesson, Receiving Pictures, as described in the previous chapter. Both Burgess and Arts Awareness staff feel that art works can also be approached on a broad, sensory, nonverbal basis, that some direct form of physical and emotional response to an art work can provide the most effective sort of empathetic communication.

***The Cloisters:*** The Metropolitan Museum of Art's program offered at the Cloisters branch, where the museum building sets the stage for the students' arts activities, must also be mentioned.

Since the Cloisters is a reconstruction of a medieval environment, all activities are based upon this particular period in history. The atmosphere is as rich in its architectural setting as it is in the variety of artifacts housed within the ancient stone walls. The program utilizes community volunteers who work with local artists, and it reaches some

Students in the Cloisters' program (of the Metropolitan Museum of Art, New York) recreate a medieval pageant as a culminating activity of the program.

Students of Cloisters Program recreate a medieval pageant.

twenty-five schools within commuting distance of the museum. The workshop programs offered the children have taken many forms based upon the nature of the funding and have included summer programs, after-school programs, and activities that take the participants out of the school during the normal school schedule. While at the center, children engage in arts activities related to the medieval setting: One group may work in stained glass, another in cloisonné, and still another in book design. They may also study calligraphy, sculpture, weaving, and any other activity for which there are authentic models for easy reference. The Cloisters' approach to art appreciation may be said to be based upon a kind of environmental saturation effect wherein children empathize with an entire period through tasks of a historically authentic nature. It is also an avenue to social studies, which is made more effective through living with the making of historically based art objects in an atmosphere of authentic, live art of a particular period in history.

*The Contexts Gallery:* The Museum of Fine Arts in Boston, also through support from the National Endowment of the Arts, has developed its own visual laboratory for children entitled Contexts, with

Joan Brownstein as Gallery Coordinator. This area—really a minimuseum within the larger institution—is part participatory and accommodates large groups of children from any part of the state. The following statements of goals and three samples of presentations are taken from the Museum of Fine Arts publication describing Contexts.

> *Contexts* is a new gallery that has been developed to provide students with an opportunity to experiment with visual thinking. It is a space in which certain physical elements can be manipulated and studied for their relationship to the individual, to objects, and to the environment itself.
>
> *Contexts* conveys information through three types of related but different experiences:
>
> 1. It presents original works of art from the museum's collections in some kind of context, whether historical, stylistic, or purely associative. Each object is accompanied by a slide-tape, a film, or photographs in order to emphasize certain aspects of the work. Since the way we see our environment today is stressed here, specific historical or bibliographical knowledge about an object is comparatively less important. That is why there are no traditional labels or taped lectures here. Similar objects presented in a different context can be found in the collections of the museum.
>
> 2. It presents physical situations in which light, a context of color, form, and space, can be manipulated. The information here relates both to the objects in the gallery and to the games which present ways of understanding one's responses to these elements.
>
> 3. Through visual games, specific aspects of light and color are explored. Color is seen having properties that are psychic, and thus relative, and optical, and thus scientific. Any color experience is a combination of these and many other contexts of color.

EXAMPLES OF EXHIBITS

### 1. UNTITLED SCULPTURE BY ALAN SONFIST

This sculpture is a seven and a half foot by six inch by six inch column of Plexiglass filled with natural crystals that change their geometric form in response to atmospheric temperature and pressure changes.

The sculpture is accompanied by a film on crystal growth, entitled *Microcosmos*, that was made by Bill Warriner at the Polaroid Corporation over a period of six weeks. In it, organic chemicals that were melted and then allowed to crystallize under a microscope were photographed through two polarized lenses that create the color changes seen in the film. The crystals grow at approximately their normal speed.

The Sonfist sculpture is an example of the use by a contemporary artist of the technical products of his age to make a poetic statement about the beauty of nature's patterns. He helps the viewer to be aware of the beauty of the constant transformations of our environment that are part of all natural processes. The work is constantly in a state of becoming something new. It is in fact a visual representation of movement, change, and time.

Additional contemporary sculpture can be found in the Sculpture Court of the museum, in the galleries, and inherent in nature.

### 2. *RED RYDER* BY JOHN CHAMBERLAIN

In this sculpture the ready-made form of the automobile is transformed into art. Chamberlain took a known form, the body and fenders of a car, and in the process of destroying this form, made us more aware of its original meaning and also created something new. It is our awareness of the different contexts in which this object has existed at different points in its history that makes it so interesting. Its beauty plus the fact that it is made of junk materials rather than the precious ones that sculpture is traditionally made from, makes one aware of the beauty inherent in the metallic, technological products of our age.

Light and color are important elements of his work. Chamberlain has taken hard, color-coated, automobile surfaces, and, by crushing and changing their form, made them to appear fragile and humanized. Their ability to reflect and refract light makes them tactile. As the hard, gaudy colors become softer in our vision, our responses to these materials change, too.

The slide-tapes that accompany *Red Ryder* stress both visual associations that it creates and some of its art historical contexts.

### 3. CYLINDER SEAL

The cylinder seal, made in Mesopotamia between 2300 and

2180 B.C., is engraved on black marble and incorporates into its design mythological subject matter intended to convey a story. The seal has a longitudinal hole in it through which a cord can be drawn or a metal pin inserted. With the pin inserted, it is possible to roll the seal over wet clay, impressing upon it the seal's continuous design.

## 4. LIGHT GAMES

The light games are an area in which students are presented with an opportunity to manipulate physically the lights in a particular area in order to explore light's function in the creation of form and in the definition of space.

Part of this area contains a platform, a white robe, flashlights, and wall lights. In this, a student can place himself, as sculpture in the round, upon the platform and, by changing the lighting situation in which he stands, dissolve or accentuate the relief in which the folds of the robe appear. The wall lights also present opportunities to try different lighting systems as in lighting an object from below or back-lighting it.

The creation of form is only one context of light. It is by light that space is defined. Light both fills a space and establishes its boundaries. Different types of light do this in different ways. Thus, multiple light-creation opportunities exist in these games. This area is related to the uses of light and color in all of the individual areas of the exhibition, but here they allow the greatest amount of physical, as opposed to purely perceptual, involvement with it.

## 5. *IN AND OUT OF CONTEXT* (COSTUME GAME) BY SUSAN MARTIN OF THE EDUCATION DEPARTMENT OF THE MUSEUM

The costume game is a participatory slide-tape that is used to present certain aspects of the problem of context and also to explore a particular discipline in different contexts.

Clothes are costumes and represent the individual's attempts to deal with both his physical and his psychological well-being. They portray the individual as he or she is and as he or she would like to be seen. They reflect the basic values and concerns of a society, and, as such, they play many roles, social, political, emotional, physical, and creative.

The game is a three-image slide-tape with music. The center screen of the game is placed so that, standing behind it, an

individual is placed within a particular costume and can see her- or himself in it and in relation to other contexts in which he or she and it could exist. The game presents ways of considering the other objects within the exhibition and in the rest of the museum.

### 6. *MEADOW AT GIVERNY, AUTUMN* BY CLAUDE MONET

This painting, done in the nineteenth century by the French Impressionist painter Claude Monet, presents one way of dealing with light and color in painting. As light is a major context of everything, he made it his primary subject. By disregarding actual color and, instead, studying the effects of atmospheric color and light on objects and the effects of colors on each other, he was able to create works that were literally filled with fresh air and sunshine.

Although there are many systems to explain and develop color sensitivities and perceptions, no one system ever adequately explains how we react to color. However, it is interesting that certain systems, developed in different ways, are used by different artists for highly diverse purposes. Monet's method of applying color, later seen in the pointillism of Seurat, is a technique that depends on optical color mixing. When two or more colors are seen simultaneously, they are seen combined, the result being a third color. The two original colors are replaced by a visual substitute.

Painting is not the only discipline that takes advantage of this particular combination of physical fact and psychic reaction. It is also used to produce a similar effect through grain structure in the films used for color photography. Color television also depends on a grid structure of colored dots to make up its image. In contemporary painting, this technique is also used in sprayed paintings.

Related experiments are done in the light games.

### 7. DOGON MASK

This painted wooden mask, loaned to the museum by Hans Guggenheim, is a Kanaga mask used in ritual dances by the young men of the Dogon tribe, who are one of the many different peoples of the modern African Nation of Mali. The music that accompanies the mask is that of the Kanaga dance, and the slides represent the making and use of this mask. Narration of

the slide-tape by Sandra Fury is optional. A second slide-tape showing different types of masks that people employ plays alternately with this slide-tape.

## NOTES

1. Stanley S. Madeja, *All the Arts for Every Child,* Report of the Arts in General Education Project (University City, Mo.: JDR 3rd Fund, 1973), pp. 33–36.

2. K. G. Pontus Hulten, *The Machine, as Seen at the End of the Mechanical Age* (New York: Museum of Modern Art, 1968).

3. Described in David Ecker, "Evaluating the Arts Curriculum: The Brookline Experience," *Art Education: Journal of the N.A.E.A.* (February 1974).

4. *Aesthetic Education: A Social and Individual Need* (St. Louis, Mo.: CEMREL, Inc., 1974).

5. The Aesthetic Education Program is published as *The Five Sense Store* by the Viking Press/Lincoln Center for the Performing Arts, New York.

6. Susanne K. Langer, *Mind: An Essay on Human Feeling* (Baltimore: Johns Hopkins Press, 1967), vol. 1, p. 87.

7. Ira Progoff, *The Symbolic and the Real* (New York: Julian Press, 1963) and Robert McKim, *Experiences in Visual Thinking* (New York: Brooks Cole, 1972).

8. Edmund Feldman, *Art as Image and Idea* (Englewood Cliffs, N.J.: Prentice-Hall, 1967), pp. 468–98.

9. Irvin Child, *A Study of Esthetic Judgment,* Cooperative Research Project no. 669 (New Haven, Conn.: Yale University, 1962); *Development of Sensitivity to Esthetic Values,* Cooperative Research Project no. 1748 (New Haven, Conn.: Yale University, 1964); and *Assessment of Affective Responses Conducive to Esthetic Sensitivity,* Final Report, Project no. 9-0029 (New Haven, Conn.: Yale University, January 1969).

10. Bernard Friedberg, *Arts Awareness: A Project of the Metropolitan Museum of Art* (New York: Metropolitan Museum of Art, 1973).

# 4 PLANNING FOR INSTRUCTION

In the previous chapters we described a number of techniques for teaching art appreciation. Most of these may be considered activities that can be built into units of instruction. The *activity* is defined by the student and the teacher in the classroom. The *unit* is a group of activities usually organized around a larger concept, theme, or idea that integrates the activities into a larger and longer-term outcome. The most difficult problem in teaching art appreciation is to make the activities, and the units into which they fit, interesting and exciting for the students. Most of the techniques currently used engage the student in dry, and sometimes dull and negative, experiences. From our experiences in the classroom and information from other teachers, an art appreciation program will not last very long, nor will the students have a continuing interest in the subject called art, if there is not some element of excitement—and, particularly at the elementary level, even play—to engage the students.

It should not be inferred that the teaching strategy of discourse or dialogue with students about the art object and its formal properties is a technique that should be abandoned. Rather, the instructional strategies and teaching techniques should be balanced so that various approaches are combined in a comprehensive art appreciation program.

The primary difference between studio art and art appreciation remains art appreciation's concentration on the aesthetic qualities of the art object rather than the learning process that produced it. Art appreciation, as we have seen, engages the student in studio activities, sensory exercises, and written or oral discourse about the qualities of

the object to enable the student to make more informed aesthetic judgments about the import of the object.

The activities that the student engages in are selected to meet these outcomes and should be varied. As we have seen, a diverse program may also include games, visits to museums and galleries, and some contact with working artists.

The main point is not to "throw the baby out with the bath water" so that the excitement of producing or creating a work of art is negated because we want to emphasize art appreciation. We do not question the validity of studio art courses. We want to provide students with the widest and best possible introduction to art. The previous chapter suggested some teaching techniques and processes that may assist the teacher in designing art appreciation units of instruction. The format and grade level are varied, and the purpose of this chapter is to show the diversity of approaches that can be used in designing instructional units and to suggest what type of content can be selected for the substantive base of the unit.

## INSTRUCTIONAL UNIT FORMATS

There could be a separate chapter arguing for and against a particular format for an instructional unit. We will not try to engage in that type of discourse, since we feel it to be a dead-end discussion. The formats that follow have been tested and found to work with elementary teachers and can provide a starting point for the developer. They may be combined or revised to fit the teacher's individual needs or abilities.

### The CEMREL Format

Within the Aesthetic Education Program, teaching materials have been developed for teachers at the elementary level. The format that has been developed for the teachers' guides is a useful one for conveying information to the user about the outcomes, activities, and content of the instructional unit.[1] Following is a brief description of the format.

A.  Introduction:   The first part of every unit will have an "introduction" with the following subdivisions:

    1.  A general description of the unit, which will include, along with a description of the content and organization of the unit, a narrative statement of the purpose and outcomes of the unit.

2. The instructional media to be used: such as films, slides, reproductions, comments about them.

3. Classroom management, including, if appropriate, notes on teaching strategies and management of additional activities.

B. In some cases it may be appropriate to divide the instruction in a unit into major "Parts" or subcomponents. Such materials would still have "Lessons" and "Activities" as defined below.

1. *Lesson Experience:* Groups of activities with a common *General Objective* of the lesson and a common *Concept.* This includes notes on organization of the lesson—that is, time required if this is crucial, additional activities, and so on. Lessons may be numbered and/or titled.

2. *Activity:* This defines what is to be carried out in the classroom—a discussion, painting a picture, creating a dance, or writing a story. A brief statement of the *concept* is included, unless this is one of a lesson's several activities that have a common concept. In other words, don't needlessly repeat a concept. It also provides a *general description* of the activity; this is a scenario of "what will happen during the activity."

3. *Materials* required for the activity.

4. *Classroom Management,* if necessary or desirable.

5. *Appraising the Activity*—what to look for, knowing when to move on, suggestions for testing for knowledge of vocabulary, and so on. This information may be in the activity directions if appropriate.

## Arts in General Education Format

An example of one format developed in the Arts in General Education Project in University City Schools follows. The lesson deals with Letter-form Collage.[2]

### Letterform Collage

Concept: Letterforms may be distorted and combined with

other letterforms to form an all-over, non-linear pattern.

Objective: The student will organize letterforms to communicate an image other than a literal one.

Number of students: thirty.

Time: two hours.

Materials:

Primary: Magazines, scissors, rubber cement, tablet block.

Secondary: BOOKS: *Basic Design: The Dynamics of Visual Form,* Maurice De Sausmarez (New York: Van Nostrand Reinhold, 1964).

*Design with Type,* Carl Dair (New York: University of Toronto Press, 1967). Excellent section on organization of space; creative use of letterforms.

*Elements of Design,* Donald M. Anderson (New York: Holt, Rinehart and Winston, 1967).

*Graphic Design: Visual Comparisons,* Alan Fletcher, et al. (New York: Van Nostrand Reinhold, 1967).

*Learning to See,* Kurt Rowland. Three volumes: *Pattern* (1968); *Movement* (1969); *Form* (1968) (New York: Van Nostrand Reinhold).

FILM: *Discovering Composition in Art,* color, 16 min., Bailey Film Associates, 11559 Santa Monica Blvd., Los Angeles, Cal. 90025. Illustrates center of interest, balance, rhythm, positive- and negative-space arrangement.

PRINTS:   Braque or Picasso collages from
          Cubist period; Robert Indiana's
          *American Dream;* Charles
          Demuth's *I Saw the Figure 5 in
          Gold;* Stuart Davis's *Odol;*
          Robert Rauschenberg's
          *Overdrive;* and Marsden
          Hartley's *Portrait of a German
          Officer.*

Related Studio Activity: Students cut up letterforms—words, letters, phrases, whole columns of words—to form a collage.

Limitations: Only black and white may be used. A picture is not to be formed; the abstract quality must be stressed.

Have the students bring in three magazines, preferably those with many advertisements. Provide the materials. Tell them to cut out words, letters, sentences, and think of them as black-and-white shapes. Find large ones, medium-size, and small groupings. The words and letters may be cut up or left whole. Tell the students that they will be making a collage and emphasize the importance of unity. Some means of achieving unity are: a point of interest or strong contrast, subtle transitions (that is, letting the white areas flow into white areas, the darks near other darks). Emphasize the need for variety and quiet areas. The students will discover that lines of small type form "grey" areas. An area of strong contrast can serve as a center of interest. Rhythm can be controlled by the direction displayed in arranging the rows of type. As a culminating activity have the students view works by artists who have used letterforms such as Robert Indiana, Picasso, Braque, Jasper Johns. Discuss the letter as shape and form and as subject matter for the artists.

Evaluation and Discussion: Display all the work when finished. Discuss the results in terms of unity, over-all pattern. Note how different the work looks from a distance. Discuss how parts are subordinated to the whole. Define the center of interest; how the eye moves around the work. If the work is unified, it should have the feeling of a weaving. That is, all parts belong to the totality.

### The Florida Format

Another possible format was created in an art curriculum development project supported by the State Department of Education in Florida

since 1971.[3] This project outlined goals, objectives, assessments, and procedures for art education. Initially, it concentrated on grade levels 9–12. In more recent projects, the program was extended to define goals, outcomes, and performance objectives for grades K–8. Within the context of this project, the format that developed for units of instruction was tied to the hierarchy of objectives designed by the project staff. The outcomes range from very general goals and learning outcomes to very specific performance objectives for a unit of instruction. The definitions given by the State Department of Education provide very specific guidelines for the statement of objectives and development of assessment and classroom strategies. Following are the format developed by the project and examples of each objective outcome by levels.

| | |
|---|---|
| Level: | 3–5 |
| Goal: | Perceive and respond to counters[*] in art. |
| Subject Goal: | Recognize and point out the surface counters, singly and in combination, in a work of art. |
| Objective: | The students will identify objects in works of art which have two or more meanings. |
| Performance Objective: | After discussing and studying symbols in works of art, and when shown a reproduction which has been studied (i.e., *The Young Girl* by Rousseau), the student will point out those objects which are symbols and tell what they mean (i.e., the little girl stands for growing up, the stones are obstacles she must overcome, the blue sky and sunshine show that she will probably grow up to be a strong person). |
| Assessment Item: | In *The Young Girl* by Rousseau, list those things that are symbols and tell what they mean. List at least four objects and their meanings. |
| Teaching Strategy: | Present concept: In many works of art, an object may have two meanings. For example, a white lily may be simply one of a number of flowers in a vase (a visual, concrete image) or it may also stand for purity (an abstract idea or quality). Students will be familiar with the concept of symbolic meaning because of its frequent occurrence in everyday life. Once the teacher has explained what a symbol is and given a few examples—love, faith, religion, hope, peace—students should be able to add a list of everyday symbols. |
| | When examining the reproductions for symbolic meaning, the first step is to ask the students to compile a list of objects that they see in whatever sample is being used. (This listing is the concrete, visual meaning.) Once the first listing is complete, the teacher may then suggest the corresponding symbolic meanings to those objects. (Not all objects in each sample contain this symbolic meaning.) |

| Resource/Reference: | Reproductions of art works which contain symbols. |
| | Examples: |

Resource/Reference:    Reproductions of art works which contain symbols.
                       Examples:    *The Young Girl*, Henri Rousseau
                                    *The Artist in His Studio*, Vermeer
                                    *Spring*, Roman fresco

Content:               A symbol is a visual image (object) which stands for an abstract
                       quality or idea such as the white lily representing purity or the
                       dove, peace. An allegory is a painting or story where a number
                       of symbols work together toward a completed symbolic meaning,
                       such as *The Artist in His Studio* by Vermeer, originally titled
                       *An Allegory of Fame*.

*A "counter" refers to forms that convey symbolic meaning in a work of art.

---

In comparing these formats there are some variations. It is obvious that the Florida format is much more detailed and precise than the other two. This format was not developed by art teachers, but by the State Department of Education as a standard for all instructional programs. It puts much more emphasis on specificity of language and behavioral objectives than the previous one.

Although the formats within the Aesthetic Education Program and the University City Project were developed by arts specialists to be used by all types of teachers, both formats were tested and revised by teachers who used them. In the Aesthetic Education Program and the University City formats, the content—what part of the subject is to be taught—is found in the statement of the concept, and the student outcome is the objective; whereas in the format used in the Florida project, the objective defines the content and the student outcome. Again, attempts to say which is better are futile, since each style has been used successfully in the schools. The teacher should use the format that is most appealing and useful. A more pertinent observation is that both methods attempt to answer the same questions for the teacher:

1.  What content (concepts) or subject is to be taught?

2.  How is it to be taught (instructional activities)?

3.  What are the learning outcomes for the student (objective)?

4.  How can the teacher tell if the instruction was successful (evaluation)?

5.  What resources and specific art works are needed for instruction (materials and media)?

Choosing the design of a format becomes a problem of how these questions can be answered so that the teacher understands the what and how of instruction and is able to carry out the instructional activities in the classroom. If you succeed on that level, your format is the best.

# DEVELOPING A UNIT OF INSTRUCTION

### Case Study: The Visual Artist

What follows is a description by Jerilyn Changar of the development process of a unit that uses the visual artist as content. In Chapter 3, a more thorough discussion of the unit in its final form was presented. This account by Ms. Changar describes how she formulated and answered the questions that are the basis for this unit of instruction.

> *In July of 1973, I joined the Aesthetic Education Program staff as curriculum developer in the visual arts. One of the first tasks assigned to me was development of The Visual Artist unit. This unit is one of a series titled "Aesthetics and the Artist." Other units in this series are The Choreographer, The Composer, The Actor, The Filmmaker, and The Writer: Poets, Storytellers, and Playwrights. The unit on The Visual Artist is planned to make students aware that artists are individuals involved with everyday human concerns, to expose them and involve them with the process that artists go through in creating a work of art, to engage students in activities similar to those artists use in creating works of art, and to enable students to respond, react, and appreciate their own works of art and the works of others.*
>
> *Staff associates with special expertise in their fields are available to assist the program's curriculum developers in the conception and formulation of the units of instruction. My staff associate is Professor Reid Hastie. A distinguished painter and art educator, he has had extensive experience teaching art on both the elementary and the university levels. I visited him in Texas, where he is currently professor of art at Texas Tech University, to try to find some direction for this unit. In the course of the conversation, Dr. Hastie and I talked about visual perception and how different people perceive their environments. I said, "What is it about an artist that makes him different from other people? Is it the way he sees, or how does an artist start to see things differently from anyone else?"*
>
> *In response, Dr. Hastie referred to the four levels of perception established by Ralph Pearson[4] which he [Hastie] described in his book* Encounters with Art.[5] *These are practical vision, curious vision, imaginative vision, and aesthetic vision. Dr. Hastie's feeling is that most people stop with the identification*

and the function of objects. The artist, on the other hand, will usually go the full route and describe what he sees in many, many different ways.

My thought was, "Maybe this is where we have to start with this kind of unit." We began to talk about that. Then we also explored approaching the materials through what the artist sees and experiences, and how he gets his ideas. We talked about how the artist organizes his thinking and how he goes about the decision-making process.

From questions of this kind, I was led to experiment with some ideas. As I tried to pull together different activities, I decided I wasn't going to go further until I actually found out what the kids wanted to know. So I went into the schools and I asked children, "What is the first thing you think of when you hear the terms 'visual artist' or 'artist'?" Their answers were very simple—things like paint and brushes.

I asked, "What if you had the chance to spend a whole day with a visual artist, in his home talking with him? What if you could ask him anything you wanted? What kinds of things would you ask?"

Some of the questions children asked were: "How did you become an artist? When do you retire? Is it fun? Who discovered your talent? Did you ever want to be something else? Who taught you how to draw?" I noticed that their questions were always formulated with the pronoun "he." Does he enjoy being an artist? Was he ever stuck for ideas? Why did he decide to become a painter?

The children's ideas of visual artists were obviously based on "he" and "painter." It was clear that one objective of any set of materials about the visual artist would be to broaden the children's ideas of who might be a visual artist and what media this person might work with.

The children asked questions about subject matter which really had to do with the artist's ideas. Most of the questions related to where he gets ideas. There were a lot of questions about what he likes to paint. Does he like to paint still lifes? Does he ever copy things? Does he like to paint the day or the night? Does he paint designs?

There were still other kinds of questions: How much money does he get? How much does his painting cost? Does he sell it or give it to an art museum? Will it go to a fair? Does he go to fairs and sketch people and sell his pictures for money? Does he have anything in the Art Institute? What museum does he like best? Does he like other artists?

There were questions about the artist's personal life: Does he like to travel a lot? Does he get crank calls? Where is his family from? One question that was just fantastic was "Does he ever do paintings to cover safes?" That seemed to come from all the television mystery programs in which every safe is covered by a painting.

The majority of the questions were very spontaneous, such as "Do most of the artists still wear those funny caps?" A lot of

these questions were repeated again and again as I talked with different groups of students. Finally, someone said, "What if it is not a he? What if it is a she?" That came out when someone asked, "Does he have a wife?" Then some child thought, "Well, does she paint too?" They also asked, "Do you think his children will become artists? Does he have any children?"

I went back to my desk and made an outline of the questions and put them into categories. The categories were: An Artist as a Person, His or Her Decision to Become an Artist, Where He or She Lives, Where He or She Comes From, His or Her Lifestyle, Where He or She Gets His or Her Ideas, What Interests Him or Her Outside of His or Her Work, How He or She Goes About His or Her Work, What His or Her Work Looks Like, What Happens to It Upon Completion, His or Her Attitudes towards His or Her Own Work. I set up interviews with four artists and sent a set of these questions to each of the artists before we met. The four artists were Robert Indiana, Richard Hunt, Marisol Escobar, and George Segal. I said, "I do not expect you to answer every one of these questions, but I want you to tell us about the things the kids are interested in. This is the kind of language that children who are nine and a half to eleven years old use."

I had had a good idea where the emphasis of the unit was to be, and my interviews with the artists confirmed my feelings. The unit would focus on where artists get their ideas and how they go about making decisions. These were the strongest areas on which to concentrate for two reasons. First, a majority of the students' questions fell into these areas. Second, concentration on these two points would help the students to become better acquainted with the creative process through which the artist works. The method I devised for involving the kids with this process was through activities in which they look first at their own perceptions of things and see how observant they are. Then, they look into where the artist gets his ideas and where they get their own ideas. Throughout the materials, I have them constantly looking at art works in relationship to their own involvement. Finally, in the concluding part of the unit, I have them look at art works in relationship to the things that people think about them: How do we feel about the art works? Do they make us all feel the same?

The children make their own artist's book, examining the same kinds of questions about themselves that were asked of the artists. For instance, a child might say, "I am so and so, I live here, this is my family, here is where I got my ideas for my art work, etc." They put their work and this personal material together in a simple book, which they would share with their family and friends. I also suggest that the teacher bring the parents in for an artists' day or something similar.

I based my selections of the artists and materials to be featured in the unit on the kind of things we wanted to get across to the kids. What I wanted was to get the children as close to the artists as possible. I wanted the artists to speak directly

*to the children and describe the sources of their ideas and how they chose to express these ideas through their particular media. I talked with other staff members about visiting artists in their studios. We asked ourselves how we could do this without a film, how we could still facilitate the children's feeling as close as possible to the artists' without the real experience. We thought that photographs and a tape would permit the children to hear the actual artist's voice, not someone reading for them. We also decided on a book to accompany the tape and photographs.*

Richard Hunt at work on a piece of sculpture.

View of Richard Hunt's studio with the sculptor's work in the background.

*The book is titled* A Special Place *because all the artists talk about special places. All of their studios are very special places. They were all something else before they became artists' studios. The children are told this at the beginning of the book. There is a shot of the museum and the question: "Did you ever wonder about these things whenever you looked at an art work?" Then there is a whole section of the kids' questions. Then the children are asked, "Did you ever want to go to an artist's studio?" The children turn the pages and go into an artist's studio via photos. They read each artist's statements and*

hear each on tape. The students complete the material about one artist and are asked questions like, "Well, we visited one person, what do you think?" Then the students continue in the book to visit someone else. The same process is repeated. The material in the book keeps building.

The book is written in the first person. For example, the artist says, "I first decided to become an artist when I was five or six years old." The book shows his work when he was five or six years old. "I told my mother and father I wanted to be an artist. I made this kind of decision. I was always drawing, etc." Then the artist says, "I got my ideas from here." In the book, a child sees the things described. The statements for the book are taken from the tape, and they are in large typeface throughout the book.

At this time, the unit concentrates on four artists, each providing a different point of view. We chose people whose work was not so deep that in trying to explain it, we would lose its essence. We chose artists whose works were visually stimulating to kids, whose work they could look at and immediately get something from, although there might have been a very long history and deep motivation behind the work. I wanted different artists, who got their ideas from different sources. I wanted people whose life-styles would not be outrageous, life-styles that the kids could deal with. I wanted people who had some feeling for kids. And I was also interested in having artists who worked full-time in their art form and made a reasonable living at it. With all this in mind, I did some research to find out if the artists I was considering ever taught, if they did other things that related to children, what they felt about doing something with children.

Each artist I selected met my criteria and was tremendously helpful. The symbols represented in Robert Indiana's work were easily communicated to the students. Even though the subtleties of the work were beyond them, the students could identify and enjoy the images and relate to some of their sources. Robert Indiana lives in a loft in New York. The loft is visually exciting and seemed to be something a child would be stimulated by. Indiana was very interesting, had taught children for a short time, and had a real concern for their needs and their ability to relate to the material I was trying to present. Richard Hunt's work left a great deal to the students' imagination. The work was not so extreme that the children could not relate to it. His living space and work area were exciting. He also had worked with children and had worked with organizations that were involved in education. He was very cooperative and made every effort to relate his creative process to the students.

In the past I had taken students to the museum and had vivid recollections of their responses to George Segal's work. They were fascinated by the life-size plaster figures. Before selecting Segal, I had chosen one artist who represents his life and immediate environment in two-dimensional symbolism and another who deals in abstract, three-dimensional organic

forms. Both live in the heart of the big city. George Segal deals with ordinary human beings and their inner feelings. He lives on an old chicken farm in a totally different environment. Indiana lives alone. Hunt also lives alone, but was married and has a child. Segal lives with his wife and two children. Segal also has a real interest in what is happening in schools. He taught for several years and is very much aware of the lack of emphasis on the arts in the schools.

At this time, the unit is somewhat imbalanced, having three sculptors and one painter to represent the visual artist. The students, in their inquiry, however, seemed to think of artists almost strictly as painters; so I felt that it was important for them to see that there are many kinds of sculptors and that sculptors are also artists. I feel, too, that students do not have as many opportunities to see sculpture as they do paintings.

The whole process that I have described—the exploratory talk with Reid Hastie; the question sessions with children; my formulation of the package to focus on the creative process; my interviews with the selected artists—grew out of my concern to bring children as close as I could to what the visual artist is all about. The unit in its present form is the result of this process.

### Case Study: Pre-Columbian Ceramics

This unit on Pre-Columbian Ceramics was developed for use by fourth graders by Larry Winegar as part of an arts curriculum development project funded by the JDR 3rd Fund. Winegar is the Elementary Art Coordinator of Jefferson County Schools, Colorado. Following is a transcript of his description of how he developed the unit.

In preparing any unit, the success of the project depends largely on how well organized the unit is. Four major areas that I feel must be considered are: techniques, media, subject matter, and resources. In this case, the technique which I introduced was slab construction pottery. The media we worked with were stoneware clay, slips, and underglazes. The subject matter was human forms based on an introduction to Pre-Columbian pottery. My resources were the Denver Art Museum; Robert J. Stroessner, Curator of New World Department at the Denver Art Museum; Lester B. Bridaham, an art historian; the Kahlua Collection; and books on Pre-Columbian art.

When I found out that I would be working with fourth-grade students from Tanglewood Elementary on slab pottery, I thought that an introduction to the Pre-Columbian pottery would lend itself to this unit. I am not an art historian, so my knowledge of this area is limited. Realizing this, I decided to sit in on a lecture on Pre-Columbian pots given by a staff member of the Denver Art Museum. Afterward, I talked with the speaker about what I would be doing and how I would like to use Pre-Columbian art as a basis for a slab pottery unit. I also

*talked with an art historian who gave me insights into the culture and habits of these people. He provided me with slides and black-and-white prints for examples. With this information, I returned to the district Instructional Materials Center and browsed through some books.*

*When I met with the kids, the first thing I did was show them all the examples I had of Pre-Columbian pottery and asked them what they noticed about this pottery compared to pottery that we commonly see. They immediately recognized the relationship of all the pots to the human form. We began to talk about the culture of the people in this era and why they did what they did. I felt that if they could see how one culture of people used clay, they might get some ideas about possibilities with clay.*

*While looking at the slides, we began talking about how these pots started out being just functional pots to hold liquids, burn incense, etc. From this basic form, the people began to add texture and appendages to the form to give it a more decorative quality and even a symbolic use. It is from this approach that we began to understand why the figures are not true, realistic reproductions of the human form. The approach is quite different from the approach sculptors, such as Michelangelo, would use. The students began to understand that the form which they thought was "corny" and primitive looking was actually intended to be that way.*

*We began talking about the technical problems these people had in creating these forms:*

1. How to attach two pieces of clay and have them remain together through the drying and the firing.

2. How to prevent the clay from breaking or cracking because of different thicknesses of the clay.

3. How to keep the clay from drying out too rapidly.

4. Learning what the limitations of clay are.

**A fourth grader's interpretation of Pre-Columbian design concepts.**

One student wanted to do an Indian with a bow and arrow. We talked about the difficulty of rolling a coil of clay out thin enough to make a bow and arrow and, with this material, how it would probably break in either shrinking, firing, or handling. The student began to understand what the limitations of clay are and how media dictate the design and form of a project. We looked at slides of Pre-Columbian pots of a warrior and saw that the weapon he was holding was a stocky, blunt instrument. It was a good example of the limitations of clay.

They now understood that they had to make the form compact in order to insure a low percentage of breakage. Most of the arms were connected in at least two places for strength—they were connected at the shoulder and then again with the hand on the body, head, or on some other part of the form.

Of all the slides we had, all but one were hollow forms connected to each other. The one that was solid gave us an insight in preventing a thick, solid piece of clay from breaking in the drying and firing process. The piece that was solid had been perforated with holes to allow a more even shrinkage rate. One of the students used this example when he constructed the arms for his pot. The body, head, and legs were all hollow; but the arms were solid because the diameter of the arms was so small that it was difficult to make them hollow. As a result, the student rolled a thick coil for the arms and stuck holes in the arms, not only creating an interesting texture, but fulfilling a functional need.

**An elementary student's creation of a woman based on Pre-Columbian culture.**

The students looked at what these people of the Pre-Columbian culture had chosen for their subject matter. There were self-portraits, ceremonial costumes, and warriors. These people had chosen themselves and their culture as the subject for their clay. We talked about how religious these people were, their belief in many gods, and their belief in human sacrifices to appease the gods. It has been recorded that in one year alone they had as many as 21,000 human sacrifices. We could then understand why they felt that the warrior was important. It takes a good army to round up 21,000 people a year for sacrificial offerings.

I explained some of the options the students would have in their projects. They could create a form resembling Pre-Columbian pottery, make a self-portrait as the people of this culture had done, or build something that they felt was important in our society.

I had the students do small sketches of their ideas and approved them before they started. The approval was only to double-check to see if their ideas were possible. However, I made some suggestions, as with the boy who wanted to do the bow and arrow. Some of the students chose to build pots resembling the Pre-Columbian examples. One girl chose to do a self-portrait, and one boy chose to do his interpretation of our mechanical society by creating an American Indian who looked like a machine.

Once their ideas were formed, we began working with the clay. I demonstrated the techniques of slab building to them, such as:

1. How thick to roll the clay.

2. How to make patterns so that all slab pieces will fit.

3. How to bond clay.

4. How to create a few examples of texture.

5. How to wrap their clay slabs around a pipe to form cylinders.

The students completed the work during the three-day workshop, and all of their pottery has been fired. A few pots were broken before firing and one broke during the firing. All the others are still intact and will be fired with a non-lead glaze.

I did not tell the students that Pre-Columbian art was the only kind of slab construction nor that it is necessarily the best kind, but that it is one kind of slab construction. By studying what these people did with clay, maybe we can get ideas on what we can do with clay. The same approach could be used with any culture—African, American Indian, Egyptian, etc. When students have this type of introduction to a unit, they have a better understanding of the material they are working

*with, the limitations and possibilities of that material, and have ideas and examples from which they can create their own work.*

These two case studies show how two art-teachers-turned-curriculum-developers went about developing their own units of instruction. The art appreciation component of each unit differs. In the Visual Artist unit, "the artist" is used as the subject and the student gains appreciation of the artist, the way he works, and what he produces through firsthand information about four contemporary artists, all of whom have differing points of view about the same questions. The Pre-Columbian unit develops an appreciation of the object—in this case, Pre-Columbian sculpture—by having the student utilize the same design concepts employed by the artists and by working in the same materials. Each person used a different sequence of steps to reach the same end: a unit of instruction in art appreciation. Each developer had to attend to the following:

1. The selection of the content to be taught. What concepts, historical facts or information, subject matter are to be taught?

2. The designing of sample instructional activities and trying them in the classroom; revising them on the basis of personal teaching experience.

3. The selection of an organizer or way of relating the activities. This can be accomplished in a number of ways: by the subject matter/content chosen (as in the Pre-Columbian unit), or by using a theme (as in the unit on the Visual Artist).

4. The statement of the lesson objectives and relating the activities to them.

5. The identification or designing of support materials such as films, slides, reproductions, or art objects.

6. The designing of the evaluation techniques or strategies.

## DESIGNING MATERIALS

In reading the text so far, you have undoubtedly come across good ideas that can be used for classroom activities. However, a key element in a

good art appreciation program is access to good reproductions of art objects. We would like to suggest that you may design your own materials for art appreciation. Think about some of the following ideas to get started.

If you cannot afford to purchase many reproductions on your school budget, there are some methods for making your own reproductions that you can use. Photographs in magazines of works of art that have good reproduction quality make low-cost reproductions. They can be mounted on cardboard through the use of a dry mounting press. If a dry mounting press is not available, a regular hand iron will do. The tissues for mounting can be purchased at any photographic store. For additional permanency the photograph can be laminated with a plastic film. Most large school systems have the equipment to do this. If yours does not, a printer can tell you where this can be done in your community.

Another method for obtaining reproductions is to photograph them yourself. Most teachers either have access to or own a 35 millimeter camera. Photographing works of art in your community is one way of starting a slide library. Most communities have works of art in private collections, galleries, museums, or in other public places that can be photographed. With the automatic 35 millimeter cameras of today, very little photographic knowledge is necessary to obtain a good-quality slide. A good photography book will give all the technical data needed to photograph works of art. Here is an important hint: When photographing paintings, try to fill the viewfinder so that none of the frame of the painting shows, even if small parts of the work are left out. This simple technique improves the quality of your slides immediately.

A third source for reproductions is a travel agency. Many travel agencies have travel posters representing works of art from different countries, and they are usually of good quality. Embassies and consulates also often have posters that contain pictures of works of art that are available for the asking.

Another resource that you can easily develop is an active file of ideas for the teaching of art appreciation. The file can be simply divided into three sections—the art object, the medium, and the artist—which can be used as starting points for teaching art appreciation. The activities in this text can also be a starting point, and others that you develop can be added. You could also list on each card the works of art that are available in your community.

A survey of community resources available for the teaching of art appreciation is another useful tool. This will relate the school art program directly to art appreciation and the works of art existing in the community. The availability of art resources in a community will vary. If you are in one of the larger urban areas, there are many valuable art

resources. However, every community has some potential. The art museum is, of course, the most logical place to start, but don't neglect the public library, the historical society, the courthouse, buildings that have architectural significance, or community art centers.

Museums are an excellent source of reasonably priced, high-quality reproductions. Postcards in particular can be used for a number of purposes, notably the creation of games as described in Chapter 2.

## EVALUATION

Techniques that answer the simple question "How is the student doing?" are important in any art appreciation activity. The general techniques suggested in the following examples depend upon the judgment of the teacher and sometimes the student. Assessment in this area is not an absolute science, yet it is not an impossible task. We have outlined five approaches to assessing student learning in art appreciation. The first uses the levels of visual learning discussed in Chapter 1, the second suggests techniques applicable to measuring the student's use of critical language, the third provides methods by which the teacher can assess the student's knowledge about art and his ability to make aesthetic judgments about works of art, the fourth discusses teacher self-evaluation techniques, and the fifth demonstrates some sample assessment measurements.

### Continuum of Visual Learning

The four levels of the continuum of visual learning that were discussed in Chapter 1—observation, description of visual relationships, selectivity, and generalization of form—are categories for assessment of the students' perception of the art object. That these levels can be defined implies that there is an ordering of the visual learning process. If a student is able only to observe the art object without any intellectualization, there is minimal understanding and cognition. However, if there is evidence that the student is recognizing and describing relationships between the art object and its formal qualities or between the art object and its setting, this indicates a higher level of understanding and means that the student's perception involves more than simple recognition that the art object exists.

The four levels of the continuum can be used as a guide to student responses to works of art. What follows is a general description of the four levels so the teacher can categorize verbal and visual responses of the student.

## Observation

1. Simple recognition that the object exists and is in some way categorized by the student: "This is a painting."

2. A description of the subject matter in a factual manner with some mention of the formal properties of the work: "This painting is of a ranch in the southwestern part of the United States."
   Related to this is recognition of parts of the subject matter of the art object: "There are green trees, cattle, a horse, a ranch house, and ranchers in the painting."

3. Recognition of the visual qualities of the art object which the subject matter conveys: "The painter was able to establish strong feeling of depth in this watercolor by his use of contrasting colors."

## Description of Visual Relationships

1. A description of the visual relationship between one or more of the formal qualities within a work of art: "The shapes that were used in the painting are square. The artist created a controlled geometric pattern that was varied by the use of texture within the square." Here the relationship between shape and texture is established and mention is made of how they relate to one another in the art object.

2. A description of the relationship between the work of art and the context or setting in which it resides. This is based on the ability to comprehend the relationship between the whole of the visual field and some object within it. "The sculpture in the courtyard has a relationship to the structure because of the use of circular forms which are similar to those used throughout the building."

3. A description of the parts of the work and how they contribute to the whole work. This is the ability to establish the relationship between one or more of the art elements within the work and the whole work. "The use of line within Rouault's painting of *The Seated Clown* unifies the variety of colors used."

1.  The selection of parts of the work which can be
    considered dominant or distinctive qualities of a work
    of art. "The use of color by Turner made his paintings
    much different from those of his contemporaries" or
    "Moore's method of creating positive and negative
    space within his sculpture makes the form unique."

2.  Ordering the importance of parts of the work based on
    criteria and rationale: "Color in this painting acts as an
    accent and is not as important a unifying element as
    the thick black lines." A relationship is established
    between the elements in the work and a judgment is
    made as to their importance to the overall composition.

GENERALIZATION OF FORM

Recognition and description of the synthesis of visual
elements as they form the whole work of art. It implies the
ability to take unrelated visual phenomena, interrelate the
parts, and then develop a rationale for their synthesis. The
rationale may be based on recognition of the style in which
the work was executed, the period or school in which it was
created, or a combination of techniques, style, and period as
in this description of Rembrandt's *The Night Watch* by Jean
Leymarie: "With its amazing tensions and complex lines of
force, this picture is a summing-up of Rembrandt's Baroque
aspirations as defined by himself: to employ the (maximum)
of movement, movement of the most natural kind."[6]

Assessment of student progress through use of this continuum can
be implemented by a simple record-keeping system developed by the
teacher. Such a system is applicable to students at the intermediate
level who can give the teacher verbal and/or written responses at the
four levels indicated. The teacher should develop tasks that give him
or her an opportunity to assess the student's ability to describe and
recognize various elements within the works of art. These can be both
written and oral, and the teacher should analyze each student's re-
sponses, using the continuum as a guide. This analysis shows when the
student is giving a more sophisticated response to the work, making
generalizations about formal qualities.

The teacher may record the students' responses on a simple check-
list or collect oral and written responses from each student. This kind
of record keeping will help the teacher determine the students'
progress over time.

**Sample Art Appreciation Checklist**

| | Cannot Accomplish Task | Shows Some Understanding of Task | Comprehends Task and Is Able to Do It |
|---|---|---|---|
| **Observation** | | | |
| 1. The student can categorize the work as a painting, sculpture, drawing, etc. | ———— | ———— | ———— |
| 2. The student can describe the subject matter and list its formal properties. | ———— | ———— | ———— |
| 3. The student can describe the parts of the subject matter of the work of art. | ———— | ———— | ———— |
| 4. The student identifies the visual qualities that the subject of the work of art conveys. | ———— | ———— | ———— |
| **Description of Visual Relationships** | | | |
| 1. The student is able to describe the relationship between the formal qualities of a work of art. | ———— | ———— | ———— |
| 2. The student is able to determine the relationship between the work of art and the setting in which it is placed. | ———— | ———— | ———— |
| 3. The student can describe the relationship between the whole work of art and the dominant art elements within it. | ———— | ———— | ———— |
| **Selectivity** | | | |
| 1. The student is able to select and identify the dominant and distinctive qualities of a work of art. | ———— | ———— | ———— |
| 2. The student is able to select the important parts of a work of art based on his own criteria or those of the scholar. | ———— | ———— | ———— |
| 3. The student is able to order the elements of a work of art according to their importance to the total composition. | ———— | ———— | ———— |

Generalization of Form

1. The student can combine or synthesize the visual elements in the whole work of art and state reasons for this synthesis.  _____    _____    _____

2. The student can recognize and give reasons for the synthesis of visual elements.  _____    _____    _____

## Critical Language

Another indicator of student progress in the art appreciation program that can be monitored by the teacher is development of a critical language. This should not be confined to simple memorization of terms but should include some recognition by the teacher of the student's use of new words that specifically relate to the formal qualities of works of art. If the student is using such words and phrases as line, color, texture, form, shape, linear quality, and surface quality of the work, he or she is developing the sophistication in language necessary to describe and analyze works of art. Simple techniques can be developed by the elementary teacher to give these kinds of indicators. Instruments and tests can be devised to help the teacher recognize the student's progress in this vocabulary development. One example is a recognition test based on the identification of elements or characteristics in slides or reproductions. This is a visual rather than a verbal assessment.

Another example of an instrument to build vocabulary is a notebook or card file to be kept by the student called "Words I Have Learned about Art" or "Words about Works of Art." This list-making process can be tied to collection by the student of reproductions of art works from magazines or newspapers and some verbal descriptions of the works. A minimal list of terms introduced by the teacher each year would be a helpful guide to match against the words that the student is using in his discourse and his card file. It is important that the words be put into the context of describing or talking about art works and that they not be learned just for the sake of vocabulary building. The easiest way to kill art appreciation is to reduce it to learning words about art without relating them to the works themselves.

Another, and very useful, way of assessing the student's development of a critical language is to introduce sorting or selection games with groups of paintings or works of art (similar to the Style Matching or Match the Boxes games described in Chapter 2), using the terms as criteria for sorting. In these games the students are asked to sort a set of paintings on the basis of given terms such as texture, shape, line, or

color. For example, the students would be asked to select works in which the artist has used line as the dominant compositional element in the work. The design of the sorting task can be determined by the teacher, or the designs suggested in Chapter 2 can be used. This kind of technique can become a simple quantitative method for assessing whether or not the student understands the terms within the context of a work of art. It also gives the teacher an opportunity to conduct discussions about the definitions of terms. A variation on the sorting technique is the design of simple matching tasks: matching the terms with works of art. The game format is a good one, and the student can display knowledge of the terms through his responses.

### Knowledge and Aesthetic Judgment

Related to assessing the development of critical language about art is the task of reassessing the student's knowledge about the works of art. This can be accomplished by evaluating the student's knowledge of the following areas:

1. Such simple facts as the title, the artist's name and the school or period in which the painting or work of art was created are, of course, the simplest level of knowledge.

2. The student's understanding of the historical development leading to the work of art and its place within the history of art.

3. The student's understanding of the period in which the work was created and his or her knowledge about the artist and the artist's relevance to the period.

4. The student's understanding of the social significance of the work and how the art work was affected by the times in which the artist lived and the period in which the work was created.

It should be cautioned here that because these are the simplest means of assessing art appreciation and because they become highly cognitive outcomes of an art appreciation program, they can end up being the only thing assessed. The teacher who restricts assessment of student learning to facts, names, and dates ignores the wider implications of a total art program and runs the risk of destroying the program's intent and excitement by confining learning experiences to what can be easily measured.

A more difficult area for assessment is the students' ability to make aesthetic judgments about the work. It is important in assessing the students' judgments about works of art to have them go beyond the "like and dislike" category of response. Students should be able to describe their response to a work of art and give reasons for their aesthetic judgments and then justify these judgments. Ecker used the following paradigm as a model for analysis of student responses:

> *X is a good painting for Y reason(s), but I don't like it.*
> *X is a good painting for Y reason(s), and I like it.*
> *X is a bad painting for Y reason(s), and I don't like it.*
> *X is a bad painting for Y reason(s), but I like it.*

These distinctions suggest the following teaching strategy, as already mentioned in Chapter 3: getting the students to report freely their feelings, attitudes, and immediate responses to works of art and, second, pointing out to the students that there are differences in how people respond to the same stimulus and that this is a consequence of different experiences and learning. Ecker outlines two other steps:

> *Get them to distinguish psychological reports which are true by virtue of their correspondence with psychological states, from value judgments which are true, or better justified, by virtue of arguments and supporting evidence. Finally, broaden their experiences with contemporary and historical works of art and develop their ability to justify their independent judgments of the merit of art objects, whether they initially happen to like them or dislike them.*[7]

This analysis has implications not only for teaching strategies, as Ecker suggests, but also for evaluation. The responses by the student should go beyond the "like-dislike" category to value judgments that are supported by arguments and data. The categorizing and recognition of the student's ability to go beyond the simple, first level of response is an important component of assessing student learning in this area. The teacher should develop simple ways to record student response in discussions and written work to show individual progress in this area. The goal for the student and the teacher would be to work toward, in Ecker's terms, "the students' ability to justify their independent judgments of the merit of art objects, whether or not they happen to like or dislike them."

### The Teacher as Self-Evaluator

In one way or another, most teachers evaluate what has taken place in their classrooms everyday. This kind of self-evaluation by teachers who

assess their performance on the basis of their own judgment is the first step in the evaluation of any program in education. It is essential to this type of evaluation that teachers set outcomes for what takes place in the classroom. They should be clearly defined and tangible enough to answer the question, "How am I doing?" The problem now becomes defining the outcomes for art appreciation lessons and activities.

The National Assessment of Educational Programs Project has outlined outcomes for art appreciation programs. The following listing of outcomes applicable to the elementary level is excerpted from its report, *The National Assessment of Educational Progress: Art Objectives*. [8] These outcomes are those that in the present authors' judgment relate specifically to the elementary level. The report categorizes the outcomes for the elementary level as follows:

PERCEIVING AND RESPONDING TO ASPECTS OF ART

(Aspects of art are defined here as sensory qualities of color, line, shape, and texture; compositional elements such as structure, space, design, balance, movement, placement, closure, contrast, and pattern; expressive qualities such as mood, feeling, and emotion; subject matter, including (1) objects, themes (the general subject of a work, i.e., landscape or battle scene), events, and ideas (general presymbolic meanings) and (2) symbols and allegories; and expressive content, which is a unique fusion of the foregoing aspects.)

To recognize and describe the subject matter elements of works of art by:

- *Identifying the objects in specific representational works of art.*

- *Describing how the treatment of objects in two or more specific representational works of art is similar or different.*

- *Identifying themes of specific works of art.*

- *Describing how the themes of two or more specific works of art are similar or different.*

- *Describing the main idea presented in a specific work of art.*

To go beyond the recognition of subject matter to the perception and description of formal qualities and expressive content (the combined effect of the subject matter and the specific visual form that characterizes a particular work of art) by:

- *Describing the characteristics of sensory qualities of works of art (that is, tell about colors, shapes, lines, and textures in a painting, building, photograph, etc.).*
- *Describing the differences between sensory qualities of two or more works of art.*
- *Describing the expressive character (feelings and moods) of works of art.*

VALUING ART AS AN IMPORTANT REALM OF HUMAN EXPERIENCE

To be affectively oriented toward art by:

- *Being openly expectant of enjoyment and enjoying experiencing works of art.*
- *Considering it important to experience works of art.*
- *Being emotionally responsive to the impact of works of art.*
- *Participating in activities related to art by:*

  Visiting art museums and attending exhibitions.
  Visiting school art displays.
  Looking at art in magazines and books.
  Observing aesthetic objects in natural and man-made environments.

To express reasonably sophisticated conceptions about and positive attitudes toward art and artists by:

- *Expressing positive attitudes toward art.*
- *Expressing positive attitudes toward the roles of the visual arts in our society.*
- *Having Empathy with artists.*
- *Having some knowledge of the visual arts in our society.*

KNOWING ABOUT ART (This category defines outcomes in the history of art.)

*To recognize major figures and works of art and understand their significance by:*

- *Recognizing well-known works of art.*
- *Telling why works of art are important or significant.*
- *Naming the artist who produced specific works of art.*

To recognize styles of art, understand the concept of style, and analyze works of art on the basis of style by:

- *Selecting from a group works of art of the same style.*

- *Explaining why two or more works of art are similar or different in style.*

To know the history of man's art activity and understand the relation of one style or period to other styles and periods by:

- *Ranking works of art in chronological order.*

- *Placing works of art in the time period in which they were produced.*

## MAKING AND JUSTIFYING JUDGMENTS ABOUT THE AESTHETIC MERIT AND QUALITY OF WORKS OF ART

(Statements of aesthetic quality are those that characterize the various aspects of a work of art, while statements of aesthetic merit are assertions about the degree of goodness or badness of the work. Justifications of aesthetic merit are based on criteria such as the degree to which the work is integrated and whether contact with the work results in a vivid and fused experience.)

To make and justify judgments about aesthetic merit by:

- *Judging a work of art to be good or bad.*

- *Giving reasons why a work of art has or does not have aesthetic merit.*

To make and justify judgments about aesthetic quality by:

- *Characterizing the aesthetic quality of works of art.*

- *Giving reasons why a work of art has a particular aesthetic quality.*

To apply specific criteria in judging works of art by:

- *Judging a work of art on the basis of whether its organization leads to feelings of pleasure or displeasure.*

- *Judging a work of art on the basis of how well its various aspects relate to each other.*

To know and understand criteria for making aesthetic judgments by:

- *Discriminating among statements containing adequate judgmental criteria and those containing inadequate criteria.*

- *Giving adequate reasons for stating that any work of art has aesthetic merit.*

**Techniques for Evaluation:**    There are a number of techniques that can be used by teachers to assess the effectiveness of instruction in their classrooms. The simplest method of teacher self-evaluation is to keep a log that systematically records happenings in the classroom. This is a record of the teacher's impression of individual lessons, student performance, and how well the objectives of the instructional programs are being met. Keeping a daily log is a time-consuming evaluation technique, but it is a cumulative account of day-to-day activities and provides a record of immediate reactions to the effectiveness of the instruction. This kind of information is very useful for improving teaching techniques and for revising units and lessons.

A teacher's log should answer the following questions:

1. What is the nature of teacher-student interaction in the classroom activities? How well are you, the teacher, communicating with the student?

2. Did you achieve the anticipated objectives for the lesson or unit?

3. What were the students' reactions to the classroom activities?

4. How effective was the mode of presenting information to students?

5. Did you find the students able to comprehend the content of the lesson or unit? Is there any need for revisions?

6. What is your overall impression of the activity, lesson, or unit? In your opinion, did it work? Why or why not?

A similar log can be kept on each student. Make a folder for each student at the beginning of the year to become a cumulative record of performance. Items for the student log include the following:

1. Student work such as writings, art work, recordings in audio or video, and photographs of their classroom accomplishments.

2. Teacher reaction to the student's performance on various tasks.

3. Records of the student's performance on controlled tasks or tests.

There are a number of controlled task techniques that can be used to assess student accomplishments over time. One is to administer a series of controlled tasks in arts criticism. These tasks can be given to the whole class at one time. For example:

1. A good beginning activity is based on presenting students with a reproduction of a painting, one that will generate classroom discussion. The task for the students is to write down all the words that they feel describe the painting and its content.

2. Two months later after a number of art activities have taken place, such as some of those described in this text, present the same painting and assign the same task. Compare the results. Judge the responses as to the number of words that were generated and the range of terms used. How many of these words identified an aesthetic quality of the object? How many terms identified an art element within the painting? There is no need for a statistical comparison, but, if the students are gaining some knowledge about the works themselves and an ability to describe and analyze them, it will show up in this simple exercise.

3. Asking the students to write a short essay about a given work is another means of assessing accomplishments. Again, do this more than once, and see if students' ability to talk about the same work of art improves. If the students have difficulty writing, have them dictate their responses into a tape recorder. Many of the games that are outlined in Chapter 2 can also be used in this way.

The purpose of keeping student logs or portfolios is not to quantify art appreciation but rather to have a means of judging the development of individual students over time on criteria such as knowledge of works

Simple essay question: "Here are two landscapes. One is more 'childlike' than the other. Can you describe other differences between the two?"

*New Hampshire Panorama* Dana Smith Gift of E. W. and B. C. Garbisch. Courtesy Museum of Fine Arts, Boston.

*Murietta's Retreat* Emil J. Kosa Charles Henry Hayden Fund. Courtesy Museum of Fine Arts, Boston.

of art, ability to describe the works using the language of visual arts, comprehension of the nuances of various works of art, and ability to establish visual relationships in works of art.

Another technique for objectively recording classroom activities is to ask someone else, a teacher or possibly a parent, to come in and observe and record what is happening. Many times teachers are so involved in the teaching process they are unable to discern objectively what is taking place in the classroom, and much of what is going on is missed or ignored. The purpose of the observation is not to assess how

well one is teaching, but whether or not one is meeting the objectives set for the classroom activity.

Observation can be made more formal through use of a checklist employed by the observer to evaluate student discussion of works of art and the extent to which the teacher is accomplishing his or her objectives. The observer should be someone the teacher trusts and works well with, because the process could be threatening to the teacher and intrusive in the classroom if it is not done correctly.

Videotape is a more sophisticated method for recording classroom activities. This method has been discussed in previous chapters as a way of evaluating student activities. It can also be an electronic observer in the classroom providing immediate feedback to the teacher, who can play back the classroom activities and analyze the content. Videotaping has an advantage over the participant-observer technique in that it records all that is happening, not just impressions, and the teacher can then judge the success or failure of the lesson or activity based on the objective record. Videotape can also be used by the teacher as a record of classroom activities over time. Not only does it give the teacher immediate feedback, but also the recording can be stored and compared with later instruction.

There are many techniques that can be used to analyze systematically what has gone on in the classroom. The simplest means is to watch the tape to gain an impression of the teacher's teaching style: how he or she stimulated discussion or the reaction to his or her method of presenting works of art. More formal methods of analysis can be developed in which the teacher starts to categorize the types of responses the students make and adds some quantitative elements to them so he or she can record the total classroom session in numerical terms. Categories such as those Brent Wilson developed in his aspective instrument, discussed earlier, can be used.

The students can also record and analyze their own activities. Small group discussions between students can be taped and played back immediately so that the students can analyze their discussion about art objects. For example, one student can present a work of art to a small group of other students. They discuss the work and record the whole discussion on tape. For follow-up, the tape is played back and the talk about art is classified using the Broudy categories: whether the responses are to the formal, sensuous, expressive, or technical qualities of the work. This gives the students experience in classifying their own responses and an example of how the process of critical analysis takes place. The exercise is concerned not with the quality of the responses *per se,* but rather with the activity of categorizing the responses. Later

the teacher can assess the quality of the discourse and how well the students were able to sort out the responses.

Other evaluation activities for students are described earlier in the text. The simulation and improvisation techniques are excellent ones to record and play back. (If videotape is not available, audio tape recordings can also be used in all of these activities.)

### Sample Assessment Techniques

It will be the task of the individual teacher to develop instruments that assess student programs in art appreciation. The authors feel they should not impose criteria or develop instruments that would encompass all the differing points of view related to art appreciation. The suggestions in this section are examples of the kind of techniques that the teacher can use.

***Formal Recognition:*** The following two instruments achieve dual purposes: first, one of "formal recognition," and then an attempt to link the meaning or some other fact about painting to formal properties, such as color or composition. The teacher shows a slide reproduction or original and makes a statement and asks the class members to mark the answer they feel is correct. Since the statement should have some validity, it may be advisable to collect such comments from critical or historical works. The teacher can ask for a show of hands following

*Interlochen* Carl Hall Charles Henry Hayden Fund. Courtesy Museum of Fine Arts, Boston.

**Visual Relationships**

**"Can you point to places in this picture where the eye is encouraged to move from one place to another?"**

each question and then see how well students defend their answers. Some examples follow.

SLIDE #1: THIS PAINTING IS BY EDWARD HOPPER.

Statements:

1. The *feeling of strength* that you get from looking at this house is brought out most strongly by:

   a. the lights and shadows
   b. the dull background
   c. the different colors

2. The *style* (artist's particular way of painting) Hopper has used is:

   a. realism (looks lifelike)
   b. selective realism (partly real)
   c. abstract (simple shapes—not very real looking)

SLIDE #2: THIS PAINTING IS BY YASUO KUNIYOSHI.

3. The words that *best* describe the way the surface of the painting feels are:

   a. thick and rich
   b. scrubbed, dry
   c. runny, drippy

4. The subject of this painting is:

   a. a circus
   b. a Halloween party
   c. a dream

5. The active, lively, and playful feeling in this painting comes *mainly* from:

   a. the straight and curved edges (of the shapes)
   b. the light and dark colors
   c. the flat shapes

6. The *style* (artist's own way of painting) of this work is called:

   a. realism (looks lifelike)
   b. selective realism (partly real)
   c. abstract (simple shapes, not very real looking)

SLIDE #3: THIS PAINTING IS BY ROBERT MOTHERWELL.

7. The subject of this painting is:
   a. black ovals and white stripes
   b. black boomerangs and white fence
   c. not important

8. The artist has made the *edges* of the shapes:
   a. neat and exact
   b. soft and fuzzy
   c. both a and b

9. The *style* (artist's own way of painting) of this work is called:
   a. abstract (simple shapes, not very real looking)
   b. selective realism (partly real)
   c. nonobjective (no subject)

SLIDE #4: *CHRISTINA'S WORLD*. THIS PAINTING IS BY ANDREW WYETH.

10. In looking at this painting, we get a feeling of:
    a. happiness
    b. anger
    c. loneliness

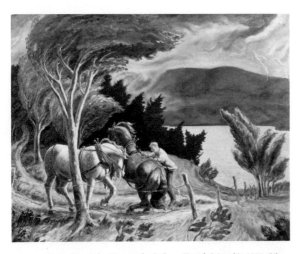

**Individual responses**

"This painting, *Storm over Lake Otsego* is by John S. Curry. The artist makes us 'feel' his subject through:

A. His emphasis on drawing.

B. His dark tones.

C. The sweeping rhythms.

D. B and C.

*Note:* While more than one answer may be true, one is more accurate than the others."

*Storm Over Lake Otsego* John S. Curry Signed. Painted in 1929. Oil on canvas. 40 X 50 in. Gift of Mr. and Mrs. Donald C. Starr. Courtesy Museum of Fine Arts, Boston.

11. In this painting the artist has used:

    a. many different colors
    b. a few colors
    c. a few colors with different shades

12. The huge area of the grassy field is made interesting because:

    a. of the realistic attention to the texture of the grass
    b. it is broken up by the lines of road and area of the meadow
    c. both a and b

13. The artist has applied the paint:

    a. in a loose, free way
    b. in a careful, exact, and neat way
    c. with a combination of loose, big strokes *and* exact, neat, small strokes

14. The artist uses a high horizon line because:

    a. the house is at the top of a hill
    b. it allows for more space between the girl and the house
    c. if he took a picture of the scene with a camera, it would have looked this way

15. The daylight in Wyeth's painting is used:

    a. to make the colors gay and full of life
    b. to outline the shape and edges of the houses and the girl and the wrinkles and folds of her dress sharply
    c. to tell us the time of day

SLIDE #5: *THE SENATE.* THIS PAINTING IS BY WILLIAM GROPPER.

16. The people and objects in this painting are placed so that the *strongest direction* is:

    a. a curved movement from lower left to upper right
    b. a movement from upper left to lower right
    c. a movement from front to back

SLIDE #6: THIS IS A PAINTING BY LEONARDO DA VINCI.

17. The people in this painting are arranged in the following way:

a. circular
b. triangular
c. rectangular

18. Leonardo left us "clues" which lead our eyes from person to person. These *"clues"* are:

   a. the same color is used on different people
   b. the actions of the hands and the turn of the heads
   c. the actions of the hands *and* the turn of the heads *and* the use of the same color on different people

SLIDE #7: THIS PAINTING, *STAG AT SHARKEY'S,* IS BY GEORGE BELLOWS.

19. The feeling of violence, movement, and action is brought about by:

   a. contrasts of dark and light
   b. the angular directions of the bodies of the boxers
   c. both a and b

SLIDE #8: THIS PAINTING IS BY PIERRE AUGUSTE RENOIR.

20. The color is painted in:

   a. large, unmixed areas
   b. mixed and smoothed-out areas
   c. small, mixed areas

SLIDE #9: THIS IS A PRINT BY KATHE KOLLWITZ.

21. The material used in this print looks like:

   a. a waxy crayon on rough paper
   b. a magic marker on rough paper
   c. a pencil on rough paper

SLIDE #10: *ZAPATISTAS.* THIS PAINTING IS BY JOSÉ OROZCO.

22. The *power and strength* of the people come from the artist's use of:

   a. the red in different areas of the painting
   b. the leaning lines of the people
   c. both a and b

23. The *style* (artist's own way of painting) of this picture is called:

## Evaluation Question

"Both of these paintings show a concern for clarity of the edges of shapes. One uses edges to enclose shapes; the other to dissolve them and extend them into the surrounding space. Identify the paintings that fit the above comments."

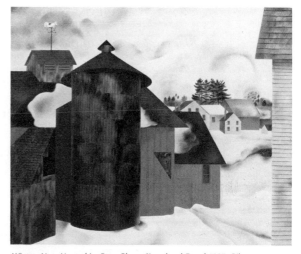

*Winter, New Hampshire* Peter Blume Signed and Dated 1927. Oil on canvas. 20 ¼ X 25 in. Bequest of John T. Spaulding. Courtesy Museum of Fine Arts, Boston.

*Regler Church, Erfurt,* Lyonel C. Feninger. Charles Henry Hayden Fund. Courtesy Museum of Fine Arts, Boston.

a.   realism (looks lifelike)
b.   selective realism (partly real)
c.   abstract (simple shapes, not very real looking)

SLIDE #11: THIS PAINTING IS BY VINCENT VAN GOGH.

24.   The brush strokes are *most* important for bringing out:

    a.   the stormy mood of the painting
    b.   the texture of the paint surface
    c.   the exciting colors in the picture

25.   The artist makes the *tree stand out* by:

    a.   the bright colors in it and the texture of it
    b.   the central placement and largeness of it
    c.   both a and b

**The Art Preference Test:**   The Art Preference Test is an example of an instrument to determine whether the tastes or preferences of the class have changed over time. The teacher may want to offer the Art Preference Test as a pre-post test to see if the course or unit has had an effect one way or another. In either case, the terms realism, selective realism, abstract, and nonobjective should be discussed prior to the test, using a number of clearly defined examples. In selecting art works, the teacher should always try to select examples from all categories that would possibly have some appeal. Thus, it would be unfair to put a dull abstract against a colorful, dynamically composed nonobjective work. After viewing the painting, the student is simply asked for a "psychological report," as follows:

This painting is by Pieter Brueghel.

I like it very much.
I like it.
I don't like or dislike it.
I dislike it.
I don't like it at all.

Changes in preference may be marked or slight, depending on length of instructional time. If a child appears to prefer a narrower range of style in May than he or she did in September, it does not follow that the teacher has failed; it may simply mean that the child's taste is becoming more selective. In fact, a narrowing of taste may well be a preliminary stage for a later, broader range of preference. The teacher, knowing the child, should be able to place the change in its proper

context. Following are paintings that fall into the broad classifications of photographic realism, selective realism, nonobjective, and abstract.

PHOTOGRAPHIC REALISM

Charles Sheeler—*Architectural Cadences*

Edward Hopper—*Pennsylvania Coal Town*

Wayne Thiebaud—*Football Player*

Andrew Wyeth—*Karl*

William Harnett—*Old Models*

Examples of photorealist group such as Richard Estes

SELECTIVE REALISM

Jack Levine—*The Trial*

Morris Graves—*Birds Singing in the Moonlight*

Paul Cézanne—*Card Players*

Charles Burchfield—*An April Mood*

Pieter Brueghel—detail from *Blind Leading the Blind*

Claude Monet—*Cathedral in Sunshine*

NONOBJECTIVE

Clyfford Still—*Painting*

Paul Klee—*Blossoms*

Gabor Peterdi—*Misty Ocean*

Hans Hoffman—*Red Trickle*

Arshile Gorky—*Garden in Sochi*

Robert Motherwell—*Western Air*

Matta—*The 50% Irrational in Matter*

ABSTRACT

Arthur Dove—*Fog Horns*

Xavier Gonzales—*Landscape #9*

Joan Miró—*Woman and Bird in Moonlight*

Pablo Picasso—*Woman Seated*

Fernand Léger—*The City*

Carl Holty—*The Carousel*

Alberto Burri—*Sacco B*

Adolph Gottlieb—*Blast*

**Written Observations:**   The use of essay-type comments on art works can reveal what the students have learned if the teacher can afford the time to analyze the responses. After only nine discussion sessions with fifth- and sixth-grade children, Ralph Smith asked his students to comment on a series of paintings that were new to them. His instructions are a clear indication of the nature of the instruction that preceded the test.

> *In our classes we have learned that in making aesthetic judgments we can make judgments about the subject, the formal relations, and the mood. We also learned that some works of art are more interesting to look at for one of these things than for another. For example, some paintings seem to emphasize only formal relations, others seem to emphasize the mood, and still others seem to emphasize the subject. Then there are paintings in which all three of these things—the subject, the formal relations, and the mood—are all interesting to see. In the paintings you will look at, make an aesthetic judgment and emphasize what you think is most interesting in the painting. Give as many illustrations as you can of what you say about the painting. If you have difficulty, try to think about the many things we have talked about during the classes.*
>
> *Write as if you were pointing out the aesthetic qualities of the painting to someone who has never seen the painting before.*[9]

One student's reply gives some indication of the level of discussion that may be expected when discussion is conducted with critical goals clearly in mind. Note that Cathy's response, if analyzed, reveals an awareness of such categories of discussion as formal qualities, style, mood, and subject.

CATHY:

RUBENS AND PIERO DELLA FRANCESCA

> *The* Battle *(Rubens) has some depth and pretty much space—its mood is violent. You get the feeling that everyone is trying to run away, and everyone is afraid. The two figures struggling are the most interesting. It's realistic.*

*The picture to the right (Piero) is quiet, peaceful, solemn. It's unrealistic. The people are too stiff-looking. They are clearly outlined. It has depth and some space. The two figures are what first draws your attention in the painting. I think they are the most interesting. The background is* very *unrealistic. The two figures and the river lead you back to the other man which leads you to the background. Then you come back to the figures and you see the ladies.*

*The* Battle. *It looks like a storm and the people in the background are terror-stricken by it. The two figures sort of remind you of an angel and a devil fighting together. I think it is much more interesting than the other painting because the other is quiet and solemn and kind of boring. The* Battle *shows more action and things going on which makes it more interesting.* [10]

## NOTES

1. Aesthetic Education Program, "Format for Teacher's Guides," working paper (St. Louis: CEMREL, Inc., 1973).

2. Jacqueline Sitkewich, *Editing: A Way of Life* (St. Louis: CEMREL, Inc., 1971). Course developed in cooperation with the Arts in General Education Project.

3. See *Florida Index to the Numerical Identification and Classification of Educational Objectives* (Tallahassee: State of Florida, Department of Education, 1972), for system of educational outcomes used to develop this format.

4. Ralph Pearson, *How to See Modern Pictures* (New York: Dial Press, Inc., 1925), pp. 29–42.

5. Reid Hastie and Christian Schmidt, *Encounters with Art* (New York: McGraw-Hill, 1969), pp. 39–42.

6. Jean Leymarie, *Dutch Painting* (New York: Skira, 1956), p. 132.

7. David Ecker, "Justifying Aesthetic Judgments," *Art Education* (May 1967), p. 6.

8. *National Assessment of Educational Progress: Art Objectives* (Denver: National Assessment of Educational Programs Project, 1971), pp. 10–19.

9. Ralph Smith, *An Exemplar Approach to Aesthetic Education,* Bureau of Educational Research, College of Education (Urbana: University of Illinois, 1967), p. 125.

10. *Ibid.*

# 5    RESOURCES

The resources described in this chapter are a collection of materials, places, information, and projects that will assist in the designing and developing of art programs emphasizing art appreciation. There has been a significant expansion of all types of support materials for the teaching of art appreciation; for example, cheaper and better printing methods have resulted in the availability of low-priced, color art reproductions for schools. Programs therefore can be designed that are low enough in cost to be used in most elementary schools. Photographic advances have made 35-millimeter slides and the filmstrip available for use in the classroom at economical prices. Programs are now being designed that use these inexpensive, good-quality reproductions, slides, and filmstrips as sources of images. The technology and the quality of the image have been improved so that it is possible to create visually exciting programs. Access to places and things has been expanded through the media—that is, television and film. The student in the classroom can have visual access to museums, art objects, people, and places that were once available only through print. The knowledge base that these two media can provide for art appreciation is enormous.

Availability of and access to materials and other resources enrich the art appreciation program. In order to make use of the teaching techniques and strategies that have been described in this text, some resources are necessary. This section describes some of the available materials and resources.

# PRINT, SLIDE, AND FILM PROGRAMS

### Teaching Through Art

*Teaching Through Art* is a multipurpose program created by Robert Saunders that tries to develop art appreciation, *visual perception,* and spatial awareness in the child through contact with and discussion of reproductions of works of art.[1] The program is divided into three series for the elementary grades: Series A uses twenty prints for a K–6 program of art activities, Series B also has twenty prints with activities directed to grades K–3, and Series C has twenty prints with activities applicable to grades 4–6. Each series is subdivided into twenty study units with each unit using one reproduction as the focus for its activities.

Each study unit is further divided into sections so it can more easily be used by the teacher. The first section provides information: a short identification of the reproduction, the artist's name, nationality, and date of birth. The second section gives the rationale for selecting the program and the type of learning activities to be expected. Here the teacher is provided with the overviews, subgoals, and general learning objectives. A third section describes the content of the painting used for study. It relates the subject matter, such as shapes, color, and other visual characteristics, to the objectives of the unit. Clues for the interpretation of the painting, information about the artist who painted it, and historical background are provided The fourth and fifth sections relate to the learning activities in which the student is to be engaged. They include discussion techniques plus art activities. An evaluation section and related activities make up the final parts of the study unit. A very high-quality print is used, and one large reproduction of the painting for each study unit is provided along with a teacher's manual for the series.

### Learning Through Art

Another program that uses reproductions as the base for the instructional program is *Learning Through Art,* developed by Clyde M. McGeary and William M. Dallum.[2] This program is described as a new and comprehensive approach to an art curriculum for the elementary and junior high school. The instructional resources for the teacher include two sets of general guidelines, one that describes the overall design of the program and another that deals with materials, tools in the visual arts, and a guide for the teacher to each lesson in the unit. The student materials are a set of prints for each unit. The program is composed of eighty lessons divided into eight series of ten lessons, with each lesson designed around one art reproduction.

The prints dealt with in the series range from the simple to the complex, and it is implied that each series is really related to a grade level. However, the authors also indicate that this may differ in each setting depending on the characteristics of the students.

The content for each lesson is based on a single reproduction. Each lesson is divided into sections that introduce the student to the work of art and the activities for that lesson. The first section is information for the teacher consisting of a description of the intent of the work and an analysis of the work, such as its use of some of the aesthetic properties of color, shape, and composition.

The second section, "Knowing the Artist," gives historical background of the artist: where he works, whom he studied with, and how he related to the mainstream of art at the time he lived or how he relates to the contemporary context.

The third section deals with comparing and contrasting this work of art with others in the series. In order to find similarities and differences, the students are also encouraged to bring in other prints that are not in the series for comparative study and to look at original works if they are available in a museum or gallery.

The fourth section deals with student activities for understanding and appreciating the work. Teaching questions are suggested to the teacher for stimulating student discussion and involvement. The questions are open-ended rather than aimed at specific facts or information about the painting. A second kind of student activity is termed creative involvement. These are studio art activities using the prints themselves as motivation or jumping-off points. Many different media and materials are suggested in each of the lessons, and the students over a period of time gain a variety of studio experiences in the visual arts.

In the fifth section of the lesson a student, through self-evaluation, indicates what he has learned. His own assessments of what he can actually accomplish with art techniques and materials are a part of the self-evaluation.

The last section gives teachers suggestions on how they can enrich the lesson by introducing other resources, such as field trips, museum visits, and artists-in-residence.

### Shorewood Art Program for Elementary Education

Another print program that is directly related to the classroom teacher is the *Shorewood Art Program for Elementary Education.*[3] This print program not only is used as a basis for the teaching of art appreciation and art but is also now designed to relate to other areas of study, such as language arts and social studies in the elementary schools. The repro-

ductions are divided into groups by grade levels and relate to general headings and topics applicable to each grade in the elementary schools. Topics for grades 1 and 2 are "Pictures Are Fun to Look At," and "Seasons"; grades 3 and 4, "City and Country," "Early Transportation," "Adventure," "Let's Tell a Story"; for grades 5 and 6, a sample topic is "How Do I Feel?" which is "a dramatic narrative based on reproductions that will encourage an imaginative journey into the life and feelings of these people, as well as stimulate the students to discuss their own feelings." The reproductions in all of the sets are selected by the Shorewood editorial board to relate to the general topic or heading. There are twelve reproductions in each set, and there are sixteen sets applicable to grades K–6. Along with each print program of twelve large color art prints, there is a booklet for the teacher that defines the outcome of the program and gives information about each print. There are also suggestions for classroom activities and discussion and related activities in other subject matters. The audience for these series is not the art teacher or the specialist in art but the classroom teachers, and the authors assume they have little or no knowledge about the history of art or techniques related to art.

### Art in Culture

*Art in Culture,* an art appreciation series of five textbooks based on color transparencies, by Sara Jenkins, is a picture study approach to art appreciation.[4] The art works are grouped around five general topics: Images of Man, Images of Fantasy, Images of Nature, and Images of Change I and II. Each topic is presented with twelve color reproductions for use on an overhead projector and sixteen duplicating pages that are worksheets for each reproduction. The books are reasonably priced, and the reproductions are of good quality. Background information for each topic is provided in the introduction to each text plus a detailed description of each work of art presented. The student activities are keyed to secondary students and would require considerable adoption for upper elementary students; the background material and the reproductions, however, are for the teacher and are applicable to elementary levels.

"Images of Man" focuses on how artists have interpreted the human experience. The art works range from Michelangelo's *Creation of Man* from the Sistine Chapel to contemporary works such as Ernest Trova's *Walking Man* and George Segal's *Cinema.* The purpose of the suggested activities is to provide direct experience in personal expression, group communication, self-evaluation, and analysis. The background material for the teacher in the introduction deals with the

human experience and how each artist viewed humanity. The author suggests that some "artists seek to record man's relationship to his external environment, while others search for an inner life." A summary of major ideas expressed in the art is given for purposes of comparison with a similar discussion at the end of the unit.

The introductory activity is based on discussion of a series of questions: "What is human nature?" "Does it change through time or is it constant?" "In what ways is man a unique being?" After the introductory discussion, each of the reproductions is used as the central topic of a lesson. A general discussion of the art work is conducted by the teacher using the background material provided in the text, and then each student works through a response sheet. Since these questions cannot be answered unless the student is familiar with the background material, many elementary students, particularly those in the lower grades, will need a lot of discussion and some related activities before they can handle the questions.

**Examples of the way that large visual material can transform the environment of an art room. In one room, the visual wall provides a background for printmaking area, while in the other, large visuals are used purely for the sake of viewing.**

© Richard Sobol

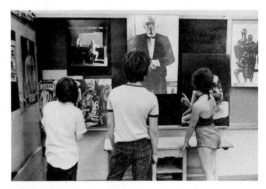

© Richard Sobol

The strengths of this program are the background material and the reproductions. It could be used for more advanced students, as a self-study program. In most cases, the teacher will have to adapt the activities and the questions to the level of elementary students.

### Portfolios

John Lidstone authored a series of *Portfolios,* containing large prints organized around the art elements.[5] Each collection has twenty-four posters printed on heavy board. Twelve posters are in black and white, while the other half are in color. A teacher's guidebook also comes with each package. The following description of the contents of one unit will present some idea of the broad, eclectic nature of the contents.

PORTFOLIO 8: SPACE

Interior of Trans World Flight Center, John F. Kennedy Airport, New York, designed by Eero Saarinen. CBS building, New York, designed by Eero Saarinen. Ford Foundation building, New York, designed by Kevin Roche, John Dinkeloo and Associates. *Playground Space,* photographs by Sheldon Brady. *Soundless Symphony* by Minoru Niizuma. Canvas over wood, *Sky 1* by Joe Tilson. Screen print.

The portfolios available are "Line," "Mass," "Organization," "Surface," "Color," "Movement," "Perception," "Space," "Light," and "Fantasy and Illusion."

Because of the scale of the images, these visuals provide a ready reference for the entire class. The teacher can point to specific referents as these are related to other problems. The posters also lend a unique visual character to any room due to the environmental transformation brought about by a series of out-sized images from many cultures and historic periods.

### The Art Appreciation Print Program

*The Art Appreciation Print Program* by Olive Riley and Elaine Lomasney is similar to the Shorewood program, but it is more general and is not related specifically to grade levels.[6] The program consists of sixty-four mounted and varnished prints of sculpture, paintings, drawings, and architecture. The prints are selected to represent the range of art forms in the domain of art appreciation rather than cover any one period or style, and the range will be extended as the program grows. On the back of each print there is a commentary for the classroom

Parents are often enlisted to help prepare reproductions for circulation. Purchasing prints is only the first stage of a process that may include dry mounting or even sewing carrying cases for framed pictures.

© Trudi Regan

This class is being conducted by a volunteer parent with some background in art history. Reproductions should be large, have some appeal to children, and reflect a specific instructional concern. Close proximity to the paintings ensures more effective participation. *From the Living Art Seminar Program of the New City Schools, New York.*

teacher. The authors emphasize that this is in simple and nontechnical, yet lively, language for easy use. The commentaries provide the teacher with information about each artist and suggestions for activities related to the works of art being viewed. The program provides phonetic spellings of difficult-to-pronounce names both on the print and in the teacher's guide. It also encourages correlation with other areas within the curriculum, such as language arts, social studies, and science.

### Visual Sources for Learning

A relatively new filmstrip program developed by Flora and Jerome Hausman, called *Visual Sources for Learning,* takes a different approach to art and the teaching of art appreciation.[7] The program is designed for grades K–8. Four major themes are used in the program:

1. *Man and Society:* Portraits; Family; Work We Do; Recreation and Sport; Performers—Circus and Theater; Masks and Figurines; and Costume and Fashion.

2. *Forms from Nature:* Animals; Birds; Flowers and Foliage; Landscapes; Sun and Sea; Nightfall and Weather.

3. *Man-Made World:* The City; Bridges; The Machine; Everyday Forms and Objects; Words, Numbers, and Letters; Crafts in America; Spaces and Enclosures.

4. *Visual Themes:* Color and Light; Shapes; Lines and Pathways; Structures; Textures and Patterns; Still-Life and Collage; Movement.

Paintings can often elicit heated discussions. These boys are discussing the finer points of an architectural study. It is important to have enough reproductions for individual study. In this case a book was cut up and each illustration mounted separately.

© Richard Sobol

The program is based on the assumption that "creating or responding to art may not be something set apart from the total school program. Learning about art is not some remote affair, rather the arts serve to make the quality of learning more vivid and imaginative."

The program is designed for use by classroom teachers as well as art specialists, and consists of twenty-eight filmstrips with an accompanying text. The filmstrips are not geared to specific levels of instruction, and the authors encourage their use in different ways and different arrangements. The contents of the filmstrips are works that relate to broad topics, such as circus, theater, and masks. Each of the photographs or reproductions is then related to student activities that can be conducted by the teacher or the students and are appropriate to the filmstrip content. Multiple arrangements—selecting images from one or more filmstrips to serve as additional references and resources to additional units that the students and/or teacher create—are a feature of this program. The filmstrips are designed as building blocks to be arranged in ways that relate to the outcomes of the students and the teachers involved. For each filmstrip there is a teacher's guide that suggests points for discussion, art activities, and reference materials for further study.

### SWRL Elementary Art Program

The *SWRL Elementary Art Program,* developed by Gilbert Clark and Dwane Greer, leads the child toward a developed adult understanding of the arts through experiences based upon those of the artist, art historian, and art critic.[8] SWRL is the Southwest Regional Laboratory, an organization that created and collects educational materials designed to accomplish specific instructional goals.

The program uses existing art works as the basis for its activities. Each new medium is introduced through a series of activities that offer the students a progressively more sophisticated understanding of the technique. The program offers instructional steps and experimental tasks that move from exploration of the medium, through acquisition of technique, to some expressive work. The program builds a knowledge of critical attributes of art works that the child can apply to his own efforts. As a major component of each activity, the program offers the viewing, analysis, and interpretation of adult artists' works that are always, in some way, related to the work of the student. These relationships between adult art works and the student's work are instructionally important. From kindergarten to the sixth grade, students will view, study, relate to their own work, and become comfortably familiar with

approximately 1,500 images of adult art works from many cultures, many periods of time, many countries, and many styles and media.

Related resources and activities are an integral part of SWRL's three-phase program of art instruction. During the Visual Analysis phase, students view and analyze images of real-world objects that will be used as subject matter in subsequent production activities. During the Production phase, students participate in technique-building activities (toward increased skills and knowledge) that they use in creating art works of individual character. Subsequently, during the Critical Analysis phase, students view, analyze, and interpret images of adult art works that reinforce ideas and activities the students have experienced in the previous phases. Since critical analysis is an integral part of a cumulative program that moves the student toward a developed adult understanding of the arts, the critical analysis activities are more than isolated "picture study."

Through negotiated access to art works owned by several museums, colleges, and private collectors, it has been possible to create a unique series of instructional visual sequences for use in the program. By photographing art works to meet prespecified needs, it has been possible to avoid reliance on the typical "art reproduction." These reproductions are most often single, frontal views of entire art objects. As such, they are useful devices for the art teacher and art student. They are, however, insufficient to fulfill many types of tasks called for in the SWRL/Critical Analysis program design.

Both the design of a theoretical structure underlying critical analysis and the realization of that design in image sequences and written materials resulted in several forms of program materials. The entire program is offered in "blocks" (half year's content) of four "units" (one month's activities), and four "activities" per unit (one week's classroom tasks). For each block of critical analysis instruction, the teacher receives four critical analysis filmstrips (one per unit) and a printed *Critical Analysis Guide* for the block. The guide and filmstrips are organized into "activity" segments. Therefore, there are four discrete segments of related instructional image sequences on each film strip with instructions for their use with students.

Use of the critical analysis filmstrip images and printed instructions provides many differing tasks and activities. Image Analysis materials direct the viewing, analysis, and interpretation of each projected image. These activities deal with visible aspects of the art work in accord with various viewer roles, for example, critic, historian, and aesthetician. All of the image analysis tasks relate to visible, displayed attributes that children can identify in the images projected. Cultural-historical

materials provide information that can expand and enrich understanding of the objects displayed. Background information about artists, techniques, art styles, places of origin, time periods, and other cultural-historical factors are provided as they relate to the images shown.

Instructional filmstrip sequences take several forms, and differing student tasks are defined for each. One form, with many variations, provides several views of a single art work. Sculpture is depicted in the many views a person might receive by walking around, or selectively focusing on various aspects of the object. Paintings or drawings are sometimes shown this way by providing views of the whole object with selected points of focus within the picture plane. Another form of image-task resources provides sets of paired images that students are called upon to compare and relate. Paired and grouped sets of images, in contrast to single images, stimulate a different type of reaction and dialogue. They call for seeing relationships, similarities, and dissimilarities and for recognizing groupings (by style, content, and other shared aspects) that are basic to understanding an art work in context. Some filmstrips present eight to ten images that reflect a technique being learned and practiced. Again, the grouped set of diverse content and origin is more effective than a single exemplar. For instance, ten paintings of diverse origin that share a mechanistic, geometric abstraction tell the student that many artists have worked this way, that the works are not alike, that each artist imprints his own work with individuality, and yet the works share obvious attributes when they are seen together.

Because the SWRL Elementary Art Program is cycled in drawing, painting, two-dimensional design, and three-dimensional construction activities, all these types of work are shown. Exemplary art work from throughout Western Europe, the United States, Mexico and Central America, China, Japan, Persia, Java and Bali, Australia, New Guinea, Canada, Peru, and many other countries are shown. Oil paintings, etchings, sculpture in all methods and media, embroidered and batiked fabrics, and many other combinations of techniques with media are shown. Works from Ancient Egypt to modern American serigraphs, from Monte Alban to contemporary Guatemalan weavings, from Australian aborigine to Canadian Eskimo carver are shown. None of these lists are inclusive. The student learns that art takes many forms—in many cultures—and that art is a pervasive form of human activity. Students also learn that some aspect of whatever *they* are doing is part of the work of the adult artist. Through this important aspect of the SWRL Elementary Art Program, the child is moved in a sequenced and cumulative set of activities toward a developed adult understanding of the world of the arts.

### Environment Filmstrip Series

The *Environment Filmstrip Series* is a sound filmstrip program for visual awareness designed by Stanley S. Madeja.[9] The filmstrips are divided into three classifications relating to general topics in our environment: (1) Our Man-Made Environment; (2) Our Natural Environment; and (3) Design in Our Environment. The last series specifically relates to how we perceive our environment and how to recognize art elements within it. A filmstrip titled "What You See," for example, investigates common objects as an artist would from different visual points of view. It instructs the viewer to look at objects from above, below, up close. Viewing objects in this way, they become redefined and take on very different visual qualities. Other topics—Leaves and Trees, Snow, Sea and Sand, and The Hidden Landscape—show various objects that the artist uses as subjects, and the aesthetic qualities of these objects in natural and man-made settings. With each set of materials, there is a sound strip that provides an original musical score for the images. The intent of this series is not to provide facts and figures but to inspire and motivate the student and to heighten his general visual perception.

### Art Single-Concept Film Series

The *Art Single-Concept Film Series* is a related series of film loops by Stanley S. Madeja and Clarence Kincaid that deals with art processes and techniques.[10] The single-concept films show, in four and five minutes, basic techniques in practically all media in which an artist works. The films are useful in art appreciation programs to help students understand how art works are created. This is particularly important when only reproductions, not originals, are used in a school's program. It is important for highlighting of certain techniques, such as watercolor, to show how effects in painting are created. The student utilizing these kinds of visual resources, and actually creating works as the artist himself has, enhances and expands his knowledge and appreciation of the process in the art object.

The series consists of some sixty short films and is a resource of information about studio processes. The series is very flexible. Each film is self-contained and can be used as a unit itself or combined with other films in the series or other series to form a larger body of information and knowledge. The available topics are painting, figure drawing, print making, design, sculpture, and jewelry.

## National Gallery of Art Extension Service

The National Gallery of Art Extension Service, Washington, D.C., is by far the most extensive of the resource services of our national museum. It provides a free loan program of slide lectures and films. The materials are based on the collection of the National Gallery, which covers the history of Western art from the Middle Ages to the present. The majority of materials are directed toward junior high to adult audiences with some developed specifically for elementary students. However, most of the materials work for upper elementary grades with some teacher explanation. The range of the visual resource is extensive, and the elementary teacher can revise the text to suit younger children with help from the Extension Service staff.

The slide lectures consist of cardboard-mounted 35-millimeter color slides and a record or cassette containing the text. Two of these are also available in Spanish and French. Related films are also available. A complete list of the slide lectures and films is contained in the Appendix.

A number of the slide lectures are on general appreciation topics; others are on specific topics or periods in art history, such as African Art or Modern Painting in France. There is also a lecture on American folk art. The following descriptions are excerpted from the Extension Service Catalogue.

700 YEARS OF ART

> The great epochs of art are vividly surveyed through outstanding works in the National Gallery of Art. Stylistic analysis of major paintings offers a clear comparison of styles, their sources —both artistic and social—and consequent influences. Both his representations of historical events and his corresponding artistic vision show the artist as recorder and interpreter of his age. 60 slides, record (50 minutes), and text.

> Related Slide Lecture: *Introduction to Understanding Art*
> Related Film: *Time Enough to See a World*

INTRODUCTION TO UNDERSTANDING ART

> As a basic introduction to art appreciation presented in simple terms, this slide lecture gives the viewer an understanding of the artist's conceptual process. Examples of painting, sculpture, ceramics, and tapestry are shown. 40 slides, record (40 minutes), and text.

Related Slide Lecture: *700 Years of Art*
Related Films: *Time Enough to See a World*
*Art in the Western World*

## THE ARTIST'S EYE: PICTORIAL COMPOSITION

The basic elements of composition—line, plane, and form—are defined and examined through a series of diagrams and overlays. Important stylistic changes in compositional modes are traced through painting from Byzantine, Gothic, Renaissance, mannerist, baroque, and rococo periods to more recent developments, including cubism. 75 slides, record (40 minutes), and text.

Related Slide Lectures: *The Artist's Hand: Five Techniques of Painting*
*Color and Light in Painting*
Related Film: *Time Enough to See a World*

## AFRICAN ART

This slide lecture is based on a major survey exhibition of African sculpture held at the National Gallery of Art. Outstanding examples from African, European, and American collections show the development of African art from 300 B.C. to the early 20th century. The lecture is divided into two parts for convenience in presentation. 77 slides, cassette (86 minutes), and text.

## BACKGROUNDS OF MODERN PAINTING IN FRANCE

Briefly covering French rococo, neoclassicism, and romanticism, this slide lecture concentrates on the impressionists and post-impressionists. Paintings by Manet, Monet, Toulouse-Lautrec, Degas, van Gogh, Gauguin, and Cezanne illustrate their diverse developments. Each artist's life is briefly explored, followed by an analysis of his art and its importance. 40 slides, record (30 minutes), and text provided in both English and French.

Related Slide Lecture: *What Is Impressionism?*
Related Films: *On Loan from Russia: Forty-one French Masterpieces, Fragonard, Degas, Renoir*

## INDEX OF AMERICAN DESIGN

A general survey of American crafts and folk art created primarily by unknown 19th-century craftsmen. Household furnishings and related objects—16 slides, carvings—8, primitive

religious paintings and carvings—4, weather vanes—4, signs—3, objects from the West and Southwest—5, regional decoration and painting—5, and miscellaneous—5. 50 slides total and lecture notes.

The films available on loan range from general titles such as *The American Vision,* tracing American painting from prerevolutionary days to the twentieth century, to treatments of specific artists, as in a documentary of Rembrandt seen through his work. Also available is *A Gallery of Children,* a filmed tour of the National Gallery for elementary students narrated by Joan Kennedy.

Other segments of the Smithsonian Institution in Washington, D.C., the Freer Gallery of Oriental art, and the Hirshhorn Museum of Contemporary art also offer many slides and reproductions at reasonable prices. Information on how they can be obtained is listed in the Appendix.

# TELEVISION

## Images and Things

*Images and Things* is a series of thirty twenty-minute television programs produced in color for ten- to thirteen-year-old students.[11] Planned and executed by John Cataldo and Alice Schwartz, the series is based on *Guidelines for Art Instruction Through Television for the Elementary Schools* by Manuel Barkan and Laura Chapman and was developed by the National Instructional Television Center.[12] The programs in the series are centered around the aesthetic and humanistic qualities of art and emphasize both visual enjoyment and learning. The focus of *Images and Things* is on the universality of human experiences as expressed in the arts through the ages and across the world.

The programs are not planned sequentially but are intended to serve as the organizing center of an art curriculum. It is also possible to develop thematic clusters of programs around such topics as the human image or the natural environment.

In addition to the thirty programs in the television series, which are also available on 16-millimeter film, there is a Learning Resources Kit of 180 slides of art works shown in the television programs. These slides can be used either in conjunction with the televised series or without reference to it. They are accompanied by a *Guide to Learning Resources,* which suggests activities through which the students may create their own art works and participate in forms of art criticism.

There are also three thirty-minute television programs for teachers. "About Images and Things" is an introduction to the series and its goals. "Using Images and Things" deals with utilization of the series and examples of follow-up activities. "Images and Things—The Child and His Art" looks at the place of art education in the overall development of the child and suggests some ways teachers can provide aesthetic experiences for their students.

The *Guide and Program Notes* contains a statement of the theme of each program and a summary of its exposition. It also suggests some possible follow-up activities and books for further research by the students. A fuller bibliography for teachers is included as well as a comprehensive guide to all the art works shown.

"Stars and Heroes" is an example of the kind of programing found in *Images and Things*. The theme is an examination of heroes, the adulation they are accorded, and some of the ways that art has been used to honor them. The program opens with a discussion of who and what is a hero. This is followed by views of personified heroic qualities exemplified in the sculptures of Sansovino, Houdon, and others. The "stars" are found in posters, paintings, and drawings by Dufy, Daumier, and Toulouse-Lautrec, and are followed by views of war heroes, conquerors, and contemporary explorers like Amelia Earhart and Charles Lindbergh. The program then turns to fictional heroes such as John Henry and Paul Bunyan. There is a sequence of images of George Washington emphasizing how the real individual is often lost in a confusion of conflicting images. The program ends with a look at the heroes of today and how they are presented by public relations and advertising. Suggested activities include making a collage of pictures of public figures from magazines, working for a comic effect.

A second example is "Sea Images." Its theme is simply the sea and the myriad ways men have responded to it creatively. Visual responses to the sea range from Winslow Homer to John Marin to William Turner, with the sea explored by both photography and paintings. Poetry is used to highlight the changing moods of the sea. The varying aspects of the sea are shown in pictures of sailors, divers, and finally storms, wrecks, and battles. Students are encouraged to join in a number of activities such as making their own prints or drawings, studying shells, making a sand casting, or collecting legends of the sea and providing appropriate illustrations.

### Shapes

The Aesthetic Education Program of CEMREL, Inc., explored some experimental uses of television for the teaching of art appreciation, and

produced the film *Shapes* in cooperation with WNET/Channel 13, New York.[13] In 1972 the Program and the school television service and experimental television laboratory of WNET filmed a program to introduce aesthetics and art appreciation to the television media. The working text of this program was based on a version of the video synthesizer, a feature of WNET experimental television laboratory.

The video synthesizer generates and emphasizes electronic shapes of various colors and sizes and provides the creator with a manipulative device to transform them into other shapes and patterns. The synthesizer was used to generate groups of geometric shapes that multiply and divide themselves in various ways. This taught the concept of shapes within shapes.

A significant part of the program is devoted to the use of television as a tool of the artist, and one whole segment concentrates on shapes that were generated by the synthesizers. This indicates to the young children that they can create shapes through their imagination and that this is the way the artist works. Many works of art are used in the program to identify the use of shapes by artists—from very contemporary works to very traditional. The emphasis, however, is on electronic generation of the shapes. The shapes generated from the synthesizer show how the medium of television can be used electronically to explain concepts in art appreciation. Television can also be used to enhance the students' ability to talk about art forms. It is a significant medium for conveying information about how artists work, who they are, and the kind of technology available to them in creating works of art.

## THE ARTIST

So far, much of the discussion about teaching art appreciation has centered around the work itself. But what about the artist? What is his or her role in the teaching of art appreciation and how should the artist as subject matter for the student be treated?

The most obvious way is to treat the artist as a person, as one who produces art, and to put the student in contact with her or him to see what develops. This approach has been popularized by federal support of visiting artists or artist-in-residence programs. The programs are now operating in all fifty states. The makeup of these programs varies, but the basic concept behind them is learning about artists and art through the producer: the sculptor, painter, potter, silversmith, filmmaker, or weaver.

## The Artist in the School

An early pilot project of the Artist in the School project disclosed three models for the artist's involvement in the schools. In a report by Madeja, Meyers, Davis, and Hoffa, it is pointed out that the role of the artist could differ because of many factors:

> *Those variables which could potentially alter any model included the availability of an artist in the locale selected, the geographic location of the sites, the status of the visual arts program within the school, the media in which the artist works (a sculptor may have a very different physical requirement than a painter) and the community setting and the constraints which each site may or may not put upon the project.* [14]

The authors describe three ways for an artist to interact with the school: as Teacher/Artist, Artist/Teacher, or Artist/Catalyst. The models are not mutually exclusive but reflect the emphasis of the artist's method of operating within the school setting.

As a Teacher/Artist, the artist intervenes directly in the school program. He or she assumes responsibility for teaching, at regularly scheduled times, either in a selected group of students or adults or in a regular class for the entire school year.

As an Artist/Teacher, the artist again intervenes directly in the program. However, teaching would occur either only once or on an irregular basis or within a specified block of time. The artist would teach or appear as a guest lecturer for a selected group of students, student apprentices, or teachers.

As an Artist/Catalyst the artist acts as a catalytic agent for the arts in both the school and the community. Encounters would be initiated by participants, and the artist has no assigned teaching responsibility. In this approach the artist has an open studio, so visitors can talk to him and observe him at work. He schedules special exhibitions of his work. He provides the opportunity for students to work with him on individual projects and conducts informal teaching situations, seminars, or workshops.

**Case Study: The Artist-in-Residence.** The case study described here is of a sculptor, Charles Huntington, who worked in the Artist in the School project as an artist-in-residence in the seventh and eighth grades. [15] His residency combined all three approaches: Teacher/Artist, Artist/Teacher, and Artist/Catalyst.

As a Teacher/Artist, Mr. Huntington assumed responsibility for teaching small groups of art students daily for nine-week periods. Of a more informal nature, in the Artist/Teacher category, he conducted two faculty workshops once a week for two hours over an eight-week

period. In the role of Artist/Catalyst Mr. Huntington had an open studio where visitors were welcomed.

The artist's approach to teaching was somewhat unusual. In addition to teaching art classes, Mr. Huntington worked as an Artist/Teacher with students who came to the studio during their weekly activity period. He counseled students but refused to impose his own views or make value judgments about their work. He felt that anyone working in the arts had to turn on by himself or herself. Mr. Huntington withheld overt evaluation in the belief that students are capable of assessing themselves when they are truly involved with what they are doing. As the word of his presence spread, students from other schools began to come in after regular school hours. Occasionally, the artist went to the neighboring schools to meet and talk with the students there.

Students assembling a modular sculpture designed by Artist-in-Residence Charles Huntington and student artists.

Many of the students worked as apprentices on modular pieces for a large sculpture to be assembled in the school's main hallway. The project, which the artist proposed, was one of creating sculpture for existing space in the school. The sculpture would be constructed from square-filled beams welded together to create an environmental type of work. The sculpture was designed to invite the viewer to touch, and feel and interact, through the shapes and structure itself. It would be stable enough for the students actually to crawl on it without damaging its surface or its structural quality.

The students discussed with the artist the design and makeup of the piece of sculpture and gained an understanding of how it was constructed and of some of the attitudes and artistic decisions that were part of its creation. This interactive process was important because the students participated in both the conceptual and assembly stages and were not passive participants. The interaction was truly the traditional one of the artist-apprentice relationship. The group of students interacted with the artist, and the sculpture came as much from the students as from the artist. The purpose of the work was, of course, to increase the aesthetic quality of the school. The students knew that because the work was modular and assembled on site it could not be removed unless it was completely dismantled. This gave a sense of permanance as well as integrity to their work.

The artist in this case had an effect on the environment of the school. He was dynamic enough as a personality and as an artist to leave a lasting mark on both the faculty and the students in the school. The way in which he interacted with the faculty and the students was unique. Possibly many artists could not duplicate his success. However, it is important to note that the artist himself became a subject matter to be studied, and the way in which he worked was related to the way in which other artists worked to enhance appreciation of the total art program.

*Integrating the Artist into the Existing Program:* Charles Huntington as an artist was integrated into the existing art program in the school. He became a resource for knowledge about art, methods, and techniques for the entire school, and especially for those students interested in art. It is this kind of integration of the artist into the total program that is necessary to make the artist's presence in the school a positive and reinforcing element of the general art appreciation program. If he or she becomes something of a sideshow freak, or someone set apart, no general appreciation of the artist or art objects is developed. Rather, the students are reinforced in the belief that art need not be a part of their life style or their value system.

Artists can be used effectively in art programs by deciding before their involvement what they may contribute. The art teacher or art coordinator in the school should be the organizer of the visiting artist to make sure the visitor is a complement to the existing program, not a replacement for the art teacher. There is a tendency on the part of the sponsoring organizations of such programs to assume that the artist outside the school can create some magic that transforms the art program into something different from what it was. Artists, like art teachers, vary, and some contribute greatly to an art program, while others detract. The key is to relate the artist to the existing art program in the school so he or she expands or complements it by providing another way to examine art works and understand how and why they are created.

Another strategy is to use the artists already in our schools. Many of our art teachers now working in schools are also practicing artists, and schools should look to the existing art staff first for talent before going outside the school system. Many art teachers would like to take time off to be a visiting painter or sculptor and show how they work as artists. The elementary schools could look to the secondary art staff for this talent if it does not exist at their level. Also, don't overlook the idea of combining the school art staff with artists working outside school. The effectiveness of a visiting artist or an artist-in-residence becomes limited as time goes on, and the more responsibility the artist-in-residence takes for instruction in the regular art program the less unique he or she becomes. If the artist is to be effective, he or she should be used as subject matter, not as an instructor. The art teacher or art coordinator still has responsibility for the total instructional program, and the artist can supplement and enlarge it.

Before beginning to work with children, visiting artists would do well to devote some of their allotted time to speaking informally with their audience. The time taken to get some idea of the audience's perceptions of what artists are, what they do, how they operate, for example, can provide valuable insights for the artist-teacher in his or her own comments. Some groups may be naïve, others more informed, and every group, it goes without saying, has its own range of experiences with the subject. The questions children ask are always illuminating.

Jeri Changar, a former elementary art teacher and a member of the CEMREL Aesthetic Education Program staff, made a study of the problem and recorded more than 900 questions asked of visiting artists. In making a content study of the questions, she discovered that there were an impressive number of categories—fifteen to be exact—that encompassed their many concerns. Some questions asked covering the various categories are:

Does he sketch first or just go on and paint?
Is his painting like a job or is it just a hobby?
Does he read about what he draws, or does he draw what he sees?
Does he paint realistic, abstract, or modern pictures?
What kinds of pictures does he like to do best?
How do you get people to notice your pictures and buy them?
Does he put pictures in museums?
Does he have his own gallery?
Does he ever draw anything imaginary?
How does he get his ideas and where?
In what kind of place does he work?
Does he make things out of metal?
Does he use a lot of texture?
How did he become an artist?
Does he do it in one sitting or does it take him a week to do it?
Does he have a big studio?[16]

A fourth variation on the artist-in-residence model that is not substantially dealt with in the previous case study concerns the artist as content or subject matter to be studied. By his residence in the school the artist is "content" for the students to study. The works he produces, how he uses the techniques and media, and why he creates the work —all of these become content for the teaching of art appreciation.

The artist is a transmitter of the content through his conversations, presentations, or the maintenance of an open studio. The following report by Al Hurwitz, coauthor of this book, shows how, after trial and error, one artist evolved a successful mode of presentation as a visiting artist.

### Case Study: The Art Supervisor as Visiting Artist

*I don't call myself "artist-in-residence," because my "act" takes only two hours, hardly long enough to call myself either an artist or someone who "resides." I operate more as a demonstrator-teacher who, in the short time allowed him, attempts to draw away the veil of secrecy that surrounds the making of an oil painting. I work in oils because that is the medium of most of the paintings dealt with in our art appreciation course, and I work sequentially in order to achieve some quality of suspense as one stage develops into another.*

*A principal or art teacher may request my services or I may suggest them to a school that I feel could derive some benefit. Once a school is scheduled, the art teacher usually prepares the*

*children by placing some reproductions which relate to the subject of my demonstration in a central display area. She also speaks to the children who will attend, building up a sense of anticipation through her own enthusiasm.*

*I arrive around 9:15 A.M., and I bring with me a clean stretched canvas (24" X 36"), my painting materials, examples of my completed work in several styles, all dealing with the same subject, usually landscapes. I also bring a few other examples of original professional work. (I don't want the audience to get the idea that the way I work is the only way to go about it.)*

*I have worked in classrooms, libraries, and gymnasiums. The most important factor is a good light, and the second is room enough to accommodate a large number of kids. I began with a small number of highly interested students who floated in and out on an informal basis, and I now work with all fifth and sixth grades in a school. My approach has changed, too, in that it is more structured and sequential. I always take a break after the first hour and allow those who want to leave to do so. Naturally, I judge my own effectiveness by the numbers who choose to leave. So far I average about six to ten students who elect to return to their rooms as opposed to about ninety who choose to remain.*

*When everyone is seated, I begin speaking while setting up the work area. The audience is fascinated by the ritual of getting ready: lining up paints, tearing the rags, pouring the oil and turpentine, and so on. When the setting is prepared, I show them my paintings—(I always turn the faces to the wall initially because given a choice of looking at a new experience or listening they will always look). I bank on the effect of a fresh visual contact to underscore the points I want to make: that I have more than one way to paint, and that my styles range from realistic to abstract to nonobjective. We discuss these terms, and they are recorded on a portable blackboard by a teacher who puts down all art vocabulary words as they emerge during my teaching. These words may be used for various purposes—for a review of the lesson, or for a tie-in with another art activity, or as a basis upon which the art teacher can develop further information and activities.*

*As soon as the class is seated, I make certain proper sight lines are observed so that all can see well. Since I am right-handed, I make certain three-quarters of the group is seated to my left.*

*Before beginning to paint, I review the materials on the table. I talk about the function and nature of solvents, pigment, brushes, supports, palette, etc. I also show them my sketch pads, pointing specifically to the sketches made when I was in Europe, which provide the basis for the painting I will begin. At one time I showed slides of Paris and even accompanied them with music by Edith Piaf, Jacques Brel, etc. I abandoned this because it gets away from the subject and requires additional materials and can take up too much time for soft young bottoms*

**The Artist in Action**

The introduction includes a brief showing of works developed from his European sketchbook.

© Richard Sobol

*on hard gymnasium floors. However, I have not abandoned the idea of incorporating slides and names, and I will probably use them again in some other context.*

The rough outlines of a Parisian street scene are sketched in. The artist talks his way through the process, explaining procedures and terminology as these arise. Questions and comments from the audience are not only acceptable, they are encouraged.

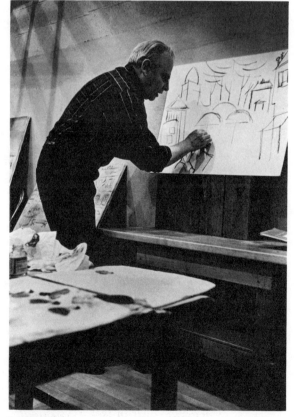

© Richard Sobol

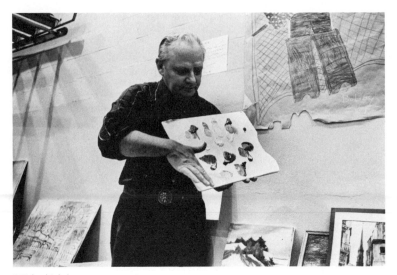

**After the sketch is completed, the palette is set up. Here, the artist demonstrates how the use of white reveals differences between apparently similar colors.**

The first stage of real work begins with a quick charcoal sketch which roughly places the main thrusts and shapes of the composition. I then fix this with a spray and set up a second palette. The first palette is not much use because the surface has been covered with my color mixing demonstration. (I explain my ordering of colors, then take a color down to its tint in order to emphasize the possible range available within each hue.)

On my second palette I spread a range of blues and reds. I then dilute the colors with turpentine and paint over the canvas freely, improvising shapes, strokes, masses, etc.—enjoying myself thoroughly. The audience is torn between alarm and vicarious pleasure. They are also puzzled and quite relieved when I begin wiping the paint away so that the canvas, now stained and tinted, is beginning to show through as a background for the fixed charcoal sketch. When I have achieved the kind of light I am after, I take a small brush and begin working over the sketch, adding details of architecture, the structure of trees, people, etc. I talk my way through the painting-trying to avoid any information that cannot immediately be observed in practice. The process is, in fact, a kind of visual conversation. I also believe in working on a recognizable image that can provide some link to the child's experience. I therefore avoid nonobjective subjects. I also enjoy kidding around a bit, even singing as I work because that is the way I actually go about things in my own studio.

After the line structure is in, I begin blending solid tones, working wet-in-wet, occasionally using a strident color that

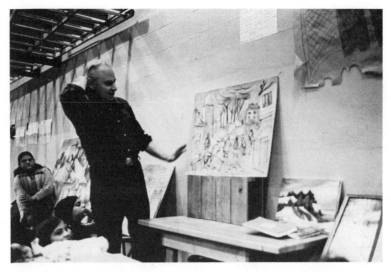

**The sketch is "fixed" and "toned," and passages of color are dispersed to achieve the first stage of unity.**

*doesn't belong. I am pleased when howls of dismay go up and I ask the class what I can do with that offending dot of lime green to make it go with the rest of the colors. I try out three or four of their solutions—none of which seem to work, but all of which are seen as slight improvement. I then adjust the troublesome color myself, explaining why I choose the modifying hues. (My own solution may not work either but they are more prone to accept my mistakes than theirs.) It is during this period that I demonstrate such terms as "chiaroscuro," "impasto," and "glaze," which I point to in completed works I have brought with me.*

*The class all along has been encouraged to ask questions as they please. The art teacher usually handles this as my back may be turned to the group.*

*I have discovered that sexual stereotypes about art which may have existed are soon dissipated. Often, it is the boys who remain to help me pack, who want to know "How much does it cost?" etc. A sampling of questions from one experience follows:*

REGARDING FIXATIVE:

What are you doing? It doesn't have any color.

REGARDING STAINING:

Why are you doing that? He's wrecking his painting.

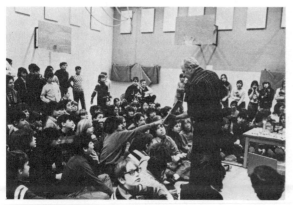

A gymnasium is not the most aesthetic environment, but it does accommodate large numbers with ease. Here, the teacher brings the painting closer to the audience for viewing of details.

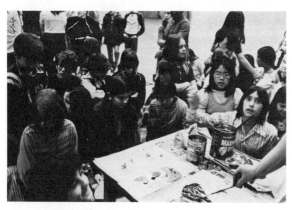

Those fortunate enough to be in the front rows find the work to be as interesting as the painting itself.

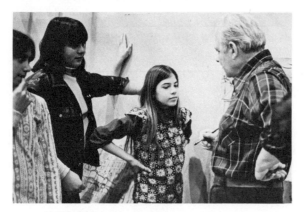

There is always time for individual discussion when the demonstration is finished. The whole process should not take more than an hour and a half.

Do you *have* to do that?

If you are going to wipe it off, why are you putting it on?

Do you do that on most of your paintings?

REGARDING MYSELF:

When did you start painting?

How old were you?

Do you do everything with the same paint brush?

Is painting your hobby? What are your other hobbies?

Who gets to keep the painting?

Will that be more like a painting or drawing?

How long does it take to dry?

When you were putting all the paint on, why didn't you just pour a bucket of paint on?

How much does it cost to become an artist? How does one become an artist?

*I have learned, not only from the students (their interests, attention span, etc.) but also from other visiting artists. In the latter case, I've learned in reverse, so to speak. I have seen artists far better than I lose kids because they cannot or will not communicate and because the work they do is excessively private in nature. I have despaired at the lost audiences that have squirmed, shoved, and pushed their way into a state of inattention and boredom. It was this kind of insensitivity to the way children learn that led me to develop over many sessions my own method of getting young people excited about the act of painting.*

## DELIVERY OF MATERIALS TO THE CLASSROOM

Resources for the teacher and student of art appreciation abound. Yet the problem remains to inform the teachers effectively that they are available for use and, probably more important, how to get them to use them. Two school systems, Jefferson County Schools of Colorado and Ladue School System of Missouri, led by two outstanding art supervisors, have outlined their arts resource centers. Each center is an example of how a school system with a large art staff and ongoing programs in the elementary schools has solved the problem of providing resources for the teacher. The Ladue School System is located in a major urban area (St. Louis) and Jefferson County is largely a suburban district.

## Case Study: Reproduction Lending Libraries

The rationale for the establishment of the lending libraries is that young students need to see relationships in the areas they study. Developing visual literacy is one means of doing this. In this instance, some aspects of the history and appreciation of the visual arts, as they are related to various cultures which the elementary child studies, are introduced through a daily association with two- and three-dimensional reproductions in their schools. The following is a description of how this can be accomplished, by Del Dace, Art Coordinator, Ladue Schools.

### ORGANIZATION AND MECHANICS

*There have been lending libraries of art reproductions in the Ladue Elementary Schools since the 1968–69 school year.*

*The Coordinator of Visual Arts Education has organized a fine arts committee in each parent association. The associations support the lending libraries financially. The parents volunteer time to prepare the two-dimensional reproductions for distribution. They mount the 22" X 28" colored reproductions, finish the raw oak frames, write and type the blurbs about the artists and the reproduction which are affixed to the back of the reproduction. They also affix the library card and envelope on the back of each reproduction, the final step to ready the library for distribution. The Coordinator of Visual Arts conducts workshops for the parents in dry-mounting the reproductions and in refinishing old frames and finishing raw oak frames with emphasis on a finish that is apropos to the subject of the reproduction. Parents cut and sew vinyl carrying cases from a pattern designed by one of the mothers.*

*The three-dimensional reproductions are purchased from Alva Cast Reproductions. These reproductions are made of dura-stone and are not as vulnerable to breakage as are those made from plaster. The tote bags for the three-dimensional reproductions are also cut, lined, and sewn by volunteers. The designs on the bags are applied by the elementary students via silk screen, magic markers, and fabric paints.*

*The reproduction selection committees from each school are comprised of two parents, the art specialists, a classroom teacher, the principal, and the Visual Art Coordinator. The committee visits Art Replicas (a store specializing in quality two- and three-dimensional reproductions). All selections are made from a wide assortment of Abrams, Shorewood, New York Graphics, and some foreign reproduction companies. The selection committee makes an effort to insure that the reproductions in the lending libraries represent a variety of artists and movements and are expressions of the best of the past and present. The reproductions present various ways of seeing things and interpreting what is seen, encouraging keener observation in daily life and broadening visual perception.*

Students are made aware of the collection in their respective schools through a continuously changing display of reproductions in the school libraries, the halls, the principal's office, the cafeterias, the art rooms, and regular classrooms. By seeing the color two-dimensional reproductions hanging in the various parts of the buildings, the students are stimulated to check out one to take home. The three-dimensional reproductions are displayed in cases and on tables and shelves in various areas around the schools.

The reproductions are checked out through the school libraries or through the art teachers. Students may check them out for a one-week or a two-week period, depending on the number of reproductions in the collection.

## SOME OBSERVATIONS ON THE PROGRAM

A lending library serves many purposes in the school and community. A closer relationship between school and home is encouraged as the student proudly displays a borrowed reproduction in his room or some other area of his home. A student will want to talk about the reproduction he has borrowed and lived with for a week or two. Students and parents have been stimulated to ask questions and to want more information about the two-dimensional and three-dimensional reproductions on loan in their homes. The libraries serve as a vehicle to extend art beyond the four walls of the classroom and to encourage family appreciation and discussion of the borrowed reproductions.

The lending libraries are a cooperative venture between the parents, the visual arts staff, and the school administration. Communication and a cohesiveness between these various groups have come about as they have worked together in the organization, preparation, and distribution of the lending libraries.

Masterpieces in reproduction representing the best artistic achievement of past and present culture can play an important role in the curriculum and can be vital instruments of learning with which to stimulate thought, perception, and creativity.

The lending libraries have been used in the classroom to enrich social studies units and in music classes.

For the past six years this program has supplemented the ongoing visual arts experience and has enriched the sequential K–6 program of visual arts education. It is an excellent example of community interest and support in the visual arts education program, and it exemplifies the cooperative spirit which has been responsible for the success of the lending libraries throughout the Ladue Schools.

## Case Study: Jefferson County Schools Resource Center

The Jefferson County School System in Colorado is one of the larger school systems in the western states. The school system serves the

county of Denver and covers an area equivalent in size to the state of Rhode Island. The system itself has a strong arts program and has some 180 full-time art teachers taking part in the art program in the elementary and secondary schools. In addition to having a very comprehensive and exciting program in the visual arts, the district has worked out a resource center for the distribution of materials that serves the entire program. Jefferson County has a curriculum guide in the arts that outlines the goals and outcomes for their program K–12. The resource center is set up to act as a complementing and reinforcing component of the program to implement this curriculum. Larry Schultz, the coordinator of art in the Jefferson County Schools, has provided this outline of the functions of the center.

*One, the center provides a resource person who becomes the catalyst for coordinating and directing the center's operation. In the case of Jefferson County, an outstanding arts resource person has been hired who is not necessarily a librarian, but primarily a person who provides services to the art teachers of the district. It is the responsibility of the resource person to identify the materials, assess their appropriateness for the curriculum either through personal or teacher review, assess the relationship between the materials selected for the center and the overall goals for the art program in Jefferson County, and recommend purchase of material that fits their criteria. An additional responsibility of the resource person once the materials are purchased is to inform the teachers of their availability and to have them reviewed for classroom use. This means occasional letters, memos, phone calls, and personal contact are necessary to get the materials to the teachers. Lu-Jean Ortiz, the director of the center, emphasizes to the teachers that "we have a number of things you can use: articles from magazines, sound tape, 16mm film and loops, and art books of various kinds." The resource person then becomes a full service person and provides the ongoing motivation for both updating and continuing to expand the center resources. But the resource person is also there to provide the necessary contact for the teachers in the district to ensure the utilization of the materials.*

*Two, the resource center functions as a central distribution system for materials that cannot be housed in the schools. For example, 16mm films which are relatively expensive cannot be duplicated in individual schools. Some means of distributing such items throughout the school system must be maintained and the center provides that kind of service. Art reproductions which are sometimes expensive cannot be provided for every school in the district, so a central means of distribution is needed. Also, the center operates a special library service. Books and other support materials which are used occasionally but not necessarily every day, as well as supplementary material for in-depth research and development are housed in the cen-*

*ter. The center should complement the schools, as many materials that the teachers use every day are housed directly in the buildings. Slides, books, and filmstrips are in the school as well as the center. If the teacher needs access to some resource on a daily to weekly basis, then the choice is made to have the item in the school rather than the center. Therefore the resource center does not capture all of the materials, but tries to get its materials in the schools and also tries to get the schools to buy the materials they need. The center also provides lists of new materials that teachers can purchase for their programs as well as a place where new materials from publishers can be reviewed.*

*A third function of the center is that it serves as a media development area for teacher materials for the art program. The teacher has the option of making filmstrips or a small film, mounting prints, or developing slide and sound shows for presentation in the classroom. It is a media center, a place where teachers can congregate and have access to resources probably not available in the individual schools. It becomes a work center as well as a distribution center.*

*A fourth function of the center is as a gathering and collecting point for information: Information on galleries and shows in the area, on where specialized art materials are available, information about artists who might be available for classroom discussions or demonstrations, and information about access to art appreciation materials that might be available through commercial agencies in the Denver area or nationally.*

*These four functions—providing a resource person as coordinator of the center, serving as the distribution center for materials, serving as the media development area for teachers, providing for the development of a major center for development in media and providing a central collecting agency for art program-related information—define the Jefferson County Resource Center.*

Larry Schultz describes how the center fulfills its four functions on a day-to-day basis.

*No one is told to participate in the center, no one is told they can't participate in the center. It is just open, it's their place. And we try to provide the things, the mat board, the acetate, the kind of mat cutters, the guides, the catalogues, the information that they need. It's a place where they could find lists and catalogues for current books that are on sale. From our budget we purchase annually a copy of all the latest books on art. An art teacher can come in to review the books, to see if in fact they are what his or her school needs; and then return to the principal and say these are the books that I think will best fit our program and the children in the school. We never say to the teacher that we have to buy all of the books or that here is a book you have to buy. We say take a look and see what you*

can use. And it seems to be working surprisingly well: it's kind of a hands-off, hands-on center.

We bring visitors into our center; we invite parents to make use of it; it's not uncommon to find a PTA mother or an artist from the area or someone from one of the local universities using our center for one reason or another. And again we hope to expand on that idea. We have been lucky and the teachers don't take advantage of the center. They don't walk off with materials, they don't use up what might be more than a fair share.

Since we maintain a quality staff person, it has become the center of the art department, truly a service center. A spin-off effect has been that, while no one person can serve on an individual basis 180 art teachers spread throughout the county, a center of this nature can. The fact that three or four teachers are there each evening, and sometimes as many as ten or twelve, means that more ideas are shared and more activity and new curriculum ideas are generated than a coordinator or art specialist could ever produce by traveling from school to school. We have found that the center has had tremendous effect on improving instruction.

It is a sharing place. Teachers bring in their ideas: if they have a unit they developed over the summer or in a college course, or if they have something that they would like to share, we duplicate it and send it around to the teachers. It's open-ended, we accept their ideas as being valid and well thought out. Our resource center is something like a human newsletter. It is not something that comes every Monday with a list of books that is mailed to the teachers throughout the district, but it is a place to come and share and exchange ideas. The center has been one of the most successful teacher education mechanisms in the district. Just by accident, by the accident of having to house lots of art books, by the accident of not having enough money to put this center in every school, it has drawn the art teachers in the district together.

In terms of purely mechanical things that we do, when a teacher requests materials, if the school is some distance from our center, we have a pony service, and it will deliver to the teacher any books, prints, slides, that he or she may want. The center is only a phone call away. The center is not only used by the art teachers but by classroom teachers in the district. And as we develop more interdisciplinary kinds of materials, our shelves are beginning to fill up with materials from theatre, materials that deal with dance, drama and music as well. It is becoming more of a non-territorial sort of center. It is a place where a classroom teacher doing a unit on Mexico will find books on Diego Rivera, or pre-Columbian Art, where someone studying the Netherlands would find information on Rembrandt and also could find what other classroom teachers are doing in this area. It is truly a resource, and we like it that way. We have all of the materials that we can find that we think have

*a relevance for the existing art program. We have materials that are recommended by teachers or consultants from outside the district or by other teachers from around the area or by university people. These are housed in an open-shelf situation. Teachers can browse, look through the prints, select from the slides, preview a film. There are places to read, places to exchange ideas, places to work; it is a very natural place.*

*In the original conception of our center we did not have the space or the facilities that we do now, but we were able little by little to establish more territory, to select more materials to develop some of our own processing, some of our own materials, and to find out how we could better service teachers. It actually worked to our advantage not to have all of the funds that we might have thought necessary initially to start a resource center, because we actually made a more human center by drawing in more people and more ideas and sharing more of what they had with us. The art teachers all were part of the center's initial stages. We all brought copies of magazines and books that we thought we could share, then we began to learn how to share these. This concept has carried us through and has kept the center open. It is really a place where we serve, not shelve.*

## THIS BOOK AS RESOURCE

In this chapter and throughout the rest of the book, a number of concepts, techniques, teaching strategies, materials, human resources, and a large amount of background information are all defined for the teaching of art appreciation. The purpose of this text is to act as a resource for the teacher of art and the classroom teacher that will enhance and expand the teaching of art appreciation in the classroom. It should be noted that the major resource in the classroom is the individual teacher —who brings the power of human intellect to assemble, categorize, and interpret content creatively for students through the teaching process. We cannot minimize the importance of the individual teacher—and the climate that he or she creates within the classroom—to the success of the teaching of art appreciation. This is one variable in the teaching process no one can control; it usually becomes the dominant variable, and whether or not the student learns and continues to develop an inquisitive attitude toward the subject matter is controlled by it. It is all-important that the teacher be supported by resources, such as we hope this text will prove to be, in improving the general instructional climate and the teaching process.

In conclusion, it should be noted that art appreciation must be integrated into the art program and be relevant to the general education program. As mentioned in the Introduction, there has been an

inadequate and somewhat haphazard amount of attention paid to teaching about art objects, artists, and the creative process they represent. We hope we have demonstrated in this text that art appreciation can be an exciting, interesting, and informative part of every art program and does not have to take on characteristics that are misleading or divorced from the mainstream of elementary educational goals.

Art appreciation should not have a mystique. It should be something that both student and teacher realize can enhance the general quality of their life as well as their appreciation of the power of works of art. It should also supply an important dimension in their lives, in terms of a descriptive language that can apply not only to works of art but also to things in everyday life. The transfer effects of the teaching of art appreciation can be made tangible in the personal life style of the students, the homes they furnish, and the community and environment in which they will live. These are potentially real and meaningful outcomes for the society as a whole and very functional outcomes for every student involved. But if vision is to become a truly joyous affair, it will be the informed teacher who must prepared to stand at the juncture between the world of the artist and that of the child.

## NOTES

1. Robert Saunders, *Teaching Through Art* (New York: American Book Co., 1971).

2. Clyde M. McGeary and William M. Dallum, *Guidelines for Learning Through Art*, teacher's guide (Baltimore: Barton Cotton, 1971).

3. *Shorewood Art Program for Elementary Education* (New York: Shorewood Reproductions, 1973).

4. Sara Jenkins, *Art in Culture* (St. Louis: Milliken Publishing Co., 1973).

5. John Lidstone, *Portfolios* (New York: Van Nostrand Rheinhold, 1970).

6. Olive Riley and Elaine Lomasney, *The Art Appreciation Print Program* (Blauvelt, N.Y.: Art Education, 1973).

7. Flora and Jerome Hausman, *Visual Sources for Learning* (New York: Sanddeck, 1974).

8. More information about the *SWRL Elementary Art Program* can be obtained from Division of Resource Services, SWRL Educational Research and Development, 4665 Lampson Avenue, Los Alamitos, California 90720.

9. Stanley S. Madeja, *Environment Filmstrip Series* (Dallas: Hester and Associates, 1974).

10. Stanley S. Madeja and Clarence Kincaid, *Art Single-Concept Film Series* (Dallas: Hester and Associates, 1969).

11. Jerry Tollifson, *Images and Things: Guide to Learning Resources* (Bloomington, Ind.: National Instructional Television Center, 1972) and Alice M. Schwartz, *Images and Things: Guide and Program Notes* (Bloomington, Ind.: National Instructional Television Center, 1972).

12. Manuel Barkan and Laura Chapman, *Guidelines for Art Instruction Through Television for the Elementary Schools* (Bloomington, Ind.: National Instructional Television, 1967).

13. *Shapes,* produced by the Aesthetic Education Program at CEMREL, Inc. (St. Louis) and WNET/Channel 13, New York, 1974.

14. Stanley S. Madeja, Nadine J. Meyers, Suzanne Dudley Hoffa, and Donald Jack Davis, *Artist in the School* (St. Louis: CEMREL, Inc., 1971).

15. *Ibid.,* pp. 34–37.

16. Questions taken from *Teacher's Guide: Visual Artist* (St. Louis: CEMREL, Inc., 1974).

# APPENDIX

- National Museums
- Art Terms
- Films
- Slides and Filmstrips
- Reproductions
- List of Art Works for Art Auction
- Bibliography

# NATIONAL MUSEUMS

National museums, located in Washington, D.C., have a number of resources that are applicable to art appreciation programs. Services are available to teachers and schools, and the following list describes these services and the location of the museums.

## NATIONAL GALLERY OF ART

The National Gallery of Art carries on two programs that have direct applicability to art appreciation at the elementary level. The most extensive part of the National Gallery's program for schools is a complete selection of reproductions and publications of and about the collection in the Museum.

A document titled *The Catalogue of Reproductions and Publications* is available from the National Gallery of Art, Washington, D.C. 20565. It contains ordering instructions, a list of color reproductions and visual aids designed for classroom use, plus portfolios, color slides, recordings, sculpture reproductions, and publications.

A second service of the National Gallery is the Extension Service, which has developed a wide range of educational materials to make the collection of the Gallery available to people across the country. The address of the Extension Service is: Extension Service, National Gallery of Art, Washington, D.C. 20565. Color slide lectures with recordings, 16mm films, special publications, and travel exhibits are available to any school or college, university, library or museum, or community group free of charge except for transportation costs. Some are also for purchase. Below is a list of slide lectures and films available free on loan from the Extension division.

## SLIDE LECTURES

1. 700 Years of Art
2. Survey of American Painting
3. Painting in Georgian England
4. Paintings of the Great Spanish Masters
5. Backgrounds of Modern Painting in France
6. Famous Men and Women in Portraits
7. Introduction to Understanding Art
8. The Artist's Hand: Five Techniques of Painting
9. Color and Light in Painting
10. The Artist's Eye: Pictorial Composition
11. Physics and Painting
12. The Christmas Story in Art
13. The Easter Story in Art
14. American Textiles
15. The Creative Past: Art of Africa
16. Florentine Art of the Golden Age
17. American Painting in History
18. Index of American Design
19. Survey of American Crafts and Folk Art
20. Popular Art in the United States
21. Early American Crafts
22. Pennsylvania German Folk Art
23. Shaker Furniture, Costume, and Textiles
24. Crafts of the Spanish Southwest
25. American Folk Art
26. Early American Pottery and Porcelain
27. Early American Wood Carving
28. Costume

FILMS

14. The Adoration of the Magi

15. Copley

16. El Greco

17. Rembrandt

18. Renoir

19. Turner

## HIRSHHORN MUSEUM AND SCULPTURE GARDEN

The newest of the Smithsonian museums in Washington, D.C., is the Hirshhorn Museum, which contains a collection of contemporary art and makes many reproductions available to the public. The museum has three lists that are available on request: postcards and reproductions; publications; and slides. Also a very comprehensive catalogue of the entire collection is available titled *Hirshhorn Museum and Sculpture Garden;* it can be ordered directly from the museum either in paperback or hard cover. The address for obtaining the above items is:

Hirshhorn Museum and Sculpture Garden
Museum Shop
Smithsonian Institution
Washington, D.C. 20560

## FREER GALLERY OF ART

The Freer Gallery of Art offers a number of resources principally in the area of Middle Eastern and Eastern Art and American Art. The museum offers both slides and reproductions of its collection, and these are categorized according to countries or regions in the Middle and Far East, and a general list on other parts of the collection. Slides are available on Japanese art, Chinese pottery, Chinese art, and Islamic art. The reproduction catalogue is available directly from the Gallery. The address is:

Smithsonian Institution
Freer Gallery of Art
Washington, D.C. 20560

# ART TERMS

The following is a list of descriptive terms that can be used as a starting point for the development of a critical language or vocabulary for the student. It should be noted that this list is not exhaustive, nor is it applied to the language development level of the student. The teacher in the elementary grades needs to make the decision as to when and how these terms are introduced. These are terms that can be used in describing, analyzing, and making aesthetic judgments about works of art and should be used with the works of art themselves, and not as a list of words to be memorized out of context.

The terms were excerpted from a list developed by Barkan, Chapman, and Kern in *Guidelines: Curriculum Development for Aesthetic Education* (St. Louis: CEMREL, Inc., 1970) pp. 88–121.

> *STRUCTURE: the organization of the sensuous qualities of a medium; the form which is, or which embodies the content of, the work of art. Structure can also be described through relationships between and among sensuous qualities, e.g., repetition with inversion in dance, temporal sequence in literature, repetition with development in music, foreshadowing in theatre, symmetrical balance in the visual arts.*
>
> *The structure of natural and man-made objects and events can be described in terms similar to those employed for art forms and through concepts pertaining to nature and science.*

## FORMAL RELATIONSHIPS

| | |
|---|---|
| asymmetry | multiplicity |
| balance | pattern |
| complexity | proportion |
| composition | repetition |
| continuity | rhythm |
| contrast | simplicity |
| design | symmetry |
| dynamics | tension |
| emphasis | unity |
| gradation | variety |
| harmony | |

## QUALITATIVE RELATIONSHIPS

relation of part to part
relation of part to parts
relation of parts to parts
relation of part to whole

relation of parts to whole
relation of wholes to wholes

## FUNCTIONS OF ART FORMS

This category lists purposes for which a work of art might have been created. The purposes may be (1) aesthetic or (2) utilitarian. The aesthetic purpose is for its intrinsic appeal; the utilitarian purpose may serve a religious, domestic, or industrial function. A single work of art can serve both purposes.

aesthetic
amusing
artistic
cathartic
commemorative
commentative
commercial
cultural
decorative
economic
educational
entertaining
experiential
expressive
historical
hypnotic
instructional

magical
moral
persuasive
political
practical
propagandistic
psychological
religious
satirical
sensitizing
social
  didactic
  satiric
spiritual
stimulating
therapeutic

## SENSUOUS QUALITIES

This category is concerned with the qualities associated with uses of a medium which are perceived through the senses— seeing, hearing, tasting, touching, and smelling. Sensuous qualities are usually perceived on a continuum such as fast to slow and light to dark; or they are perceived as pervasive phenomena — reddishness, angularity, fluidity, gradual modulation, rising action.

### Color

advancing—receding
bright—dull
light—dark
opaque—transparent

pure—mixed
saturated
strong—weak
warm—cool

## Energy or Tension

active—passive
diminishing—augmenting
directed—free
free—bound

high—low
stable—unstable
static—dynamic
strong—weak

## Form or Shape

concave—convex
conical
curvilinear
foreshortened
free—bound
geometric—biomorphic
natural—artificial

parabolic
pyramidal
rectangular
rigid
simple—complex
transparent—opaque
triangular

## Images

imaginary—real
real—imitated

virtual—real

## Light

Artificial—natural
bright—dim
bright—dull
dark—light
direct—indirect

direct—reflected
light—shade
night—day
reflected—absorbed

## Line

convergent—divergent
dark—light
heavy—light
jagged—smooth

parallel
pointed—obtuse
straight—zig-zag
thick—thin

## Mass or Volume

big—small
bulky
empty—filled

heavy—light
solid—open
stable—unstable

## Movement (motion)

accelerated
circular—straight

forward—backward
real—virtual—implied

convergent—divergent
crosswise—lengthwise
fast—slow

side—diagonal
spontaneous—directed
up—down

## SIZE

changing—stable
exaggerated
large—small
little—big
microscopic—telescopic

natural (real)
proportional
reduced
relative
tall—short

## SMELL

acrid—sweet
burning

pungent
spicy

## SOUND

big—small
changing—stable
close—distant
complex—simple
diminishing—augmenting

high—low
loud—soft
natural—artificial
shrill—mellow

## SPACE

deep—shallow
empty—filled
extended—enclosed
interstitial

narrow—wide
open—closed
vast—small

## TASTE

bitter—sweet
bland—spicy
hot—cold

piquant
salty
sweet—sour

## TEXTURE (SURFACE)

artificial—natural
course
even—uneven

porous
raised—lowered
real—simulated

granular

harsh

metallic

pebbled

regular—irregular

rough—smooth

soft—hard

## TIME

endless

expanding—contracting

fast—slow

implied

long—short

present—past—future

real—unreal

virtual

# FILMS

ACI Films, Inc., 16 West 46th Street, New York, New York 10036

Aims Instructional Media Services, Inc., P. O. Box 1010, Hollywood, California 90028

American Crafts Council, Research and Education Department, 29 West 53rd Street, New York, New York 10019

American Federation of Arts, 41 East 65th Street, New York, New York 10021

American Handicrafts Company, 83 West Van Buren Street, Chicago, Illinois 60605

Audio Film Center, 34 MacQuesten Parkway South, Mount Vernon, New York 10550

Audio Visual Center, Indiana University, Bloomington, Indiana 47401

Audio Visual Center, University of Kentucky, Lexington, Kentucky 40506

Bailey Film Associates, 11559 Santa Monica Blvd., Los Angeles, California 90025

B.F.A. Educational Media (Columbia Broadcasting System), 2211 Michigan Avenue, Santa Monica, California 90404

Boston University Film Library, 765 Commonwealth Avenue, Boston, Massachusetts 02215

Brandon Films, Inc., 221 West 57th Street, New York, New York 10019

British Information Services, 30 Rockefeller Plaza, New York, New York 10020

Canadian Centre for Films on Art, P. O. Box/CP 457, Ottawa 2, Ontario, Canada

Center Cinema Co-op, Art Institute of Chicago, Michigan and Adams, Chicago, Illinois 60603

Center for Mass Communication of Columbia University Press, 562 West 113th Street, New York, New York 10025

Churchill Films, 662 North Robertson Blvd., Los Angeles, California 90069

Coast Visual Education Company, 5620 Hollywood Blvd., Los Angeles, California 90028

Columbia Cinematheque, 711 Fifth Avenue, New York, New York 10022

Contemporary Films, Inc., 330 West 42nd Street, New York, New York 10036

Contemporary Films/McGraw-Hill, Princeton Road, Highstown, New Jersey 08520

Educational Audio Visual, Inc., Pleasantville, New York 10570

Encyclopedia Britannica Films, Inc., 425 North Michigan Avenue, Chicago, Illinois 60611

F.A.C.S.E.A. (French-American Cultural Services), 972 Fifth Avenue, New York, New York 10022

Film Distributor Corporation, 43 West 16th Street, New York, New York 10011

Film Images, 1034 Lake St., Oak Park, Illinois 60301

Films, Inc., 1144 Wilmette, Illinois 60091

Francis Thompson Productions, 935 Second Avenue, New York, New York 10022

Hester and Associates, 11422 Harry Hines Blvd., Dallas, Texas 75229

Hack Swain Productions, Inc., P. O. Box 10235, Sarasota, Florida 33578

International Film Bureau, Inc., 332 South Michigan Avenue, Chicago, Illinois 60604

Janus Films, 745 Fifth Avenue, New York, New York 10022

McGraw-Hill Films, 1121 Avenue of the Americas, New York, New York 10036

Monument Film Corporation, 267 West 25th Street, New York, New York 10001

Museum at Large, Ltd. Films, 157 West 54th Street, New York, New York 10019

Museum of Modern Art, 11 West 53rd Street, New York, New York 10019

Museum Without Walls, Universal City Studios, Inc., 221 Park Avenue South, New York, New York 10003

National Film Board of Canada, 400 West Madison Street, Chicago, Illinois 60606

NBC Educational Enterprises, 30 Rockefeller Plaza, New York, New York 10020

New York University Film Library, 26 Washington Place, New York, New York 10003

N.I.T., Bureau of Audio Visual Education, School of Education, Indiana University, Bloomington, Indiana 47401

Perennial Education, Inc., 1825 Willow Road, Box 236, Northfield, Illinois 60093

Pyramid Films, Box 1048, Santa Monica, California 90406

Radim Films, Inc., 17 West 60th Street, New York, New York 10023

SIM Productions, Inc., Weston, Connecticut 06880

Sterling Movies, 375 Park Avenue, New York, New York 10022

Syracuse University Film Library, Collendale Campus, Syracuse, New York 13210

Thorne Films, Inc., 1229 University Avenue, Boulder, Colorado 80302

Time-Life Films, 43 West 16th Street, New York, New York 10011

Universal Education Visual Arts, 221 Park Avenue South, New York, New York 10003

University of Illinois Visual Aids Service, 704 South 6th Street, Champaign, Illinois

University of Southern California, Film Distribution Section, University Park, Los Angeles, California 90007

Warren Schloat Productions, Inc., Pleasantville, New York 10570

# SLIDES AND FILMSTRIPS

Alinari Fratelli, Via Nazionale, 6, Florence, Italy 50123

American Council on Education, 1785 Massachusetts Avenue, N.W., Washington, D.C. 20063

American Crafts Council, Research and Education Department, 29 West 53rd Street, New York, New York 10019

American Federation of Arts, 41 East 65th Street, New York, New York 10021

American Library Color Slide Company, P. O. Box 5810, New York, New York 10017

Ancora Productions, Consejo de Ciento, 160 Edificio Creta, Barcelona, Spain

Art Council Aids, Box 641, Beverly Hills, California 90213

Art Institute of Chicago, South Michigan Avenue and East Adams Street, Chicago, Illinois 60603

Audio Visual Center, Indiana University, Bloomington, Indiana 47401

Bailey Film Associates, 11559 Santa Monica Blvd., Los Angeles, California 90025

Dr. Block Color Productions, 1309 North Genese Avenue, Los Angeles, California 90046

Budek Films and Slides, 1023 Waterman Avenue, East Providence, Rhode Island 02906; or P. O. Box 307, Santa Barbara, California 93102

Carnegie-Mellon University, College of Fine Arts, Schenley Park, Pittsburgh, Pennsylvania 15213

Center for Humanities, Inc., 2 Holland Avenue, White Plains, New York 10603

College Art Association, Slide Project (Sterling Callisen) 16 East 52nd Street, New York, New York 10022

Colonial Films, 71 Walton Street, Atlanta, Georgia 30303

Educational Audio Visual, Inc., Pleasantville, New York 10570

Educational Dimensions Corporation, Box 488, Great Neck, New York 11022

ESM Documentation of the Contemporary Arts, C.M., Documentations, 125 Cedar Street, New York, New York 10006

Grolier Educational Corporation, 845 Third Avenue, New York, New York 10022

Haeseler Slide Publishers, 2666 Virginia Street, Berkeley, California 94709

Hester and Associates, 11422 Harry Hines Blvd., Dallas, Texas 75229

Image Color Slides, P. O. Box 811, Chapel Hill, North Carolina 27514

International Film Bureau, Inc., 332 South Michigan Avenue, Chicago, Illinois 60604

I.V.A.C., 37 Rue de Linhout, Brussels, Belgium

Latin American Audio Visual Materials, P392 Pan American Development Foundation, 17th St. and Constitution Avenue, N.W., Washington, D.C. 20006

Life Filmstrips, Time-Life Building, Rockefeller Center, New York, New York 10020

McGraw-Hill, 1121 Avenue of the Americas, New York, New York 10036

McIntire Visual Publications, P. O. Box 297, North Main Street, Champlain, New York 12929

Miniature Gallery, 60 Rushett Close, Long Ditton, Surrey KT7 OUT England

National Gallery of Art, Constitution Avenue and 6th Street, N.W., Washington, D.C. 20001

Pennsylvania Gallery of Fine Arts, Broad and Cherry Streets, Philadelphia, Pennsylvania 19102

Philadelphia Museum of Art, Division of Education, 25th Street and Benjamin

Franklin Pkwy., Philadelphia, Pennsylvania 19130

Dr. Konrad Prothmann, 2378 Soper Avenue, Baldwin, New York 11510

Sandak, Inc., 4 East 48th Street, New York, New York 10017

Saskia, P. O. Box 440, North Amherst, Massachusetts 01059

Society for Visual Education, Inc., 1345 Diversey Pkwy., Chicago, Illinois 60614

Taurgo, 154 East 82nd Street, New York, New York 10028

Thorne Films, Inc., 1229 University Avenue, Boulder, Colorado 80302

University of South Alabama, Department of Art, College of Arts and Sciences, Mobile, Alabama 36608

University Prints, 15 Brattle Street, Harvard Square, Cambridge, Massachusetts 02138

Van Nostrand Reinhold Company, 450 West 33rd Street, New York, New York 10001

Warren Schloat Productions, Inc., Pleasantville, New York 10570

# REPRODUCTIONS

Harry N. Abrams, 110 East 59th Street, New York, New York 10022

American Book Company, 450 West 33rd Street, New York, New York 10001

American Federation of Arts, 41 East 65th Street, New York, New York 10021

Art Education, Inc., Blauvelt, New York 10913

Artext Prints, Inc., Westport, Connecticut 06880

Associated American Artists, Inc., 663 Fifth Avenue, New York, New York 10022

Catalda Fine Arts, Inc., 225 Fifth Avenue, New York, New York 10010

Far Gallery, 746 Madison Avenue, New York, New York 10021

Metropolitan Museum of Art, Fifth Avenue and 82nd Street, New York, New York 10028

Museum of Modern Art, 11 West 53rd Street, New York, New York 10019

My Weekly Reader—Art Gallery, Education Center, Columbus, Ohio 43216

National Gallery of Art, Constitution Avenue and 6th Street, N.W., Washington, D.C. 20001

New York Graphic Society, 140 Greenwich Avenue, Greenwich, Connecticut 06830

Oestreicher's Prints, Inc., 43 West 46th Street, New York, New York 10036

Penn Print Company, 572 Fifth Avenue, New York, New York 10036

Dr. Konrad Prothmann, 2378 Soper Ave., Baldwin, New York 11510

Raymond and Raymond, Inc., 1071 Madison Avenue, New York, New York 10028

Shorewood Reproductions, Inc., Department 2, 724 Fifth Avenue, New York, New York 10019

Skira Art Books, Distributed by World Publishing Company, 2231 West 110 Street, Cleveland, Ohio 44102

UNESCO, Place de Fontenoy, Paris 7e, France

UNESCO Catalogues, Columbia University Press, 440 West 110th Street, New York, New York 10025

University Galleries, Dept. SA, 520 Fifth Avenue, New York, New York 10036

University Prints, 15 Brattle Street, Harvard Square, Cambridge, Massachusetts 02138

Van Nostrand Reinhold Company, 450 West 33rd Street, New York, New York 10001

E. Weyhe, 794 Lexington Avenue, New York, New York 10021

# List of Art Works for Art Auction[*]

| Artist | Title |
|--------|-------|
| Josef Albers | Homage to the Square: Glow |
| Jean Arp | Human Lunar Spectral |
| Francis Bacon | Study for Portrait of van Gogh III |
| Constantin Brancusi | Sleeping Muse |
| Honoré Daumier | Unknown (Toothless Laughter) |
| Stuart Davis | Rapt at Rappaport's |
| Willem De Kooning | Two Women in the Country |
| Edgar Degas | Woman Arranging Her Hair |
| Thomas Eakins | The Violinist |
| Adolph Gottlieb | Two Discs |
| Winslow Homer | Country Store |
| Edward Hopper | Hotel by Railroad |
| Fernand Léger | Still Life: King of Diamonds |
| Morris Louis | Point of Tranquility |
| Reginald Marsh | George C. Tilyou's Steeplechase Park |
| Henri Matisse | Back I |
| Joan Miró | Circus Horse |
| Georgia O'Keeffe | Goat's Horn with Red |
| Pablo Picasso | Head of a Jester |
| Jackson Pollock | Number 3, 1949 |
| Auguste Rodin | Half-Length Portrait of Balzac |
| Charles Sheeler | Staircase, Doylestown |
| Frank Stella | Darabjerd III |
| James A. M. Whistler | Girl in Black |

[*]These are all available (as of July 1976) from the Hirshhorn Museum, Washington, D.C., on 35mm slides.

# BIBLIOGRAPHY

## BOOKS FOR GETTING A BACKGROUND FOR APPRECIATION

Abisch, Roz, and Boche Kapan. *Art Is For You.* New York: David McKay Co., Inc., 1967.

Aitchison, Dorothy. *Great Artists.* Ladybird books, Series on Rubens, Rembrandt, Vermeer, Leonardo, Raphael, Michelangelo, and others. Loughborough, England: Wells and Hepworth Ltd., 1970.

Barkan, Manuel and Laura Chapman. *Guidelines of Art Instruction Through Television For The Elementary Schools.* Bloomington, Ind.: National Center for School and College T. V., 1967.

Belves, Pierre, and Francois Mathey. *Enjoying The World of Art.* New York: Lion Press, 1966.

_____*How Artists Work: An Introduction To Techniques of Art.* New York: Lion Press, 1967.

*The Book of Art.* 10 vol., New York: Grolier Educational Corp., 1966.

Cady, Arthur. *The Art Buff's Book: What Artists Do and How They Do It.* Washington, D.C.: Robert B. Luce, Inc., 1965.

Canaday, John. Mainstreams of Modern Art: David to Picasso. New York: Simon and Schuster, 1959.

Discovering Art Series. *Nineteenth Century, Chinese and Oriental Art, Greek and Roman Art, Seventeenth and Eighteenth Century Art, Art of The Early Renaissance, Art of The High Renaissance, Prehistoric Art, and Ancient Art of The Near East.* New York: McGraw-Hill Book Co.,

Dondis, Doris A. *A Primer of Visual Literacy.* Cambridge: M.I.T. Press, 1973.
Feldman, Edmund Burke. Becoming Human Through Art: Aesthetic Expression in The School. Englewood Cliffs, N.J.: Prentice-Hall, Inc., 1970.

Franc, Helen M. *An Invitation To See: 125 Paintings From The Museum of Modern Art.* New York: Museum of Modern Art, 1973.

Gettings, Fred. *The Meaning and Wonder of Art.* New York: Golden Press, 1963.

Hastie, Reid and Christian Schmidt. *Encounter With Art.* New York: McGraw Hill Co., 1969.

Marcouse, Renee. *Using Objects: Visual Learning and Visual Awareness in the Museum and Classroom.* New York: Van Nostrand Reinhold Co., 1974.

Paul, Louis. *The Way Art Happens.* New York: Ives Washburn, Inc., 1963.

Pickering, John M. *Visual Education in The Primary School.* New York: Watson-Guptill Publications, 1971.

Plummer, Gordon S. *Children's Art Judgment.* Dubuque, Iowa: Wm. C. Brown Co., 1974.

Taylor, Joshua. *Learning To Look.* Chicago: Univ. of Chicago Press, 1961.

# BOOKS FOR CHILDREN TO STUDY

Borreson, Mary Jo. *Let's Go To An Art Museum.* New York: G. P. Putnam's Sons, 1960.

Borten, Helen. *Do You See What I See?* New York: Abelard-Schuman, 1959.

_____. *A Picture Has A Special Look.* New York: Abelard-Schuman, 1961.

Downer, Marion. *Children In The World's Art.* New York: Lothrop, Lee and Shepard Co., Inc., 1970.

Fearing, Kelly, Clyde Martin and Evelyn Beard. *Our Expanding Vision.* Austin, Texas: W. S. Benson Co., 1960.

Glubok, Shirley. *Art of Africa.* New York: Harper & Row, 1965.

_____. *Art of Ancient Egypt.* New York: Atheneum, 1962.

_____. *Art of Ancient Greece.* New York: Atheneum, 1963.

_____. *Art of Ancient Mexico.* New York: Harper & Row, 1968.

_____. *Art of Ancient Peru.* New York: Harper & Row,

_____. *Art of Ancient Rome.* New York: Harper & Row, 1965.

_____. *Art of Colonial America.* New York: Macmillan, 1970.

_____. *Art of India.* New York: Macmillan, 1969.

_____. *Art of Japan.* New York: Macmillan, 1970.

_____. *Art of Lands in the Bible.* New York: Atheneum, 1963.

_____. *Art of the Eskimo.* New York: Harper & Row, 1964.

_____. *Art of the Etruscans.* New York: Harper & Row, 1967.

_____. *Art of the North American Indian.* New York: Harper & Row, 1964.

_____. *Art of the Southwest Indians.* New York: Macmillan, 1971.

_____. *The Art of the Spanish in the United States & Puerto Rico.* New York: Macmillan, 1972.

_____. *Fall of the Aztecs.* New York: St. Martin's Press, 1965.

_____. *Fall of the Incas.* New York: Macmillan, 1967.

Glubok, Shirley, ed. *Digging in Assyria.* New York: Macmillan, 1970.

_____. *Discovering the Royal Tombs at Ur.* New York: Macmillan, 1969.

_____. *Discovering Tut-Ankh-Amen's Tomb.* New York: Macmillan, 1968.

Hollman, Clide. *Five Artists of The Old West.* New York: Hastings House, 1965.

Holme, Bryan. *Drawings To Live With.* New York: Viking Press, 1967.

Janson, H. W. and Dora Janson *The Story of Painting For Young People From Cave Painting To Modern Times.* New York: Harry N. Abrams, Inc., 1962.

Janson, H. W. *History of Art For Young People.* New York: American Book Co., 1971

Kainz, Luise C., and Olive L. Riley. *Understanding Art: Portraits, Personalities, And Ideas.* New York: Harry N. Abrams, Inc., 1967.

Kohn, Bernice. *Everything Has A Shape And Everything Has A Size.* Englewood Cliffs, N. J.: Prentice-Hall, 1964.

Moore, Lamont. *First Book of Architecture.* New York: Franklin Watts, Inc., 1961.

_____. *First Book of Paintings.* New York: Franklin Watts, Inc., 1960.

_____. *First Book of Sculptured Image.* New York: Franklin Watts, Inc., 1967.

MacAgy, Douglas, and Elizabeth MacAgy. *Going For A Walk With A Line: A Step Into The World of Modern Art.* Garden City, N.Y.: Doubleday and Co., Inc., 1959.

Moore, Jane Gaylor. *The Many Ways of Seeing: An Introduction To The Pleasures of Art.* Cleveland and New York: World Publishing Co., 1968.

# INDEX